*Frederic Edwin Church and the National Landscape*

# Frederic Edwin Church

*Franklin Kelly*

NEW DIRECTIONS IN AMERICAN ART

# and the National Landscape

Smithsonian Institution Press, Washington, D.C., London

Library of Congress Cataloging-in-Publication Data.
Kelly, Franklin.
    Frederic Edwin Church and the national landscape.
    (New directions in American art)
    Bibliography: p.
    Includes index.
    1. Church, Frederic Edwin, 1826–1900.   2. Land-
scape painting, American.   3. Landscape painting—
19th century
—United States.   I. Title.   II. Series.
ND237.C52K45   1988      759.13        88-4605
ISBN 0-87474-592-6 (cloth)
        0-87474-563-2 (paper)

British Library Cataloguing-in-Publication Data is
available.

10  9  8  7  6  5  4  3  2  1

The paper used in this publication meets the minimum
requirements of the American National Standard for
Permanence of Paper for Printed Library Materials
Z39.48–1984.

Printed in Hong Kong by South China Printing
Company.

# Contents

# *Preface*

None need be told that Church is great—that he is national.
*The Knickerbocker,* July 1861

And he came to nature not to copy its external features, but with the real inspiration of art, to interpret it.
Charles Dudley Warner, *Paintings by Frederic E. Church, N.A.,* 1900

The subject of this book is the sequence of North American landscapes that Frederic Church created between 1845 and 1860, which I propose should be seen as a series of national images that addressed matters of pressing importance and interest to the American nation. As such, these paintings are distinctly different from the less ambitious works generally created by Church's contemporaries in the Hudson River School. From the first, Church's landscapes were marked by a breadth of scope and a willingness to embrace challenging subjects of profound historical or allegorical significance that went far beyond anything that most of his fellow landscape painters attempted.

Church's contemporaries recognized the potency of his vision of landscape and realized that he was singularly successful in uniting the realistic and factual with the less tangible higher qualities of serious art. For the decade or so that he was at the height of his career, Church was enormously popular, not only with a public that sought entertainment, but also with critics and enlightened connoisseurs who applied loftier standards to their assessment of American art. That Church could succeed in this dual arena, that he could at once entrance the public with the beauty, exoticism, and technical brilliance of his paintings, and win acceptance from aesthetically demanding viewers who studied works of art more probingly is proof that his art was not simply a matter of straightforward realism and nothing more. As Gerald Carr has noted, one particularly astute observer, writing in the *New York Commercial Advertiser* in 1861, compared Church to the English historian Thomas Babington Macaulay in his ability to entertain and instruct, because his paintings had both "those lesser, but 'taking' qualities appreciable by the most uncultivated," and "those higher qualities essential to great art, and only to be recognized by an eye well educated. . . ." Or, as Church's friend Theodore Winthrop observed more succinctly of *The Heart of the Andes:* "A great work of art is a delight and a lesson." The

same can be said of all of Church's most important works, including those defined here as national landscapes.

Many others who have written about Church and his art before me have stressed that to understand him one must look beyond the arresting beauty of his paintings in search of the complex ideas and associations they embody. Even as early as 1900 an anonymous writer in *The International Studio,* although generally critical of Church's works, observed that they were "fundamentally didactic." The basic sense of that assertion—that Church's paintings were somehow instructive and meaningful in their own day—has appeared again and again in subsequent discussions of the painter. As E. P. Richardson wrote in his *Painting in America* of 1956: "His landscapes, too, are filled with light, not only of the sun, but of an intellectual vision." But explaining that intellectual vision precisely and pinpointing what Church was saying in his paintings, and exactly how he managed to convey his meaning intelligibly to his audience, has proven more difficult.

David Huntington, in his doctoral dissertation of 1960 and monograph of 1966, did more than anyone else to answer these questions and explore the full implications of what lay behind Church's vision of landscape. Perceptively seeing in the artist a fertile mix of artistic and intellectual influences from such sources as Thomas Cole, John Ruskin, and Alexander von Humboldt, Huntington defined Church as the leading pictorial spokesman for the era of Manifest Destiny, a new Adam who both explored and interpreted the New World Paradise. Huntington has expanded his interpretation of Church in several recent studies, but his original view of the painter remains the fundamental point of departure for all subsequent scholars.

Recent discussions of Church have stressed the importance of evaluating his accomplishments within a broad cultural context. For Barbara Novak, writing in her 1980 *Nature and Culture,* Church was "a paradigm of the artist who becomes the public voice of a culture, summarizing its beliefs, embodying its ideas, and confirming its assumptions." Similar reasoning has informed two important studies that have greatly enriched our understanding of specific aspects of the artist's work: Gerald Carr's *Frederic Edwin Church: The Icebergs* and Katherine Manthorne's *Creation and Renewal: Views of Cotopaxi by Frederic Edwin Church.*

It has, then, become possible today to appreciate Church and his art in a way that, at least in some measure, approximates the point of view held by his contemporaries. It is the goal of this study to achieve that kind of appreciation of Church's North American landscapes and to trace his changing attitude toward his native land as seen against the background of contemporary cultural and political events. In doing so, I have paid particular attention to Church as the true successor of Thomas Cole, who Tuckerman and many others credited with establishing "landscape painting as a national art in the New World." Seeing Church as Cole's heir is not a new notion by any means; S. G. W. Benjamin, for instance, wrote in 1879 that Church had "carried to their full fruition the aspirations of his master," and Samuel Isham observed in 1905 that "it was probably from Cole that he got the idea that a picture should be grander, more ennobling than a mere transcript of everyday nature." But some more recent writers have tended to downplay Cole's influence, arguing that Church largely abandoned his master's teachings as outmoded and unsuited to the realities of mid-century America.

Nothing could be further from the truth. In fact, recognition of Cole's continuing influence in the 1850s on younger artists is crucial to a complete understanding of the achievements of our national school of landscape. There is, to be sure, a certain amount of appeal and reason in seeing a work such as Asher B. Durand's *Kindred Spirits* of 1849 as perhaps more representative of the next decade than, say, Cole's *The Cross and the World.* But the influence of Cole's allegorical and imaginary landscape style did not die out quite as quickly as has some-

times been assumed. As Jasper Cropsey wrote in 1850 in a letter to his wife: "Though the man has departed, yet he has left a spell behind him that is not broken."

Among Church's early works, there are several major paintings—*Hooker and Company, Christian on the Borders of the 'Valley of the Shadow of Death', To the Memory of Cole, The River of the Water of Life, The Plague of Darkness,* and *The Deluge*—that can only be interpreted as attempts by the young artist to emulate what Cole called "a higher style of landscape." Such works are the proof of just how seriously Church regarded his teacher's grand style, and just how much under his "spell" he remained. Cole's influence is perhaps less easily recognizable in the more seemingly straightforward landscapes that brought Church his first great successes, works such as *West Rock, New Haven, Twilight, "Short Arbiter 'Twixt Day and Night," New England Scenery,* and *Mount Ktaadn.* But it is there nevertheless, and, as I argue in the chapters that follow, these works should be seen as deliberate attempts by the young painter to infuse realistic landscape with deep and profound content. They represent, in essence, a melding of the strains of the real and the ideal that had, in Cole's art, seemed irreconcilable.

Church did, of course, ultimately develop his own powerful and distinct manner that was different from Cole's in many ways. By the late 1850s and 1860s, Church had perfected his brand of scientific realism fused with epic scope and exotic subject matter, and he was creating some of the most ambitious landscapes—works such as *The Heart of the Andes, Twilight in the Wilderness, The Icebergs,* and *Cotopaxi*—created by any artist of the nineteenth century. Yet, the very ambition of these works, their seriousness and moral purpose, represent Church's greatest homage to his master, the "full fruition" of Cole's "aspirations."

If Cole did aspire to teach Americans something about themselves and about their nation through the means of landscape, he never succeeded to the extent that his pupil did. For in the series of national landscapes that form the subject of this book Church did precisely that, creating a body of work that is unquestionably among the supreme achievements of the era.

# Acknowledgments

This study had its genesis in two earlier projects concerned with Church and the North American landscape. The first was my doctoral dissertation for the University of Delaware, "Frederic Edwin Church and the North American Landscape, 1845–1860," completed in 1985. The second was an exhibition of Church's early landscapes that Gerald Carr and I organized at the Amon Carter Museum in Fort Worth, Texas, in the spring of 1984. This exhibition was the occasion for the annual Anne Burnett Tandy Lectures in American Civilization, which were delivered by Carr and myself. The lectures, along with a catalogue of the exhibition, have recently been published as *The Early Landscapes of Frederic Edwin Church, 1845–1854* (Fort Worth: Amon Carter Museum, 1987).

Although I have endeavored to refine and, in some cases, expand, the arguments presented in my dissertation and in the Amon Carter Museum publication, much of what I set forth here had its first airing in those earlier studies. Accordingly, to all of those associated with these projects I owe a special debt of thanks. First and foremost, I am grateful to Wayne Craven, my advisor, who has enthusiastically supported and encouraged my work on Church from the first. My thanks also to the other members of my dissertation committee, Nina Kallmyer, Damie Stillman, and John Wilmerding, all of whom provided useful comments after reading the dissertation. John Wilmerding, in particular, deserves special thanks for his generous and continuous support, which has aided me in more projects than just this one. I am very grateful to the staff, both present and former, of the Amon Carter Museum, all of whom ably assisted me in my work on the exhibition and Tandy lectures. In particular, I appreciate the efforts of Matthew Abbate, Linda Ayres, Carol Clark, Jane Myers, Jan Muhlert, and Ron Tyler. Select material from the Amon Carter publication is reprinted here in slightly different form by kind permission of the Amon Carter Museum.

Many other individuals have provided generous assistance during the course of my work on Church, and it is a pleasure to acknowledge them here. I owe a primary debt to several other students of the artist's work, most notably David Huntington. His challenging and brilliant approach to Church and his extraordinary understanding of the artist and his era have been of constant inspiration, and information he provided at various points helped make my task inestimably easier. Special thanks also to Gerald Carr, with whom I enjoyed working on the Amon Carter projects. Carr's work on the artist has been of exceptional importance and has already borne fruit in a number of key studies. Church scholars will welcome Carr's forthcoming catalogue of the artist's works in the collection of Olana. Carr has constantly helped me with information, and he and I have spent many enjoyable hours discussing Church and his art, for which I am grateful. Katherine Manthorne's work on Church and South America has proven equally stimulating and helpful, and to her I also extend grateful appreciation.

Anyone who has worked seriously on Church will understand the very special thanks I owe to James Ryan and the staff of the Olana State Historic Site near Hudson, New York. To have access to the rich bounty of material there is a great privilege, and to experience the beauty and wonder of Church's own home is, in itself, an extraordinary pleasure.

The National Gallery of Art has provided important support at various points in my work on Church. A Samuel H. Kress Fellowship at the Center for Advanced Study in the Visual Arts during 1981–83 allowed essential time for concentrated research and writing. More recently I have been given research leave from my position at the Gallery while I was completing the manuscript for this book. To my colleagues at the Gallery and, most especially, to my associate in the Department of American Art, Nicolai Cikovsky, Jr., go my thanks.

Many museums, dealers, and private collectors helped by supplying information and photographs and by allowing me to examine works by Church in their possession. In addition, the following individuals deserve thanks for special assistance and encouragement: Nancy Anderson, Kevin Avery, Annette Blaugrund, Doreen Burke, Russell Burke, Cheryl Cibulka, Michael Conforti, Elaine Dee, Charles Eldredge, Stuart Feld, Abigail Gerdts, Linda Jackson, Christopher Johns, Elizabeth Johns, George Keyes, Brian Lukacher, Angela Miller, Colonel Merl M. Moore, Jr., M.P. Naud, Gwendolyn Owens, John Peters-Campbell, Susan Rather, Paul Schweizer, J. Gray Sweeney, William Talbot, Virginia Wagner, Allan Wallach, Christopher Kent Wilson, and Kathy Kuhtz.

At the Smithsonian Institution Press, I am grateful to Amy Pastan, Michelle Smith, and Janice Wheeler.

All of those whom I have acknowledged rightfully expected that I would make the most of the assistance and encouragement they offered. If this book has failed to live up to their expectations, or if it contains errors of specific fact or general substance, I have only myself to blame.

Finally, my thanks to my family. And to Karen, who willingly accepted a husband who came encumbered with a manuscript to complete, and who steadfastly encouraged him to do so, my loving thanks.

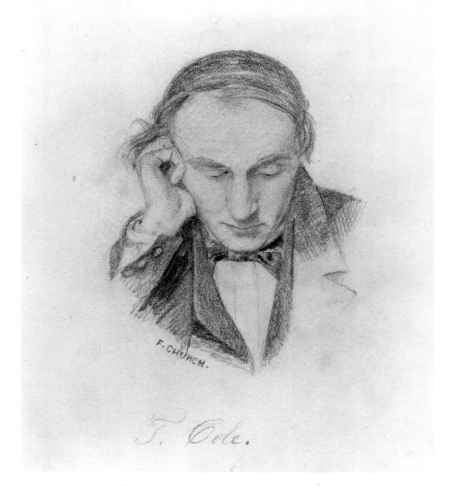

1. Frederic Edwin Church, *Portrait of Thomas Cole*,
c. 1845, pencil on paper, 6⁷/₈ × 6 in., private collection.

# Chapter I · Thomas Cole's Pupil

I have frequently heard of the beautiful and romantic scenery around Catskill . . . it would give me the greatest pleasure to accompany you in your rambles about the place observing nature in all her various appearances.
Frederic Church to Thomas Cole, May 20, 1844

. . . it was with Mr. Cole in his Catskill home, that Mr. Church was stimulated in his love of nature, and began to learn how to interpret it.
Charles Dudley Warner, *Paintings by Frederic E. Church, N.A.* (1900)

Frederic Church began his career as a painter of the American landscape under singularly favorable circumstances. Born in Hartford, Connecticut, Church was the son of a wealthy and prominent family that made certain he had "every advantage" once they were reconciled to his chosen profession.[1] And there could have been no greater advantage for an aspiring landscape painter in America during the 1840s than an apprenticeship with Thomas Cole (1801–48). Nor could there have been a more appropriate place to begin than in the shadow of the Catskills, which had already become the symbolic heart of a new national school of painting.

In June of 1844, when Church arrived in Catskill, Cole was at the height of his fame as America's preeminent landscape painter. Many triumphs—the great early wilderness pictures, *The Course of Empire, The Voyage of Life,* and others—were behind him, with the undoubted promise of more to come. Cole, however, had never before accepted a formal pupil, and Church was acutely aware of his good fortune.[2] "If unremitting attention and activity can accomplish anything," he wrote, "it shall not be my fault if I am not a worthy pupil of so distinguished an artist."[3] To this vow of industriousness Church added one of serious purpose: "My highest ambition lies in excelling in the art [of landscape painting]. I pursue it not as a source of gain or merely as an amusement, I trust I have higher aims than these."[4]

Admittedly, these are the words of a supplicant eager to please, but Church's youthful respect for Cole and his art was genuine, and it would grow ever stronger. As he wrote late in life, "Thomas Cole was an artist for whom I had and have the profoundest admiration."[5] Church left us telling evidence of that admiration in a small pencil drawing of his teacher deep in thought (figure 1)—a moving portrait of Cole as a sensitive, imaginative genius.[6] To understand Church's development over the course of his own highly successful career, and to appreciate his lifelong debt to his teacher, requires

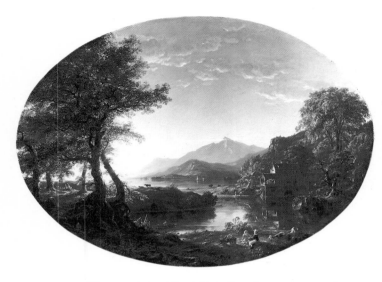

2. Thomas Cole, *The Old Mill at Sunset,* 1844, oil on canvas, 26¹/₈ × 36 in. (oval), collection of Jo Ann and Julian Ganz, Jr.

recognition of the importance of his early training at Catskill. Henry Tuckerman, although seeing little affinity between the two artists, admitted that it was "impossible that an artist could live with Cole without deriving from his pure and earnest love of beauty, and reverent observation, invaluable suggestions."[7] Louis Noble, Cole's biographer and Church's close friend, was more succinct: "Those pleasant days, when his artistic talents were directed by his distinguished master, will ever occupy a large place in the memory of the pupil."[8]

We know little about the precise nature of Church's apprenticeship with Cole, not even if they followed any systematic course of study. Doubtless Cole gave a certain amount of technical instruction in drawing, composition, and the like, but it was probably limited. Church already had, according to Cole, "the finest eye for drawing in the world," and his earliest drawings reveal a level of competence that equaled, or even surpassed, that of his master.[9] Of far greater importance for Church in his time with Cole was "the conversation of so noble and true a man, and the mutual study of nature."[10] Throughout his career Cole had willingly expressed his theories about art and nature to those who cared to listen, and he surely did so with his young pupil. We cannot, of course, reconstruct the conversations that they had. But we can outline what Cole believed about art in the 1840s and what he would have imparted to Church. To do so is crucial to grasping the full richness and complexity of Church's art, for he retained much of what Cole taught him and drew inspiration from it throughout his career in continually inventive ways.

In the mid-1840s Cole was more committed to his ideals about art than at any other time in his career, but seemingly less able to put them into practice. His American landscapes of the period—often late afternoon and twilight scenes—are radiantly peaceful, with less reliance on the dramatic and Sublime effects that had characterized so many of his early works. Such paintings as *The Old Mill at Sunset* (figure 2), *The Hunter's Return* (figure 42) and

*Home in the Woods* (figure 3) are among Cole's most beautiful. Clearly, these were painted by an artist who could pronounce himself "content with nature."[11] He shows man comfortably at home in the American environment; the tumultuous skies, twisted trees, and gaping chasms that dramatically punctuated Cole's earlier works are no longer present. Now the forms of nature—trees, fields, lakes, and mountains—gently frame the area of man's activities. Although this pictorial format is reminiscent of the Claudian mode Cole had often used before, it now carried greater conviction. A strong autobiographical urge permeates these works, as if Cole identified—as he surely did—with the archetypal settlers and pioneers he painted. But paintings such as *The Hunter's Return* and *Home in the Woods,*

although they embraced and promulgated one of the most cherished mythic symbols of mid-nineteenth century America—the self-reliant, virtuous pioneer family living on the fringes of civilization—represented the more personal, less ambitious side of Cole's art than the great public serial pieces he considered "a higher style of landscape."[12]

In the mid-1840s, when Church joined him in Catskill, Cole was hard at work on what would prove to be his last such suite of works, *The Cross and the World* (figure 4), which remained unfinished at his death in 1848. In these Cole grappled

3. Thomas Cole, *Home in the Woods,* c. 1846, oil on canvas, 44 × 66 in., Reynolda House Museum of American Art, Winston-Salem, North Carolina.

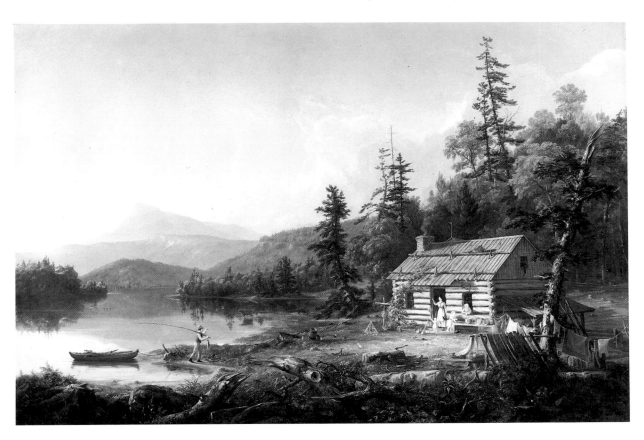

4

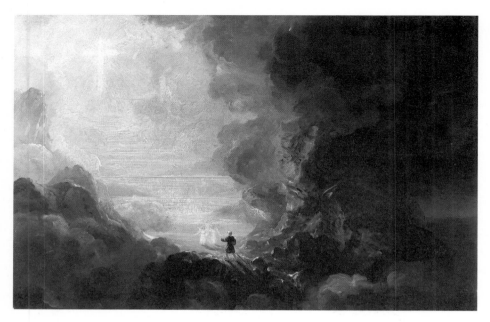

4. Thomas Cole, *The Pilgrim of the Cross at the End of his Journey,* 1846–47, oil on canvas, 12 × 18 in., National Museum of American Art, Smithsonian Institution, Washington, D.C., museum purchase (1965.10).

with complex theological issues concerning the individual's quest for salvation. *The Cross and the World* was not only the most overtly religious of Cole's works, but also the most abstract stylistically.[13] Whereas his American landscapes of the period were increasingly attuned to natural beauty (reflecting his contentment with nature as it was), his allegorical works came to depend less on the faithful depiction of natural forms and more on the imagination. As Barbara Novak has stated, "The real and the ideal, which had so often conflicted in his art, seem to have separated out like oil and water."[14]

The issue, however, was almost certainly not so easily laid to rest for Cole, nor was the separation so completely achieved. For although Cole perfected a new approach to American nature in the 1840s—a vision that was charged with a new sense of clarity and conviction—he was not able to find a comparable means for bringing his allegorical and imaginary works to completion. Cole's last years were marked

by numerous unfinished works of considerable ambition, of which *The Cross and the World* was only the most well known.[15] He was, in fact, facing a dilemma that pitted his successful new style of American landscape against the tired if not altogether exhausted mode of grand allegorical pictures.

Frederic Church, even though a novice, would have recognized that dilemma. He could watch Cole paint with considerable authority such works as *The Hunter's Return,* but also see him labor without resolution on *The Cross and the World.* The experience forcefully conveyed to Church not only the vital appeal of Cole's American landscape style, but also just how deeply held were his master's convictions about the higher purposes of landscape art. As Cole wrote: "An artist should be in the world, but not of it: its cares, its duties he must share with his contemporaries, but he must keep an eye steadfastly fixed on his polar star, and steer by it whatever wind may blow."[16] Church, as time would prove with resounding certainty, turned out to be a far better and far more successful helmsman than Cole in following that elusive course.

Church patterned his early approach to painting landscapes along lines very similar to his master's, and his first works reveal a pronounced dependence

on Cole for both stylistic and thematic guidance. A small oval picture known as *Twilight Among the Mountains* (figure 5)—in all likelihood one of the two works Church exhibited in his debut at the National Academy of Design in 1845—readily invites comparison with such works by Cole as *The Old Mill at Sunset* (figure 2).[17] Beyond the obvious similarity of the oval format (which Church would abandon after the 1840s), Church's painting shows a close relationship to Cole's work in composition, coloring, and light effects. Just as in *The Old Mill,* we see a peaceful scene with a foreground stage for figures (children in both cases), large framing trees, a body of water in the middleground, and gentle hills giving way to mountains in the distance. Everything is bathed in the golden glow of late afternoon, and an appealing sense of day's peaceful resolution prevails.

During the mid-1840s Cole's contentment with American nature and his increasing interest in depicting scenes where man and nature existed in harmony led him away from the dramatic wilderness themes that had earlier been his specialty. Even as early as 1835, in his "Essay on American Scenery," Cole had noted the attractions of the civilized landscape when he wrote:

> The cultivated must not be forgotten, for it is still more important to man in his social capacity—necessarily bringing him in contact with the cultured; it encompasses our homes, and, though devoid of the stern sublimity of the wild, its quieter spirit steals tenderly into our bosoms mingled with a thousand domestic affections and heart-touching associations—human hands have wrought, and human deeds have hallowed all around.[18]

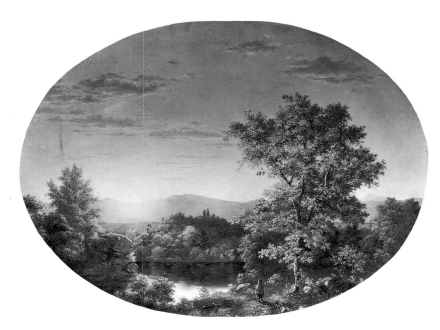

5. Frederic Edwin Church, *Twilight Among the Mountains*, c. 1845, oil on canvas, 16¹/₄ × 23¹/₄ in. (oval), New York State, Office of Parks, Recreation and Historic Preservation, Olana State Historic Site (OL.1981.25).

*The Old Mill at Sunset* is a perfect pictorial statement of this aspect of Cole's interpretation of the American landscape. The forms of nature are carefully placed, providing comfortable and secure locales for human habitation, which seems to intrude little upon the calm order of the natural world. Still, Cole's lingering pessimism about man's ultimate effect on nature is evident in the presence of a favorite motif—the sawn tree stump, an unmistakable symbol of America's brutal subjugation of the wilderness.[19]

Church's early landscapes evince a similar point of view, although with no trace of Cole's pessimism. *Twilight Among the Mountains,* while far less complex than *The Old Mill at Sunset,* is equally a vision of American nature as compatible with American civilization. The child who walks along the path (possibly Cole's son Theodore, who often accompanied Church on his outings) is clearly not an intrepid pioneer braving a hostile wilderness, but is at home in an already-settled and tamed environment. Other early works by Church, such as *The Catskill Creek* (ca. 1845, Olana State Historic Site), show precisely the same attitude, and this vision of the North American landscape dominates his work for much of the next ten years. Church's deliberate choice of such subject matter and his continual celebration of man's place in nature expressed his own deeply held ideas about the identity and character of the American nation at mid-century.

*Twilight Among the Mountains* and other landscapes from 1845–46 indicate that Church was quickly mastering the basic conventions of landscape painting. Cole must have been pleased with his young pupil's progress, because he soon gave him a more ambitious assignment. By the time of the spring exhibition at the National Academy of Design in 1846, Church had painted a large landscape that marked his first effort in the "higher style of landscape" his teacher held so dear. *Hooker and Company Journeying Through the Wilderness from Plymouth to Hartford, in 1636* (colorplate 1) was

Church's first important success, for in the fall of 1846 the Wadsworth Gallery (now the Wadsworth Atheneum) in Hartford purchased the painting.[20]

The story of Reverend Thomas Hooker's departure from Massachusetts and the founding of Hartford had special relevance for Church, because he was a native of Hartford and numbered among his ancestors one of Hooker's elect band.[21] Hooker had come from England to Massachusetts in the fall of 1633 and had been appointed pastor of the Newtown parish.[22] After barely six months, Hooker and his congregation had become restless, feeling they had not been allotted enough land. Although granted permission to find a new site within the established colony, Hooker declined, feeling it was too crowded, with the existing towns already too closely grouped. In June of 1634 Hooker sent six of his followers on a mission "to discover the Connecticut River," and in September the members of the Newtown parish formally requested permission to move.[23] The leaders of the colony, feeling this would represent a break of the covenant, refused. By May of 1636 Hooker and his congregation had agreed to defy the colony and leave, and it was their momentous journey that Church chose to portray in his painting.

Despite Church's personal interest in the story, it was almost certainly his teacher who suggested it to him, for it appears on Cole's list of possible subjects for paintings:

> The migration of the settlers from Massachusetts to Connecticut—through the wilderness—see Trumbull's History of Connecticut—history of the U.S.[24]

Cole no doubt gave his pupil close guidance on the painting's overall conception, but the precise details Church would have needed were provided by Benjamin Trumbull's account.[25] According to Trumbull, the group made their way more than a hundred miles through a "hideous and trackless wilderness" and "over mountains, through swamps, thickets, and rivers, which were not passable but with great difficulty." The people carried their own posses-

sions and drove with them a hundred and sixty cattle. Mrs. Hooker, who was in frail health, was "borne through the wilderness upon a litter."

Church carefully constructed his painting to provide appropriate places for the various historical details. There is the litter carrying Mrs. Hooker, several cows, and a representative sampling of the men, women, and children—all in seventeenth-century dress—who made up Hooker's band. The handling of the foreground, with its tangle of branches, roots, rocks, and undergrowth, recalls the expressive language of Cole's wilderness pictures, but the rest of the landscape hardly suggests the "hideous and trackless wilderness" of Trumbull's account.[26] In Church's precisely ordered scene the settlers follow a path that leads them across a shallow ford and then turns toward their goal. A small figure indicates with authority the direction the travelers are to go; there is no hint that they might become lost in the wilderness. Instead, they pass through the area unimpeded, as if God had cleared their way by parting this New World equivalent of the Red Sea.

Church's interpretation of Hooker's journey accorded perfectly with the view held by many of his contemporaries. By the mid-nineteenth century the story had been elevated to the status of epic legend and had come to be seen as an archetypal American experience embodying religious principles, moral courage, and the drive to settle the vast unexplored reaches of the country.[27] Hooker's journey provided the mid-nineteenth century with an appealing, and ennobling, historic justification of the politics of expansionism. It thus had, beyond its specific relevance for Connecticut history, potent larger associations for the national identity. As one of Church's contemporaries wrote:

> What was this band, now composed, that thus ventured through the wilderness to found a Town, and aid to found a state? One of the exiles from their fatherland for faith and liberty—a band of serious, hardy, enterprising hopeful settlers, ready to carve out, for themselves and their posterity, new and happy homes

6. Thomas Cole, *The Departure*, 1837, oil on canvas, 39 3/4 × 63 in.; in the collection of the Corcoran Gallery of Art, gift of William Wilson Corcoran, 1869 (69.2).

> in a wilderness—there to sink the foundations for a chosen Israel—there to till, create, replenish, extend trade, spread the gospel, spread civilization, spread liberty—there to live, act, die and dig quiet sepulchres, in a hope and happiness that were destined to spring, phoenix-like, from the ashes of one generation to illumine and beautify the generation which was to succeed.[28]

One could hardly ask for a more complete catalogue of American virtues and American aspirations, or a more appropriate subject for an ambitious young American landscape painter.

Church's debt to his master's painting style remains evident in *Hooker and Company*. Comparison with Cole's *Departure* (figure 6), for example, reveals that Church made use of a similar composition employing large framing trees, a stagelike area for the figures, and a path that moves laterally across the picture plane and then turns abruptly into the distance. There are other similarities, but also indications of Church's own developing manner. A crisp, precise brushwork, already evident in his works from 1845, is even more noticeable here. Every form is described in intricate detail, and one suspects that Church was displaying his virtuosity in this important picture. Although traces of impasto reminiscent of Cole's manner remain, the

7

picture is manifestly more controlled and less technically expressive than anything the older man ever painted. Its calmness and its literalness aligned it far more to the future of American landscape painting than to its past.

Church's most significant departure from Cole's manner, however, was in his handling of light.[29] Rather than obscuring the sun behind a group of trees, as Cole did in *Departure,* Church located it just above the horizon. Light fills the scene as it radiates through the sky, reflects from the water, and shines on rocks and trees. Although its golden tone might suggest ancestry in Claude Lorrain's great idylls, Church's light is too direct and brilliant to have much in common with such vaporous presentations. It is a purifying and revealing presence in the landscape, an agent of clarity and revelation, not of diffusion and obscurity. From this moment, symbolically charged light would be a central element in Church's art.

This intense focus on the sun might be seen as reflecting Church's preoccupation with the observation of atmospheric effects.[30] However, light must also be seen as integral to the meaning of the picture. Even without the figures, which are only minor elements in the overall scheme, the landscape could be recognized as an image of a world blessed with promise by divine light. The emphatic rays of light, which fan out from the sun like the spokes of a great cosmic wheel, recall those seen emanating from God, Christ, the Holy Spirit, or various saints in countless Christian images.[31] Appropriately, the sun's rays illuminate everything except the deepest (and most impure) recesses of the wilderness. The travelers pass out of darkness into light, and the way is shown to them not only by the terrestrial path, but also by heavenly light. This physical journey of men across the New World landscape to a new home becomes a spiritual journey to salvation emblematic of the young nation's drive toward its ordained destiny. Church reserved the most brilliantly lit area of the entire canvas for the goal of

that journey. As a Connecticut historian later wrote:

> Ere long they reached the summit of the hill where the path broke from the forest's shade into the plantation's clearing. Thus the glories of the Connecticut valley, of which they had so often dreamed, burst upon their view.[32]

The journey is near its end, and the faithful are about to be rewarded for their courage and belief.

The general religious character of *Hooker and Company* is reinforced by its echoing of two great biblical journeys, the flight into Egypt and the exodus of Moses and the children of Israel. The linking of Moses and Hooker would have been a particularly fitting example of New World typology, and it was one that Church certainly intended. In the same year he completed *Hooker and Company,* Church also painted a small oil of *Moses Viewing the Promised Land* (figure 7). Significantly, Moses,

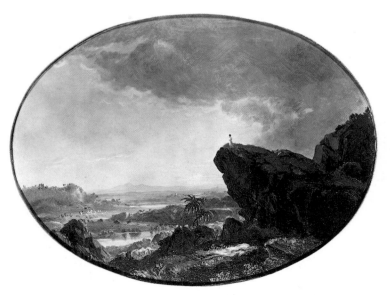

7. Frederic Edwin Church, *Moses Viewing the Promised Land,* 1846, oil on academy board, 9½ × 12¼ in. (oval), collection of Dr. Sheldon and Jessie Stern; photograph courtesy of Kennedy Galleries, New York.

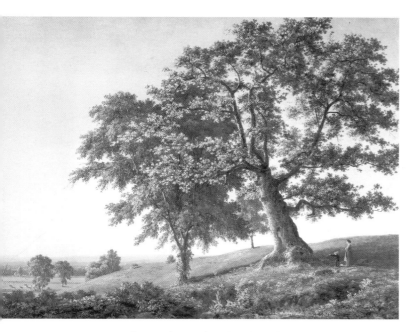

8. Frederic Edwin Church, *The Charter Oak,* 1847, oil on canvas, 22¹/₈ × 30¹/₈ in., New York State, Office of Parks, Recreation and Historic Preservation, Olana State Historic Site (OL.1981.16).

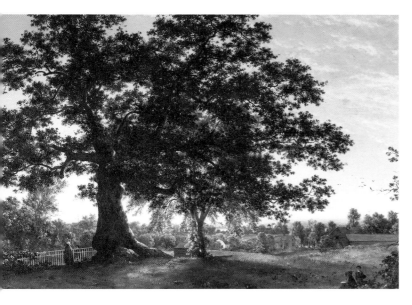

9. Frederic Edwin Church, *The Charter Oak at Hartford,* c. 1846–47, oil on canvas, 24 × 36 in., collection of Mary M. G. Donley.

perched on a high rock, looks out across a verdant valley into the sun. In both *Moses* and *Hooker* Church allowed the viewer to participate in a moment of optimistic joy and promise as the peaceful landscape is revealed to biblical and New World traveler alike. The difference, of course, was that Hooker and his New World followers did not, like Moses and the children of Israel, lose their way on their journey to salvation. In 1846, Church was confident that the American nation would also reach its glorious destiny without difficulty and without straying from the path of righteousness.

In painting *Hooker and Company* Church may have been responding to a general call in the 1840s for works of art that dealt with great events from America's past. Artists were encouraged to depict "some of the instructive events of our own history," especially those of "moral grandeur and heroism."[33] Although Church would never again paint a work that portrayed a specific historical event, over the next year or so he did turn to several subjects that had potent historical associations.

One of these was the famous Charter Oak in Hartford, which Church painted twice in 1846 (figures 8 and 9). This venerable tree was well known to artists of Church's era, although none before him had portrayed it in a major picture. Cole had sketched it around 1827 when in Hartford working on a commission for Daniel Wadsworth, and William Sidney Mount made a sketch of it in July 1843 while on his way to Catskill to visit Cole.[34] Church first drew it in 1845, and then again in 1846.[35]

The Charter Oak was located on an elevation in the southern part of Hartford and was a favorite stop for visitors touring the city.[36] In 1686 Sir Edmund Andros, first Governor-General of New England, had written to the colony of Connecticut, which had been founded by Hooker and his followers a half century earlier, demanding that they resign their charter. When they refused, Andros took troops to Hartford, intent on seizing the charter by force. During a meeting of the opposing sides the

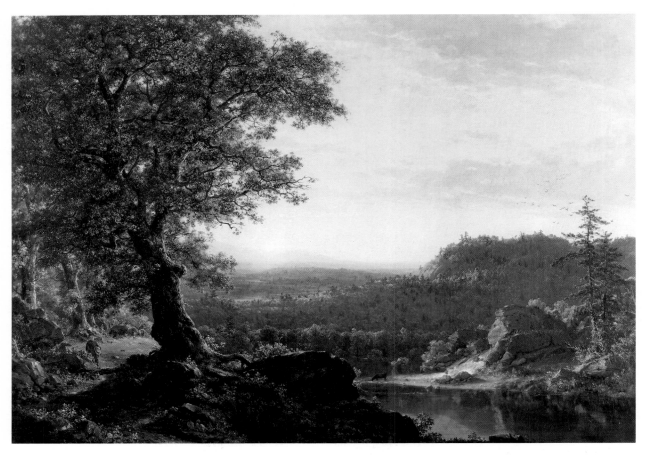

10. Frederic Edwin Church, *July Sunset,* 1847, oil on canvas, 29 × 40 in., private collection.

lamps illuminating the room were suddenly extinguished, and when they were relit, the charter was gone. According to legend, Captain Joseph Wadsworth (ancestor of Daniel Wadsworth) had taken the charter and hidden it in a cavity of a great oak, and it was this tree that became famous as the Charter Oak. By the mid-nineteenth century the tree was already over three hundred years old, battered by the elements but still standing, "vigorous and strong, reminding us of other days, and pointing with cheerful hopes to the future."[37]

Church, although surely aware of the story of the Charter Oak, chose not to portray the historical event, as Cole might well have done (and as he himself had done in his *Hooker and Company*), but instead depicted the site as it was in his own time. That he made this kind of temporal adjustment, and would do so again as in *West Rock, New Haven* of 1849, is significant, for it suggests that he now believed the importance of such historical events lay in their relevance to the present. America could cherish inspiring memories from its early years but could also learn from them. For Church the Charter Oak was a subject rich in past associations and in timely lessons.

Church exhibited one of his paintings of the Charter Oak at the American Art-Union in New York in the fall of 1847, along with four other works. Two other pictures were on view at the National Academy the previous spring, and Church thus had a total of seven works before the New York public in 1847. He began to receive lengthier and more carefully considered reviews. A growing demand for paintings, both from the general public

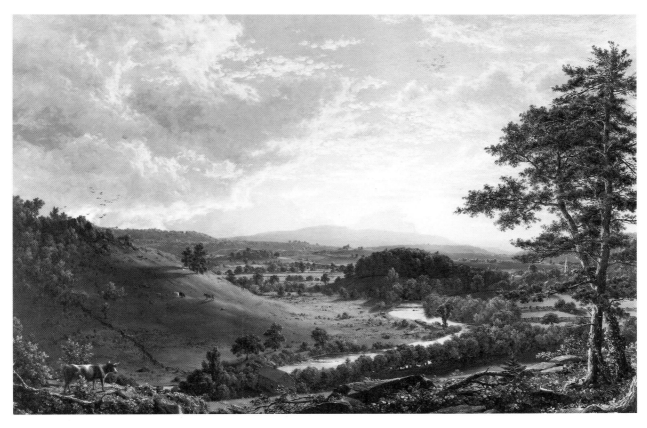

11. Frederic Edwin Church, *View Near Stockbridge,*
1847, oil on canvas, 27¼ × 40 in., private collection.

and from the Art-Union, which purchased works for distribution by lottery, made this an opportune time for a young painter. Church, no doubt with Cole's blessing and encouragement, left Catskill and after a brief stay in Hartford established his residence in New York in the fall of 1847.[38]

Church now began a period of considerable productivity, creating numerous fine works depicting the scenery he had come to know well in Massachusetts and New York. Many of his landscapes of 1847–48, such as *July Sunset* (figure 10), which shows Catskill Creek, and *View Near Stockbridge* (figure 11) portray well-settled areas where the wilderness had long before been tamed.[39] Man seemed to have settled peacefully into American nature, adapting it and modifying it, to be sure, but not

destroying it. In the 1840s it was easy to believe that New England had always been composed of cleared fields picturesquely interspersed among hills and forests. Most of the area had been inhabited and cultivated for a century or more, and the scars of deforestation had long since disappeared. The dense primeval forest was now but a memory increasingly tinged with romantic nostalgia.

Church had taken a similar point of view in his earliest paintings, which usually contained some trace of man and his works. In taking this view, however, he was avoiding, whether consciously or not, what was the key dilemma facing any interpreter of American nature in the 1840s: the recognition of the inherent, unavoidable conflict between the growth and expansion of American civilization and the preservation of American nature. It was, of course, a dilemma well known to Cole, to James Fenimore Cooper, to William Cullen Bryant, and to countless others who wrote and spoke about it in

the years before the Civil War. An essential ingredi-
ent in the national identity—untouched wilder-
ness—was being sacrificed to the demands of
progress. Landscape painters were inevitably faced
with a choice. Should they depict the raw, undis-
turbed wilderness that was, even in the 1840s, al-
ready becoming scarce in the East, or should they
paint the type of landscape they more commonly
saw, which was punctuated with farms, cleared
fields, and settlements? Opinion was divided.
Cooper, for example, observed:

> It has been a question among admirers of natural sce-
> nery, whether the presence or absence of detached
> farm-houses, of trees, of hedges, walls and fences, most
> contribute to the effect of any inland view.[40]

Thomas Cole had ultimately faced the inevitabil-
ity of progress in America's ceaseless expansion into
new territory (as in *Home in the Woods,* figure 3),
but still decried the "ravages of the axe" until his
dying day.[41] Some observers openly called for a na-
tional art that celebrated wilderness. In 1847 the
critic for *The Literary World* made his feelings clear
in a now-famous statement:

> We wish it were in our power to impress it upon the
> minds of our landscape painters, particularly, that they
> have a high and sacred mission to perform; and woe
> betide them or their memories if they neglect it. The
> axe of civilization is busy with our old forests, and
> artisan ingenuity is fast sweeping away the relics of our
> national infancy. What were once the wild and pictur-
> esque haunts of the Red Man, and where the wild deer
> roamed in freedom, are becoming abodes of commerce
> and seats of manufactures. Our inland lakes, once shel-
> tered and secluded in the midst of noble forests, are
> now laid bare and covered with busy craft; and even
> the old primordial hills, once bristling with shaggy pine
> and hemlock, like old Titans as they were, are being
> shorn of their locks, and left to blister in the cold na-
> kedness of the sun.[42]

Church almost certainly read these very words,
because they appeared in a review of the annual
exhibition of the National Academy, which in-
cluded two of his works. Nevertheless, most of his

paintings of this period (although there are excep-
tions) suggest that depicting the vanishing wilder-
ness was not for him a major concern. On the
contrary, he deliberately sought out places already
visited by the "axe of civilization." And the majority
of the landscapes he exhibited in these years—those
he chose to represent him before his critics and pub-
lic—almost always included houses or mills, domes-
ticated animals, and human figures. Unlike the
Transcendentalist George Ripley, who considered
American rural scenery ugly, Church clearly found
beauty in such scenes.[43] Yet one wonders what else
he found in them, and whether they offered special
meanings that could account for his persistent re-
turn to them. More important, what do these paint-
ings tell us about Church's early attitude toward the
national landscape?

A key to answering such questions is provided by
an event that occurred in 1847 at a meeting of New
York's Sketch Club. The Sketch Club had under-
gone various changes since its founding ten years
earlier, but its primary purpose was still to bring
together artists, and others, for an evening of
amusement and conversation.[44] At each meeting the
host suggested a subject, which the members would
then spend an hour drawing, each interpreting it
according to their own ideas. The subject for the
meeting in question was "Too Soon," and most of
the results were predictable.[45] One artist showed a
dying horse, whose rider was waving off vultures
with a Colt revolver, and another depicted a group
of boys falling through ice. Yet another showed a
boy arriving at school before the appointed hour,
and two of the artists portrayed the figure of Death,
in one case interrupting the activities of a painter,
and in the other putting an end to the pleasures of a
gourmand.

Church, however, painted a landscape showing
"a family grocery store established in an almost un-
inhabited wilderness." A small painting (figure 12)
that is certainly Church's interpretation of "Too
Soon" has recently been identified.[46] A substantial
family store seems to have been dropped into the
wilderness, and its only surroundings are stumps,

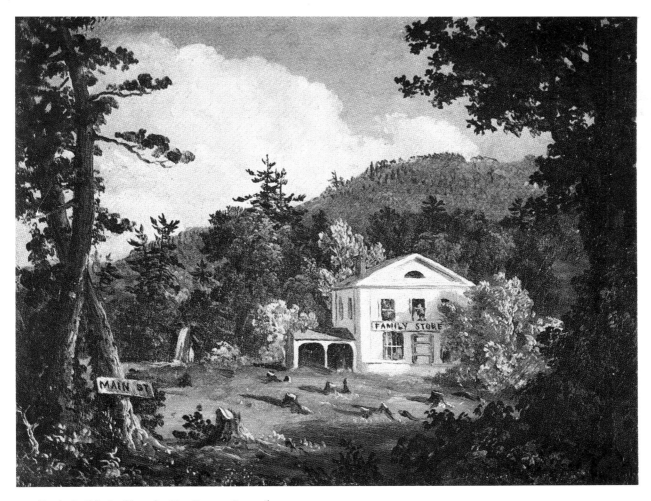

12. Frederic Edwin Church, *Too Soon,* 1847, oil on board, 7 × 9 in., Arvest Galleries, Inc., Boston.

trees, and hills. No other habitation or sign of man is visible. A crude sign reading "Main Street" has been nailed to a foreground tree, but the road, if it can be called that, seems to come from and go nowhere.

Church had a marvelous sense of humor, frequently exercised, and this small sketch is undeniably amusing. Without attaching too much significance to this product of an evening's entertainment, it is nevertheless a most revealing document. Whereas his fellow artists all chose conventional subjects that might have occurred to an artist of any nationality, Church created a scene with unmistakable national overtones. Wilderness was essentially American, as the writer for *The Literary World* made clear. Moreover, the collision of American civilization with American nature, as stated so economically in Church's sketch, was, as has been discussed, one of the most emotionally charged issues of the day. The sketch is humorous, but with a core of serious meaning.

The growth and change that were hallmarks of American life in the 1840s were not ignored by Frederic Church, nor did he look at them with profoundly mixed emotions, as did Cole. The family that established its store in the wilderness was guilty only of being a little premature in its enthusiastic efforts to settle the new land. Church did not portray them as despoilers of American nature or defilers of the national identity. On the contrary, they embodied for him essential American traits and val-

14

ues just as much as did Thomas Hooker and his followers. Better to do something "too soon," Church might have argued in 1847, than to do nothing at all. The future greatness of America could only be attained through the efforts of its most industrious citizens, those who believed in its potential and who were willing to make responsible use of its natural bounty. Whether expressed historically—as in *Hooker and Company*—or in terms of the present moment—as in *Too Soon*—Church's early commitment to that vision was unshakable.

In the late 1840s Church was a constant witness to what Americans were doing to the landscape, for his travels took him far and wide throughout rural New England during a period of considerable change. In several drawings and paintings Church prominently portrayed one of the era's most potent symbols of change, the sawmill. Few artists of his day dared include this troublesome emblem of progress in their works, because sawmills were seen by many as greedy devourers of timber and advance soldiers in the battle to subdue the virgin wilderness. But for others, the sawmill was an ally of civilization and even an object of pride, because its technological perfection represented one of America's most significant contributions to the early years of the Industrial Revolution.

Mills, of course, were common in Europe and had been a conventional element in landscape painting for centuries. These, however, were invariably gristmills, whether wind or water driven. Sawmills were rare on the continent and almost unheard of in England, where scarce supplies of timber and strong sawyers' guilds made them uneconomical. But in America, with its abundant forests and limited supply of manpower, virtually every village had a sawmill either in it or nearby, and the countryside was filled with them. American engineering skill quickly adapted the structure of European water-driven gristmills to this new purpose, creating highly efficient sawing operations that could be run with a minimum of men.[47] European visitors to America during the first half of the nineteenth century were frequently struck by the prodigious out-

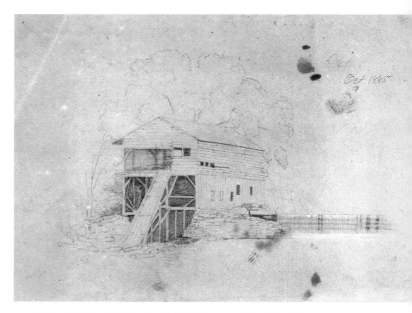

13. Frederic Edwin Church, *Mill*, 1845, pencil with white chalk on paper, 6¹/₁₆ × 8¹¹/₁₆ in., New York State, Office of Parks, Recreation and Historic Preservation, Olana State Historic Site (OL.1980.1356).

put of New England sawmills, and often praised Americans for their ingenuity in making the most of the abundant natural water power.[48]

By 1700, almost every town in Massachusetts had at least one sawmill, and the increase in numbers from that point on was nothing short of phenomenal. In 1810, Berkshire and Hampshire counties in Massachusetts had, for example, a combined total of 150 sawmills. In 1836, when Cole settled permanently in Catskill, there were 26 sawmills along Catskill Creek alone.[49] Even that number, however, is dwarfed by the 250 sawmills that Thoreau noted were on the Penobscot river and its tributaries in timber-rich Maine in 1837.[50] Obviously, sawmills were a fact of life that the landscape painter could hardly avoid. As he worked his way through the forests of the Northeast he would have heard the shrill noise of their blades, smelled the sawdust they produced, and seen their indirect effect on the nearby forests, even if he was fortunate enough not to blunder onto one perched beside a picturesque waterfall.

Church saw them, and painted and drew them, from the first. Instruction books by his early

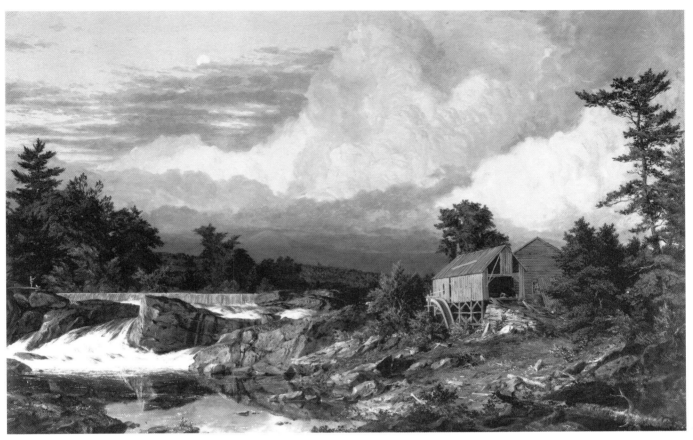

14. Frederic Edwin Church, *Rutland Falls, Vermont,*
1848, oil on canvas, 20 × 30 in., The White House,
Washington, D.C.

teacher, Benjamin Coe, included drawings of mills
and other buildings that were to be copied by stu-
dents.[51] Church depicted mills in drawings dated
from 1844 on, and included a mill in a painting of
1845, *Scene Near Hartford* (Olana State Historic
Site). One notable drawing from October 1845 (fig-
ure 13) shows a sawmill standing by a dammed
stream, with cut logs ready to be sawed crowded
around its base. Although by no means as uncom-
promising as some images of sawmills, Church's
drawing makes no effort to disguise the true pur-
pose of the mill.[52] Its open end gapes like a cavern-
ous mouth, and its chute reaches out to the logs like
a long, greedy tongue. Similar sawmills, less promi-
nently displayed, but obvious enough, appear in
paintings of 1848 (figure 14) and 1849 (figure 15).

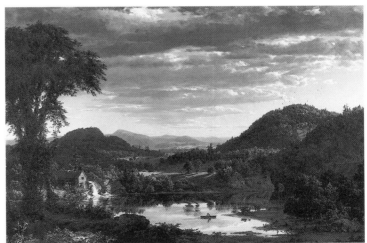

15. Frederic Edwin Church, *New England Landscape
(Evening After a Storm),* c. 1849, oil on canvas,
25¹/₈ × 36¹/₄ in., Amon Carter Museum, Fort Worth,
Texas (11.79).

15

Mills appear in American landscapes by other artists of Church's era, but, as in the case of their European prototypes, they were usually gristmills, more benign and less emotionally charged images.[53] Cole's *Old Mill at Sunset* (figure 2) is a typical example. Such paintings, unlike Church's, are fundamentally nostalgic, as the use of the word "old" in the title implies. They celebrate a form of technology that was quickly, even in Cole's day, giving way to larger, more mechanized operations. Images of "old" mills proliferated in the years after the Civil War, as Americans looked back to a simpler era when villages were self-sufficient communities and when gristmills were an indispensable part of any small town's economy. The taste for such pictures culminated around the time of the Centennial Exhibition, which was at once modern in its celebration of technological wonders such as the Corliss engine, and nostalgic in its launching of the Colonial Revival and its canonization of Jasper Cropsey's *The Old Mill* (1876, Chrysler Museum, Norfolk, Virginia) as an American icon whose meaning endures to this day.[54]

Although a few American painters depicted sawmills—for example, Fitz Hugh Lane in his *Lanesville* of 1849 (private collection)—none did so as frequently and consistently as did Church during the early years of his career. By the 1840s, the ecological consequences of sawmill operation were becoming more widely recognized. In addition to encouraging unchecked logging, which led to erosion and general disruption of aquifers, sawmills themselves were serious polluters of waterways with the tons of sawdust they created.[55] There were other problems and potential problems, such as the flooding of farmland caused by mill dams and the destruction of fish habitats and migratory routes.[56] But the point to be stressed here is that the sawmill, like the axe, was a double-edged symbol.[57] It was both a destroyer of nature and a tool of civilization. Some observers of the American scene, such as Timothy Dwight and James Fenimore Cooper, actually looked forward to the day when some of the

vast tracts of eastern forest would be at least partially cleared, thus making the landscape more interesting—and more hospitable—in appearance. Church's optimistic faith in progress allowed him to accommodate the sawmill as a symbol of transformation into his vision of the national landscape, because he believed Americans were capable of governing their use of the land's resources with responsibility and restraint.

That belief would have been reinforced by the economic activities of Church's own family, which had a financial stake in the technological transformation of New England. Church's father Joseph and his uncle Leonard Church owned a paper mill in Lee, Massachusetts, that had been founded by their father.[58] This mill was purported to have been the first established in the western part of the state, and it played an early part in the taming and settling of a state that Frederic Church came to know very well. Leonard Church subsequently became the sole owner of the mill in Lee, but Church's father continued to invest in mills. In light of his family's longstanding involvement in the milling industry, it is likely the young artist felt a certain amount of pride in this commitment to technological progress. Cyrus Field, whom Church knew by 1845 or 1846, was also well acquainted with New England mills (including the Churches' mill in Lee) from his travels as a paper merchandiser in the early 1840s.[59] This young capitalist was a firm believer in the potential of technology and the development of rural areas, and he surely shared his enthusiasm with Church. Indeed, when Church painted *Lower Falls, Rochester* (private collection) for Field in 1849, he included a large tanning mill that Field knew from his early travels in New York.[60]

Church's landscapes from the first years of his career focused primarily on the settled areas of New England. But many of the places he visited during those same years offered more dramatic scenery that fell within the traditional vocabulary of the Sublime, which had been so favored by his teacher, Thomas Cole. Church occasionally painted such

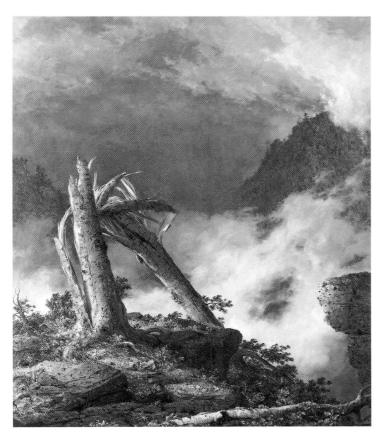

16. Frederic Edwin Church, *Storm in the Mountains
(Blasted Tree),* 1847, oil on canvas, 29⁷/₈ × 24⁷/₈ in., The
Cleveland Museum of Art, gift of various donors by ex-
change and purchase from the J. H. Wade Fund
(CMA65.52).

subjects, creating works that stand in marked con-
trast to his more peaceful and picturesque
landscapes.

 *Storm in the Mountains,* of 1847 (figure 16) and
*Morning,* of 1848 (figure 17) depict views from high
mountain vantage points in the vicinity of the Cats-
kill Mountain House, where Church sketched as
early as 1844.[61] The blasted tree in the former, and
the large and prominent rocks in the latter, combine
with the sudden drop-off into space, swirling
clouds, and vibrant colors to evoke the feelings of
awe and wonder basic to the Sublime. The effect is
very different than that of a work such as *View
Near Stockbridge* (figure 11), which is more con-

sciously composed and less immediately involving.
In *Stockbridge,* the trees at the right, meandering
river, and receding hills create a measured rhythm
of movement, allowing the viewer's eye to wander
easily across the landscape. Something very differ-
ent is at work in *Storm in the Mountains, Morning,*
and other similar works from the late 1840s (e.g.,
*Above the Clouds at Sunrise,* 1849, Warner Collec-
tion, Gulf States Paper Corporation, Tuscaloosa,
Alabama). Church deliberately breaks down the tra-
ditional barriers between the painting as an artistic
interpretation of nature that is placed before the
viewer and the direct sensations the viewer would
actually receive from experiencing the scene itself.
Church organized everything to thrust the viewer
into the pictorial space quickly and forcibly, so that
the sensation of looking at a picture is replaced by a
feeling of actually being present in the scene. The
immediacy and directness of these pictures are un-
like effects in Church's other works of the same
years, but these paintings foretell such later master-
pieces as *Niagara, The Heart of the Andes, Twilight*

17. Frederic Edwin Church, *Morning,* 1848, oil on can-
vas, 18 × 24 in., collection Albany Institute of History
and Art, gift of Mrs. Abraham Lansing (1940.606.7).

18. Frederic Edwin Church, *Christian on the Borders of the "Valley of the Shadow of Death," Pilgrim's Progress,* 1847, oil on canvas, 40¹/₂ × 60¹/₄ in., New York State, Office of Parks, Recreation and Historic Preservation, Olana State Historic Site (OL.1981.50).

*in the Wilderness,* and *Icebergs,* where spectators were able to imagine themselves present in the very scenes they observed.

Church also used Sublime effects in some of his imaginary and allegorical works of the late 1840s. His commitment to the "higher style of landscape" initiated by Cole had been demonstrated by *Hooker and Company* of 1846, which had appeared at the National Academy with a pure landscape called *Winter Evening* (unlocated).[62] In each of the Academy exhibitions of the next two years, Church once again had two works, one a straightforward landscape, and the other a subject piece reminiscent of Cole. In 1847, *July Sunset* (figure 10) was shown with *Christian on the Borders of the "Valley of the*

*Shadow of Death," Pilgrim's Progress* (figure 18).[63] The rocky setting and blasted tree of *Christian* recall *Storm in the Mountains* and *Morning,* but the work is charged with supernatural intensity through its striking light and "demon-cloud hovering over the 'everlasting fire.'"[64]

Bunyan's "universally read and world-renowned book" also provided the subject for *The River of the Water of Life* (unlocated), which was exhibited at the Academy in 1848 with *View Near Stockbridge* (figure 11).[65] Church considered it a "companion" to his *Christian* of the previous year, and again displayed his virtuosity in portraying dramatic light effects.[66] But the most spectacular of Church's early imaginary works was *The Plague of Darkness* (unlocated), which was exhibited at the Academy in the spring of 1849 and at the Art-Union the following fall. This large (50 x 60 inches) work was praised for its "originality of design and grandeur of effect." As one reviewer wrote:

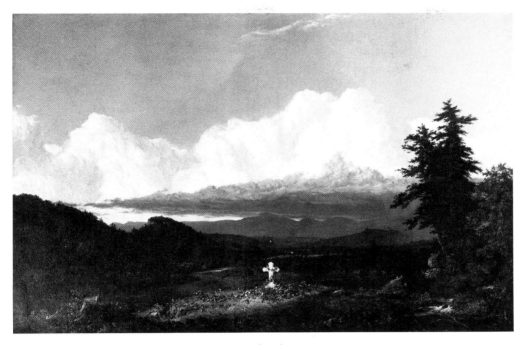

19. Frederic Edwin Church, *To the Memory of Cole,* 1848, oil on canvas, 32 × 49 in., Des Moines Women's Club, Des Moines, Iowa.

Here, as in several other of Church's works, the sky is the scene of his triumph. The horizon is low, and the long lines of massive architecture are shown dimly under reflected lights. A lofty crag in the foreground, and the white-robed figure of the Great Law-Giver, who stands upon it,—the solitary living being in this scene of desolation—alone catch the sunshine, all beneath being enveloped wholly or partially in supernatural darkness. Far above appears a remnant of blue sky, from which these few lingering rays fall upon the earth. The eye, to reach it, traverses an almost illimitable vista of clouds, black and frowning, excepting where their fleecy sides are touched by those passing sunbeams. This piece has much of the grandeur which characterizes Martin's celebrated pictures.[67]

Clearly, Church was not adverse to working in the highly dramatic idiom of his teacher, for this description suggests that *The Plague of Darkness* was as melodramatic as such works as Cole's *Expulsion from the Garden of Eden* (1827–28, Museum of Fine Arts, Boston). At this stage in his career, Church was exploring every type of landscape subject that his master's example offered, and in dividing his time between pure landscapes and storytelling pictures he was following exactly the same course as did Cole in the 1840s. Thus, the generally held conception of Church as one who rejected Cole's dramatic and imaginary works as useless to his own art must be regarded as inaccurate.[68] If such works as *The River of the Water of Life* and *The Plague of Darkness* were extant, perhaps the longstanding image of Church as an unimaginative realist and nothing more would at last be laid to rest. Indeed, the recent rediscovery of his *To the Memory of Cole* of 1848 (figure 19) may help do just that, for it makes his commitment to his teacher's aesthetics all the more obvious.[69]

*To the Memory of Cole* presents a landscape devoid of human presence. A garland-wreathed cross stands prominently in the foreground, illuminated by a patch of light. To the right is a stand of evergreen trees, and below them issues a stream that winds through the landscape into the distance. At the lower left is a sawn tree stump, and in the distance are ranges of hills. The sky is filled with clouds; the lowermost are pink and curiously jagged in appearance and the upper ones are great billowing cumuli. As in other paintings by Church from this period, the handling of paint is crisp and the forms are rendered in careful detail.

One could hardly imagine a more pronounced contrast than that between this spiritually charged, almost otherworldly scene and Asher B. Durand's *Kindred Spirits* of 1849 (figure 20). In Durand's memorial are Cole and his friend, the nature poet William Cullen Bryant, happily situated within the sylvan glories of the Catskills. Clearly, this pays homage to Cole the painter of the *American* landscape, not the painter of the great allegorical cycles *The Course of Empire* and *The Voyage of Life.* Durand was deliberately emphasizing that Cole's example as a student of nature provided the most appropriate direction for his followers to take. Their proper subject would be the American landscape, which was in itself sufficiently meaningful and important to make imaginary works unnecessary.[70]

*To the Memory of Cole* also pays homage to Cole's familiar landscape territory, because its background mountains are recognizably the Catskills. But, unlike Durand, Church also chose at this crucial moment to champion Cole as the painter of the ideal and elevated landscape. Indeed, *To the Memory of Cole* presents a veritable index of Cole's archetypal symbols. The stream recalls the one in *The Voyage of Life,* and the cross evokes not only the unfinished *Cross and the World* series, but other late paintings such as *The Cross in the Wilderness* (figure 21). The stump was, of course, one of Cole's favorite motifs, appearing time and time again in

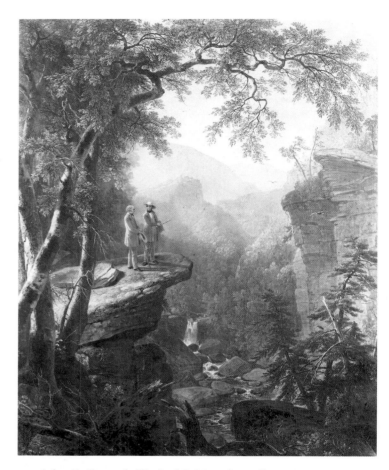

20. Asher B. Durand, *Kindred Spirits,* 1849, oil on canvas, 44¹/₈ × 36¹/₁₆ in., Courtesy of The New York Public Library, Astor, Lenox and Tilden Foundations.

his landscapes (e.g., figures 2 and 3). By its inclusion of these various elements readily identified with Cole, Church's painting gives homage to his departed teacher as the master of the symbolic landscape. And it does so with its own intelligible iconography, for Church has cast his master in the role of the traveler, both voyager on the stream of life and pilgrim in search of the cross and salvation. Cole has now passed over to the final stage of his journey and no longer inhabits the world of men.

Death has come, and the tree has been felled. But the promise of everlasting life is manifested in the new growth sprouting around the base of the cross and in the permanence of the evergreens.

*To the Memory of Cole* and Church's other imaginary landscape paintings demonstrate how strong the appeal of Cole's grand style remained for his young pupil in the late 1840s. But Cole's premature death disrupted the direction of American landscape painting at mid-century, leaving Church, and others, without inspiration and leadership. That role would gradually be assumed by Asher B. Durand, who would ultimately lead a realignment of the Hudson River School, moving it away from imaginary and allegorical works and toward straightforward landscapes. In the years immediately following Cole's death there was considerable flux among New York painters and a general reassessment among critics and connoisseurs as to the proper direction of the school. As pure landscapes gradually became more and more the vogue, many painters abandoned the high style Cole had struggled so hard to establish. Frederic Church, however, did not. With considerable creativity and intelligence he investigated ways in which Cole's beliefs could be adapted to the new tastes of mid-century. In doing so, he embarked on the process that would lead to the creation of some of the most complex, profound, and meaningful landscapes of his era, works that truly represented the "full fruition [of] the aspirations of his master."[71]

21. Thomas Cole, *Study for The Cross in the Wilderness,* c. 1844,, pencil and white, grey-green, and green-brown chalks on paper, 7⁵/₁₆ in. (diameter), National Gallery of Art, Washington, D.C., John Davis Hatch Collection, Avalon Fund (B-33,791).

# Chapter 2 · Landscapes of Deeper Association

. . . numerous modern artists are distinguished by a feeling for nature which has made landscape, instead of mere imitation, a vehicle of great moral impressions.

Henry T. Tuckerman, *Sketches of Eminent American Painters* (1849)

A picture or any other work of Art, is worth nothing except in so far as it has emanated from mind and is addressed to mind. It should indeed be read like a book.

"Correspondence," *The Crayon* (1855)

In the spring of 1849, as Church neared his twenty-third birthday, he completed a new landscape that became the subject of considerable attention even before it debuted at the National Academy in May. This painting, *West Rock, New Haven* (colorplate 2) was shown with two others, *The Plague of Darkness* and *A Mountain Tempest*. The latter, a stormy landscape inspired by Byron's *Childe Harold*, shared the dramatic mood of *The Plague of Darkness*.[1] Seen on the walls of the Academy, *West Rock* must have provided a striking contrast to these other works, with their charged effects of light and subject matter reminiscent of Cole. Unlike them, *West Rock* was a quiet, restrained vision of the pastoral beauty of the American present painted in a straightforward, realistic style that avoided sensationalism. It seems more closely allied to a typical Durand of the period, such as *Dover Plains, Dutchess County, New York* (1848, National Museum of American Art, Washington) than to the imaginary works that accompanied it. *West Rock* was an im-

mediate popular and critical success, for in its detailed transcription of reality it satisfied the requirements of truthfulness to nature. It was, in the words of one critic, "a faithful, natural picture," and another found that its depiction of water met perfectly "the 'Oxford Graduate's' conditions of excellence."[2] John Ruskin's works had only recently arrived in America, but Americans had already found their own exemplar of his "truth to nature" theories. As the writer for the *Bulletin* of the Art-Union enthusiastically noted: "Church has taken his place, at a single leap, among the great masters of landscape."[3]

The painstaking realism of *West Rock* was surely a significant part of its appeal, but its theme of the harvest must also have contributed to its success. Church's painting is an early example of a subject that would become important in American painting. His drawing of the site, dated July 1848, does not include the mown hay, the men, or the carts, so the harvesting subject was deliberately added.[4] There

were, of course, precedents for the theme in American painting, some of which Church may have known. William Sidney Mount's numerous depictions of haying scenes (e.g., *Haying Scene,* c. 1835, New-York Historical Society; and *Farmers Nooning,* 1836, Museums at Stony Brook, Long Island, New York) come to mind, although these generally focused on the figures rather than the landscape. Somewhat closer in spirit to Church's painting is Asher B. Durand's *Haying* of 1838 (Vose Galleries, Boston), although it shows men unloading rather than harvesting the hay. Thus, *West Rock* is a key early work celebrating the harvest of the unending bounties of the New World, an image of a land blessed by Providence, where industrious men are rewarded for their labors with the riches of nature. Other artists would exploit this theme to full advantage in later years, as in Jasper Cropsey's *American Harvesting* of 1851 (Indiana University Art Museum), Durand's *The First Harvest in the Wilderness* of 1855 (Brooklyn Museum), and Jerome B. Thompson's *The Haymakers, Mount Mansfield, Vermont* of 1859 (private collection).

In the quiet and pastoral mood of *West Rock,* Church had moved far away from the world of Cole's historical and allegorical works and his own dramatic subject pictures such as *The Plague of Darkness.* Accordingly, one might suspect that *West Rock* represented a shift away from his teacher's influence in favor of the more prosaic naturalism espoused by Durand. But there is more to *West Rock* than immediately meets the eye—or, more properly, than meets the twentieth-century eye—for the subject itself embraced a deeper level of meaning that was not lost on Church's contemporaries. As Cole had pointed out in his "Essay on American Scenery":

> American scenes are not destitute of historical and legendary associations—the great struggle for freedom has sanctified many a spot, and many a mountain, stream, and rock has its legend, worthy of a poet's pen or the painter's pencil.[5]

West Rock was one such sanctified spot.

Soon after its completion, Church's painting was engraved and used as an illustration in *The Home Book of the Picturesque,* a gift book published in 1852.[6] The engraving opens a five-page chapter on West Rock written by Mary E. Field, the younger sister of Church's friend Cyrus Field.[7] The chapter starts with a discussion of the natural beauties of the site. Field praises the picture's accuracy, comparing it to a daguerreotype, and briefly describes the scene.[8] However, after only three brief paragraphs, she moves to what is her main subject, noting:

> West Rock has another interest. The artist here gives us not only a beautiful and well-known scene, but illustrates a passage of colonial history. That rugged pile recalls a story of trial and fortitude, courage and magnanimity, the noblest friendship, and a fearless adherence to political principles from religious motives.[9]

The author proceeds to outline the story of the Englishmen Edward Whalley and William Goffe, who had opposed the English crown and held prominent positions under Cromwell. Following Cromwell's death and the restoration of the monarchy, the two men fled to America, arriving in Boston in 1660. Constantly pursued by royal agents, they moved on to Connecticut and were hidden in a cave high up on West Rock. Because the townspeople protected them and provided them with food and water, Whalley and Goffe remained safe. They eventually went on to other hiding places, but West Rock came to be seen as their memorial. Their slogan, "Opposition to tyrants is obedience to God," was carved on the wall of the cave.[10]

The story of Whalley and Goffe, who were considered symbolic "regicides,"[11] was seen by later generations of Americans as prefiguring colonial opposition to England. Thus, West Rock, a "renowned place" where the very soil was "consecrated to freedom," stood as a permanent and prominent reminder of the principles upon which the new nation was founded.[12] The peace and plenty of the present were only possible because of the struggles of the past. In Church's painting, a straightforward

landscape thus resonates with deeper meaning through association with a famous historical event. In this sense, *West Rock* may be regarded as a logical development from *Hooker and Company* (colorplate 1). Yet it did what *Hooker* could not: it made a history painting out of the physical facts of the American landscape itself.

*West Rock* was Church's first fully mature work and it helped establish him as an independent artist. It was, as he must have realized quite clearly, a perfect fusion of the two strains—the real and the ideal—that he had previously been investigating in separate works. Cole would doubtless have approved of this ingenious solution to his own dilemma. As previously noted, Cole recognized the appeal of landscapes with associations from American history, and, in fact, the story of Whalley and Goffe—like that of Hooker—was one that he had included on his list of subjects:

> The story of the regicides Goffe, Whalley, and Dixwell afford [*sic*] in my opinion fine subjects for both poetry and painting. A poem in which Goffe, on the solitary rock near New Haven, should be made to give vent to his feelings as an exile—his thoughts springing from the past and looking forward to the future—the first part might be Morning and the second Noon the third Evening the fourth Night.[13]

Significantly, Cole envisioned a suite of paintings (or a long poem) so that he could trace the story through its full narrative sequence, embracing past, present, and future, complete with a complementary cycle of the times of day. Church, however, not only distilled the essence of the story into a single work, but also set it in the present, making it relevant for the American of 1849. *West Rock* contains no lingering attachment to Cole's brand of moody, romantic musing; it was of its own time and infused with the actuality of American existence. By linking the physical facts of the American landscape to momentous events of the historic past, and by portraying the industrious labors of present-day Americans harvesting the bounty of the New

World Garden, Church had created his first fully successful national landscape.[14]

The success of *West Rock, New Haven,* both in terms of its critical and popular acclaim and its fusion of realistic landscape with deeper meaning, might have suggested to Church that this was the type of subject in which he should now specialize. But though the landscape around West Rock came ready-made with meaningful associations, the vast majority of scenes Church might choose did not. There were certainly famous landmarks throughout the East, but Church did not want to devote himself to depicting them, because there were already countless popular illustrators who made such sites their specialty. Furthermore, Church had inherited some of Cole's impatience with the purely topographical mode. Only few times more in his subsequent American landscapes would he paint a specific famous spot, such as Virginia's Natural Bridge, which he portrayed in 1852.[15] Instead, he continued to investigate ways in which his more generalized compositions could be made to convey meaning.

During the summer of 1849, following the success of *West Rock, New Haven,* Church was "again rambling among his favorite haunts in the hills of Vermont, studying the mountain scenery and atmospheric effects in which he so much delights."[16] As the decade of the 1850s dawned, he sought new means for interpreting the American landscape. Some of the results were peaceful and pastoral, but others were dramatic and turbulent. Numerous new influences came to bear on his work as he entered a period of intense activity.

Church's sketching tour in Vermont during the summer of 1849 gave him a large stock of material for use after he returned to New York that fall. As in previous years, he was drawn to settled areas, and his drawings from the trip were often of peaceful villages and included numerous houses, barns, mills, winding roads, and fenced fields. The oil sketches depicted similar sights, but were generally very broadly brushed, indicating that Church was

22. Frederic Edwin Church, *Ira Mountain, Vermont,* c. 1849–50, oil on canvas, 40⅝ × 61⅝ in., New York State, Office of Parks, Recreation and Historic Preservation, Olana State Historic Site (OL.1981.49).

concentrating on capturing large masses, areas of light and shade, and general color effects.

One of the first paintings Church executed upon his return to New York was *Ira Mountain, Vermont* (figure 22).[17] This was one of his largest landscapes to date, and he deemed it suitable for exhibition at both the National Academy and the American Art-Union. With its profusion of barns, houses, fences, and other elements, *Ira Mountain* reads as an assertive depiction of the settled landscape, leading one reviewer to note:

> They [i.e., Church's landscapes] are worthy of more notice as being mostly faithful reproductions of American nature, and that not in the picturesque regions of lake and mountain scenery, but in the less romantic though more cultivated districts of New England. The farming interest is uppermost in many of his pictures. He paints nature with the barns, ditches, and fences left in.[18]

Church did take particular interest in farming, and some of his drawings include careful notations of the types of plants and vegetables growing in the fields and gardens he portrayed. But more importantly, works such as *Ira Mountain* reveal that his commitment to portraying the interaction of American civilization with American nature remained firmly in place during the late 1840s and early 1850s.

Given its size, complexity, and quality of execution *Ira Mountain* represented a major effort for Church, but its pale coloring and subdued tones caused it to be all but overwhelmed by the brighter and more dramatic pictures of several other artists that were hung near it in the Academy. One reviewer, writing for the *New York Tribune,* decried

this fact, for he recognized that this "delicate, tender, and highly elaborate" picture with its "beautiful and rare sentiment" was lost amidst its higher-keyed neighbors. And he noted that a similar fate befell another work by Church, *View Near Clarendon, Vermont* (unlocated), because it was hung next to a particularly brilliant sunset piece by Regis Gignoux.[19]

Church's major work of 1850, however, could not be so easily thrust into the background. This "striking picture," *Twilight, "Short Arbiter 'Twixt Day and Night"* (colorplate 3) was considered Church's "best work" of the five he exhibited at the National Academy.[20] Like *Ira Mountain,* the painting was a result of Church's experiences in Vermont in 1849. It was derived from a small oil sketch known as *Evening in Vermont* (figure 23), which, like others by Church from the period, is freely and vigorously painted and was certainly executed on the spot. The finished painting, despite adjustments to the contours of the land and the addition of various elements, including the stream, outcropping of rock, and the house, retains much of the sketch's feeling of immediacy and directness. Little suggests that this is a scene of any significance and the title gives no indication of location.

All of the paintings Church exhibited with *Twilight, "Short Arbiter"* at both the Academy and the Art-Union were pure landscapes, with titles that either designated specific locations (e.g., *Ira Mountain,* or *View Near Clarendon, Vermont*), or were merely prosaic descriptions, such as *A Wet Day.*[21] For the first time since his debut at the Academy in 1845, he exhibited no grand imaginary or obviously allegorical or historical picture. It might seem that the influence of Cole was beginning to lose its hold on Church, leading him to abandon the high style of his master. Given the triumphant success his realistic *West Rock* had enjoyed the year before, Church could hardly have been blamed if he had continued with similar works. But *Twilight, "Short Arbiter"* is clearly different. It is one of the most dramatic and most intensely wrought of Church's

23. Frederic Edwin Church, *Evening in Vermont,* 1849, oil on academy board, 5¹/₂ × 11 in., collection Vassar College Art Gallery, Poughkeepsie, New York, gift of Matthew Vassar (864.1.17).

early works, with a brooding and stormy aspect completely opposed to the quiet moods of *West Rock* and *Ira Mountain.* It was as if Church had transferred the highly charged light and atmospheric effects so essential to such paintings as *Christian on the Borders of the "Valley of the Shadow of Death"* (with its "demon-cloud") and *The Plague of Darkness* (with its "illimitable vista of clouds, dark and frowning") to a pure landscape setting. That he would do so suggests that Church intended *Twilight, "Short Arbiter 'Twixt Day and Night"* to be his great thematic work for the year. It was, in fact, yet another attempt to extend the tradition of Cole, making it viable and attractive to the audience of 1850.

Certain stylistic aspects of the painting indicate that Church was attempting, through purely pictorial means, to evoke something of the actual spirit of Cole's pictures. Some passages are painted in a manner quite different from the precisely detailed style Church had used to such success in *West Rock, New Haven.* This is most noticeable in the sky, with its broadly brushed clouds. For a similar handling, one has to look to Cole's evocative skies,

24. Thomas Cole, *View Across Frenchman's Bay from Mount Desert Island After a Squall*, 1845, oil on canvas, 38¼ × 62½ in., Cincinnati Art Museum, gift of Miss Alice Scarborough (1925.569).

as in the *View Across Frenchman's Bay* of 1845 (figure 24), or to the work of Jasper Cropsey in his most Colean phase, as in *The Coast of Genoa* (1848, New York art market) or *The Spirit of War* (figure 25). Church's painting shows a striking contrast between the peaceful, pastoral character of the landscape, which is painted with more restrained brushwork, and the sky, where the freer handling creates an agitated feeling. One critic, although praising the landscape itself, protested against the "effects" of the picture, with its "rare spectacles which common experience exclaims against."[22] Such a turbulent sky might be acceptable in a picture like *Christian on the Borders of the "Valley of the Shadow of Death"* (figure 18) or *The Plague of Darkness,* but not, it would seem, in a pure landscape. Others, however, were less censorious and

25. Jasper Francis Cropsey, *The Spirit of War,* 1851, oil on canvas, 43⅝ × 67⅝ in., National Gallery of Art, Washington, D.C., Avalon Fund (1978.12.1).

sensed that Church was attempting something new. One deemed the "clouds and sky a masterpiece in their way," and another recognized the accuracy with which the sky had been depicted, even though it was "a sort of harsh truthfulness."[23]

The bold coloring and expressive brushwork of *Twilight, "Short Arbiter 'Twixt Day and Night"* help draw the viewer into the scene, immersing him in the experience of natural phenomena. In this way it recalls *Morning* of 1848, which, as we have seen, could evoke a similar response. In both works this power to encourage viewer identification with the actual scene was an important part of the effect. Reviewers recognized this, with one noting that Church

> seizes upon some occasional and impressive effects of clouds, or some transitory phenomenon of light, and painting it with almost crude reality, and a careful attention to atmospheric truths, transports us to the scene at once. . . . We seem to breathe the air of the landscape while we look at it, and to feel the cool breeze, which wreaths smoke in eddying volumes about the chimney, blowing also upon us.[24]

The painting thus fulfilled, as had *West Rock* through different means, one of Ruskin's most challenging precepts, for it approximated the actual experience of nature. It was not enough for a painting to present facts coldly; it also had to evoke the sentiments involved in the perception of those facts. Church's ability to do just that in his paintings was a key ingredient in his success in the early 1850s, and it is first truly evident in *Twilight, "Short Arbiter."* Just how closely the painting paralleled actual experience—despite the objections of the critic who exclaimed against such "rare spectacles"—may be seen in comparing it to a description of a remarkably similar sunset written by one of Church's contemporaries:

> The sky, last night, was such as made me feel almost a part of it—giving my spirit a buoyancy equal to its brilliancy. It was sufficiently dull and leaden in parts to show its earthly origins, but all rimmed and tipped and

shaded with a lustrous glow worthy to be a gate of heaven—the spot of the setting sun all on fire, like a furnace of purification, a few dark patches suspended in it like wavering martyred spirits. Some minutes more, and the whole sky was tissued over with a delicate ashy purple, but dashed, and stroked and spotted with its former splendor, like the scattered particles of an explosion.[25]

Judging from phrases such as "a furnace of purification," "wavering martyred spirits," and "scattered particles of an explosion," such a sky could clearly excite dramatic and powerful associations in the mind of the receptive viewer. Church intended for the sky in his painting—so full of eerie darkness and the promise of unstable weather—to do the same, because the mood of uncertainty and potential danger it generates serves to enhance the full meaning of the picture. Even the title makes reference to the sky (and, importantly, to a transitional time of day), rather than the land, as was the case with *West Rock, New Haven* and *Ira Mountain, Vermont.*

Church took the title from the opening lines of Book Nine of John Milton's *Paradise Lost:*

> The sun was sunk, and after him the star
> Of Hesperus, whose office it is to bring
> Twilight upon the earth, short arbiter
> 'Twixt day and night, and now from end to end
> Night's hemisphere had veiled the horizon round,
> When Satan, who late fled before the threats
> Of Gabriel out of Eden, now improved
> In meditated fraud and malice, bent
> On man's destruction, maugre what might hap
> Of heavier on himself, fearless returned.[26]

This, then, is the very moment when Satan returns to Earth, ready to sow the seeds of discontent in the Garden of Eden. As in so many key passages in *Paradise Lost,* Milton set the stage for this portentous event by using a striking contrast of light and dark and a change from one time of day to another.

It was hardly unusual for landscape painters of Church's day to be reminded of Milton, or numerous other poets for that matter, when interpreting a

particular scene. Charles Lanman, for example, compared a thunderstorm in the Catskills to "Milton's description of hell."[27] Cole was frequently given to Miltonic musings, for the Englishman was one of his favorite writers.[28] He even lamented the fact that the poet had never visited the New World:

> We have many a spot as umbrageous as Vallombrosa, and as picturesque as the solitudes of Vaucluse; but Milton and Petrarch have not hallowed them by their footsteps and immortal verse.[29]

Several of Cole's works, including his *Expulsion from the Garden of Eden,* and the pendants *L'Allegro* (figure 43) and *Il Penseroso* (1845, Los Angeles County Museum of Art) were inspired by Milton, and Louis Noble considered the late series *The Cross and the World* to be "Miltonic" in conception.[30] However, Church's appending of a line from Milton to a painting that is ostensibly just a view of a scene in America clearly presents a different, and somewhat more complicated matter.[31]

The tradition of exhibiting landscape paintings with lines of poetry appended to their frames or included in exhibition catalogues was well established by 1850. The great English painter J. M. W. Turner was famous for this practice.[32] But the tradition was also well established in America, and several important American painters had used poetry this way.[33] Cole, of course, had been well aware of the potential in this pairing. In addition to the aforementioned *L'Allegro* and *Il Penseroso,* he created such works as *The Cross in the Wilderness* (figure 21), which had a specific source in Mrs. Heman's poem of the same name, as well as several works inspired by his own poetry.[34] Jasper Cropsey exhibited his *Nameless River* at the National Academy in 1846, with a poem of the same title included in the catalogue.[35] Church himself first exhibited a poetically inspired work in 1849, when he exhibited *A Mountain Tempest,* which, as has been mentioned, was drawn from Byron's *Childe Harold.*

It was Asher B. Durand, however, who perhaps most often found inspiration in poetry, and he set an important example for younger painters such as

26. Asher B. Durand, *Early Morning at Cold Spring,* 1850, oil on canvas, 59 × 47¹/₂ in., collection of The Montclair Art Museum, Montclair, New Jersey (45.8).

Church. In 1849 Durand had given high visibility to the link between the two arts in his famous memorial to Cole, *Kindred Spirits* (figure 20). The following year he exhibited two major works at the Academy that were based on poems by William Cullen Bryant. *Landscape, Summer Morning* (*Early Morning at Cold Spring,* figure 26) was inspired by "A Scene on the Banks of the Hudson," and *Landscape, Scene from "Thanatopsis"* (figure 27) illustrated Bryant's well-known poem.[36] In each case, the poetic source is essential to a complete understanding of the picture. *Landscape, Summer Morning* was accompanied by the lines, "O'er the clear still water swells/ The music of the Sabbath bells."[37] In the painting, a solitary figure in the fore-

29

27. Asher B. Durand, *Landscape, Scene from "Thanatopsis,"* 1850, oil on canvas, 39¹/₂ × 61 in., Metropolitan Museum of Art, New York, gift of J. Pierpont Morgan, 1911 (11.156).

ground (looking curiously like Cole as he appears in *Kindred Spirits*) stands under a natural arch formed by trees and gazes across the water toward a town. His slender, upright form is echoed by the shape of the steeple of the town church. The two are so emphatically linked visually that the viewer easily makes the association that he is listening to the sound of the bells. The implication is that one can worship in nature, under natural vaults, just as well as one can in a church. This nicely parallels the sentiment of the poem, and the two thus serve as perfect complements.

*Landscape, Scene from "Thanatopsis"* is more an illustration of Bryant's meditation on death than it is an attempt to evoke an analogous sentiment

through pictorial means. Indeed, it was so closely tied to its literary source that it was criticized by some observers. As one complained, "It does not explain itself, and without the key afforded by the lines quoted in the catalogue, could hardly be understood."[38] Another reviewer, who considered allegories a "class of pictures very objectionable, being rarely able to tell their tales without the aid of textual description," managed to find the painting acceptable, because pure landscape predominated, making the other elements of "no importance."[39]

Durand's paintings and their poetic sources are relevant in this context for two reasons. First, Church may have been aware of these pictures before they actually appeared at the Academy, and this might have encouraged his use of a poetic title for his own major work of the year. By 1850 Durand was the premier landscape painter of the day and he had considerable influence as president of the National Academy. Church was certainly cognizant of his activities and may even have looked at

this moment to the older artist for some guidance. Although we usually think of the two as following very different courses, they were not so far apart in the early 1850s, for it was then that Durand remained perhaps closest in spirit to the tradition of Cole.

Durand's works also provide a useful example of how contemporary critics responded to the use of poetic sources for landscapes. *Landscape, Summer Morning* and its source poem were both naturalistic in content, without overtly allegorical or imaginary elements. As such, they fell comfortably within the prevailing taste for straightforward landscape that had begun to assume dominance around 1850. *Thanatopsis,* on the other hand, was far too allegorical to suit most observers; it did not ground the ideal solidly enough in the real. Nature poetry might provide a proper source for American landscape painting, but allegorical and imaginary poetry, with its attendant moralizing, was clearly deemed less suitable.

There was, however, another type of art at midcentury for which such poetry was a frequent and generally accepted source of inspiration. This was the popular panorama, and Church had previously had personal experience with these entertaining blends of art and theater. Earlier in 1850 he had worked with John C. Wolfe on a panorama based on Bunyan's *Pilgrim's Progress,* which had its debut in New York that summer. Church contributed a "design," derived from his oil painting of 1847 (figure 18), for the scene showing "Christian at the Valley of the Shadow of Death." Like other young artists involved in creating the panorama, Church was praised for his part in bringing this noble and elevated work of moral literature before the public in an accessible and entertaining form.[40]

Wolfe's next project, which was probably in the planning stages by the spring of 1850, was a panorama based on Milton's *Paradise Lost* and *Paradise Regained.*[41] Given Church's previous association with Wolfe, he doubtless would have been aware of this new panorama and he may even have been

asked to participate in its realization. Whatever the case, it was surely more than mere coincidence that Church chose, at this very moment, to quote Milton for the title of one of his landscapes.

As in the case of Wolfe's *Pilgrim's Progress,* the new panorama stressed the moral overtones of the story and its relevance for an American audience. Was Church inspired by this example to do the same, albeit on a more modest scale and through the means of pure landscape? We cannot say with certainty, because no critic seems to have taken any notice, at least in print, of the connection between Church's *Twilight, "Short Arbiter"* and *Paradise Lost.* The painting made reference to its source only in its title, unlike Durand's two landscapes, which had lines from their source poems included in the Academy's exhibition catalogue. Moreover, the painting had no narrative elements suggesting that it was meant to tell a story or was anything other than the straightforward landscape it appeared to be. The critic of *The Albion*—this was the man who found allegories "very objectionable"—thus had nothing obvious to which to object. And for those who did not know their Milton, the title would have seemed only a "poetic" description of the painting's subject.

But the fact is that for Americans of Church's day Milton's *Paradise Lost* was a familiar, well-understood text. Along with the Bible and Bunyan's *Pilgrim's Progress,* Milton's poem was a standard part of the education of children old enough to understand it. So it was with Church's friend Cyrus Field, for instance, who had all three read to him by his father at an early age.[42] It is safe to say that many of those who saw *Twilight, "Short Arbiter 'Twixt Day and Night"* would have appreciated the allusion to Milton, but it is harder to know what they would have made of it.

Many mid-nineteenth century Americans would have found a particular relevance in any work of art that made reference to the Garden of Eden, for the New World was, of course, widely regarded by its proud citizens as a second Eden. As we have

seen, the title Church chose for his painting specifically evokes the Garden, for it refers to the moment when Satan returns to Paradise. Nothing about the image, to be sure, suggests the traditional notion of the Garden's lush tropical landscape; but there are, nevertheless, passages in *Paradise Lost* that do offer parallels to *Twilight, "Short Arbiter."* In Book IV, Milton gives an extended description of Eden, as seen through the eyes of Satan. Included are phrases such as "her enclosure green," "sylvan scene," a "Heaven on Earth," "a happy rural seat of various view," and "lawns, or level downs, and flocks grazing the tender herb." Milton also notes the numerous streams flowing through Eden, which gather in a lake like a "crystal mirror."[43] Certainly the verdant landscape of Church's painting is in keeping with these phrases, although it does not, of course, literally illustrate them.

More important, however, than any of these textual similarities is that Church here employed a composition that had a specific meaning for him. *Twilight, "Short Arbiter"* was derived from a specific oil sketch (figure 23) that lacks several key elements found in the finished painting, most notably the stream, the house, and the outcropping of rock. All of these appear in a small oil that is most likely one Church exhibited as *A Passing Storm* at the Art-Union in 1849 (figure 28).[44] This work, which may have served as a first trial for *Twilight, "Short Arbiter,"* was, in turn, reminiscent of Church's 1846 *Moses Viewing the Promised Land* (figure 7). In the latter the rocky outcropping served as a place for Moses to view the Edenic landscape of the Promised Land. That the format of *Twilight, "Short Arbiter"* was a descendant of this composition is suggestive, indicating that Church was deliberately employing a compositional type that he associated with a special kind of landscape, a landscape of promise and future potential. No figure is actually present in the painting, leaving the viewer free to imaginatively ascend the rocky pulpit and behold a New World version of the Promised Land—or the Garden of Eden. But as the viewer gazed upon the

28. Frederic Edwin Church, *The Harp of the Winds (A Passing Storm)*, 1849, oil on canvas, 14 × 12 in., M. and M. Karolik Collection of American Paintings, courtesy Museum of Fine Arts, Boston (48.415).

peaceful scene he would have also sensed the tension of the storm and the gathering shadows of night.

If Americans were aware that they were, at least symbolically, living in a new Eden, they were also aware, as has often been demonstrated, that they were thus new Adams.[45] And if these new Adams were figures of "heroic innocence and vast potentialities," they were also aware that the earlier Adam had fallen and been expelled from Paradise.[46] Was a similar fate in store for Americans?

Cole had addressed the Adamic myth several times in his work. In the *Expulsion from the Garden of Eden,* Adam and Eve, having lost the peaceful security of the Garden, must begin life again in a harsh and unstable new world. That Cole intended to make an analogy with the wilderness of the New World seems certain. In his great series *The Course of Empire* (completed 1836, New-York Historical Society), an early, Edenic world identified as *The Pastoral (or Arcadian) State* (figure 41), gives way to a decadent society that has lost touch with nature and with morality. In the fourth painting of the series, *Destruction,* this society meets its doom at the hands of barbarous attackers; overhead is a dark and stormy sky. Clearly Cole meant for this story of a civilization that had fallen from grace to serve as a warning to Americans. "We are still in Eden," he wrote, "the wall that shuts us out of the garden is our ignorance and folly."[47]

In *Twilight, "Short Arbiter 'Twixt Day and Night"* Church may have been stating his own awareness of the potential for an American fall. The peaceful green hills and the comfortably nestled cottage of this new Eden are threatened by the lowering storm clouds and by the approaching shadows of night. As in *Too Soon* of 1847 (figure 12), this house is emblematic of American civilization as a whole, which exists for the moment in harmonious equilibrium with nature. But the balance is tenuous, and Paradise regained might be on the verge of reverting to Paradise lost.

Did Church actually perceive some immediate

danger facing the nation at the time he painted *Twilight, "Short Arbiter"*? His early works were invariably optimistic about America and American progress, so it would be difficult to account for such a sudden reversal. There were, to be sure, widespread feelings of anxiety in the 1840s and 1850s that America had simply failed to live up to its political, economic, and social promise and perhaps never would. Large tracts of forest land had already fallen victim to progress, and many easterners were afraid Eden was rapidly vanishing under the onslaught of unchecked expansion. And the emotionally charged issue of slavery, with its attendant sectional antagonisms, was already threatening the security of the nation, in spite of momentary solutions such as the Compromise of 1850. Church, like others, would have been well aware of the Great Debate in Congress in February and March of 1850. Did he, too, share the growing sense of uneasiness?

Perhaps Church's *Twilight, "Short Arbiter"* does contain some undercurrent of doubt about the fortunes of the American nation. But it is more likely that he was primarily investing a straightforward landscape with some of the high drama of Cole rather than making any definite ideological statement. The overlaying of Miltonic meaning on an American scene was certainly a novel approach to updating Cole's art, for it allowed Church to convey something of the spirit and content of Cole's *Expulsion from the Garden of Eden* without recourse to imaginary effects. Thus, just as *West Rock, New Haven* represented a rethinking of a Colean subject in modern terms, so did *Twilight, "Short Arbiter"* find a place for complex moralizing in a New World context.[48]

Whatever the reasons that lay behind its creation, *Twilight, "Short Arbiter 'Twixt Day and Night"* remains an unusual, even enigmatic, work. Church never again made such a specific link between a text and a painting.[49] He also only rarely again used such fluid brushwork, preferring instead his more tightly controlled, detailed style.

*Twilight, "Short Arbiter"* established Church's reputation as the master of the twilight landscape, and it occupies a key position at the beginning of the series of paintings leading to the great *Twilight in the Wilderness* of 1860. It includes virtually all of the elements—hills, rocks, trees jutting into the sky, reflecting water—of the great work of 1860 and in a sense outlines the basic vocabulary for the entire series.[50] But one key ingredient was yet lacking. Soon after *Twilight, "Short Arbiter"* had appeared at the National Academy in the spring of 1850, Church set off to seek material in a new and very different area—Maine. His experiences there would ultimately transform his art and his conception of the North American landscape, for in Maine he found a dramatically different kind of landscape than that he had come to know in New York, Massachusetts, and Vermont.

Although he was the greatest painter of Maine landscapes before Winslow Homer, Church was by no means the first important artist to visit the state. Thomas Doughty had made a sketching trip there in the 1830s and, as early as 1836, had exhibited at the Boston Atheneum a picture of the lighthouse at Mount Desert.[51] Cole made a summer visit in 1844, just after Church became his pupil. Like Doughty, he was drawn to coastal areas and was especially captivated by the spectacle of great waves crashing against rocky shores. Paintings such as *Frenchman's Bay, Mount Desert Island* (figure 29) and *View Across Frenchman's Bay, From Mount Desert Island, Maine, After a Squall* (figure 24), portray the type of dramatic scenery Cole found so appealing, and which he described vividly in his journal:

> Sand Beach Head, the eastern extremity of Mount Desert Island, is a tremendous overhanging precipice, rising from the ocean, with the surf dashing against it in a frightful manner. The whole coast along here is ironbound—threatening crags, and dark caverns in which the sea thunders.[52]

Such scenery was virtually a ready-made version of the Sublime landscape, as Cole's use of such

29. Thomas Cole, *Frenchman's Bay, Mount Desert Island, Maine,* 1844, oil on panel, 13$^{1}/_{2}$ × 22$^{7}/_{8}$ in., collection Albany Institute of History and Art.

words as "frightful" and "threatening" indicates. The experience of Maine could serve as a powerful contrast to the urban landscape of much of the Northeast, for in perhaps no other eastern state could the traveler encounter a scene so much like the one that greeted the first settlers in the New World. It was for this reason that Thoreau left Concord in 1846 on the first of his three trips to Maine.[53] From his experiences there he gained a new understanding of the American wilderness and an increased appreciation for its rugged beauty and power.

Church was probably drawn to Maine because he, too, was seeking more dramatic scenery than that he had previously explored. The taste for the Sublime, inherited from Cole, and evident in such works as *Storm in the Mountains* (figure 16) and *The Plague of Darkness,* had never entirely dropped out of his art. In *Twilight, "Short Arbiter,"* with its stormy sky, he had given a comparable dramatic charge to a rather bucolic landscape, suggesting

that he was now interested in a less pastoral inter-
pretation of the American scene. He would have
known from Cole that the "iron-bound" coast of
Maine could offer a dramatic alternative.[54]

However, the work of another influential artist,
the German painter Andreas Achenbach, was of
equal importance, according to one contemporary
account:

> Church, Gignoux, and Hubbard have gone to the coast
> of Maine, where, it is said, that the marine views are
> among the finest in the country. None of these artists,
> we believe, have [*sic*] hitherto attempted such subjects,
> and we look forward to the results of this journey. The
> exhibition of the magnificent Achenbach last year in
> the Art-Union Gallery seems to have directed the atten-
> tion of our younger men to the grandeur of Coast
> scenery.[55]

Achenbach's "magnificent" picture, generally known
as *Clearing Up—Coast of Sicily* (figure 30) was ex-
hibited several times during the 1850s, receiving
considerable popular and critical attention.[56]

During the late 1840s and early 1850s American
artists were continually advised to study the works
of Düsseldorf masters such as Achenbach. The Ger-
mans were particularly praised for their "careful
and accurate drawing," the lack of which was felt
to be a weakness of the American school.[57] With
the exhibition of Düsseldorf paintings at the Art-
Union in 1849 and the subsequent opening of the
Düsseldorf Gallery, New York artists had ample op-
portunity to study the achievements of the German
school. Church may well have profited from such
study, but his own style was already sufficiently
"careful and accurate" to suggest that any such sty-
listic influence was limited.[58] In fact, Church and
his fellow artists were warned against mindlessly
copying Achenbach's style:

> There have been cases where imitation—perhaps un-
> conscious—of the German painter showed itself in an
> application of the warm coloring of the Sicilian shore
> to the colder rocks and sands of this region. It would
> be better to imitate only the fidelity with which natural

appearances had been studied in this foreign work [i.e.,
*Clearing Up*], and which made it one of the most strik-
ing pictures we have ever seen.[59]

The main effect of Achenbach's painting on
Church was to inspire him to try "his pencil in a
new field of art," namely, marine painting. Al-
though he is not today much known for it, Church
was a highly accomplished marine painter, and his
marine subjects form an important part of his inter-
pretation of the North American scene. As one es-
pecially knowledgeable critic could note by 1852,
Church was "without doubt the first [i.e., the best]
of our marine painters."[60] Church's 1850 trip to
Maine should thus be seen in light of his early inter-
est in this new subject. His ultimate destination was
Mount Desert, where Cole and Doughty had found
such stirring coastal views, and where Fitz Hugh
Lane also went for the first time in the summer of
1850.[61]

A series of four letters by Church published in the
*Bulletin of the American Art-Union* and entitled
"Mountain Views and Coast Scenery, By a Land-

30. Andreas Achenbach, *Clearing Up, Coast of Sicily,*
1847, oil on canvas, $32^{1}/_{4} \times 45^{3}/_{4}$ in., The Walters Art
Gallery, Baltimore (37.116).

scape Painter," make it possible to follow him on this trip and to gain an excellent idea of how he was affected by his experiences.[62] The first two letters, dated July 1850, describe the initial stage of the journey through Vermont and New Hampshire. The third letter, also dated July, is postmarked "Mount Desert Island," and recounts how Church and his companions reached the island. The first leg of the trip was a steamboat ride from Centre Harbor to Wolfborough:

> We left in a storm of wind and rain at five in [the] afternoon of our second day there, on board of a little steamer, the "Lady of the Lake." The captain, who was only a fresh water sailor, declared with emphasis, that it was the severest storm he had ever experienced, though it seemed to us very tri[f]ling.[63]

This "trifling" storm, or perhaps another experienced during the trip gave rise to an interesting rumor that Church had "imitated the example of Backhuysen [*sic*], who went to sea in a tempest, and sketched the billows in the very zenith of their convulsion."[64] Church's name was thus added to the illustrious roster of artists, including Joseph Vernet and J. M. W. Turner, who were believed to have made similar voyages, putting their quest for truthful effects above concern for their own safety.[65]

From Wolfborough the party traveled by rail to Portland and from there took a steamer to Belfast. A fishing sloop took them on to Castine, where they boarded another steamer, the "Charles," bound for Mount Desert. Finally, "about two hours before sunset," Church and his companions "came to Seal Cove, on the southeastern coast of the island."[66] They explored the island thoroughly in the ensuing days, pronouncing themselves "exceedingly delighted with the scenery," and accomplishing "considerable sketching and painting."[67] They soon sought out Frenchman's Bay, where Cole had been before them, and where they hoped to see the surf beating against the rock cliffs. One morning they were rewarded with "the pleasure of seeing some

immense waves." Church described the experience vividly:

> We were out on "rocks" and "peaks" all day. It was a stirring sight to see the immense rollers come toppling in, changing their forms and gathering in bulk, then dashing into sparkling foam against the base of old "Schooner Head," and leaping a hundred feet into the air. There is no such picture of wild, reckless, mad abandonment to its own impulses, as the fierce, frolicsome march of a gigantic wave. We tried painting them, and drawing and taking notes of them, but cannot suppress a doubt that we shall neither be able to give the actual motion nor roar to any we may place upon canvas.[68]

The numerous oil sketches preserved at Olana and at the Cooper-Hewitt Museum that depict waves and rocks (many are dated 1850 and inscribed "Mount Desert") are testimony to Church's diligent study of such coastal spectacles. That he sought out this type of scenery indicates he was thinking of painting works similar to Cole's views of the Bay and Achenbach's *Clearing Up*.

At times the island was blanketed with thick fog for a day or more, which provided "the only drawback to the enjoyment of [its] beauties."[69] One of the paintings Church exhibited at the National Academy in 1851, *An Old Boat* (figure 31), was painted during this kind of weather. As Church wrote: "We have just got to the edge of one [i.e., a fog], which, however, has not prevented our transferring to canvas an old hull of a boat and some rocks this morning."[70] *An Old Boat,* though modest, has a remarkable feeling of immediacy that anticipates the work of Homer. It was much admired when shown in New York; the critic of the *Tribune* called it "a singular success" and found "the moist, white opacity of the mist . . . remarkably well rendered."[71] Another observer, who was "an artist," considered it "a sea-side pastoral" and found his "pleasure was greatly enhanced by hearing two well-known *connoisseurs* talking in a delightful strain on its merits."[72] *Fog off Mount Desert Island* (figure 32), exhibited at the Art-Union in 1851, is

31. Frederic Edwin Church, *An Old Boat,* 1850, oil on board, 11 × 17 in., Thyssen-Bornemisza Collection.

another small oil that was executed on the island.[73] This beautifully painted view of a rocky coast and breaking waves has its direct ancestry in Achenbach's *Clearing Up,* but its vibrancy and charm make it unmistakably Church's creation.

*An Old Boat* and *Fog off Mount Desert Island* were relatively minor efforts in Church's "new field," and they were completely overshadowed by two larger works also derived from his Maine experiences, *The Deluge* and *Beacon, off Mount Desert Island.* Both were shown in the National Academy and Art-Union exhibitions of 1851. *The Deluge* marked Church's return to subject matter reminiscent of Cole. As it turned out, it would be Church's

32. Frederic Edwin Church, *Fog off Mount Desert,* 1850, oil on board, 12 × 15¹/₂ in., private collection.

33. Frederic Edwin Church, *Study for The Deluge,*
c. 1851, pencil on paper, 9⅞ × 14⅞ in., New York
State, Office of Parks, Recreation and Historic Preserva-
tion, Olana State Historic Site (OL.1980.1454).

34. Frederic Edwin Church, *Study for The Deluge,*
c. 1851, oil on canvas, 14¼ × 20⅛ in., New York State,
Office of Parks, Recreation and Historic Preservation,
Olana State Historic Site (OL.1980.1901).

last such picture, because it proved to be the most
resounding failure of his early career.

*The Deluge* is untraced since the nineteenth
century, but two surviving preparatory sketches
(figures 33 and 34) and several contemporary
descriptions help give an idea of this large (48 x 68
inches) and dramatic picture. It was described suc-
cinctly in the Art-Union catalogue:

> In the foreground, upon a crag which is just about to
> be torn by the rushing water from the side of the
> mountain, are a woman and child and a tiger, who
> have sought refuge there from torrents. The rain falls
> in overwhelming sheets, while the lightning and a lurid
> sunset add to the terrors of the scene.[74]

Not surprisingly, what most critics found wanting
in the picture was truth to nature. As one observed,
with no attempt to temper his sarcasm: "Had Mr.
Church seen the deluge, he would no doubt have
painted it to better advantage."[75] Imaginary and al-
legorical works were obviously beginning to wear
thin with Church's audience, and he was increas-
ingly advised by critics to give up such subjects.
The point was made all the more clearly by the
praise bestowed on Jasper Cropsey's *The Cove [sic]
(Storm in the Wilderness)* (figure 35), which was ex-
hibited near *The Deluge*. Although Cropsey's work
was equally dramatic and turbulent, it was a scene
from the American wilderness and thus an accept-
able subject.

*The Deluge* was considered by at least one promi-
nent reviewer to be Church's "most important and
ambitious picture" in the Academy exhibition of
1851. Its failure must have been particularly discour-
aging to the young painter, but his disappointment
would have been more than a little assuaged by the
success of his other major work of the year, *Bea-
con, off Mount Desert Island* (colorplate 4). This
was, for one critic, "a strong and truthful picture,
with more imagination in its reality than the effort
at the Deluge by the same artist."[76]

*Beacon* was based on an oil sketch (figure 36)
that depicts a radiant dawn sky above Frenchman's

35. Jasper Francis Cropsey, *Storm in the Wilderness*, 1851, oil on canvas, 60 × 47¹/₂ in., The Cleveland Museum of Art, gift of the Horace Kelley Art Foundation (CMA46.494).

36. Frederic Edwin Church, *Mount Desert*, c. 1850, oil on paper, 9 × 14¹/₁₆ in., Cooper-Hewitt Museum, Smithsonian Institution / Art Resource, New York, given by Louis P. Church (1917-4-332).

Bay, looking toward Schoodic Point. In the final painting, Church shifted the location to the area of Seal Harbor and the entrance to "Eastern Way."[77] He eliminated the areas of land, setting the scene in the open water, with only the beacon and its rocky base visible in the expanse of sea. The configurations of the clouds are repeated exactly from the oil sketch. A few boats are on the water, but the painting is primarily an image of sea and sky and the solitary beacon. The beacon itself was painted from a careful drawing included on a page with several sketches of ships (figure 37).

*Beacon* is an unusual picture, almost stark in its simplicity. However, it does have similarities to

37. Frederic Edwin Church, *Study of Sailing Ships and Coastal Scenery,* c. 1850, pencil on paper, 9⁷/₈ × 7³/₁₆ in., Cooper-Hewitt Museum, Smithsonian Institution/Art Resource, New York, given by Louis P. Church (1917-4-271A).

Achenbach's *Clearing Up—Coast of Sicily* (figure 30). The subject of both works is comprised of water, rocks, and sky (with a few wheeling gulls), and the animating element is light. *Beacon* is less stormy—Church had reserved such effects for *The Deluge*—but the curling waves and splashing spray closely recall Achenbach's handling of water. In short, the picture may be seen partly as an American version of the German work, which is precisely what the writer who had advised imitating Achenbach's "fidelity" had called for.

*Beacon* was an immediate success with critics and public alike as "deservedly one of the most popular" works in the National Academy exhibition.[78] By the time of the Art-Union sale of 1852, this "famous" picture was worth more than the larger *Deluge,* which was sold at a loss.[79] *Beacon* was especially popular with reviewers because of its remarkable fidelity to nature. Although some observers had recognized the veracity of *Twilight, "Short Arbiter 'Twixt Day and Night,"* its overall effect was generally considered too disturbing. *Beacon* affected viewers quite differently. It was a "charming work—worth almost as much in the sensations it produces, as a visit from the hot city in August to the still, cool sea-side."[80] To be immersed in this experience of nature was obviously a rather pleasant affair.

Church's ability to suggest the very feel of a landscape environment through his pictures was a key part of his appeal. But this, no matter how important, was not his sole aim. For those who cared to look, the painting offered more. George William Curtis, writing in the *Tribune,* spoke of the "sentiment" of the picture:

> As the spectator looks, he muses, and the sea and the shore and their eternal mystery and sadness gather in his mind. . . . This work of Mr. Church . . . is broadly conceived, and its feeling and association command a universal sympathy.[81]

Curtis was not alone among Americans of his day in seeking expression and content in landscape art that reached beyond the mere description of natural facts. The purely imaginary mode—epitomized by Church's *Deluge*—may have been largely discredited by 1851, but the notion that landscapes of the national scene could contain serious meaning was still a matter of firm belief. Durand was in these years perfecting his own solution to the problem in the deification of American nature, but Church was pursuing different means.

*Beacon, off Mount Desert Island* might appear resistant to interpretation, for its subject is ostensibly the beacon itself and nothing more. Surpris-

ingly, though, this seemingly mundane object was interesting enough to have attracted the notice of Cole, who did not normally pay much attention to such things. Cole sketched it in the corner of a page of a sketchbook he had with him on his visit to the island in August and September of 1844 (figure 38). That he showed his pupil Church this group of studies upon his return to Catskill is beyond doubt. He had, after all, stopped in Hartford on his way to Maine and stayed there for a day with the Churches. When Cole returned to his studio his pupil was awaiting him, no doubt eager to see the fruits of the trip. We will probably never know if Cole had plans for a picture of the beacon, or what associations he might have found in the subject. Nevertheless, in considering Church's *Beacon, off Mount Desert Island* we must heed this faint, but suggestive echo of Cole and look beyond the obvious reality of the scene for the "feeling and association" of which George Curtis wrote.

The beacon Church portrayed served as a marker at the approach to a harbor, and was visible for miles around. As such, it was an emblem of safety, not a warning of danger. For the mariner who had crossed the vast ocean it was a signpost to safe har-

38. Thomas Cole, page from a sketchbook, c. 1844, pencil on paper, 11³/₈ × 16¹⁵/₁₆ in., The Art Museum, Princeton University, gift of Frank Jewett Mather, Jr.

bor after the hazards of a long voyage. Mount Desert itself had long been an important landmark for seamen, and ships from England often used the peaks of Green or Cadillac mountains, visible from sixty miles out, in setting course for landfall in the New World. Considered in the context of Church's other major work of the year, *The Deluge,*—a marine picture of a very different type—*Beacon* takes on significance it would not have had on its own. In fact, the two were linked compositionally, for the central motif of each was a prominent rock surrounded by water. In *The Deluge,* however, Church portrayed a past world on the brink of being purged of evil and corruption by the all-consuming waters of the Flood. The rock, a final stronghold for the last remnants of humanity, is about to crash into the waters. But the rock in *Beacon* is stable and secure, an emblem of solidity and permanence; the waters lap at its edge, but do not threaten to overwhelm it.

*Beacon* thus reads as a positive, even hopeful, image in contrast to *The Deluge,* with its "unmitigated horror." Calm water, a resplendent dawn, and the promise of safe landfall replace raging flood waters, a storm-torn sky, and inescapable disaster. It does not tax the imagination to see one as a sequel to the other. After the Flood, Noah and his companions were able to start life anew on a planet that had literally been washed clean of the mistakes of the past. The parallel with the New World of America is obvious, for it, too, was a place of new beginnings. The decay and vice of the Old World were left behind by virtuous pioneers who crossed the watery wastes of the Atlantic—itself a kind of symbolic flood—in modern arks. They were rewarded with an unspoiled land God had reserved for them. The peak of Ararat appearing above the waters had signaled to Noah the end of the Deluge. For the nineteenth-century voyager completing a dangerous Atlantic crossing, the sighting of a coastal beacon marking the boundaries of the New World and the passage to safe harbor may well have been an analogous experience.

Such thinking was indeed current in America in the 1850s, for as the Reverend Elias Magoon, whom Church knew, wrote:

> On the side of the globe opposite to the first Ararat, shall a second be reached by the ark of conservative civilization, whereon human reason and divine righteousness will repose in the sublimest earthly union, and thence send down a perfect race to propagate their virtues and redeem mankind.[82]

After having encountered the horrific drama of Church's *The Deluge* in the first gallery of the Academy, some viewers might very well have found themselves thinking something similar when they came upon *Beacon* in the sixth gallery.[83]

The interpretation of *Beacon, off Mount Desert Island* proposed here might well prove elusive if the painting was not considered in the context of *The Deluge*. That both works ultimately derived from the same seaside studies done in Maine indicates just how closely associated in Church's mind the two strains of the "real" and the "ideal" could be. He might perceive external reality with the clear vision that informs *Beacon*, but he could also find in the same reality of crashing waves and ocean surges an echo of the drama of the story he portrayed in *The Deluge*.

The success of *Beacon, off Mount Desert Island* and the failure of *The Deluge* taught Church important lessons. He realized, at long last, that the imaginary landscape mode no longer had any real future in America. But more important, he also learned that a seemingly straightforward and apparently undidactic picture such as *Beacon* could be constructed so that it was not only entrancingly beautiful, but also quietly suggestive of deeper content. If a viewer wished to ponder the implications of a picture, he could, but Church would no longer insist on being so explicit in delivering his message, as he had in *The Deluge*. The key lay in allowing a wider scope of possibilities; to be dogmatic, as Cole too often had been, was to restrict and narrow the appeal of landscape.

That Church learned these lessons well was immediately evident. Working quickly during the summer of 1851, he managed to complete a new picture in time for the Art-Union exhibition that fall. In it, he expressed a new vision of landscape that was completely his own. No longer did he have to rely on extrinsic elements such as poetry, the Bible, or even American history itself to achieve his goal. This new painting proved to be the summation of all that he had learned in his early years, and his contemporaries instantly proclaimed it a masterpiece.

## Colorplates

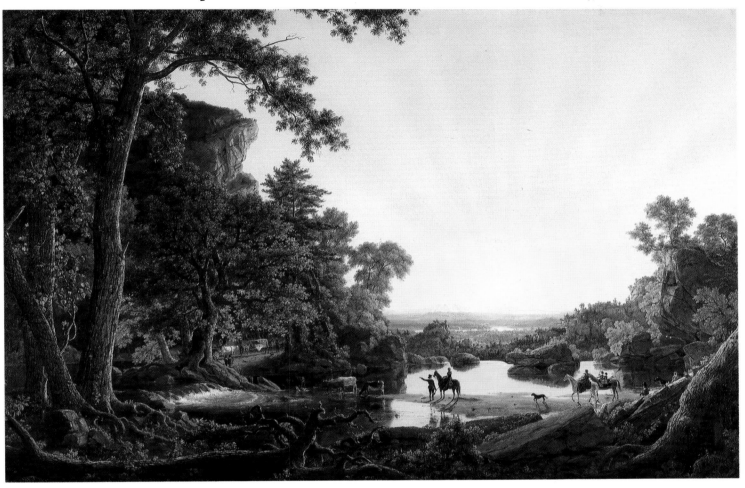

1. Frederic Edwin Church, *Hooker and Company Journeying through the Wilderness from Plymouth to Hartford, in 1636*, 1846, oil on canvas, 40¹/₄ × 60³/₁₆ in., Wadsworth Atheneum, Hartford, Connecticut (1850.9).

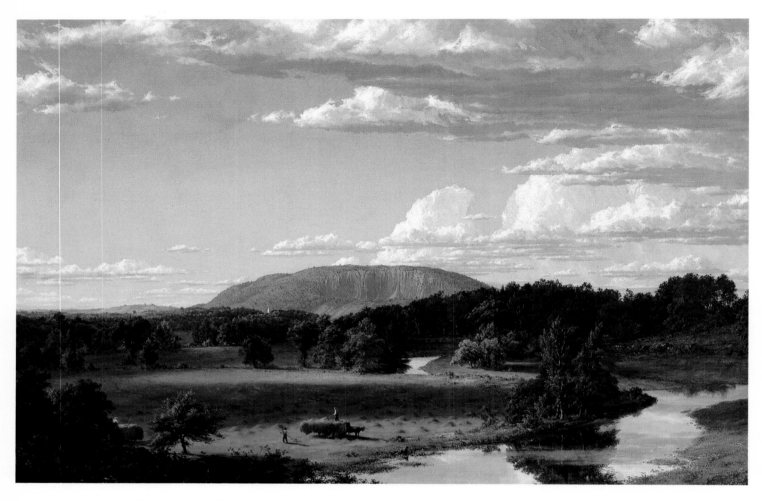

2. Frederic Edwin Church, *West Rock, New Haven,*
1849, oil on canvas, 26¹/₂ × 40 in., New Britain Museum
of American Art, New Britain, Connecticut, John Butler
Talcott Fund.

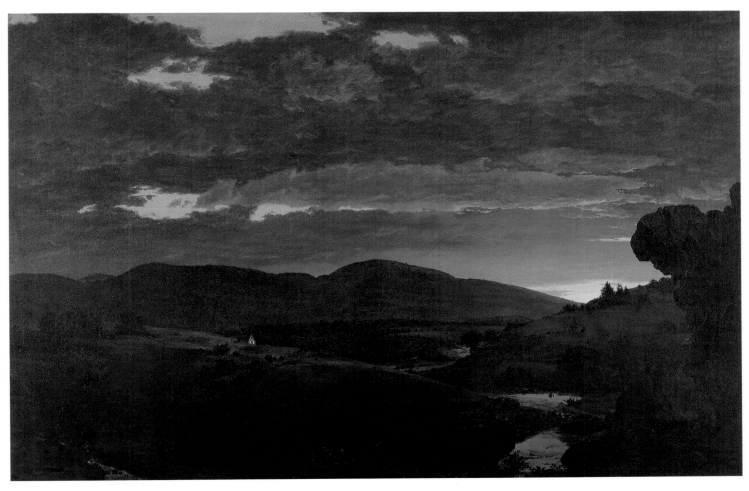

3. Frederic Edwin Church, *Twilight, "Short Arbiter
'Twixt Day and Night,"* 1850, oil on canvas, 32 × 48 in.,
The Newark Museum, purchase, Wallace Scudder Be-
quest (56.43).

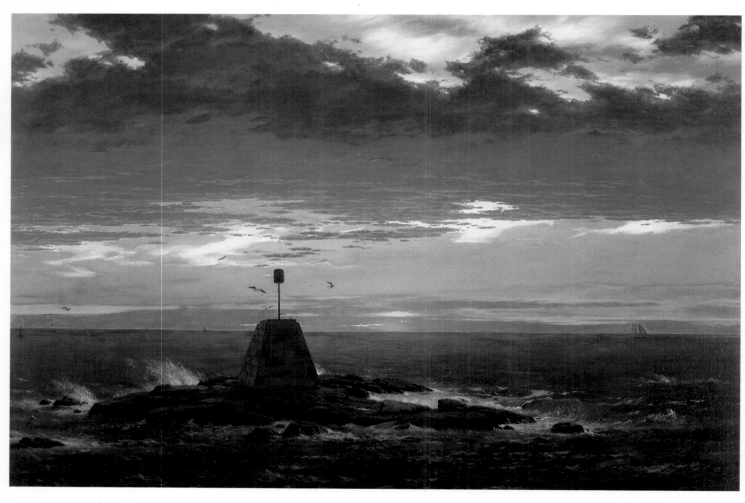

4. Frederic Edwin Church, *Beacon, off Mount Desert
Island,* 1851, oil on canvas, 31 × 46 in., private collection.

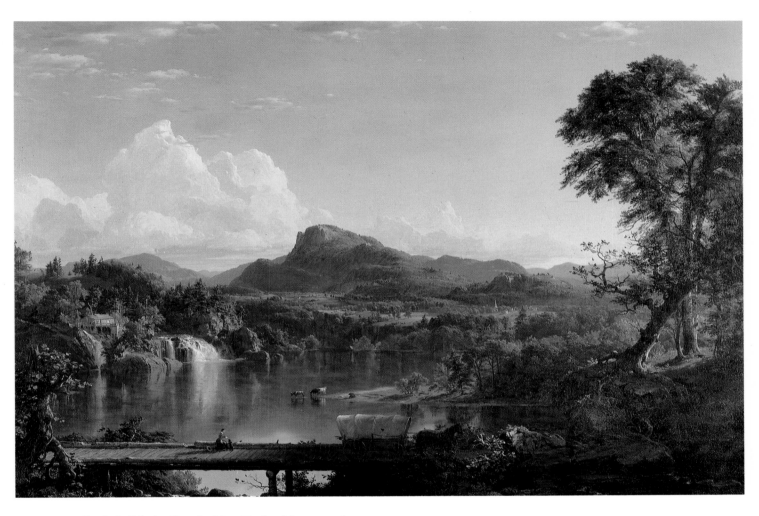

5. Frederic Edwin Church, *New England Scenery,* 1851,
oil on canvas, 36 × 53 in., George Walter Vincent Smith
Art Museum, Springfield, Massachusetts.

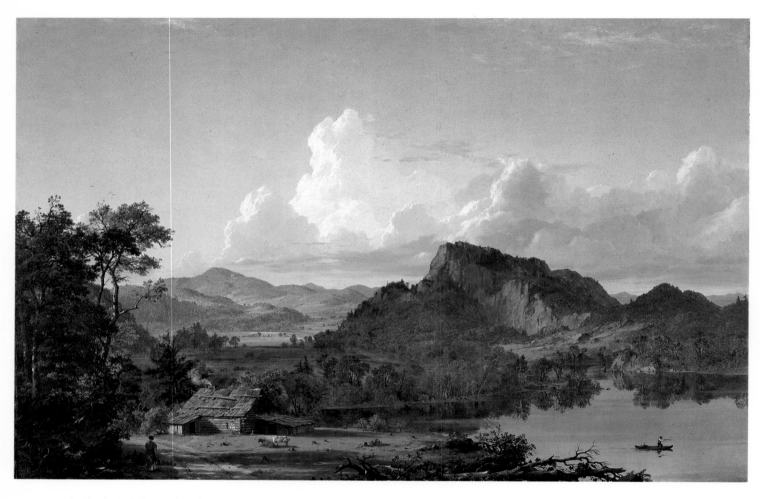

6. Frederic Edwin Church, *Home by the Lake,* 1852, oil on canvas, 31⁷/₈ × 48¹/₄ in., Walker Art Center, Minneapolis, Minnesota, gift of the T.B. Walker Foundation.

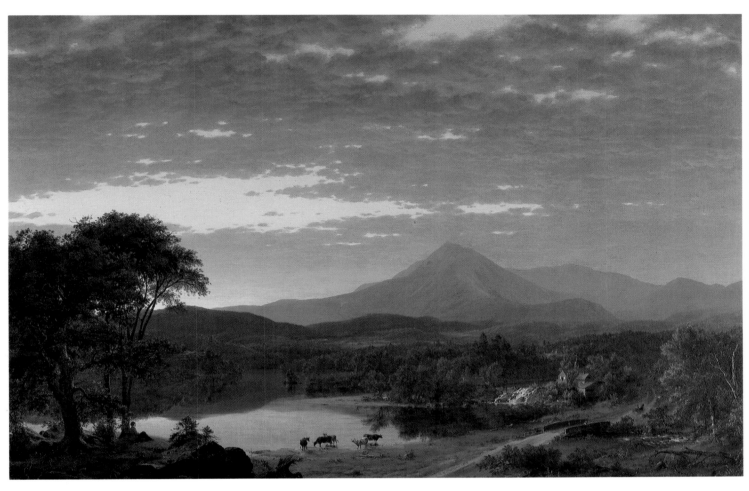

7. Frederic Edwin Church, *Mount Ktaadn,* 1853, oil on
canvas, 36¼ × 55¼ in., Yale University Art Gallery,
New Haven, Connecticut, Stanley B. Resor, B. A. 1901,
Fund.

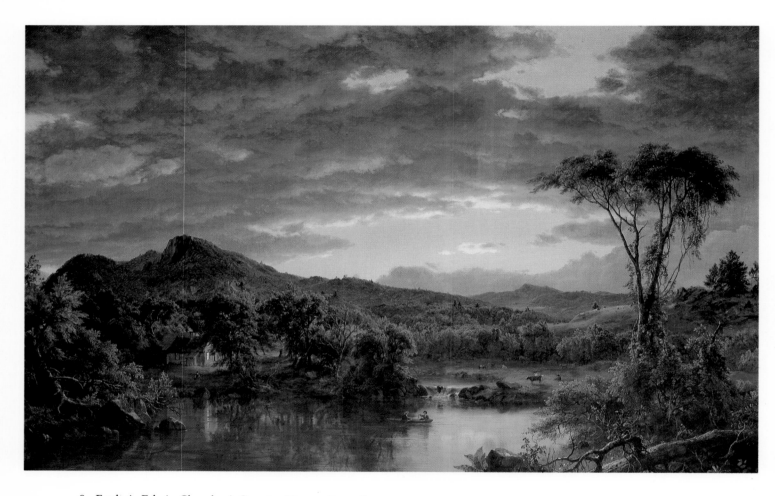

8. Frederic Edwin Church, *A Country Home,* 1854, oil
on canvas, 45⅝ × 63⅝ in., The Seattle Art Museum,
gift of Mrs. Paul C. Carmichael (65.80).

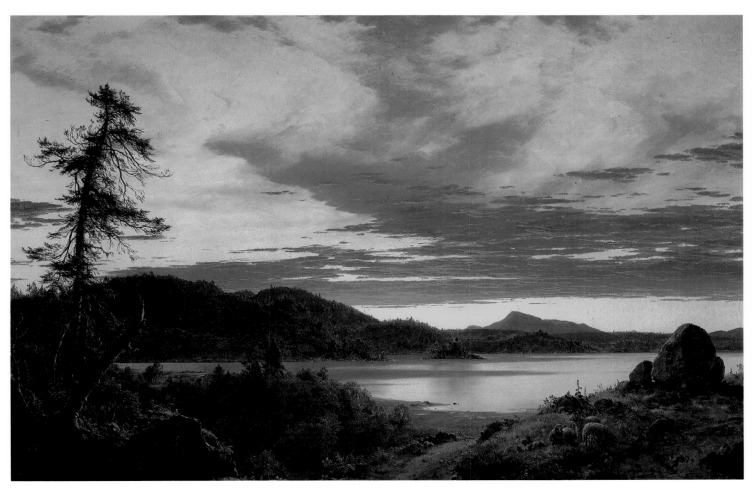

9. Frederic Edwin Church, *Sunset,* 1856, oil on canvas,
24 × 36 in., Munson-Williams-Proctor Institute, Utica,
New York, Proctor Collection.

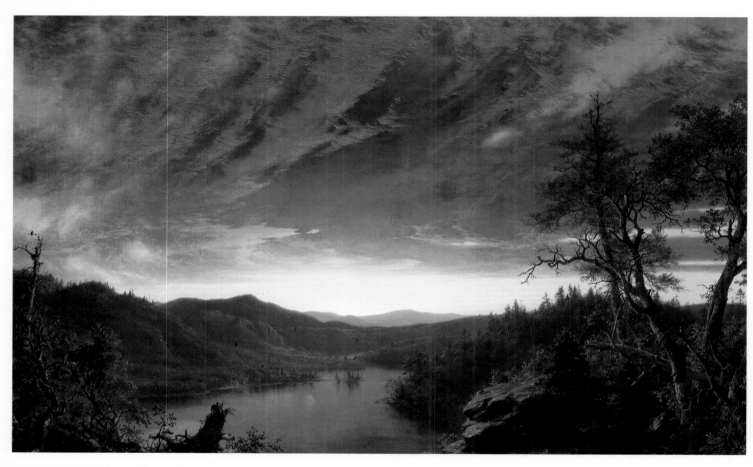

10. Frederic Edwin Church, *Twilight in the Wilderness,*
1860, oil on canvas, 40 × 64 in., The Cleveland Museum
of Art, purchase, Mr. and Mrs. William H. Marlatt Fund
(65.233).

# Chapter 3 · Heroic Visions

Heroic landscape painting must be a result at once of a deep and comprehensive reception of external nature, and of [an] inward process of the mind.

Alexander von Humboldt, *Cosmos*, 1848

Art should not be an imitator of the productions of former times, nor should it neglect the study of the great old masters. The spirit of the age, the spirit of the nation, should form the soul of the artist; the light shed and the inspiration breathed from the productions of the past should purify his taste, and quicken his perceptions of beauty.

"The Fine Arts in America," *The Home Journal*, 1853

By 1851 Church was widely considered one of the leading landscape painters in America. He had been faithful and constant in showing at the annual exhibitions of the National Academy and the Art-Union, and his works had repeatedly elicited favorable reviews in leading New York newspapers and periodicals. "A very happy and brilliant career seems open to him," wrote one observer; "the works of none of the younger artists have attracted more attention."[1] But few of those who observed Church's progress would have been prepared for the remarkable advance announced by his *New England Scenery* (colorplate 5) when it appeared at the Art-Union in the fall of 1851.[2] Within a matter of months the picture had taken on special status, for it was "considered by many to be the chef-d'oeuvre of the artist."[3]

There may seem little about this "view of water and mountain scenery, glowing with sunlight" to occasion such attention.[4] In the foreground a rustic timber bridge spans a ravine; near its right end is a horse-drawn covered wagon. A woman and a dog are on the bridge; beyond them are many things to arrest the viewer's attention as it is directed to several distinct scenes and different types of landscape. The viewer sees a calm body of water extending into the distance, cows watering at the edge of a sandy spit, a rocky waterfall with a mill beside it, cleared fields and groves of trees, a white church with a columned porch and a steeple, gently rolling hills leading to distinctive mountains, and, finally, a sky filled with majestic cumulus clouds. But such a summary description gives little idea of the painting's rich detail, from the twisted form of an old tree in the left foreground, to the meticulously rendered sawmill in the middleground, to the precisely drawn rocky cliffs of the distant hills. Much more could be mentioned, but the point is that in *New England Scenery* Church for the first time united his ability to portray the world in minute detail with an expansive composition that surpasses any of his earlier works. His contemporaries, who praised the

53

"great breadth of effect, with wonderful excellence
in details," saw this clearly.[5]

*New England Scenery* was Church's first attempt
at a new kind of landscape, and it represented a
watershed in his artistic development equal to that
of Cole's first attempts at a "higher style of land-
scape" in 1828. Unlike Church's previous land-
scapes, which were either views of specific places
(*West Rock, New Haven; Ira Mountain, Vermont*)
or scenes of fairly limited geographical extent (*Twi-
light, "Short Arbiter 'Twixt Day and Night"*), *New
England Scenery* presented a panorama of the na-
tional landscape that encompassed miles of Ameri-
can space. The various elements of the painting
were based on sites Church had visited in his travels
throughout the northeastern United States. The wa-
terfall recalls the falls on the Genesee River, or per-
haps Pittsford Falls in Vermont. The mill and its
environs could evoke many places (see figures 13
and 14), but specifically suggest Maine (figure 39),
and the rolling topography of the distance brings to
mind the Green Mountains of Vermont and the
White Mountains of New Hampshire.[6] Church was
assembling representative details from widely sepa-
rated areas into a single landscape, and in doing so
he was following advice from a new source of
influence.

This new influence—the first of real importance
for Church since Cole—originated in the theories of
the German naturalist Alexander von Humboldt.
Humboldt was perhaps the last great mind of the
Enlightenment, a man whose knowledge covered
virtually every field of human endeavor. As a writer
for the *New York Times* observed in 1853:

> Humboldt seems to have run through each nobler
> mode of human science, and become master of all. No
> part of that large, bright circle seems untouched by his
> hand—whether it concerns the stars, planets, and the
> other phenomena of the firmament, electricity, magne-
> tism, geology, anatomy, botany, chemistry, ethnology,
> archaeology, history, geography, hydrography, mathe-
> matics, metallurgy, or poetry.[7]

39. Frederic Edwin Church, *Lumber Mill at Mount
Desert,* c. 1850, pencil and gouache on grey-toned paper,
10¼ × 15 in., New York State, Office of Parks, Recrea-
tion and Historic Preservation, Olana State Historic Site
(OL.1980.1610).

It was through Humboldt's famous book *Cosmos,*
widely available in English editions in America by
the late 1840s, that most people were familiar with
his theories.[8] Humboldt believed that the world
contained distinct climate zones, each with its own
characteristics. His findings were based on years of
careful research and fact-gathering, and he used de-
tailed information to provide the underlying struc-
ture for his grand theoretical systems.

Landscape painting particularly interested Hum-
boldt, because it could serve as a visual equivalent
to written descriptions and give people an idea of
places they would probably never see. His influence
on the arts was widespread, reaching its apogee,
perhaps, in the enormous panoramas and cosmo-
ramas that were so popular around mid-century.[9]
*Cosmos* included a lengthy chapter on landscape

painting in which Humboldt surveyed the history of the art. He compared paintings to written descriptions of "natural scenes and objects," noting that both show us the "external world in all its rich variety of forms, and both are capable . . . of linking together the outward and inward world."[10] The proper ingredients for landscape were a great "mass and variety of direct impressions" recorded through sketches and notes, and a suitably fertile imagination to make use of all this information. The result would be "heroic landscape painting" that brought the physical facts of the natural world into the higher sphere of art through an "inward process of mind."[11]

Church was already a resolute recorder of natural facts—as his sketches and drawings attest—and was fully capable of the "deep and comprehensive reception of the visible spectacle of external nature," called for by Humboldt. But he had never before attempted to use his skills in the ambitious way the German writer envisioned. Reading *Cosmos* encouraged Church to expand his compositions dramatically, so that they now embraced much larger portions of the world. Even the title of his first effort, *New England Scenery,* announces this expanded scope, for it brings to mind not a specific locale, but a vast area covering thousands of square miles in several states.

Church, then, had painted a synthetic composition meant to portray the essence of the New England scene he had come to know well through his travels and studies. But if the painting did only that, and nothing more, it would not be so important to an understanding of Church's vision of the national landscape. Most significant is that in this imagined scene carefully and consciously selected elements create an ideal of what New England—and, by extension, the nation—should be. Each major element plays a symbolic role in defining the character of this ideal world. The bridge and road show that a system of transportation exists; the mill, as in other of Church's early landscapes, represents a comfortable accommodation of technology into the natural world; the cleared fields represent agriculture; and the church establishes the presence of religion. The forms of nature—trees, underbrush, the lake, the hills, and mountains—surround man and his creations, but do not threaten them. This is manifestly an image celebrating an equilibrium between nature and civilization: no sawn tree stumps mar the foreground, no sawdust from the mill or runoff from the fields pollutes the water, and no smoke from a forge or railroad engine fouls the air. From this painting one would have little hint that many of New England's industrious citizens were, by 1850, fleeing westward to escape the overcrowding, the soil exhaustion, the increasing industrialization, and the general lack of opportunity that were already radically altering the physical and social character of the region. *New England Scenery,* then, presents a world that might still have existed in 1851, but that was destined to change with astounding speed over the next decade.

The Conestoga wagon assumes a special role in Church's painting, for even by 1850 such wagons were archetypal symbols of American expansionist politics. It serves as the means of exporting the people and ideals of the young nation's symbolic center—New England—to the new, untouched lands of the West. The implication is that New England has, after several generations of hard work, been transformed into the Paradise God had ordained for Americans and is now "completed." It was time to apply its example to the settlement of the West. Church would have agreed with his fellow New Englander James Russell Lowell, who wrote in 1849: "We have . . . a continent to subdue with the plough and the railroad."[12] Not to do so would be to waste the bounty God had given the nation and to fail in continuing to bring about the millennial age that American writers had long predicted.[13]

That Church intended to give *New England Scenery* this broader frame of reference embracing westward expansion is made clear by considering the preliminary sketch for the painting (figure 40). Most of the changes between sketch and finished

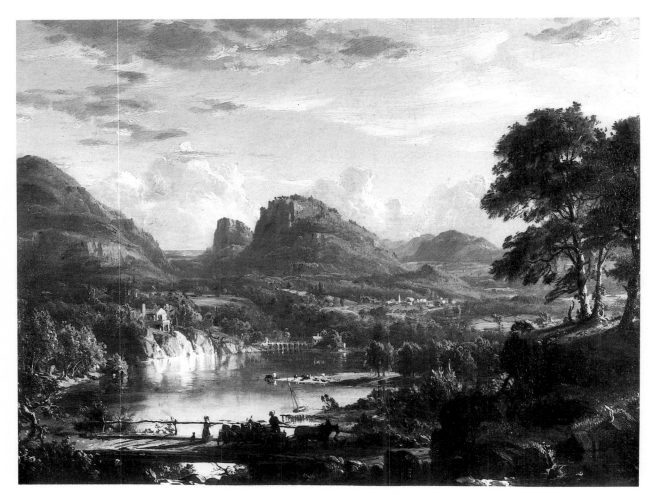

40. Frederic Edwin Church, *Study for New England Scenery,* 1850, oil on canvas, 12 × 15 in., Lyman Allyn Museum, New London, Connecticut.

painting are minor, but two are not. In the distance of the oil study, beyond the mountain ranges, Church included a glimpse of the ocean that he eliminated in the final oil.[14] The sea is as much a part of New England's identity as the land, but in this context its presence would have fixed the point of view directly into the East, leading the viewer perhaps to think of the Old, rather than the New, World.[15] The second change is more obvious, perhaps, but is equally revealing. The sketch does not have the Conestoga, but only a farm wagon of the type used to move goods short distances. In the time between sketch and finished painting Church saw the need to connote cross-country travel.

In spite of all Church's careful planning and work, *New England Scenery* is ultimately somewhat

"more cosmic in ambition than in realization."[16] The landscape is meticulously constructed with a synthetic, even artificial character unlike more compositionally cohesive works such as *West Rock, New Haven* or *Twilight, "Short Arbiter 'Twixt Day and Night."* Indeed, *New England Scenery* has more in common with the heroic landscapes of the seventeenth-century masters Claude Lorrain, Nicolas Poussin, and Salvator Rosa than it does with most mid-nineteenth century American works. Church's painting is as carefully composed as a Poussin, but it also manages to have some of Rosa's vigor and some of Claude's golden light. But what the picture most clearly shares with its seventeenth-century ancestors is a deliberately intellectual approach to landscape in which the individual components of external reality are reformulated into a pictorial conception that functions both as an image of the world and as a means for conveying complex ideas. Just as the letters of the alphabet may be assembled in certain combinations to convey meaning, so are the various components of New England—trees, rocks, hills, clouds, people, animals, buildings—carefully arranged so that the complete image speaks coherently. The random and chance patterns of nature that an artist such as Durand might have valued for their own sake are reordered by Church to suit his own vision. In large measure, this is precisely what Humboldt, who knew and understood the European landscape tradition very well, envisioned in an art that resulted from both a "deep and comprehensive reception of the visible spectacle of external nature" and an "inward process of mind." Once a painter was capable of achieving this creative fusion of physical perception and mental process, he would, in Humboldt's words, transform "the actual into the ideal."[17]

For Church those words would have addressed the very substance of what he hoped to achieve in his own art. Humboldt, however, only offered advice concerning the components necessary for creating such landscapes. He did not present a formula for their organization or for the complete realiza-

tion of this type of artistic vision, for he was not, after all, a painter. For this he could only offer vague recourse to the mind, which would receive this "mass and variety of direct impressions . . . fertilize [them] by its own powers, and reproduce [them] visibly as a free work of art."[18] To a young painter like Church, this no doubt was easier said than done. *New England Scenery* proves that Church had heeded Humboldt's advice to create a "heroic" landscape, but it also proves that in doing so, he had turned once again to the example offered by his teacher's work.

Cole, of course, had drawn heavily on the Old Masters in creating his own brand of synthetic landscape, and he understood perfectly the principles of landscape composition. As he observed in a oft-quoted letter to Robert Gilmor:

> The most lovely and perfect parts of nature may be brought together, and combined in a whole, that shall surpass in beauty and effect any picture painted from a single view. . . . He who would paint compositions, and not be false, must sit down amidst his sketches, make selections, and combine them, and so have nature for every object he paints.[19]

Cole painted several major landscapes according to these principles, and he must have conveyed similar ideas to his pupil. In formulating *New England Scenery*, Church turned to one of the greatest of Cole's compositions, and the one that offered the most appropriate thematic parallel to his own intentions: *The Pastoral State,* from *The Course of Empire* (figure 41).

There are compelling similarities between *New England Scenery* and *The Pastoral State.* Both compositions are organized with the same principal elements: a foreground area for human activity, each with a bridge; large trees flanking the right-hand sides of the compositions, with gnarled and twisted tree snags on the left; a body of water spanning the area from the middleground to the distance; and a great, pyramidal mountain form anchoring the background.[20] Church further transformed certain specific details from Cole's painting into their mod-

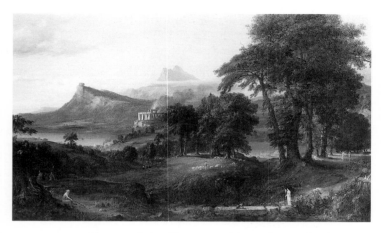

41. Thomas Cole, *The Pastoral State,* from *The Course of Empire,* completed 1836, oil on canvas, 39¼ × 63¼ in., courtesy New-York Historical Society, New York (1858.2).

ern equivalents. The Stonehenge-like temple is replaced by the quintessential New England white-steepled church, and Cole's emblem of primitive industry (boat building) is updated in the form of the sturdy Maine sawmill. A contemporary description of *The Pastoral State*—"in this picture we have agriculture, commerce, and religion"—could just as easily apply to *New England Scenery.*[21]

In these ways, Cole's painting offered Church an accessible structure on which to base his own image of a pastoral paradise. As in *West Rock, New Haven* of 1849, Church had taken a theme of interest to Cole but had transformed it into one of far wider interest to the American people. He had achieved the goal he had been working toward steadily since the earliest days of his career. He had elevated the real to the realm of the ideal and, in doing so, had created a modern American landscape that was equal to the great works of the past. *New England Scenery* took the raw materials of American nature and American culture and made from them high art in a way that no other contemporary painter had been able to do. It had not required a literary sub-

ject, a specific historical event or site, or even a poetic title; instead it took for its theme the here and now of the New World. *The Deluge,* with its Old World resonance, had been a resounding failure, but *New England Scenery,* even more than *Beacon, off Mount Desert Island,* was a triumphant success. Americans were, at last, ready to find in their own surroundings and in the details of their own lives, the stuff of a national mythology. *New England Scenery* expressed both the general substance and the specific facts of this new American mythology perfectly. After this point Church painted no more allegorical or imaginary works, for he had found the means to endow pure landscape with the elevated meaning he believed essential to his art. The mainspring of his work now became the expression of the complex matrix of issues formed by the conjunction of nature and the national identity.

Late in 1852 *New England Scenery* was sold for thirteen hundred dollars, setting a record price for an American landscape. Church was understandably pleased with this monetary validation of his masterpiece, but he had already expressed his aesthetic satisfaction in several subsequent works. The basic format of a landscape with rolling hills punctuated by rocky mountains and a sky filled with large cumulus clouds reappears in a number of works from the period 1851–53. Church spelled out the formula for such pictures in a letter of 1852 written to an officer of the Pennsylvania Academy of the Fine Arts:

> I am painting a scene expressive of Maine or New England Scenery with a rocky mountain, clear sky with large white rolling cloud. The distance sunlit and the foreground principally in deep shadow. . . . The general hue of the light I intend to have golden.[22]

The painting Church referred to was shown at the Pennsylvania Academy in 1852 under the title *New England Scenery.*[23] A work conforming to the description and size (26 x 40 inches) given in the letter is now at Olana and is undoubtedly the *New En-*

*gland Scenery* of 1852.[24] Although it does share certain elements with its more famous namesake of the previous year, the Olana painting is more rugged in character, depicting only a rudimentary settlement. In that respect, the 1852 *New England Scenery* prepared the way for Church's next important work, the splendid *Home by the Lake* (colorplate 6).

*Home by the Lake* (or, as it later became known, *Home of the Pioneer*) is the finest of the works derived from the 1851 *New England Scenery*.[25] *Home by the Lake* relates closely to the earlier painting in its handling and composition, but it presents a very different scene. A dirt road leads from the immediate foreground into the picture; beside it stands a woman with a pail. A small area of cleared land with several tree stumps and a pair of cows surrounds a rustic log cabin. A lake stretches into the middleground and to the right side of the composition, and on it is a boat with a figure firing a gun. In the distance are fields and mountains, and above is a vast blue sky with large white cumulus clouds. A golden light comes from the left and casts long shadows across the foreground. The critic for *The Knickerbocker* found the sky "excellent, beautiful and refined in form, and true in color," and G. W. Curtis praised the painting as a "fine illustration of Mr. Church's best characteristics."[26] However, for the first time, a major work by Church was criticized as being overly detailed at the expense of "breadth" and "unity and repose."[27]

Certain details in *Home by the Lake*—the recently cleared area of land, the pile of brush in the foreground, and especially the modest log cabin—suggest that this is an outpost on the very edge of the frontier. The painting thus served as a sequel to the original *New England Scenery*. The settlers who headed west in the Conestoga wagon have now found their own portion of Paradise and are busily transforming it from untamed wilderness into a domestic Arcadia. Church's painting thus anticipates by three years Durand's classic statement on this theme, *The First Harvest in the Wilderness* (1855, Brooklyn Museum). It is, in fact, a pictorial response to a plea Church would have read in a review of the National Academy exhibition of 1850:

> Is there any striking representation here of one of the controlling passions and ideas of our own time and country? We are unable to find on these walls any expression of the American courage which seeks out at a day's notice a new home thousands of miles distant; of the American self-reliance which defies the wild beast and the savage, and plants a corn-field in the remote prairie; . . . of the chivalric respect for woman which adorns the rudest log cabin beyond the mountains; of the sublime march of that broad column of civilized men which slowly advances year by year into the vast and silent regions of the West. There is no adequate record of these great facts which mould our thoughts, which fill our hearts, which shape and control our every-day life![28]

The direct thematic ancestors of *Home By the Lake* are Cole's *The Hunter's Return* (figure 42) and *Home in the Woods* (figure 3). Both of these works are from the mid-1840s, when Church was working with Cole (see chapter 1), and show rustic cabins and resourceful pioneers who have carved out a

42. Thomas Cole, *The Hunter's Return,* 1845, oil on canvas, 40¹/₈ × 61¹/₂ in., Amon Carter Museum, Fort Worth, Texas (156.83).

peaceful and harmonious existence in the American wilderness. The long shadows falling across each scene mark the time as late afternoon. Smoke comes from the cabin chimneys, and a peaceful mood of quiet ends a productive day. In both *The Hunter's Return* and *Home in the Woods,* Cole depicted the pioneer father as provider of food (fish and game) for his family. Church's painting follows Cole's model in all of these respects, even down to the wisp of smoke coming from the cabin and the motif of the food-providing father, who is hunting on the lake.

*Home by the Lake* also includes tree stumps, a potentially troublesome symbol which, as we have seen, Church, unlike Cole, depicted only rarely in his paintings. Generally, their presence would have sounded too disturbing a note in his otherwise peaceful and harmonious compositions. As Henry Ward Beecher observed, tree stumps in a landscape might remind one of the tombstones of the dead in a cemetery.[29] However, a fully convincing image of a frontier settlement virtually required the inclusion of tree stumps. The clearing of trees was, after all, the first order of business for the pioneer so that he could plant his crops. Trees also provided the material for the construction of his shelter. The presence of the stump in a landscape helped convey the newness of the scene and give an indication of the recently fought contest between man and wilderness.[30] Church had used stumps to precisely this end in his *Too Soon* of 1847 (figure 12), a work that might be seen as a modest prototype for *Home by the Lake.* In *Home by the Lake* the stumps, although plainly visible, are not prominent or assertive as they are in so many of Cole's pictures. They serve the theme, not its troubling implications. Church had, once again, followed a fine line in expressing his belief in the sanctity of American progress without raising its less positive associations.

Cole's *Home in the Woods* and *The Hunter's Return* were important precedents for *Home by the Lake,* but another of his works from the period Church studied with him, *L'Allegro* (figure 43), pro-

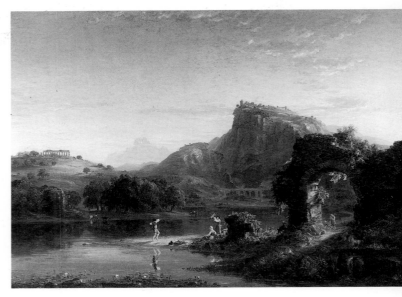

43. Thomas Cole, *L'Allegro,* 1845, oil on canvas, $32^{1}/_{16} \times 48^{1}/_{16}$ in., Los Angeles County Museum of Art, gift of the Art Museum Council and the Michael J. Connell Foundation (M.74.53).

vided compositional influence. *Home by the Lake* and *L'Allegro* are strikingly similar in overall format, with water running from foreground to middleground and rolling hills in the distance. And although the rocky mountain that anchors the composition of *Home by the Lake* is a close relative of the one in *New England Scenery,* it is also suggestively like the mountain in Cole's *L'Allegro.* In *L'Allegro* Cole portrayed a nostalgic, idyllic world of dancing peasants, ancient ruins, and foraging goats. In Church's work these elements were replaced by industrious settlers, a rustic cabin, and grazing cows. If *New England Scenery* may be read as a conscious updating of *The Pastoral State,* *Home by the Lake* is *L'Allegro* temporally and spatially relocated to the America of 1852. It is then Cole's wistful vision of an imagined Arcadia transformed by the infusion of American character (and, perhaps, a touch of the Puritan work ethic) into a real and attainable version of Paradise.[31]

44. Frederic Edwin Church, *The Wreck,* 1852, oil on canvas, 30 × 46 in., Cowan Collection, The Parthenon, Nashville, Tennessee.

Church exhibited only one other work in the National Academy exhibition of 1852, and it was markedly different in character from *Home by the Lake.*[32] *The Wreck* (figure 44), similar in general conception to *Beacon* of the previous year, is among the finest of Church's early marine paintings. Like *Beacon,* it is primarily an image of sky and water. The cloud formations recall those in the earlier work, although they are now less solidly rendered. In the distance are great cumulus clouds much like those seen in *New England Scenery* and *Home by the Lake.* The foreground area of *The Wreck* is more animated than that in *Beacon,* with swirling waves and jagged rocks arranged across the picture plane. A wrecked schooner is prominently placed on the rocks at the right side of the composition, and other boats are seen far out at sea.

According to G. W. Curtis, *The Wreck* was "one of the most popular pictures in the exhibition," and it established Church as "without doubt the first of our marine painters."[33] At a time when painters such as Fitz Hugh Lane were exhibiting regularly in New York, this was high praise indeed. Curtis compared Church to Turner in the power and poetic qualities of his works, praising in particular his mastery of evanescent effects of light. But he also noted that marine pictures, when treated without imagination, were a low form of art. Fortunately for Church, Curtis found in *The Wreck* "a genuine poetic impulse:

The highest triumph we remark in Mr. Church's marines is the *solemnity* of the sea. In other pictures we recall certain features of ocean character, certain aspects of calm and storm, certain superficial and striking details of effect. But through and above all the fine detail of Mr. Church, which no one surpasses, his pictures have a broad and grave character—a meaning—a thought which elevates them from sea-pieces into works of art. Whoever has been overtaken by nightfall upon the shore, and, as the twilight darkened, saw some relic of the sea's fury drifting by or lodged among the rocks, and as he looked across the heaving waste felt in the gathering gloom its melancholy wail made visible, so that by sight and sound he was sympathetically enthralled—he has had that feeling of pathetic so-

lemnity in the ocean of which Mr. Church, this year, and the last, has shown himself the Poet.[34]

Other reviewers were not so unreserved in their praise. The critic for *The Albion* considered it not up to Church's usual standards although he admitted "there is something original and striking in all he paints."[35] *The Knickerbocker*'s critic thought *The Wreck* "much inferior" to *Home by the Lake,* even though "the effect was bold and correct."[36] Nevertheless, Curtis was not the only one to recognize that Church was already, at the age of twenty-six, a talent that stood apart from the mainstream of American landscape painters. As the *Literary World* noted: "Church is an original, striking genius, and in his own peculiar feeling and powers, is unequalled by any living artist with whose works we are acquainted."[37]

The setting of *The Wreck* resembles the coastal scenery that Church had sketched at Mount Desert during the summer of 1850 and again the following year. However, the jagged rocks, especially those at the far right, bear some resemblance to the striking formations at Grand Manan Island in the Bay of Fundy, which Church also visited in the summer of 1851.[38] In one of these locations, most probably Mount Desert, he sketched a schooner called the *Joseph Ham* out of Halifax, Nova Scotia (drawings at Olana). Although not wrecked, the *Joseph Ham* closely resembles the ship seen in the painting, since it has a similar design, black hull, and a painted band (green instead of the red in the painting) running around the gunwales.

The theme of wrecked or stranded boats was extremely popular in nineteenth-century American painting, and examples occur in the works of such major artists as Asher B. Durand, Fitz Hugh Lane, Martin Johnson Heade, Jasper Cropsey, Albert Bierstadt, and Alfred Thompson Bricher. Considerable attention has been devoted to the study of scenes of ships actually wrecking or images of boats engulfed by storms, and these are themes that have an obvious bearing on the stranded or wrecked

boat.[39] But less attention has been paid to images of the aftermath of shipwrecks.

From the outset, we must distinguish between boats that are actually wrecked and abandoned and those that are merely beached but otherwise sound. In Heade's *Stranded Boat* of 1863 (Museum of Fine Arts, Boston), for example, it is clear that the boat has been either left high and dry by the tide or pulled up onto the beach by its owner. The prominently displayed mooring line and the loosely stowed sails indicate that the boat has recently been used and will be used again. In other cases are boats that have been intentionally beached for repairs to the hulls. This type of scene was occasionally painted by Robert Salmon and by other artists such as William Bradford (e.g., *Repairing the Fishing Luger,* 1862, private collection). In these paintings the activities of men at work indicate that the boat has not been abandoned or wrecked but is being repaired.

The theme of abandoned or wrecked boats is far more poignant and evocative than beached boats and it held great appeal for American artists. Within this general theme are two basic types. First are the images of small rowboats, dories, or sailboats, often shown pulled up on shore as if they had been forgotten by their owners and left to rot and decay with time. Church's *An Old Boat* (figure 31) is an example of this type. Others include Cropsey's drawings of a rowboat on the shore of Wawayanda Lake (1846, Newington-Cropsey Foundation)[40] and Lane's *Norman's Woe, Gloucester* (1862, private collection), which has the remains of a small rowboat among the foreground rocks.[41] In general, these small boats evoke a personal, individual response because the viewer tends to identify with the image. Such boats are generally for one or two people, and we think of them not so much as emblems of the tragedy of humanity at large, but in terms of more personal disappointments and sorrows. These forgotten vessels, decaying with time and weathered by the elements, speak of lost hopes and dreams. Like the ever-present skulls in seven-

teenth-century portraits and gravestones, they function as *memento mori.* Indeed, in Lane's *Norman's Woe,* the side planks of the boat have fallen away, leaving the ribs protruding starkly like the bones of a human skeleton.

The second category of stranded- and wrecked-boat imagery includes depictions of larger vessels that have clearly met their end through disaster rather than neglect. These images are sequels to the far more common shipwreck scenes that were so popular in nineteenth-century painting. The drama of the storm and loss of life has passed, leaving only the moldering hulks of the once proud ships. These boats are almost always dismasted and shattered and are frequently trapped by jagged rocks. Remnants of once-taut rigging hang in loose disarray, and torn sails flap uselessly in the breeze.

This type of image occurs not only in nineteenth-century painting, but in poetry as well:

> Clouds in the evening sky more darkly gather
> And shattered wrecks lie thicker on the strand.[42]

For John Ruskin, a wrecked ship, like a ruined building, was a worthy subject because

> man's work has therein been subdued by
> Nature's. For a wrecked ship, or shattered
> boat, is a noble subject, while a ship in full
> sail is an ignoble one; not merely because the
> one is, by reason of its ruin, more picturesque
> than the other, but because it is a nobler act
> in man to meditate upon Fate as it conquers his
> work, than upon that work itself.[43]

Thus the wrecked or stranded ship could evoke more than meditations on individual mortality; it could lead to contemplation of the greater issues of man's creations and his civilizations and their ultimate relationship to nature and fate. In Cole's *Desolation,* the architectural ruins serve this purpose, but—as he so often lamented—America was still too young to have such inspiring sights. However, the rocky and treacherous coasts of the New World provided an ample supply of wrecks, and these

could be used to evoke similar associations and bring to mind themes of considerable interest to Americans of Church's day.[44]

America had, of course, been settled from the sea, and the sea remains to this day a key element in the national identity because of its importance in transportation, military strategy, and food production. It has also always been seen, even from the earliest days of settlement, and especially by seafaring New Englanders, as a dangerous place of wildly unpredictable forces. Long after the wilderness areas of inland New England had been tamed, the coastal regions were still perceived as a different but equally threatening kind of wilderness.[45] Shoals, rocks, shifting sandbars, and unstable channels were constant hazards to coastal navigation, and they left a grim legacy of place names—such as Norman's Woe—testifying to their dangers. It took centuries for mariners to prepare proper charts for the American coast, and well into the nineteenth century it remained the very "objectification of chaos."[46] As Thoreau wrote following his visit to Cape Cod, where he saw wreckage and corpses from a shipwreck, and where he later himself almost drowned:

> Before the land rose out of the ocean, and became *dry* land, chaos reigned . . . and between high and low water mark, where she is partially disrobed and rising, a sort of chaos reigns still, which only anomalous creatures can inhabit.[47]

For Americans of Church's and Thoreau's time, then, the sea and the coast were mysteriously fascinating, inspiring emotions ranging from the pleasant to the horrific. Shipwrecks received wide attention in the press; some, such as the one off Fire Island, New York, in July 1850 that drowned Margaret Fuller and her young daughter, were among the most sensational events of the day.[48]

One of the first major American artists to explore the theme of the wrecked ship was Asher B. Durand, whose *Stranded Ship* (now unlocated), was exhibited at the New-York Gallery of Fine Arts in

1844.[49] The painting was accompanied by the following verses:

> Where, hapless bark, are they who furled the sail,
> When o'er thee burst the fury of the gale?
> Where they, who grasped the shrouds with
>    desperate hand,
> When the mad billow flung thee on the land?
> Do these blue waves that now in sunshine leap
> Roll o'er their corpses far within the deep?[50]

Durand repeated this subject in a painting entitled *Shipwreck, Clearing Up After A Storm* (unlocated) which Church would have seen at the National Academy in 1850.[51] According to the critic for *The Albion,* there was "more real poetry, and more feeling in this picture of a crippled and deserted ship, than in any other in the exhibition."[52] Church could hardly have missed these words of praise, because they occurred on the very page where his own works in the same exhibition were discussed. Thus it is possible that Durand's example led Church to the subject of the wrecked boat.

    Another likely influence was Fitz Hugh Lane, whose paintings of Maine scenery exhibited in New York in 1849 may have played a role in Church's decision to visit Maine and try his hand at marine subjects. Certain similarities between Lane's *Twilight on the Kennebec* (figure 45) and *The Wreck* suggest that Church may have been thinking of Lane's work in 1852, but there are also important differences. The sky in *The Wreck* is considerably more dramatic than that in *Twilight on the Kennebec,* which is more quietly suggestive. Church's scene is a rocky ocean coast, whereas Lane showed an inland river. The most important difference, however, concerns the character of the ships themselves. Church's ship is clearly wrecked; the title is unnecessary to make this apparent. Lane's image is more enigmatic; the sails are still on the schooner, and they do not appear to be torn. A row of logs in the foreground suggests that the boat may have just unloaded or is perhaps just about to be loaded. Furthermore, this vessel is not trapped among threatening rocks; it is merely aground near shore.

45. Fitz Hugh Lane, *Twilight on the Kennebec,* 1849, oil on canvas, 18 × 30 in., private collection.

Still, there are hints that all is not well; the pronounced starboard list is unsettling and one of the bowsprits appears to be broken. Are we looking at a recently abandoned ship that has been left to waste, or one that might be awaiting repair? The answer is uncertain.

    Whereas Lane's message in *Twilight on the Kennebec* is unclear, Church's painting is more direct, although no less evocative. As G. W. Curtis's comments suggest, *The Wreck* is a richly poetic image that invites the viewer to muse upon the tragedy of the scene. It is, in Ruskin's definition, a "noble subject" that leads "man to meditate upon Fate as it conquers his work."

    Such sentiments come close to the spirit of Cole, and bring to mind *The Course of Empire.* In that series, an Arcadian moment of bliss gave way to the mixed blessings of an advanced civilization, which, in turn, fell victim to the weaknesses brought on by its own excesses. In the final painting, *Desolation* (figure 74)—and recall that this was the work that

Church admired perhaps above all others by his master—the ruins of the civilization are shown on the verge of being overwhelmed by nature.[53] Thus we are returned to the beginning of the cycle, with nature reverting to the "savage (i.e., uncultivated) state." The stage is set, then, for another "course of empire," but in Cole's pessimistic outlook, no guarantee prevented man from repeating his mistakes, thereby dooming himself to, literally, a vicious cycle of attainment and loss that would continue until the end of the world.

Given Church's belief in the virtues of Cole's moralizing landscapes and his particular admiration for *Desolation, The Wreck* might be seen as his own interpretation of the same theme. But whereas Cole's pessimism required man to be banished from the scene—*Desolation* is without human presence—Church was invariably more optimistic. Thus, in *The Wreck* the other boats in the distance show that New World man is still very much on the scene, and presumably able to learn from his mistakes so that he will not lose this new, God-given empire. With the blessing of God and the bounties of a new Paradise laid before him, would it not be possible for the American Adam to break the vicious cycle of doom? The streaming light from the sky, which promises to overcome the storm clouds, and the unmistakable cross formed by the mast of the wrecked schooner, hint that divine power will be with him in his attempt to do so.

These issues are further clarified when *The Wreck* is considered in the context of the other painting Church exhibited at the National Academy that year, *Home by the Lake*. The two works—the only ones Church exhibited at the Academy in 1852—make a striking pair, with *The Wreck* playing *Il Penseroso* to *Home by the Lake*'s *L'Allegro*. They are of nearly identical size and the dramatic—or Sublime—characteristics of *The Wreck* provide an evocative contrast to the more peaceful—or Beautiful—traits of *Home by the Lake*. We may further note the pairing of a sunrise and a sunset. Paired paintings would, of course, have been familiar to

Church from such works by Cole as *Departure* and *Return* (Corcoran Gallery of Art) or *Past* and *Present* (Mead Art Museum, Amherst College) and also Asher B. Durand's *Morning of Life* and *Evening of Life* (National Academy of Design). Indeed, it is clear that pendants were far more common in mid-nineteenth century American painting than has been assumed.[54]

Whether or not *Home by the Lake* and *The Wreck* were actually conceived as pendants, it is likely that Church specifically intended the thematic and stylistic relationships between them. As suggested in the previous chapter, there was a link in Church's mind between *The Deluge* and *Beacon, off Mount Desert Island* of 1851, and he may have had similar thoughts for his two pictures of 1852. *The Wreck* is an image of decay and tragedy, but it also hints at a more prosperous and happy world. That world is given concrete form in *Home by the Lake*, which shows Americans taking responsible advantage of the promise and potential of the New World. One image invites meditation upon the transience of earthly things; the other presents a world of security, peace, and future promise. The wrecked ship with its shattered and rotting hull is replaced by the pioneer's cabin made of freshly hewn logs. Death gives way to life as the old gives way to the new.

In his landscapes of 1851–52 Church had addressed new themes and expressed new ideas, and had done so with a new maturity and certainty. *New England Scenery, Home by the Lake,* and *The Wreck* are among his most compelling early paintings, and they stand at the beginning of a series of increasingly powerful works that would fully achieve the kind of "heroic" landscape painting Humboldt envisioned. As in previous years, Church continued to seek out new scenery and new material for paintings. In the summer of 1852 his travels once again took him to Maine. The following chapter examines his experiences there that brought him face to face with some fundamental, and challenging, truths about the national landscape.

46. Frederic Edwin Church, *Ktaadn from Ktaadn Lake,*
1852, pencil on paper, 12 × 17³/₄ in., New York State,
Office of Parks, Recreation and Historic Preservation,
Olana State Historic Site (OL.1980.1992).

# Chapter 4 · The Pastoral Ideal

Our landscape artists, too, give us views of our scenery on their canvas, that are like reflections in a mirror.
"Fine Arts," *Putnam's Monthly,* 1853

Church sends four landscapes, and truly wonderful productions they are. . . .they all possess that charm of completeness, that truthful and yet not labored effect, which enables one to lay out an imaginary journey over hills, across streams, to take a sail on a slightly-ruffled lake, or make a friendly call in one of those away-off farmhouses.
"Exhibition of the National Academy of Design," *The Knickerbocker,* 1853

Church's major work of 1853, *Mount Ktaadn* (colorplate 7), is the most richly symbolic painting of his early career.[1] *Mount Ktaadn* was the largest (36 x 55 inches, or slightly larger than *New England Scenery*) of the four works he exhibited at the National Academy in 1853.[2] The painting was a result of Church's visit to the mountain late in the summer of 1852. Only a few details concerning this trip are known, and only a limited number of sketches (e.g., figure 46) may be dated to it with certainty.[3]

According to Theodore Winthrop, who would accompany Church on a later trip to the mountain (see chapter 5), the painter's first visit was made in the company of "a squad of lumbermen" in "those days when he was probing New England for the picturesque."[4] He stayed briefly at the house of a "Mr. Hunt" and then made the ascent from the eastern side of the mountain.[5] However, the weather was poor, and Church and his companions spent "wet and ineffective days in the dripping woods," so the painter had to vow "to return and study the mountain" someday.[6] Such is the scant information available to us concerning Church's first visit to an area that would ultimately provide him with the subject matter for some of his most important North American landscapes.

Fortunately there are other accounts of travels to Katahdin in the same period, the best of which is by Thoreau.[7] Thoreau set out from Concord on August 31, 1846, eagerly in search of a pure wilderness experience. Few white men had ever visited the area, and Thoreau observed that it would "be a long time before the tide of fashionable travel sets that way."[8] What immediately impressed Thoreau in Maine were the vast areas of "primitive" forest and the forbidding character of "the grim, untrodden wilderness, whose untangled labyrinth of living, fallen, and decaying trees only the deer and moose, and bear and wolf can easily penetrate."[9] Roads were scarce, and the few cultivated fields showed

evidence of a hard-fought struggle with nature:

> The mode of clearing and planting is, to fell the trees, and burn once what will burn, then cut them into suitable lengths, roll into heaps, and burn again; then with a hoe, plant potatoes where you can come at the ground between the stumps and charred logs. . . . In the fall, cut, roll, and burn again, and so on, till the land is cleared.[10]

In this rugged land, civilization advanced as best it could, leaving ugly and obvious scars upon the land.

As Thoreau neared the great mountain, all signs of habitation disappeared except for an occasional logging camp. While making the arduous ascent, he looked out over a wilderness of "immeasurable forest" with "no clearing, no house," and "countless lakes."[11] Thoreau found himself forcibly struck by this wild scene:

> Perhaps I most fully realized that this was primeval, untamed, and forever untameable *Nature,* or whatever else men call it. . . . It is difficult to conceive of a region uninhabited by man. . . . And yet we have not seen pure Nature unless we have seen her thus vast and drear and inhuman. . . . Nature was here something savage and awful, though beautiful. . . . Here was no man's garden, but the unhandselled globe. It was not lawn, nor pasture, nor mead nor woodland, nor lea, nor arable, nor waste-land. It was the fresh and natural surface of the planet Earth.[12]

When Thoreau came down from Katahdin, it was with the knowledge of just "how exceedingly new this country still is," and he now had a hearty respect for the ameliorating effects of civilization.[13] He had not lost his dislike for the materialism that was despoiling American nature, but he had come to regard untamed wilderness as equally problematic and unpleasant.

What attracted Frederic Church to this rugged and desolate area? Perhaps his experiences on Mount Desert and Grand Manan Islands had whetted his appetite for more dramatic and sublime scenery. Perhaps, too, he was seeking a great geo-

logical wonder that would outshine all the others he had previously seen, whether at West Rock, Natural Bridge, or Grand Manan Island. Cole had found in Mount Etna a subject of almost unending inspiration, and his young pupil had seen him paint at least one or two of his several views of the volcano.[14] Church may well have looked to Katahdin as a New World Etna; indeed, the mountain was considered volcanic in appearance by some of Church's contemporaries.[15]

Whatever his reasons for going to Mount Katahdin, Church, like Thoreau, found the experience of this "primeval" wilderness overwhelming. His drawing, *Ktaadn from Ktaadn Lake* (figure 46), shows a landscape much like the one Thoreau described, with "immeasurable forest, no clearing, no house." However, in the finished painting Church completely transformed the scene. *Mount Ktaadn* is not an image of Thoreau's "grim, untrodden wilderness," where there was "not lawn, nor pasture," nor even arable land. It is instead a pastoral scene complete with a young boy, cattle, a road, a bridge, a mill, and a horse-drawn carriage. Unlike *Home by the Lake* of the previous year, *Mount Ktaadn* implies that civilization is not new to this region. The bridge, road, and carriage indicate a well-established system of transportation, and glimpses of other buildings in the background suggest that settlement is widespread. Most important, the prominent mill in the middleground is not a sawmill, nor even a grist mill, but something far more substantial. It asserts the presence of advanced industry; one reviewer called it a "factory seat," and its architectural form, with a distinctive ornamental cupola, is, in fact, characteristic of the textile mills that had, by the 1850s, become familiar sights along New England streams and rivers.[16]

If this view of "our scenery" was, as one writer who had obviously never been to Maine wrote, "like reflections in a mirror," those reflections were of what Church wished reality to be, not what it truly was.[17] Like Thoreau, Church at this point found it "difficult to conceive of a region uninhab-

ited by man," for he depicted as civilized the very area that had convinced the writer of the beneficial effects of civilization. *Mount Ktaadn* thus represents the "damp and intricate wilderness"[18] of northern Maine transformed by the coming of the American pastoral state. As such, it was manifestly not an image of the reality of 1853. Rather it was an optimistic vision of the promise of the future.[19]

Why did Church effect this remarkable transformation? As stated earlier, during the first decade of his career, he only rarely painted the pure wilderness. Over and over again, he was drawn to settled areas, to places where Americans had smoothed the rough edges of the raw material of the land. Even when painting the remote borders of the frontier, as in *Home by the Lake,* his faith in the nation's destiny determined that he show a peaceful and harmless assimilation of man into the natural world. In the interior of Maine, however, where he spent "wet and ineffective days in the dripping woods," Church could only have been struck by how new the landscape still was. The few signs of civilization he would have seen during his trip—rudimentary roads, loggers' camps, and potatoes growing between stumps in scorched and blackened fields—could hardly have been comforting. To see inland Maine as he wanted to see it, to bring it into line with his established vision of the national landscape, he had to see it as he believed it would be in the not too distant future. For Church this would not have been to paint falsely any more than it had been to create the synthetic world seen in *New England Scenery.* In 1853 he fully believed American civilization would soon find its way to the most remote corners of the continent, and he would have encouraged such progress. His point of view would have been shared by Marshall O. Roberts, the owner of the *Mount Ktaadn.* Roberts, whose own background and Puritan character made his world view similar to that of Church, was one of New York's most active financiers and businessmen, a man who saw the future of America in terms of infinite expansion. Roberts made a fortune invest-

ing in steamships and railroads, shrewdly seeing the potential in undeveloped areas long before others did. In *Mount Ktaadn,* then, the interests of painter and patron coincided perfectly, for both found in the landscape of America confirmation of their own beliefs about the nation.

In transforming the landscape of Maine, Church did more than simply smooth out the rough features of the wilderness and add props of civilization. He constructed a richly symbolic landscape that speaks of a world to come rather than a world that is. Understanding how he did this requires examining certain aspects of the painting in detail. As in the case of Church's earlier *Beacon, off Mount Desert Island* or *New England Scenery,* the viewer was free to enjoy the painting solely for its aesthetic merits if that was all he sought. But those who cared to look further could find far more complex associations.

The key element for interpreting *Mount Ktaadn* is the figure of the young boy, who sits below a tree at the lower left of the composition (figure 47). He gazes across the lake, to the opposite shore, where the windows of the mill gleam in the light like a second pair of eyes. As in the case of Church's *Morning* (figure 17), this figure functions as a *doppelgänger,* allowing the viewer to share in his vision. Clearly this boy is in the midst of quiet contemplation, and we may posit that what he is contemplating is the American future. Like his counterpart in Cole's famous *Youth,* from *The Voyage of Life,* this young man can see "castles in the air." But unlike Cole's traveler, whose dreams were perforce unattainable fantasies, the boy in *Mount Ktaadn* visualizes a real world that is within reach, and which might well be achieved by the time he reaches manhood.

By the mid-nineteenth century, there was a well-established tradition, especially in literature, of musing about the nation's potential and future glory. Leo Marx, in *The Machine in the Garden,* has discussed this tradition and cited numerous examples.[20] Certainly one of the most extravagant was *The Golden Age: Or, Future Glory of North*

47. Frederic Edwin Church, *Mount Ktaadn* , oil
on canvas, 36¹/₄ × 55¹/₄ in., Yale University Art Gallery,
New Haven, Connecticut, Stanley B. Resor, B. A., 1901,
Fund.

*America Discovered by an Angel to Celadon in Several Entertaining Visions,* a pamphlet published in 1785.[21] The story concerns a man named Celadon, who wishes to know what the future holds for the new nation. One night, as he sits musing under a tree by the banks of a stream, he falls into a trance-like state. An angel appears and reveals to him America's destiny. He sees a landscape of "spacious cities . . . thriving towns . . . a thick conjunction of farms, plantations, gardens." The vision culminates with Celadon observing the untouched wilderness of the West and imagining the day when it, too, will be transformed into a pastoral paradise.

Timothy Dwight, in his *Travels; in New England and New-York,* published in 1821–22, described a similar experience, although without the mystical overtones of Celadon's account:

> The present, imperfect state of the settlements in this region will, I am well aware, prevent many persons from forming just views concerning the splendor of its scenery. In so vast an expansion the eye perceives a prevalence of forest which it regrets . . . this temporary defect, from a long acquaintance with objects of this nature, and a perfect knowledge from experience of the rapid progress of cultivation, I easily overlook, and am, of course, transported in imagination to that period in which, at a little distance, the hills, and plains, and valleys around me will be stripped of the forests which now majestically and even gloomily overshadow them, and be measured out into forms enlivened with all the beauties of cultivation.[22]

The true believer in the sanctity of progress could thus see beyond the "present, imperfect state" of the American scene to a glorious future of ordered prosperity. Frederic Church and those who purchased and commissioned his paintings, men such as Roberts, were true believers.

Of course, during the nineteenth century, pure wilderness had been endowed with powerful positive associations of its own. As noted in chapter 1, many observers felt American artists should devote themselves to depicting the wilderness before it vanished under the onslaught of the "axe of civiliza-tion." Yet this was not necessarily the only or even the dominant attitude, for American responses to nature in this period were complex and varied.[23] In many cases, appreciation of the wilderness went hand in hand with a corresponding recognition of the positive values of civilization. Thoreau's experiences in Maine, for example, led him to a more pragmatic view of American culture and American nature. Even Thomas Cole, so often the champion of a pure wilderness aesthetic, was not immune to dreaming of a glorious American future:

> But American associations are not so much of the past as of the present and the future. Seated on a pleasant knoll, look down into the bosom of that secluded val-ley, begirt with wooded hills—through those enamelled meadows and wide waving fields of grain, a silver stream winds lingeringly along—here seeking the green shade of trees—there, glancing in the sunshine: on its banks are rural dwellings shaded by elms and gar-landed by flowers—from yonder dark mass of foliage the village spire beams like a star. You see no ruined tower to tell of outrage—no gorgeous temple to speak of ostentation; but freedom's offspring—peace, secu-rity, and happiness, dwell there, the spirits of the scene. . . . And in looking over the yet uncultivated scene, the mind's eye may see far into futurity. Where the wolf roams, the plough shall glisten; on the gray crag shall rise temple and tower—mighty deeds shall be done in the now pathless wilderness; and poets yet un-born shall sanctify the soil.[24]

To be sure, Cole remained wary of the unchecked advance of civilization across the American land, but in such works as *The Oxbow* (1836, Metropoli-tan Museum of Art), where wild scenery is juxta-posed with the cultivated, and *Home in the Woods* (figure 3), and *The Hunter's Return* (figure 42), where man exists in harmony with the wilderness, he openly expressed his hopes for a reconciliation between nature and progress.

Others shared Cole's hopes, and some believed that nature's permanence and its ability to absorb progress were beyond doubt. As Asher B. Durand and William Cullen Bryant hopefully observed:

The hum of industry and the sounds of joy and peace echo over the graves of the sons of wilderness; but the beauties of the lake can never be lost: they are a feature of nature that civilization may slightly change, but never destroy.[25]

What the "visions" of Celadon, Dwight, Cole, Bryant, and Durand share is a belief that there can be a state of perfect balance—a "middle land-scape"—between civilization and nature. Church's *Mount Ktaadn* is a classic image of the middle land-scape, for it depicts just such a world in perfect equilibrium.[26] The musing boy, his eyes filled with the light of a glorious sunset, sees with his "mind's eye . . . far into futurity" to a time when the wilder-ness will be "measured out into forms enlivened with all the beauties of cultivation."

*Mount Ktaadn* presents additional evidence in fa-vor of such a reading. A review in *The Knicker-bocker* alerts us to an aspect of the painting we might otherwise overlook:

> One of this artist's peculiarities is the *correctness* of everything represented. An elm or an oak, six or eight miles off, is as individual as the model tree in the fore-ground, whether elm or oak.[27]

Now, in one sense, this "correctness" of representa-tion may be seen simply as typical of the aesthetic of the moment, which favored detailed realism. Durand, in his "Letters on Landscape Painting" of 1855, was specific about the need for such accuracy. "If your subject be a tree," he wrote, "observe par-ticularly wherein it differs from those of other spe-cies. . . . Every kind of tree has its traits of individuality."[28] However, there was more to the proper depiction of trees than merely a call for a careful and truthful representation of nature. As James Moore has shown, each kind of tree evoked different associations, which could be used to aug-ment or amplify a painting's theme or message.[29]

Pine trees, for example, might represent immor-tality (as they did in Church's *To the Memory of Cole* [figure 19]), because they are evergreens, and they could further be associated with wildness,

heights, and the Sublime. Oak trees were invariably thought of as old and had strong connotations of the past and history. The elm, generally associated with rural areas, could be a "paragon of beauty and shade"[30] that outstripped all other trees. As Henry Ward Beecher wrote:

> the elm, alone monarch of trees, combines in itself the elements of variety, size, strength, and grace, such as no other tree known to us can at all approach or re-motely rival. It is the *ideal* of trees; the Absolute Tree![31]

Furthermore, whereas the oak might be linked with the Old World, because of its connotations of his-tory, the elm was specifically associated with the New World. It is, as Beecher continued

> no less esteemed because it is an American tree; known abroad only by importation, and never seen in all its magnificence, except in our own valleys. The old oaks of England are very excellent in their way, gnarled and rugged. The elm has a strength as significant as they, and a grace, a royalty, which leaves the oak like a boor in comparison.[32]

In Church's *Mount Ktaadn,* then, the prominent pairing of an oak and an elm at the lower left, shown with perfect "correctness," should be seen as more than just an added touch of realism. In fact, realism is precisely what it is not, because neither the oak nor the elm grew in the Katahdin region.[33] Church deliberately included them because the asso-ciations of these trees worked in concert with the general theme of the painting. The "American" tree—the elm—which reaches its true "magnifi-cence" only in the rural fields and valleys (i.e., not the untamed wilderness, but the land as improved by man) of the New World, looms above the mus-ing boy. It sanctifies and blesses his vision, its branches forming a protective arch above his head. In fact, the elm, "the noblest arch beneath the sky," with its "sacred . . . roof of green," had strong re-ligious connotations. It was also seen as providing a perfect setting in which to sit and muse:

> The sunset often weaves
> Upon thy crest a wreath of splendor rare,

While the fresh-murmuring leaves
Fill with cool sounds the evening's sultry air.

. . . . . . . . . . . . . . . . .

When, at the twilight hour,
Plays through thy tressil crown the sun's last gleam,
Under thy ancient bower
The schoolboy comes to sport, the bard to dream.[34]

Behind the elm, a gnarled, "old" oak twists away as the vision of the New World to come takes shape. It evokes not only the Old World (and England, specifically) but also the great antiquity of the land itself, which God preserved through the millennia for a chosen people. Katahdin and the surrounding hills—"sole representatives of the primal continent"—now accept into sheltered valleys their new citizens, who bring with them the beneficial effects of civilization.[35] Overhead is a radiant sky and a glorious sunset that predicts a new age of peaceful prosperity to dawn in the tomorrow of the future.

Church surely intended for his painting to function as just such an optimistic vision of American destiny. That he understood the symbolism of oak and elm was demonstrated in his early painting of *The Charter Oak* (figure 9). There he had shown not only the patriarchal oak that represented the historic origins of Hartford, but also a young, vibrant elm growing next to it that spoke of the future that awaited his home town.[36] Just as in *West Rock,* it is the lessons of the past that inform the reality of the present. No doubt Church also understood the symbolic function of the motif of a figure musing under a tree, for in the National Academy exhibition of 1845, where he made his debut, he would have seen Durand's *An Old Man's Reminiscences* (figure 48). Significantly, in Durand's nostalgic picture, the old man, seated under a gnarled oak tree, dreams of the past of his childhood.[37] For him, the perfect middle landscape is one of memory. The boy in *Mount Ktaadn* is unencumbered by such wistful reverie; he is a citizen of the present of 1853 and a hopeful participant in the world of the future. Durand himself, in his major work of the same year, *Progress* (figure 49), expressed an opti-

48. Asher B. Durand, *An Old Man's Reminiscences,* 1845, oil on canvas, 38$^{1}/_{2}$ × 58$^{1}/_{2}$ in., collection Albany Institute of History and Art.

49. Asher B. Durand, *Progress,* 1853, oil on canvas, 48 × 71$^{15}/_{16}$ in.; from the Warner Collection of Gulf States Paper Corporation, Tuscaloosa, Alabama.

mistic view of American destiny more in line with the vision of Church. According to *The Knickerbocker, Progress* told "an American story out of American facts, portrayed with true American feeling, by a devoted and earnest student of Nature."[38] It was, in other words, an American history painting with the requisite stamp of the real. The same could be said for Church's *Mount Ktaadn,* although it conveyed its message in a far less bombastic and programmatic way.

*Mount Ktaadn* is the culminating work of Church's early career and the most complete statement of his youthful faith in America. It brought full expression to the ideas he had first explored in his modest *Too Soon* of 1847 (figure 12) and it did so with a lyrical beauty that makes it among Church's most satisfying creations. *New England Scenery* was more ambitious in intent, but no more successful in effect. Whereas the great work of 1851 was confidently obvious in conveying its message, *Ktaadn* was more subtle, but ultimately more convincing; where *New England Scenery* was overtly, even boisterously, nationalistic, *Ktaadn* was more profoundly meditative and evocative. Like the type of landscape Durand would celebrate two years later in his "Letters on Landscape Painting," *Mount Ktaadn* held appeal for "the rich merchant and capitalist" willing "to look into the picture instead of on it, so as to perceive what it represents. . . .

> It becomes a thing of more than outward beauty or piece of furniture. It becomes companionable, holding silent converse with the feelings, playful or pensive— and, at times, touching a chord that vibrates to the inmost recesses of the heart.[39]

In short, *Mount Ktaadn* defined a perfect world, a pastoral ideal. It was a vision of an America that had reached a peaceful accommodation between the needs of progress and the needs of preserving the heritage of the land itself, a nation poised between its own past, as embodied in the "primal continent," and its future, as predicted by the arrival of civilization. And like all perfect visions, it was one that could not last.

Just at the time *Mount Ktaadn* was on exhibit at the National Academy, Church set off in the company of Cyrus Field for South America.[40] Fired by what he had read in Humboldt, and no doubt encouraged by Field's eagerness to explore the commercial possibilities of South America, Church undertook the trip with enthusiasm.[41] The journey lasted some six months, and the painter returned to New York with a stock of new materials that would serve him well over the next few years. From this point on, Church became identified as the painter of the tropics, indeed the very man for whom Humboldt had called. Although he did not abandon the depiction of the North American landscape, he did come to see it differently as the result of his South American experiences. Accordingly, although the journey of 1853 need not be considered in detail here, it is necessary to examine the ways in which it affected his art in general and his vision of North America in particular.

From his reading of *Cosmos,* Church was aware that he would find in South America a world vastly different from the one he knew in the northern United States. As Humboldt noted, "to each zone of the earth are allotted peculiar beauties."[42] It was the duty of the explorer-artist to perceive and record the salient characteristics of each zone where he worked and to convey these in the finished work of art. Only in this way could a proper understanding of individual parts of the world be reached and then applied to an understanding of the whole. "Nature, in every region of the earth," observed Humboldt, "is indeed a reflex of the whole."[43] In the past, however, painters had been unable "to seize the general characteristic impression of the tropical zone."[44] According to Humboldt, these general characteristics of a region could be apprehended through the study of four basic components—plant life, animal life, climate, and geographical features. The artist had to pay careful attention to all of these elements in order to assemble an accurate inventory of facts for his work. As Humboldt wrote:

> The azure of the sky, the form of the clouds, the haze

resting on the distance, the succulency of the herbage, the brightness of the foliage, the outline of mountains, are elements which determine the general impression. It is the province of landscape painting to apprehend these, and to reproduce them visibly.[45]

To aid the painter in "apprehending," and then "reproducing," these elements, Humboldt advocated the use of "colored sketches taken on the spot" of extensive topographical areas and a "large number of separate studies" that were more detailed.[46] Church followed Humboldt's advice to the letter and also kept the kind of careful written descriptions of what he saw that Humboldt further recommended.

Church's sketches and written descriptions from his first South American trip show that, in many cases, what he saw reminded him of North America. With Humboldtian precision he noted the different types of animals and foliage, but sometimes the broader view melded North and South in his mind. As he wrote to his sister: "There is much more cultivation in this valley than in the Magdalena and in some places might resemble New England were it not for the tropical foliage."[47] At times, even the distinctive foliage could be a source of confusion. After sketching a tree in his notebook, Church wrote on the sheet: "This tree grows in many beautiful forms often resembling the Elm, with a multiplicity of branches which are more irregular than the Elm."[48]

There was, however, a major aspect of the South American scene—the atmosphere and climate—that Church, the ever-alert observer of the sky, would never have confused with northern locales. Humboldt wrote of "the humid mountain valleys of the tropical world," and another observer noted that "compared with the Old World, the New World [of South America] is the humid side of our planet, the *oceanic,* vegetative world."[49] Yet, strangely enough, Church seems not to have gone to any great length to record the South American atmosphere in either his written descriptions or his sketches. He concentrated instead on sketches of foliage, an occasional

bird or animal, and extensive vistas and mountain views. He had thus covered three of the four general areas that Humboldt advised the artist to study, but what of the atmosphere? That Church took note of it is certain, because his first paintings of South American scenes show an increased concern for depicting softer and more glowing atmospheric (i.e., more "humid") effects. Taking note of Church's new feeling for "warm, rich, hazy air," George Templeton Strong wrote in 1855:

> His earlier landscapes have been marked most distinctly by a northern character, a love of cold, stern New England seaside atmosphere, and have shewn special power in rendering it on canvas. He seems to deal quite as well with this new field of subjects; is as strong, as real, and true in depicting the still sunny inland lake and the tropical wilderness as in the Mt. Desert region.[50]

For Henry Tuckerman, Church's ability to achieve a "true expression of local atmosphere" represented one of his greatest achievements.[51]

What is of special interest in this context is that the first important pictures executed immediately upon Church's return to New York are of North American scenes, but they show evidence of this new type of atmospheric handling. It would seem that Church was not prepared immediately to attempt a tropical landscape and instead returned to a familiar and well-rehearsed theme. Both of the works he exhibited at the National Academy in the spring of 1854, *A Country Home* (colorplate 8) and *A New England Lake* (figure 50),[52] were simply elaborations of the type of subject he had treated many times before. As one reviewer noted:

> In the present exhibition he has two pictures stamped, as usual, with the peculiarities upon which, perhaps, as much as their art merits, the reputation of his pictures is based. . . . None of our landscape painters except, possibly the late Mr. Cole, has painted so perpetually like himself as Mr. Church. . . . One can no more fail to point out all his pictures by the peculiarities of one of them, than he could fail to detect a cartload of peaches by a single specimen.[53]

50. Frederic Edwin Church, *A New England Lake,* 1854,
oil on canvas, 30 × 42 in., private collection.

The more important of the two pictures is the
large and impressive *A Country Home*. This work
was the subject of several lengthy laudatory reviews
and was one of the most admired of all of Church's
early landscapes.[54] The critic for *The Albion* called
*A Country Home* "Mr. Church's most loveable
landscape," and *Putnam's* considered it "the great
work of the year."[55] The editor of *Harper's* offered
his opinion that "Mr. Church has not painted a
more universally pleasing picture. . . ."[56] Only the
*Tribune* voiced a dissenting view, noting that
Church (and Durand, for that matter) was becom-
ing repetitious and that in *A Country Home* the

result was not "as happy as in former works of the same character."[57]

The painting is essentially a fusion of the type of scene Church had depicted in *Home by the Lake* with the twilight sky from *Mount Ktaadn* (colorplates 6 and 7). The clouds in *A Country Home,* however, are almost too soft and fleecy, quite unlike those found in his earlier works. As the *Tribune's* critic noted, they "are less distinctly formed, and are so blended as to be pervaded by an unnaturally wooly [sic] appearance."[58] Other critics, however, greatly admired the sky in *A Country Home.* One noted that it had "a sky which looks deeper and clearer, and more real, the longer you look into its bright depths," and another wrote that "all that it [i.e., the painting] contains . . . lies under the same atmospheric influences."[59] The sky in this painting does appear more radiant and glowing—in short, more "atmospheric"—than the skies of any of Church's earlier works. An almost palpable sense of light, air, and moisture prevails, sure evidence that Church's study of the "humid mountain valleys" of South America had given him a greater sensitivity to these effects.

That Church was drawing on his South American experiences when he painted this northern landscape is confirmed by the prominent tree at the right of the composition. This curiously tropical-looking tree was, in fact, derived from the one Church had sketched because it reminded him of an elm. An indelible South American tone also permeates *A New England Lake.* The sky is much like that in *A Country Home,* but with an even greater sense of moist, glowing atmosphere that makes a work such as *Home by the Lake* of 1852 seem almost airless in comparison. The mingling of northern and southern characteristics apparent in Church's writings and sketches from his 1853 trip was carried over into his finished paintings. For Humboldt, "Nature in every region of the earth" might be "a reflex of the whole," but Church's vision seems to have been somewhat confused at this point. He had seen a new world and a different

landscape, and this was causing him to look with different eyes at the familiar territory of North America.

Given that neither *A Country Home* nor *A New England Lake* broke new thematic ground for Church, it is worth asking why they received such positive attention from the critics. Without question, they are beautifully painted, but then so are most of his other early works. But *A Country Home* and *A New England Lake* express their meaning more obviously—perhaps even too much so—than any of Church's previous works, because they synthesize favorite elements from many pictures. In *A Country Home,* for instance, the mountains recall those seen in *New England Scenery,* the reflecting window brings to mind the same motif in *Twilight, "Short Arbiter 'Twixt Day and Night",* the woman carrying the pail is quoted from *Home by the Lake,* and the boatmen are like those found in many other works of the late 1840s and early 1850s. In the same way, *A New England Lake* amplifies the characteristics of several earlier lake scenes (e.g., *Scene in Vermont,* 1852, private collection).[60] Church had now perfected, after a decade of steady work, a type of pastoral landscape that conveyed its meaning clearly, and pleasantly, to his contemporaries. His vision of the national landscape had, by 1854, crystallized into something that could not be further perfected. As one reviewer put it succinctly, "He appears now to have achieved the difficult task of elevating the commonplace."[61] What Church had managed to elevate to the realm of high art was the very substance of everyday American life, a feat no other landscape painter of his era could equal. That task achieved, he turned to a new challenge.

That new challenge was to interpret the very different kind of New World landscape he had found in South America. In his first South American scenes, *The Cordilleras: Sunrise* (figure 51) and *La Magdalena* (figure 52), he made use of his newly perfected atmospheric handling in the skies, but based the actual configurations of the landscapes on the tried and true formula of his earlier North

American pastoral compositions. Thus, *The Cordil-
leras: Sunrise* is a southern reformulation of *A
Country Home,* just as *La Magdalena* might be seen
as a tropical version of *A New England Lake.*[62] But
this allegiance to his earlier compositional manner
did nothing to lessen the impact these highly de-
tailed tropical visions had on his contemporaries,
who marvelled at the exotic unknown world they
portrayed. Church quickly became known as the
painter of the tropics, and his earlier successes with
the North American landscape began to fade from
memory.

With *The Andes of Ecuador* of 1855 (figure 53)
Church broke more decisively with his early style.
The scene now is vast, expansive, and brimming
with light and atmosphere. As one contemporary
observer noted:

> Who that stands before the picture . . . and gazes at
> the magnificent prospect, the lofty ranges, the distant
> outline melting into the clouds, the hazy peaks, the
> shimmering sun of the tropics, the gorgeous-tinted
> earth and sky, but must acknowledge that the artist has
> caught and conveyed a new feeling to mind. His canvas
> lives.[63]

In every respect—pictorial scope, physical size, and
mastery of light and atmosphere—*The Andes of
Ecuador* far exceeded any of Church's previous
works. It heralded a new vision of the world that
was more closely attuned to rugged and dramatic
scenery and vast, overwhelming prospects. *New
England Scenery* was heroic landscape through re-
course to seventeenth-century tradition, but *The
Andes of Ecuador* was heroic on its own terms. It
was Church's first epic landscape, and the first to
express what Humboldt called "the comprehension
of a natural whole, the feeling of the unity and har-
mony of the Cosmos."[64] The key ingredient is light,
which animates and unifies the entire scene. It is
worth noting that Durand, at that very moment,
was advising younger painters to study atmospheric
effects carefully:

> Atmosphere is, as you know, a veil or medium inter-

51. Frederic Edwin Church, *The Cordilleras: Sunrise,*
1854, oil on canvas, 28 1/2 × 43 in., collection of Jo Ann
and Julian Ganz, Jr.

52. Frederic Edwin Church, *La Magdalena,* 1854, oil on
canvas, 28 × 42 in., National Academy of Design, New
York, Suydam Collection (photo: Frick Art Reference
Library).

53. Frederic Edwin Church, *The Andes of Ecuador, 1855,*
oil on canvas, 48 × 75 in., Reynolda House Museum of
American Art, Winston-Salem, North Carolina.

posed between the eye and all visible objects—its final
influence is to obscure and to equalize. It is *felt* in the
foreground, *seen* beyond that, and *palpable* in the dis-
tance. It spreads over all objects the color it receives
from the sky in sunlight or cloudlight. . . . I can do
little more than urge on you the constant study of its
magic power, daily and hourly, in all its changes, at
times shortening, at other lengthening, the space before
you; now permitting to be defined in all its ruggedness,
the precipice on the mountain side—and now trans-
forming it to a fairy palace, and the solid mountain
itself to a film of opal.[65]

Church had already mastered the portrayal of this
"magic power," and *The Andes of Ecuador* is proof
of his success. At this point he entered a new phase
of his career, and his art became more assured and
more independent. The change is evident in both
the South American and North American land-
scapes, although it came more gradually to the lat-

ter. After 1855, Church painted no more New
England pastoral landscapes; instead, he began to
explore the more dramatic aspects of North Ameri-
can scenery. The results were at first tentative and
uncertain, but he gradually moved toward an en-
tirely new conception of American landscape in
which wilderness became the dominant theme.

# Chapter 5 · Toward a Wilderness Aesthetic

Ours is wilderness, or at least only half reclaimed, and untamed nature everywhere asserts her claim upon us, and the recognition of this claim represents an essential part of our Art.
"Sketchings," *The Crayon,* 1855

We both needed to be somewhere near the heart of New England's wildest wilderness.
Theodore Winthrop, *Life in the Open Air,* 1863

*The Andes of Ecuador* (figure 53), "a panoramic conjuration of landscape elements," was Church's first full-scale effort in his mature style and one that signaled a new interest in the more dramatic and rugged aspects of nature.[1] A corresponding shift away from the pastoral point of view that had dominated his earlier works may be noted in his North American landscapes of 1856–60, which were increasingly depictions of wilderness scenes. During the mid-1850s several influences affected the role and image of wilderness in American culture, and it is against this background that Church's own interests must be considered.

In particular, awareness was growing among well-educated easterners of the positive values of pure, untouched wilderness.[2] For Thoreau, who made his second trip to Maine in 1853, this new evaluation of pristine nature may be clearly observed. As has been discussed, Thoreau's first trip into the deep woods of Maine had left him deeply disturbed by the primitive density of the "untrodden" forests. The experience convinced him that too much wilderness was undesirable. However, by 1853, as the relentless human assault on the land was reaching epic proportions, he had begun to see things differently. "For one that comes with a pencil to sketch or sing," he wrote, "a thousand come with an axe or rifle."[3] The result was that

> Maine, perhaps, will soon be where Massachusetts is. A good part of her territory is already as bare and commonplace as much of our neighborhood. . . . We seem to think that the earth must go through the ordeal of sheep-pasturage before it is habitable by man.[4]

Whereas he had previously felt the need for the benefits of civilization to help temper the rawness of the wilderness, Thoreau now came to believe that the wilderness itself needed protection from the corrupting and destructive forces of progress. Noting that the "kings of England formerly had their forest" preserves, he issued one of the earliest calls for a national effort to preserve the American wilderness:

Why should not we . . . have our national preserves, where no villages need be destroyed, in which bear and panther, and some even of the hunter race, may still exist, and not be "civilized off the face of the earth,"—our forests, not to hold the king's game merely, but to hold and preserve the king himself also, the lord of creation,—not for our own idle sport or food, but for inspiration and our own true recreation? Or shall we, like villains, grub them all up, poaching on our own national domains?[5]

Thoreau had come to recognize that the wilderness played a positive role in the spiritual and intellectual life of Americans and was worth preserving as essential to the national identity.

Also during the 1850s came a new awareness of the ecological value of the wilderness within the sensitive balance of nature. In the heavenly dictum of Genesis 1:28, which charged man to go forth, increase, and conquer the earth, Americans may have originally found a moral justification for the subjugation of the New World, but the realities of mid-century required a new reading.[6] As George Perkins Marsh observed in his influential *Man and Nature:* "Man has too long forgotten that the earth was given to him for usufruct alone, not for consumption, still less for profligate waste."[7] Marsh discussed the various consequences of deforestation and improper land management, hoping to slow the unchecked spread of American civilization.[8] He used the example of history to add strength to his arguments, noting that the decline of such great civilizations as the Roman Empire often went hand in hand with "man's ignorant disregard of the laws of nature."[9] Thus the message of Cole's *Course of Empire,* in which the imaginary civilization grew ever more alienated from nature as it approached its doom, could be seen as having a historic justification. There was, however, an important difference. In Cole's world view, which clung to outmoded beliefs about "noble savages" and the appeal of rudimentary stages of civilization, it was the "middle landscape" of *The Pastoral State* that offered the most attractive alternative of the five stages. Marsh thought otherwise:

In successive stages of social progress, the most destructive periods of human action upon nature are the pastoral condition, and that of incipient stationary civilization. . . . In more advanced stages of culture, conservative influences make themselves felt.[10]

When we recall Thoreau's descriptions of burned fields in Maine and the savage process of clearing the forests, Marsh's thesis is entirely reasonable. As civilization fights to take hold, there is relatively little concern for preserving the land itself. Hence the frequent observation on the part of European visitors to America that the people seemed not to realize how ugly their surroundings were; the pioneers and farmers simply had no time for such sentiments. Only with the "consummation" of civilization, and the rise of more "advanced states of culture," and the corresponding isolation of men from nature, did the recognition of what had been lost in the process begin to take shape.

Seen in this light, Church's early North American landscapes are images that resulted primarily from an outlook that may have accepted the wilderness, but found no particular value in it, either as a key element in the national identity or as an attractive and meaningful subject for art. Such works as *New England Scenery, Home by the Lake, Mount Ktaadn,* and *A Country Home* are conscious and deliberate evocations of human interaction with the land as much as they are images of the land itself. The image of the nation presented in these early works was precisely the "pastoral condition," with its "incipient stationary civilization," that Marsh decried. The very way Church saw the American landscape during the first decade of his career—"with the barns, ditches, and fences left in"—was due to his pronounced bias in favor of civilization and human, as opposed to natural, history.[11] In one sense, as has been discussed, he was following the example of the Thomas Cole he knew in the mid-1840s, the painter of *The Old Mill* and *Home in the Woods.* Indeed, Cole, although a vocal supporter of the wilderness, not only recognized, as we have seen, the positive values of civilization, but also re-

tained some of the lingering fear of the wilderness common to the early Romantic period. The horrific component of the Sublime endured in his mind. At one point in his early "mountain rambles," he watched a violent thunderstorm with mounting fear and dread and was greatly relieved when it had passed. The sight of a cottage with smoke coming from its chimney reassured him.[12] A blasted tree might remind Cole of the "power of some storm," but experiencing that same power in the lonely depths of the wilderness could make him think fondly of a warm room in a cozy cottage. Furthermore, he felt that "simple nature" was not quite sufficient as a subject for art and saw the need for "human interest and action, to render the effect of the landscape complete."[13] But Cole remained profoundly ambivalent about the conflict between nature and civilization throughout his life. His more pragmatic pupil, on the other hand, was not one to cling to an old belief if new ones proved it untenable. And by the mid-1850s Church increasingly came to doubt his formerly unquestioning faith in the sanctity of national progress and the attainability of the pastoral ideal.

Several factors influenced the shift in Church's attitude toward the American wilderness after 1855. The growing awareness, especially among culturally sophisticated easterners,[14] of the positive spiritual, intellectual, and ecological qualities of wilderness was surely one factor. Church was such a person, and so were most of his patrons. Another factor was certainly Church's own developing interest in rugged scenery, whether found in Maine or South America. Finally, a renewed call for depictions of wilderness was openly expressed by certain arbiters of artistic taste in New York in the mid-1850s.

One of the most important new sources of opinion was *The Crayon,* founded in 1855. *The Crayon* strongly advocated landscapes of the wilderness, for these were seen as profoundly American in sentiment. As one writer stated:

> The pictures of most of our native landscapists have another desirable quality, and one which would seem

to mark our school of Art—the freedom and air of wildness characteristic of our scenery. It is not worthwhile to compare the value of the wild landscape subject, with the cultivated or the humanized. Our country *is* wild, and must be looked at by itself, and be painted as it is. We have not a country like England, filled with tokens of the presence of past generations, and so made full of human interest. Ours is wilderness, or at least only half reclaimed, and untamed nature everywhere asserts her claim upon us, and the recognition of this claim represents an essential part of our Art.[15]

In its opening volume, over the course of three months, *The Crayon* ran the fourteen-part series, "The Wilderness and its Waters." This series was a detailed account by an artist of a summer excursion in "the wilderness that occupies the northern part of New-York State, a labyrinth of lakes and streams."[16] "The Wilderness and its Waters" is an exuberant celebration of the virtues of direct experience of the wilderness, and it is an interesting prototype for the trip Church would take with Theodore Winthrop in the summer of 1856.

*The Crayon*'s commitment to wilderness as the most fitting subject for national art also found expression in Durand's "Letters on Landscape Painting" of 1855. After attempting to convey an impression of the "elevated character" of landscape art in his first letter, Durand, in a well-known passage, directed his imaginary student to his proper subject:

> Go not abroad then in search of material for the exercise of your pencil, while the virgin charms of our native land have claims upon your deepest affections. Many are the flowers in our untrodden wilds that have blushed too long unseen, and their original freshness will reward your research with a higher and purer satisfaction, than appertains to the most brilliant exotic. The "lone and tranquil" lakes embosomed in ancient forests, that abound in our wild districts, the unshorn mountains surrounding them with their richly-textured covering, the ocean prairies of the West, and many other forms of Nature yet spared from the pollutions of civilization, afford a guarantee for a reputation of originality that you may elsewhere long seek and not find.[17]

54. Asher B. Durand, *In the Woods,* 1855, oil on canvas, 60³/₄ × 48 in., Metropolitan Museum of Art, New York, gift in memory of Jonathan Sturges by his children, 1895 (95.13.1).

At the same time he was writing his "Letters," Durand was painting such pictures as *In the Woods* (figure 54), which *The Crayon* found to be an image of "perfect and sublime wilderness."[18]

Church's own activities during 1854–55 were primarily concerned with painting South American landscapes, but he did take time out in the summers of 1854 and 1855 for visits to Mount Desert.[19] Although Church did some sketching on the island (e.g., figure 59), no important pictures immediately resulted from these trips. His interest in marine views, which had been so strong in 1851–52, waned in the mid-1850s, and virtually all of his North American oils for the next few years, with the ex-

ception of *Niagara,* came from his travels in the interior of Maine.

There are indications that Church was beginning to reformulate his pictorial treatment of the North American landscape early in 1855. One component in his new attitude may have involved a fresh look at his teacher's earlier paintings, which were generally more rugged and dramatic in effect than those of the 1840s. As a writer for *The Crayon* observed in January 1855:

> We were pleased to see at Church's studio, a few days since, a picture of Cole's, which we had never before seen, a wild and stormy composition, with a strong Poussin feeling of tone and color, and differing very strongly from his later works. It is bold and energetic in its handling and conception.[20]

This painting was almost certainly one of Cole's early American landscapes or dramatic allegorical works. By the following January Church had two of Cole's major works in his studio, the *Tornado in an American Forest* of 1835 (figure 55) and the *Prometheus,* about 1847–48 (private collection).[21]

55. Thomas Cole, *Tornado (Tornado in an American Forest),* 1835 (1831?), oil on canvas, 46³/₈ in. × 64⁵/₈ in.; in the collection of the Corcoran Gallery of Art, Washington, D.C., museum purchase, Gallery Fund, 1877 (77.12).

Church's first painting of the North American
landscape that provides evidence of his changing
perceptions is *Twilight* (figure 56). According to an
inscription on the back of the canvas, this work
was painted in January 1856 for Erastus Dow
Palmer, the sculptor of Albany. Church and Palmer
were close friends, and late in 1855 they apparently
agreed to exchange examples of their work.[22]
Church received the relief *Innocence*, which still
hangs at Olana today, and Palmer took the
*Twilight*.

In general conception and format, *Twilight*
strongly recalls *Twilight, Short Arbiter 'Twixt Day
and Night* of 1850 (colorplate 3). As in the earlier
work, the sky is brooding and unsettled, although it
is more richly colored, with mottled oranges and
reds. The terrain of the landscape is also similar,
with hills in the middleground and mountains in the
distance. As in *Twilight, "Short Arbiter,"* a house
with reflecting windows (in this case a somewhat
larger house with dormer windows) and smoking
chimney just protrudes above the hills. In all of
these respects, *Twilight* is almost a recreation—or
recollection—of the great painting of 1850.[23] As
Church began to explore a new and more intense
interpretation of the American scene, it was fitting
that he turn to what was, after all, one of the most
dramatic of his earlier efforts. Nevertheless, there
are differences between the two works that point to
Church's changing conception of the North Ameri-
can landscape.

The most obvious difference is in the way the sky
has been painted in *Twilight*. The loosely brushed
clouds of *Twilight, Short Arbiter,* although dramati-
cally effective, ultimately tend to flatten out into
recognizable areas of pigment, especially in the up-
per portion of the canvas. In the *Twilight* of 1856,
Church's new sensitivity to atmosphere, already evi-
dent in his landscapes of 1854, enabled him to ren-
der the clouds as convincing masses of floating
water vapor suffused with light. As a result, the
entire sky reads as a panorama of light and color,
and the painting was much admired for this reason.

56. Frederic Edwin Church, *Twilight (Sunset),* 1856, oil
on canvas, 16¹/₄ × 24¹/₄ in., Collection Albany Institute
of History and Art, gift of Beatrice Palmer.

As was observed in 1859: "The profession regard
this as a wonderful picture, and one of the most
eminent in it, a subtle judge of color, declares he
never saw its equal."[24]

The organization of the landscape is also handled
differently in *Twilight*. In *Twilight, "Short Arbiter,"*
a zig-zagging interplay of hills and stream gently
leads the eye into space. In the work of 1856, a low
foreground area abruptly gives way to a dramati-
cally higher middleground, which in turn leads to
even higher mountains.[25] The bluff-like border of
the middleground hills effectively serves as a bar-
rier, denying easy access to any area beyond the
foreground. Church occasionally used a similar for-
mat, which dispensed with logical and orderly tran-
sitions from zone to zone, in his South American
works of the same period.[26]

*Twilight,* unlike the earlier work, includes figures:
two men are near a small boat at the water's edge.

57. Frederic Edwin Church, *Twilight,* c. 1856–58, oil on canvas, 24 × 36 in., private collection.

At the left a campfire is burning, and a tree stump at the lower left suggests that these men may have recently cut the fuel for the fire. One is immediately struck by this curious conjunction of what is essentially a wilderness camping scene in the foreground with a domesticated landscape, complete with house, in the middleground. What connection, if indeed any, do the men have with the house, which lies hidden from their sight, just beyond the hill? The painting remains enigmatic, but, for whatever reason, Church deliberately juxtaposed the wild with the settled, much as he had done humorously in his *Too Soon* of 1847 (figure 12). The foreground of *Twilight* is sufficiently rugged, with its dark woods and waterfall, to be the wilderness, but the substantial house clearly belongs in a well-settled area. This conjunction of the wild and civilized is paralleled by the painting's composition, which brings these two zones into close proximity but keeps them clearly separated.

Why Church made such a curious conjunction between the wild and the cultivated in *Twilight* is unclear. However, in a closely related work, also known as *Twilight* (figure 57), he used the same basic format, but replaced the stately house with a lowly trapper's hut.[27] He thus abandoned the overt reference to civilization in favor of a detail that was easily compatible with a wilderness area only occasionally visited by man. *Twilight* was derived from an oil sketch, now at Olana (figure 58), that depicts precisely the same cloud patterns and a similar hilly site. A small house or hut, like the one in the painting, with a reflecting window, also appears in the sketch. In the finished oil, Church lowered the vantage point somewhat, included a body of water in the foreground, with the hut at its edge, and generally gave the scene a more rugged wilderness char-

58. Frederic Edwin Church, *Study for Twilight,* c. 1856–58, oil on paper, 12 × 18 in., New York State, Office of Parks, Recreation and Historic Preservation, Olana State Historic Site (OL.1978.12).

acter by increasing the prominence of the mountains and giving them a more jagged silhouette.

The close association between the painting and the preliminary oil sketch provides an excellent opportunity for a few observations on Church's working methods in this period. The sketch, which was certainly executed on the spot (although just where is unknown), is primarily an attempt to record the color and shape of the cloud formations and the general configurations of the land below. It is very broadly and freely brushed, no doubt the result of fifteen or twenty minutes of careful observation and work. Owing to its free handling and roughly textured pigment, the sketch gives little illusion of depth to the sky or mass to the clouds. However, in the finished oil, Church, although adhering closely to the general scheme of the sketch, transformed the sky and clouds. The clouds seem soft, vaporous, and suffused with light, and the pigment has been skillfully manipulated to leave little trace of brushstroke that would interfere with the illusion. Clearly Church had learned through long study exactly how

to capture such evanescent effects. As John Ruskin would comment some years later, "He can draw clouds as few men can."[28]

Church's working method is even more apparent in another important work of 1856, the striking *Sunset* (colorplate 9).[29] This painting was almost certainly executed in the fall of 1856, after Church and his friend, the writer Theodore Winthrop, had returned from a two-month excursion in the Maine wilderness. As will be discussed, Church's image of American nature as expressed in *Sunset* is closely related to his experiences in Maine. However, before considering that trip, it is necessary to look back to 1854 and Mount Desert, for it was then and there that Church saw the prototype sunset for the painting.

A rapid pencil drawing (figure 59), inscribed "Mt. Desert/Sep-1854," was the first record of this remarkable twilight sky. The view looks across a bay flanked by low hills; two small ships are at anchor on the water. With a few quick strokes of the pencil Church sketched in the contours of the land and noted the shapes and arrangement of the clouds. His attention was focused on recording the rapidly changing hues, and the drawing is covered with color notations. At the top Church noted "mottled clouds in regular ranks;" somewhat lower, and to the left, was "open sky" that gave way to "superb clear brilliant blue" and "exquisite warm blue." The sunset colors ranged from "brilliant splendid orange" to "cooler green gold brilliant." The colors of the lower clouds were denoted by the number "4," which was identified at the bottom of the sheet as "illuminate with rich orange and lake [i.e., purplish-red] light/in parallel lines but dim compared with open sky/also broken with openings showing the cool bright sky/shadow tint brownish purple." Church also carefully recorded the reflected colors of the water's surface, which were in some places "splendid silvery blue" and in others "duller and darker." Additional notations give an indication of time and weather: in one place Church observed the water was "ruffled by wind," while at the bottom of

59. Frederic Edwin Church, *Twilight, Mount Desert,* 1854, pencil on paper, 5 × 9 in., New York State, Office of Parks, Recreation and Historic Preservation, Olana State Historic Site (OL.1980.1448).

the sheet he wrote "2ᵈ Twilight." Second twilight occurs after the sun has dropped below the horizon and the sky is beginning to grow dark. Some of the most dramatic sunset colors may be observed then.

Church's exuberant written and drawn description of this twilight sky reveals not only that he was a sensitive observer of such sights, but was moved by them as well. His sketches frequently include such words as "exquisite," "splendid," and "brilliant," or phrases such as "glorious beyond description." His vision, both in its exactness and its evocativeness, was paralleled by that of Thoreau, who repeatedly described sunsets in his journal.[30] For both Thoreau and Church sunset was a daily pageant of light and color that never became boring, and both men delighted in recording its effects throughout their lives.

At some point after completing the Mount Desert pencil sketch, Church worked the subject up as an oil study (figure 60), giving color and form to his previous black and white outline. The sketch is not dated, but must surely have been executed not long after the drawing and before the effect had faded from Church's memory. The small oil is a faithful

transcription of the initial study, and retains the same configurations of land and sky, although it adds a foreground area of undergrowth and beach. The brilliant colors noted on the drawing—blues, oranges, green-golds, and lakes—come to life in the painted sky, with the lower clouds rendered by small brushstrokes and the upper expanse of sky brushed in with sweeping strokes. A sense of approaching darkness is in both the highest portion of the sky and the deeply shadowed hills below.

Certain passages of this oil sketch strongly resemble Church's earlier handling of paint. Comparison of the work with the preliminary study for *Beacon off Mount Desert* (figure 36) reveals that the brightly lit small orange clouds of the lower sky in each case are similarly painted. Although the later work is somewhat looser and more spontaneous in feeling, the general character of the sky is less atmospheric and vaporous than in other works of this period. No doubt this might, in part, be explained by the particular character of this coastal weather front. Yet Church may also have been thinking back to his *Beacon* of 1851. His handling of twilight skies up to this point in his career may be divided into

60. Frederic Edwin Church, *Study for Sunset,* c. 1854–55, oil on paper, 10¼ × 17¼ in., New York State, Office of Parks, Recreation and Historic Preservation, Olana State Historic Site (OL.1981.72).

two general types. One showed vaporous and soft cloud-filled skies, as in *A Country Home* and the two *Twilights* discussed previously. The other type has more sharply defined clouds arranged in ranks receding into space, as in *Beacon* and *Sunset*. The main difference is largely one of perspective; the former implies distance and recession through atmospheric perspective, whereas the latter relies more heavily on linear perspective. By 1860, Church had learned that the two were not necessarily incompatible.

After completing the Mount Desert oil study, Church put it aside. Perhaps he was no longer interested in this type of coastal view, but he was also busy during 1854 and 1855 with South American landscapes, and he painted few North American landscapes of consequence during these years. However, the very fact that Church went to the trouble of working up an oil sketch from the drawing—which was not the case with most of his drawings—suggests that he was quite taken with the effect. Two years later the sky in the sketch still held its appeal, but Church would then use it above a landscape of quite different character. His experiences in Maine in the summer of 1856 suggest why he did so.

Church's companion on the trip was Theodore Winthrop (1828–61), the promising young writer whose first published work would be *A Companion to The Heart of the Andes* in 1859.[31] Like Church, Winthrop was from Connecticut and had traveled widely. Although trained as a lawyer, he gave up law in favor of writing, a choice that was strongly encouraged by his friend George William Curtis, art critic of the *Tribune* in 1851–52. The connection with Curtis is significant, because he, more than any other critic in the early 1850s, had attempted to delve beyond the obvious in evaluating Church's art—just as Winthrop would do in his pamphlet on *The Heart of the Andes*.[32] Accordingly, Winthrop's record of his visit to Maine with Church, *Life in the Open Air,* is key to understanding Church's North American landscapes of the later 1850s. Although

*Life in the Open Air* was not written as a companion to a specific picture, certain passages nevertheless are virtual descriptions of paintings such as *Sunset*. Winthrop carefully observed Church at work sketching and painting during the trip and subsequently watched him paint finished pictures in New York. The two men constantly discussed their feelings about American nature, its meaning for both individuals and the nation as a whole, and the means for expressing its importance in their own works. The close association, then, between Winthrop's prose and Church's art is anything but coincidental.

The object of Church's and Winthrop's journey was to have an authentic, vigorous wilderness experience. As Winthrop noted: "We both needed to be somewhere near the heart of New England's wildest wilderness."[33] Their ultimate goal was "Katahdin—the distinctest mountain to be found on this side of the continent."[34] The journey was made via Albany and Lake Champlain. This initial stage was like an appetizer to Winthrop: "As before banquets, to excite appetite, one takes the gentle oyster, so we, before the serious pleasure of our journey, tasted the Adirondack region."[35] Earlier in Church's career, the "taste" of such regions had been sufficient for him, but as Winthrop further observed:

> The Adirondacks provide a compact, convenient accessible little wilderness,—an excellent field for the experiment of tyros. When the tyro, whether shot [i.e., a hunter], fisherman, or forester, has proved himself fully there, let him dislodge into some vaster wilderness . . . for a tough struggle with Nature. It needs a struggle tough and resolute to force that protean lady to observe at all her challenger.[36]

The real problem with the Adirondacks for Winthrop was not the scenery, which was suitably "shaggy," but the hordes of tourist visitors "found at every turn."[37] Church and Winthrop were eager to break free from these persistent reminders of civilization, and they pushed on across to Vermont and into New Hampshire.

Finally, "one August afternoon," they "left rail-

ways and their regions" and entered "the valley of the Upper Connecticut."[38] It was here that the two took the first real step on their pilgrimage to the wilderness:

> It was a fair and verdant valley where we walked, over-looked by hills of pleasant pastoral slope. All the land was gay and ripe with yellow harvest. Strolling along, as if the business of travel were forgotten, we placidly identified ourselves with the placid scenery. We became Arcadians both. Such is Arcadia, if I have read aright: a realm where sunshine never scorches, and yet shade is sweet; where simple pleasures please; where the blue sky and the bright water and the green fields satisfy forever.[39]

Church and Winthrop were traversing the landscape as if it were organized like that in Cole's *Course of Empire,* but in reverse. Having left the city of *Consummation* they had now reached the *Pastoral* or *Arcadian* state. Church and Winthrop were not, however, content—as Cole might have been—to linger there, where everything would lull and "satisfy forever." Their goal was not this picturesque, pastoral state of existence—"picturesque," observed Winthrop, "is a curiously convenient, undiscriminating epithet"—but rather, the mentally and physically challenging world of the *Savage State,* and the "proper field of action" was Maine.[40] Before departing Arcadia, however, they were treated to a glorious sunset:

> Now, as may be supposed, Iglesias [i.e., Church] has an eye for a sunset. That summer's crop had been very short, and he had been for sometime on a starvation-allowance of cloudy magnificence. We therefore halted by the road-side, and while I committed the glory to memory, Iglesias intrusted his distincter memorial to a sketch-board.[41]

Church and Winthrop worked their way into Maine, traveling along lakes and rivers. Overhead, the sky provided an ever-changing display:

> To the cloud-forms modelled out of formlessness the winds gave life of motion, sunshine gave life of light, and they hastened through the lower atmosphere, or

sailed lingering across the blue breadths of mid-heaven, or dwelt peacefully aloft in the regions of the cirri; and whether trailing gauzy robes in flight, or moving stately, or dwelling on high where scope of vision makes travel needless, they were still the brightest, the gracefullest, the purest beings that Earth creates for man's most delicate pleasure.[42]

Although the pair had not yet penetrated into the true wilderness, they felt strong currents of inspiration:

> And while we flashed along the gleam of the river, Iglesias fancied that he might see the visible, and hear the musical, and be stirred by the beautiful. These, truly, are not far from the daily life of any seer, listener, and perceiver; but there, perhaps, up in the strong wilderness, we might be recreated to a more sensitive vitality.[43]

When Church and Winthrop reached Moosehead Lake, they boarded a small lumber steamer that transported them to the upper end of the lake. From the deck they caught their first glimpse of Katahdin, "a dim point" far off over the horizon.[44] Finally, the steamer left them at a wharf at the lakehead, and they pushed on:

> As we started, so did the steamboat. The link between us and the inhabited world grew more and more attenuated. Finally it snapped, and we were in the actual wilderness.[45]

From this point on, Church and Winthrop became thoroughly immersed in the wilderness experience and began a "new life" sanctified by a "baptism" in the Penobscot River.[46] They kept their eyes trained on Katahdin, a "fair blue pyramid . . . still many leagues away."[47]

The travelers eventually reached the great mountain, ascended it in a dense fog, and then began their homeward journey. Church continually sketched the sights, recording colors and hues with "cabalistic cipher, which only he could interpret into beauty."[48] Once back in New York, Church turned his attention to painting finished pictures based on these studies. His goal was to capture as

61. Frederic Edwin Church, *Landscape-Mount Katahdin,*
1856, oil on canvas, 8 × 11³/₄ in., Addison Gallery of
American Art, Phillips Academy, Andover,
Massachusetts.

much as possible of the actual feel of the wilderness
and to celebrate what had been for him and Winth-
rop a journey "crowded with novelty and beauty,
and fine, vigorous, manly life."[49]

One of Church's first efforts was probably a
small view of Katahdin from the lake (figure 61),
which was subsequently engraved as the frontispiece
to Winthrop's *Life in the Open Air.* This painting,
although little more than a pictorial souvenir of the
trip, clearly shows that Church's view of the Katah-
din region had changed dramatically from that ex-
pressed in his earlier works. The small painting
shows only wilderness, with man present as a visi-
tor, not as a settler. This image is, in fact, close to

Church's drawing of 1852 (figure 46), which, as
stated earlier, more accurately reflected the reality
of inland Maine in the 1850s than did *Mount
Ktaadn* (colorplate 7). The transformation of the
wild into the pastoral that he effected in the oil of
1853 was not repeated. Church now deemed na-
ture—in particular untouched, wild nature—as
worthy and meaningful in its own right. Like Tho-
reau, he had reassessed his earlier viewpoint and
modified it in response to new realities.

In *Sunset* (colorplate 9) Church's new vision is
stated with a forceful clarity that makes his mean-
ing unmistakable. The sky in *Sunset* had been based
on Church's observation of a "second twilight" at
Mount Desert two years earlier. Winthrop's account
indicates that Church saw and sketched several im-
pressive sunsets during the 1856 trip, so it is curious
that he returned to the earlier work. However, the
weather and cloud patterns Church saw on Mount

Desert were not unlike those he observed in the region of Katahdin, because the two areas are not far apart. Winthrop noted that he and Church could actually see the island from the mountain, "far away on the southern horizon."[50] Thus, it was not false for Church to use the Mount Desert twilight, in which he had seen enough potential two years earlier to warrant producing an oil sketch. More to the point, Church had saved the Mount Desert sketch for something special, recognizing the potential in its striking arrangement of clouds. Indeed, the great spatial sweep in the sky of the sketch offered just what he needed at the moment.[51]

What is of most significance here is how Church transformed a rather straightforward coastal view into his first great statement on the theme of the American wilderness. Comparing the oil sketch with the finished painting seems to show only slight differences between them. The sky in each is virtually identical, as are the patterns of reflected light on the water. The hills in the middleground have been heightened slightly in the finished work, but are otherwise similar. However, each change that Church did introduce—and these are primarily in the foreground and background—is important.

The indiscriminate area of underbrush and beach in the Mount Desert sketch is replaced by a more elaborate foreground in the painting. A dirt path or road leads into space from the lower center, but curves out of sight abruptly. To the right, on a small rise, are several boulders and large rocks, and three sheep. To the left are tangled underbrush, a blasted tree, and a single tall spruce.[52] Each of these elements plays a role in conveying the message of the painting.

The foreground is a last vestige of civilization.[53] The Arcadian realm—complete with sheep, rustic road, and a patch of cleared, but rocky, land—is giving way to the rugged world of Cole's *Savage State*. The trees and tangled brush at the left are emblematic of the wilderness that lies beyond. The blasted tree tells of the brutal force of nature's powers, and the spiky young tree is the model, or arche-

type, for the trees that make up the forests in the distance. The choice of this tree is significant, for it could evoke special associations:

A solitary Fir or Spruce . . . when standing in an enclosure or by the roadside, is a stiff and disagreeable object; but a deep forest of Firs is not surpassed by any other species. These trees must be assembled in extensive groups to affect us agreeably; while the Elm, the Oak, and other wide-spreading trees are grand objects of sight when standing alone or in any other situation.[54]

The "stiff and disagreeable" tree in *Sunset* contrasts markedly with the graceful elm in *Mount Ktaadn*. Unlike that benevolent and protective natural shelter for a musing boy, *Sunset*'s spruce seems too concerned with its own survival in a harsh land to encourage quiet contemplation. It deliberately challenges the viewer to abandon any preconceived "picturesque" notions about the appearance of the true wilderness. The forests that lie beyond are not the province of "wide-spreading trees" like the elms of the pastoral zone; such expectations should be left behind in Arcadia with the sheep. On the hills in the distance we can just make out the tops of other "briskly-aspiring spruces" that thrust their tops into the sky.[55] Beyond the forest, then, past the lake that inhibits further easy penetration of the space, lies precisely the kind of wilderness Church and Winthrop were seeking.

Presiding over the entire scene is a great mountain in the distance. It both suggests the appearance of Katahdin specifically and functions as an archetypal American mountain, much like the one found in the background of Cole's *Home in the Woods* (figure 3). But unlike Cole's mountain, or the one in Church's earlier *Mount Ktaadn,* which provided shelter and protection to their surrounding landscape, that in *Sunset* lies far distant, a remote landmark seemingly beyond the reach of man and his civilization. "Besides sky," wrote Winthrop, "Katahdin's view contains only the two primal necessities of wood and water."[56] Sky, wood, and water;

these are the basic components of all that lies be-
yond the immediate foreground of the painting.
The scene is of vast proportions but elemental sim-
plicity. It is the addition of the mountain itself that
completes the transformation of the limited vision
implicit in the oil sketch to the epic grasp of *Sunset.*
Consider Winthrop's thoughts upon seeing Katah-
din far off on the horizon:

> Mountains are the best things to be seen. Within the
> keen outline of a great peak is packed more of distance,
> of detail, of light and shade, of color, of all the quali-
> ties of space, than vision can get in any other way. No
> one who has not seen mountains knows how far the
> eye can reach. Level horizons are within cannon-shot.
> Mountain horizons not only may be a hundred miles
> away, but they lift up a hundred miles at length, to be
> seen at a look. Mountains make a background against
> which blue sky can be seen; between them and the eye
> are so many miles of visible atmosphere, domesticated,
> brought down to the regions of earth, not resting over-
> head, a vagueness and a void. Air, blue in full daylight,
> rose and violet at sunset, gray like powdered starlight
> by night, is collected and isolated by a mountain, so
> that the eye can comprehend it in nearer acquaintance.
> There is nothing so refined as the outline of a distant
> mountain: even a rose-leaf is stiff-edged and harsh in
> comparison. Nothing else has that definite indefinite-
> ness, that melting permanence, that evanescing
> changelessness.[57]

In *Sunset,* the viewer, lingering in the foreground
at the edges of Arcadia, looks across the middle-
ground of wood and water to the sentinel mountain
form in the distance; he is thus placed on the
threshold of the wilderness experience. The painting
is a perfect visual counterpart to a particularly vivid
passage from *Life in the Open Air,* which describes
Church and Winthrop poised at just such a border
zone between the pastoral and the wild. They have
paused at an old abandoned and tumbledown lum-
ber station and hay farm, the last remnants of civili-
zation. As the sun sets, Church, "fondled by breeze
and brightness, and whispered to by all sweet
sounds," sketches the scene that Winthrop here
describes:

> . . . I saw a landscape of vigorous simplicity, easy to
> comprehend. By mellow sunset the grass slope of the
> old farm seemed no longer tanned and rusty, but rip-
> ened. The oval lake was blue and calm, and that is
> already much to say; shadows of the western hills were
> already growing over it, but flight after flight of illu-
> mined cloud soared above, to console the sky and the
> water for the coming of night. Northward, a forest
> darkled, whose glades of brightness I could not see.
> . . . Furthermost and topmost, I saw Katahdin twenty
> miles away, a giant undwarfed by any rival. The re-
> mainder landscape was only minor and judiciously ac-
> cessory. The hills were low before it, the lake lowly,
> and upright above lake and hill lifted the mountain
> pyramid. Isolate greatness tells. There were no under-
> ling mounts about this mountain-in-chief. And now on
> its shoulders and crest sunset shone, glowing. Warm
> violet followed the glow, soothing away the harshness
> of granite lines. Luminous violet dwelt upon the peak,
> while below the clinging forests were purple in shel-
> tered gorges, where they could climb nearer the sum-
> mit, loved of light, and lower down gloomed green and
> somber in the shadow.[58]

*Sunset* might well be the very image of these
words, a landscape of "vigorous simplicity," yet
powerfully evocative. *Mount Ktaadn* of 1853, with
its elevated viewpoint, was a landscape that the
viewer could study with some detachment. In *Sun-
set* the point of view is distinctly lower and the
space is more immediately accessible and involving.
To understand just how fresh and original is the
vision it expresses, we may compare it to *Chocorua
Peak, New Hampshire* (figure 62) by one of
Church's contemporaries, David Johnson. On a su-
perficial level, the two works are strikingly similar:
each has a rocky foreground with various flowers
and grasses precisely delineated; a large framing
tree stands to one side; a reflecting body of water
occupies the middleground; and the distance is
dominated by a distinctive mountain. There are,
however, telling differences between the two paint-
ings, and these are most evident in each artist's atti-
tude to light and space. *Chocorua Peak* is composed
within standard Hudson River School conventions,
even though it is painted more crisply and with

62. David Johnson, *Chocorua Peak, New Hampshire,* 1856, oil on canvas, 19¹/₈ × 28¹/₄ in., collection of Elizabeth Feld.

more insistent details. The various zones of pictorial space lead easily from one to another, so that the viewer's eye can conveniently traverse the landscape. The mountain serves as an earthly terminus, leading the eye upward to a sky filled with an assortment of clouds and suffused with a glowing golden light. The viewer, at the end of his visual journey through this landscape, may feel that he has not gone very far at all, and has had a rather easy time of it. The world as seen in *Chocorua Peak* is a contained and orderly place. In short, it is the world seen through the experience of art, not a pictorial translation of a direct and immediate experience of nature.

*Sunset* has a quite different effect. The zones of earthly space do not flow easily from one to another, but instead are arranged parallel to the picture plane, just as in the slightly earlier *Twilight* (figure 56). To penetrate the space, the viewer instinctively looks to the sky, where the ranks of clouds lead him in a headlong rush toward the mountain peak. Light and atmosphere show the viewer the vastness of the picture's scope, while the landscape itself functions as a series of impediments to his progress into that vast space. As Winthrop observed, one must undergo a "tough struggle" to reach nature at her most pristine. The imagination is free to soar across the miles with the clouds, but the physical realities of the actual journey to primeval nature require a firm resolution to leave the paths of Arcadia behind and plunge boldly into the wilderness.

In *Sunset,* Church had broken decisively with the mainstream of American landscape painting, and this may be further demonstrated by comparison with another classic image of American nature from the mid-1850s: Asher B. Durand's *In the Woods* (figure 54). This much-admired picture of "perfect and sublime wilderness," as *The Crayon* characterized it, expressed an attitude very different from that of Church's *Sunset.* "In sentiment," wrote one observer, "it appeals to our love of the wild and free, and leads us to a glade in the wilderness where . . . we see no sight and hear no sound that reminds us of civilization or humanity."[59] *In the Woods* invites the viewer to step into its sheltered recesses for a moment of meditation and contemplation. The scale is human and inviting, the atmosphere quiet and soothing; even the timid forest creatures seem unconcerned at human approach. Just as the harried city-dweller might escape the noise and crush of crowded streets by entering the cool interior of an urban chapel, so could the civilization-bound viewer of the painting travel to this forest sanctuary, complete with leafy vaults, a tree-lined nave, and a glowing "window" of light at the end of the vista. There, as in a church, he could be spiritually refreshed. Durand's "wilderness" is thus a benign and benevolent oasis in a world rife with contention and turmoil. As such, it is necessarily accessible and attainable for the viewer, as the title suggests, since it implies we are actually "in" the woods. It is a component of the known and inhabited world, a

space contiguous to the realm of everyday experience. The thickets and fallen trees are only minor obstacles to passage, and as the viewer mentally steps over them, he symbolically steps past the cares and troubles of the world "outside the woods." Durand well understood how landscapes could function in this way, and in the well-known passage from his fourth "Letter," he described how the "rich merchant and capitalist" might find such a work "soothing and strengthening to his best faculties."[60]

Church's painting has a different effect, for it stresses the remoteness and inaccessibility of the wilderness and hints at the physical test one must endure to reach it. *Sunset* and *In the Woods* thus reflect two poles within the American attitude toward wilderness at mid-century. Durand's picture is of a wilderness of sentiment, a mental image of a few square yards of archetypal American forest, scaled to human dimensions and human associations, a kind of miniature Walden for the enlightened connoisseur. Church's work is a challenging vision of a vast, primeval nature (Thoreau's "unhandselled globe") that exists independently of man and his demands. When man enters this wilderness, he no longer dominates his surroundings, but is reduced to a minuscule component in the natural order. And to understand the meaning of that natural order one must, according to Winthrop and Church, embark on a rigorous quest in which all lingering traces of civilization are ultimately left behind.

The expression of these ideas and the move toward a more epic scope in *Sunset* indicate that the new vision of the world first evident in *The Andes of Ecuador* had now become an integral part of Church's interpretation of the North American landscape. There are, in fact, strong parallels between his North and South American pictures by this time. As was this case with his paintings of 1854 (see chapter 4), each subject was influencing the treatment of the other. *Sunset,* for instance, is strikingly similar in style and conception to a work of the same dimensions, *In the Tropics,* also of 1856

(figure 63).[61] These two paintings share a certain rugged character in their land forms, sense of vast space, and basic compositional scheme with prominent foreground tree and curving path. Yet they are equally a study in contrasts, with humid, tropical atmosphere opposing cool, northern air, languid, lush palm opposing spiky spruce, and volcanic geology opposing glacially formed landscape. Church was fascinated by such contrasts between the landscapes of North and South, and in these years he executed a number of pairs of pictures comprised of one South American and one North American scene.[62] In these he frequently contrasted times of day (morning and evening) or seasons (summer and autumn). But the point to be stressed here is not that *Sunset* and *In the Tropics* were actually conceived as pendants, but that they demonstrate that Church was evolving a single pictorial approach that enabled him to express the essence of both northern and southern scenes without compromising the veracity of either. Like Humboldt, he recognized both the distinct differences between various zones of the globe and the greater "unity and harmony of the cosmos."

Church's activities during 1857 were dominated by two major events, both of which have been thoroughly discussed by other students of his work. The first of these was the creation and exhibition of *Niagara* (Corcoran Gallery of Art), the painting that catapulted the artist into international fame.[63] Although obviously a North American landscape with nationalist overtones, *Niagara* exists in its own category within Church's *oeuvre*. It has little direct relevance to his other depictions of the North American landscape because Niagara itself was already a veritable national icon that came ready-made with complex associations.[64] Church's painting of the falls resonates with meaning not so much because of its own iconography, then, but because it captured more perfectly than had ever been done before, the very essence of this great American wonder. With its overwhelming tour-de-force of illusionistic realism and its radical composition,

63. Frederic Edwin Church, *In the Tropics,* 1856, oil on canvas, 25¼ × 36¼ in., Virginia Museum of Fine Arts, Richmond, Glasgow Fund (65.28).

*Niagara* recreated the actual experience of being physically present at the scene. A similar sense of physical immersion into the experience of nature was an important ingredient in Church's greatest North American landscapes, including *Twilight in the Wilderness,* but no other is so inextricably tied to such an immediate and all-encompassing evocation of the Sublime.

The other important event of 1857 was Church's second trip to South America, which began in May and lasted until August. This visit, made in the company of Louis Remy Mignot (1831–70), was confined to Ecuador, and Church had some specific goals in mind.[65] In particular, he wanted to visit several great volcanoes—Chimborazo, Cotopaxi, and Sangay—to make studies for a series of epic

64. Frederic Edwin Church, *The Heart of the Andes,* 1859, oil on canvas, 66¹/₈ × 119¹/₄ in., Metropolitan Museum of Art, New York, bequest of Mrs. David Dows, 1909 (09.95).

landscapes.[66] Church, on the heels of his success with *Niagara,* was clearly thinking in ambitious terms, and he now began the creative and intellectual investigations that would lead to his masterpieces of the late 1850s and early 1860s. His sketches now manifested a greater interest in more sweeping views of nature and in more spectacular geographical, geological, and atmospheric effects.[67] This heightened awareness of nature's grand scheme would first bear fruit in the monumental *Heart of the Andes* of 1859, and it would also lead Church to his quintessential depiction of American nature, *Twilight in the Wilderness.* In essence, the means that enabled him to transform the promise of *The Andes of Ecuador* into the fulfillment of *The Heart*

*of the Andes* is the same that led him from *Sunset* to *Twilight in the Wilderness.*

Accordingly, this examination of Church's North American landscapes will be illuminated by a brief examination of *The Heart of the Andes* (figure 64). By January of 1858, Church had already begun planning the picture, for *The Crayon* reported that

> Mr. Church, who has taken possession of a new studio in the Tenth street building, has under way a landscape, on a canvas some ten feet in length. Mr. Church has in his room a number of very pleasing studies, the result of his late trip to South America.[68]

The Tenth Street Studio Building had opened in 1857 and was filled with tenants by early 1858.[69] In addition to Church, other landscapists working there by the late 1850s or early 1860s included: Albert Bierstadt, John William Casilear, Sanford Robinson Gifford, Regis Francois Gignoux, William Hart, William Stanley Haseltine, Martin Johnson

96

Heade, Jervis McEntee, and Louis Mignot.[70]
Winthrop also maintained a room in the building,
and it was there that he wrote his pamphlet on *The
Heart of the Andes* as well as his best-known novel,
*Cecil Dreeme*.[71]

Church stocked his studio with potted plants and
other mementos of his travels in the tropics to serve
as inspiration as he painted the great work. A
brightly colored tropical butterfly preserved under
glass was a constant reminder of the myriad hues of
South America, and Church often pointed it out to
visitors to the studio.[72] Using sketches from his
journey of 1857, he began to rough out the first
ideas for the grand composition he envisioned. His
movement toward the final configurations of the
painting can be seen in a small oil on canvas sketch
of 1858 (figure 65). The major difference between
the sketch and the finished oil may be observed in
the group of trees at the lower right in each.[73] In
the preliminary study is a pair of rather listless
palms, which stand out only tentatively from the
surrounding jungle. In the finished painting a trio of
heroic trees towers over its surroundings, giving
that side of the picture powerful emphasis. In addi-
tion, other more subtle differences between the two
works help indicate how Church transformed the
raw material of a compositional sketch into a fully
realized work of art. While doing so, he may have
thought back to his early studies with Cole, who
had taught him the importance of that stage in the
creative process between study and finished work.

Church first slightly altered the viewpoint; in the
sketch the viewer is vaguely situated somewhere
above the scene, looking down at the area of the
palms. In the finished work, the implied location is
roughly on the same level of ground as the trees,
although the viewer is separated from them by an
intervening gulf. The observer still looks down into
parts of the landscape, but the immediate view is
more directly into the scene, so there is a strong
sense of physical and intellectual identification with
it. This was an essential step in breaking down the
distinction between pictorial space and the space of

65. Frederic Edwin Church, *Study for The Heart of the
Andes,* 1858, oil on canvas, 10¼ × 18¼ in., New York
State, Office of Parks, Recreation and Historic Preserva-
tion, Olana State Historic Site (OL.1981.47).

the viewer, a step with which Church experimented
throughout much of his early career.

Church's other adjustments had perhaps less im-
pact on the overall appearance of the work, but
remain significant. He added a projecting tree or
shrub at the lower middle of the composition,
which provides a foreground scale reference to be
read against the leap into space to the next zone. At
the left he introduced a prominent dead tree, estab-
lishing another foreground point of reference. A
path leads into the left hand side of the picture, and
near it stands a cross and two peasants; these ele-
ments are not present in the preliminary sketch.
The other significant changes are in the background
mountains, which Church increased in mass while
also emphasizing their rugged and jagged contours.

The work was finally completed in the spring of
1859, and on the evening of April 17 "a goodly com-
pany of artists, amateurs and *connoisseurs*" were
able "to enjoy the first public glimpses" of *The
Heart of the Andes*.[74] David Huntington has dis-
cussed the remarkable reception the painting re-
ceived in New York and elsewhere and has analyzed
the picture's structure and meaning.[75] In the present

context, apprehending certain points about *The Heart of the Andes* is crucial to a full understanding of Church's subsequent major works in general and *Twilight in the Wilderness* in particular.

First are the actual circumstances of the painting's exhibition. Although it was on view concurrently with the annual exhibition of the National Academy of Design, it was not shown in a general exhibition. Indeed, it was not shown with any other pictures at all, but as a single attraction, paid-entrance event.[76] This was not the first time Church had done this—that distinction belongs to *Niagara*—but in this case it was done with a level of organized showmanship that he never surpassed. The painting was shown in a darkened room, lit by gas-jets, and surrounded by tropical plants. An almost endless series of newspaper reviews and commentaries discussed the picture, and the pamphlets of Louis Noble and Winthrop interpreted it to eager readers.[77] It is hard to imagine today just how remarkable an event the exhibition of *The Heart of the Andes* was, but the following account gives some suggestion:

> The public present behaved as usual, admirably and respectful. Some gazed in silence, others had to read the description of the painting, in order to know what they were looking at. All remarks were made in whispers; we could hear here and there quotations from newspapers such as aereal perspective, beautifully done, chiar-oscuro, frame looking like out of a window, harmony, Herring, mezzotint, Moissonnier [*sic*], landscape, Landseer, power, Powers, Poussin, school, scholar, Salvadore, softness, studio, stillness, and so on.[78]

Everyone came to see the picture; Mark Twain made at least three separate admiring visits,[79] Washington Irving came "by special invitation,"[80] and George William Curtis, Church's early champion and Winthrop's close friend, stood beside the painter Daniel Huntington and studied the great work.[81]

The exhibition of *The Heart of the Andes* was thus an "event" that went beyond mere popular en-

tertainment, because seeing it was intended to be an edifying and uplifting experience. Indeed, the painting itself was but one component—albeit by far the most important one—in a complex program for the expression of meaning through landscape. It followed in the tradition Cole had established with *The Course of Empire* and *The Voyage of Life*. Above all, the picture was meant to be read, to be interpreted, to be understood. The people who quoted from newspaper reviews or read the pamphlets of Noble and Winthrop as they studied the painting knew this. In fact, they would have demanded it of any landscape that was put forward, as *The Heart of the Andes* surely was, as being serious and elevated art. Such a work had to be meaningful as well as entertaining. As Winthrop stated succinctly: "A great work of art is a delight and a lesson."[82]

From the modern perspective, which is generally suspicious of "popular" or "entertaining" art, it would be easy to regard *The Heart of the Andes* as superficial, shallow, and ultimately lacking in content. To do so, however, is to exhibit cultural anachronism, seeing the nineteenth century through the eyes of the late twentieth century. To say, as one modern observer has, that Church was "a conventional fellow and straightforward family man who enjoyed selling melodramatic paintings for high prices and taking sketching trips to far-off places" is perfectly reasonable.[83] However, to conclude, as this same observer did, that he was nothing more than this and merely a technically proficient but rather emptyheaded painter is to be blind to the way he conceived his pictures and the way they were received by his contemporaries. To be sure, Church had his detractors, many of whom felt he was all flash and no substance; but for each of those with negative opinions were many more who found his work meaningful and serious. For the fact is, Church achieved in his major works a remarkable synthesis of the popular with the profound. Winthrop recognized this when he referred to great art as both a "delight and a lesson" and

when he further noted that the "applause of a mob has a noisy charm . . . but the tidal sympathy of brother men stirs the life-blood of the artist."[84] Church's "brother men" were those who were able to see beyond the obvious in his painting, and thus recognized that "the master artist works his way to the core of Nature, because he demands not husks or pith, but kernel."[85]

The "kernel" at the "core" of *The Heart of the Andes* was a complex construct of multilayered meaning, and the painting invited interpretation on several levels. It was, perhaps most obviously, an emblem of an entire zone of the earth, Humboldtian both in its epic scope and in its firm grasp of the facts of physical reality. To quote Reverend Theodore Cuyler, it was "a complete condensation of South America . . . into a single focus of magnificence."[86] Or, as Winthrop noted with typical enthusiasm: "Mr. Church has condensed the condensation of Nature. It is not an actual scene, but the subtle essence of many scenes combined into a typical picture."[87] Winthrop divided the painting into ten different "regions" and proceeded to analyze each carefully, discussing how it embodied some aspect of the tropics and what meaning it conveyed.[88] He thus treated it like "many pictures in one," but recognized that "the dramatic construction" of the work was such "that no scene is an episode, but each guides the mind."[89] Church had taken Cole's conception of a cycle of separate paintings which were tied together by human narrative, and fused it into a single work that was "many pictures in one" linked by the carefully organized flow of one area of landscape into the next. To read Winthrop's discourse on the painting is to take an imaginary walking tour, as Diderot himself might have done, through the "course" of nature's "empire." In Winthrop's classification we commence at "The Sky" of the upper left, study "The Snow Dome," move on to the "The Lana, or central plain," ascend "The Cordillera," examine "The Clouds, their shadows and atmosphere," return to earth and visit "The Hamlet," "The Montana, or

central forest," "The Cataract and its Basin," "The Glade on the right foreground," and finally end our journey at "The Road and left foreground." The boat ride in Cole's *Voyage of Life* seems brief in comparison.

For Winthrop, and no doubt many others who came to see the painting, taking this sweeping tour of the tropics gave one the knowledge to read "Nature like an open book."[90] Although he made some references to the spiritual character of the painting, this was not his major concern. He had "delighted to haunt the studio of his friend Church, and watch day by day the progress of the picture,"[91] and his own writing was a verbal parallel of the artist's progress through the stages of creation. However, many other observers saw the painting in a religious context. Reverend Cuyler felt the great snow-capped mountain of the upper left recalled "the Apocalyptic visions of heaven,"[92] and a writer for *The Christian Examiner* was reminded of "the miracle of the marriage of Cana" at one point, and the "I know that my Redeemer liveth" passage from Händel's *Messiah* at another.[93] *Russell's Magazine* expressed the spiritual effect of the painting succinctly: "The deep meaning of nature, its purifying, elevating influences are profoundly felt in the presence of this truly *religious* work of art."[94]

The key detail that guaranteed that the religious sentiment of the picture would not be overlooked was the cross. As one New York reviewer wrote:

> The happy introduction of the Holy Cross, the symbol of our faith, and the figures kneeling, as the vesper chimes float faintly from yonder hamlet, are highly suggestive in the blending of the spiritual and the material, and by one subtle *coup de grace* place the picture in the highest range of art.[95]

This was not, of course, the first time Church had included a prominently placed cross in one of his paintings, nor would it be the last. The central motif of *To the Memory of Cole* (figure 19), it will be recalled, was a garland-wreathed cross that foreshadows the one in *The Heart of the Andes*. Furthermore, *The Andes of Ecuador* of 1855 (figure 53)

66. Frederic Edwin Church, *The Cross in the Wilderness,*
1857, oil on canvas, 16¹/₄ × 24¹/₄ in., Thyssen-Borne-
misza Collection.

included a scene of pilgrims before a cross that was
the direct prototype for the later work. Also rele-
vant to *The Heart of the Andes* is the so-called
*Cross in the Wilderness* (figure 66).[96] Although the
rocky, barren landscape in this elegiac work is obvi-
ously unlike the scene in *The Heart of the Andes,*
the prominent role of the cross as the symbol of
faith is closely related in both paintings.

Louis Noble, as one would expect, was pro-
foundly moved by the spiritual qualities of *The
Heart of the Andes* and his pamphlet, although sim-
ilar to Winthrop's in its descriptive manner, is more
metaphysical in interpretation. Believing that relig-
ious faith was indispensable to the very act of land-
scape painting, Noble observed:

> Evidently, some apprehension of the process of land-
> scape-*making* by the instrumentalities of the Creator, is
> necessary in order successfully to conduct the process
> of landscape-*painting* by the feeble instrumentalities of
> man.[97]

Church, who possessed this "apprehension" succeeded in "linking all confusion into order, blending all parts into, running up an infinity of things into one living organic whole, and leading the mind into the presence of the Maker."[98]

Ultimately, *The Heart of the Andes* functioned as an elevated work of art that brought together three of the most pressing issues of its day: nature, science, and religion. Although to some modern observers it has not stood the test of time as well as such other paintings as *Niagara* or *Cotopaxi,* it was undeniably the most ambitious and the most thematically complex work of Church's entire career. In large measure, it established the direction for his art over the next fifteen or twenty years. More specifically, this summary image of the South American landscape was the immediate precedent, indeed even the prerequisite, for what would be Church's comparable image of North America, *Twilight in the Wilderness*.

# Chapter 6 · *The Stillness of Twilight and the Solemnity of Undisturbed Primeval Nature:* Twilight in the Wilderness

. . . a combination of crystaline and glow, of solitude and serenity, of wildness and beauty, such as atmosphere, water, firmament, and vegetation only so combine to produce in America.
*Boston Evening Transcript,* June 1860

Oh! time was, when as the sunrise nobly spurred me, so the sunset soothed. No more. This lovely light, it lights not me; all loveliness is anguish to me, since I can ne'er enjoy. Gifted with high perception, I lack the low, enjoying power; damned, most subtly and most malignantly! damned in the midst of Paradise!
Herman Melville, *Moby Dick,* 1851

On Wednesday, June 6, 1860, "a discerning few" invited guests had the first look at Church's latest work, *Twilight in the Wilderness* (colorplate 10), at Goupil's Gallery on Broadway.[1] Throughout the spring, reports had appeared now and then about the artist's progress on this new painting, and the critics and public had eagerly awaited its unveiling. After they had seen it, virtually everyone agreed it was one of Church's finest works, both a worthy successor to *The Heart of the Andes* and an admirable forerunner to his "long talked of picture of an iceberg at sea."[2] The painting remained on view until July 25, with hundreds of visitors going to see it, each paying twenty-five cents admission, just as had been the case with *The Heart of the Andes.*[3] In every respect, *Twilight in the Wilderness* was a triumphant success for Church, and today it is considered one of his greatest works and an undisputed masterpiece of American painting. To understand the painting fully and to appreciate its remarkable richness and complexity, we must trace its actual creation, consider how Church's contemporaries received it, and attempt to decipher its content and meaning.

The story actually begins some two years before the painting first went on view in New York. Church was established in the Tenth Street Studio by early 1858 and spent much of the spring there laboring on *The Heart of the Andes.* As of May 4, he was still in New York,[4] but the next known evidence of his whereabouts dates from late July. At that time he was in East Hampton, New York, where he executed numerous small drawings of skies and details of scenery.[5] Then, in August, he went to Niagara, where he once again sketched the falls and made close-up studies of trees on Goat Island.[6]

Church's whereabouts in this period are of special interest, because one contemporary source provides the date when he saw the sunset that served as the inspiration for the sky in *Twilight in the Wilderness.* In describing Church's *Twilight, a Sketch* (figure

67. Frederic Edwin Church, *Twilight, a Sketch,* 1858, oil on canvas, 8 × 12 in., New York State, Office of Parks, Recreation and Historic Preservation, Olana State Historic Site (OL.1981.8).

67), a compositional study for *Twilight in the Wilderness* that was exhibited at the National Academy in 1859, one writer noted: "We understand that this is the record of a remarkable sunset that blessed the world in the summer solstice of 1858."[7]

Although it is impossible to pinpoint Church's location on June 21–22, 1858, it is likely that he saw this sunset in New York City. There are no known sketches dated June 1858, and evidence (the East Hampton sketches) of him leaving the city dates from July. During the spring and early summer of 1858 Church was hard at work painting *The Heart of the Andes,* and this task would have kept him in his studio on Tenth Street much of the time. Church seems occasionally to have sketched twilight skies from his studio window, because several small oil

sketches and pencil drawings at the Cooper-Hewitt Museum show dramatic sunsets above urban buildings.[8] The handling of these works suggests a date of the late 1850s, and, in some cases, the thick strokes of pigment highlighting the undersides of clouds are very close to passages in *Twilight, a Sketch*. Thus, it is quite possible that it was from his studio window that Church observed the spectacular sunset that became the basis for *Twilight in the Wilderness*.[9]

The New York newspapers do not mention any dramatic sunset in the period around June 21–22, but, of course, such a sight would hardly have been news. However, a violent series of thunderstorms struck the New York area and the Hudson Valley on Monday, June 21, causing widespread destruction and some loss of life.[10] The storm began around five o'clock in the afternoon and had passed by the time of sunset, which was "clear."[11] If the sunset in question did occur then or the following day, it may well have seemed to "bless the world" after the terrible weather.

*Twilight, a Sketch* is clearly a studio production of a type with the preliminary study for *The Heart of the Andes* (figure 65), and the landscape it depicts obviously has nothing to do with New York City. Church's on-the-spot record of the sunset, which most likely would have been a quick pencil sketch similar to those previously discussed (e.g., figure 59) is missing. Extant, however, are the several sky sketches he made in East Hampton only a month later, and these give a good indication of his working methods at this time. These drawings are generally similar to earlier ones, with the cloud forms drawn with quick, simple strokes and the colors recorded by a numbered system. In a typical example, entitled *Sky—East Hampton* (Cooper-Hewitt Museum), he noted the various colors, including "rich orange," "luminous orange gradually turning warmer and warmer until last in neutral," "luminous yellow," "warm shade of green," and "dark neutral touch of purple." Very similar colors are found in the sky of *Twilight in the Wilderness*.

After making one or more initial pencil studies of the sunset, Church may have done a quick oil sketch of the effect or perhaps worked up an oil version of one of the drawings, as he had done in the case of the study for *Sunset* (figure 60). Once again, there are no works presently known that are likely candidates for such studies. However, judging from an oil sketch that almost certainly dates from this period (figure 68), Church had fully perfected his rapidly brushed and richly colored method of recording twilight effects. This particular sketch is close in spirit to *Twilight in the Wilderness*, especially in its glowing band of yellow color broken with luminous bars of green, blue, and orange just above the mountainous horizon.

At some point in 1858, Church began to paint *Twilight, a Sketch* using whatever studies he had made of the sunset. As the title implies, this work was executed with a larger, or more ambitious, painting in mind, and this assumption is borne out by a consideration of Church's procedure in creating his major works of this period. In every case, including *The Heart of the Andes, Icebergs,* and *Cotopaxi,* the final composition was preceded by a small oil study on canvas. These other studies were not shown publicly, but Church felt confident enough of the merits of *Twilight, a Sketch* to send it to the National Academy exhibition of 1859. Although some reviewers felt that this was only a token gesture and that Church should have offered *The Heart of the Andes* instead, others praised the small work and saw in it great promise.[12]

The most extensive commentary on the picture was found in the *New York Times,* which noted that "Church, like Turner, has mastered the secret of painting space. He leads the eye into the distance less by lineal or aerial perspective than by his receding gradations of color."[13] This review raises several interesting points. In praising the sense of spatial recession in the painting and comparing Church to Turner in this regard, the reviewer indicated that he was aware of one of Church's major concerns: the achievement of a convincing atmospheric perspec-

68. Frederic Edwin Church, *Sunset*, c. 1858–60, oil on paper, 10¹/₂ × 13⁵/₈ in., private collection, Washington, D.C.

tive in a sky with a complex arrangement of clouds.[14] As has been discussed, in the later 1850s Church experimented with two types of cloud-filled skies. There were the soft, highly illusionistic clouds of such works as the two *Twilights* (figures 56 and 57), and the more tightly rendered, dramatically receding formations of *Sunset* (colorplate 9). In *Twilight, a Sketch* he was moving toward a fusion of the two types by attempting to portray the clouds as masses of vapor that still possessed sufficient form to lead clearly into space. But, as the *Times*'s critic noted, the result was not entirely satisfactory: "The effect which these clouds produce is rather that of a mass of vapors whirled about into a kind of eccentric chaos upon the background of a blank space than of a floating atmospheric panorama."[15] Whereas Turner could create a swirling vortex of clouds that both penetrated and filled space, Church, in this work, had only managed "eccentric chaos." But it was a fault he would remedy brilliantly in *Twilight in the Wilderness*.

The landscape in *Twilight, a Sketch* is certainly one that Church composed, but it does have certain similarities to the scenery of areas he visited in the later 1850s. The wildness of the terrain, with its heavily wooded hills, is reminiscent of the Maine

69. Frederic Edwin Church, *The Evening Star,* 1858, oil on canvas, 7³/₄ × 10¹/₂ in., Jamee and Marshall Field.

scenery Church had portrayed in *Sunset* and *Twilight* (figure 57). The trapper's hut with single glowing window, which is barely visible by the waterfall at the lower right, recalls the one in *Twilight.* Thus, the general impression conveyed by *Twilight, a Sketch* is of the remote wilderness of Maine with the only presence of humanity represented by the trapper's hut.

Church chose a similar wilderness locale as the setting for another small twilight picture of 1858, *The Evening Star* (figure 69).[16] According to *The Cosmopolitan Art Journal,* this "exquisite picture, representing the setting of a single star upon a

placid lake," was painted as a memorial to a recently deceased child of Erastus Dow Palmer, who had been named after Church.[17] In this work, Church explored the more pensive and melancholy associations of sunset, although without the brooding intensity found in *Twilight, Short Arbiter 'Twixt Day and Night* of 1850 (colorplate 3). Earlier in his career Church had generally read hope and promise in the glories of fading day (as in his *Mount Ktaadn,* colorplate 7), but he now was sensitive to more complex and ambiguous meanings.

The darkly shadowed scene of *The Evening Star,* with its still lake, quiet sky, and single, glowing star, evokes an appropriate mood of elegy. Also known as Hesperus, from the Greek word for west, the evening star is the first star to appear as the sky darkens after sunset, and it is the brightest object in the nighttime sky other than the moon. It is, of course, not actually a star, but rather the planet Venus.

Poets often used the evening star symbolically. Milton, for instance, referred to Hesperus several times in *Paradise Lost,* perhaps most notably in the passage that provided the title for Church's *Twilight, Short Arbiter.* However, it was especially during the eighteenth and nineteenth centuries that it developed powerful symbolic content. William Blake, in his "To the Evening Star," saw it as a benevolent guardian spirit in the gloomy wastes of the night sky, whereas Ralph Waldo Emerson considered it a "holy" light that could lead one into communion with God.[18] The most prevalent associations evoked by the evening star, however, had to do with death, as in Percy Bysshe Shelley's "Adonais: an Elegy on the Death of John Keats" of 1821.[19] The poem opens with a quotation from Plato, as translated by Shelley:

> Thou wert the morning star among the living,
> Ere thy fair light had fled—
> Now, having died, thou art as Hesperus, giving
> New splendor to the dead.[20]

Venus can be both the morning and evening star,

and thus its transition through the phases of day and night could serve as a parallel to the cycle of human life. In the concluding stanza of "Adonais," Shelley looks toward the evening star:

> The breath whose might I have invoked in song
> Descends on me; my spirit's bark is driven,
> Far from the shore, far from the trembling
> throng
> Whose sails were never to the tempest given;
> The massy earth and sphere'd skies are riven!
> I am borne darkly, fearfully, afar;
> Whilst burning through the inmost veil of
> Heaven,
> The soul of Adonais, like a star,
> Beacons from the abode where the Eternal are.[21]

In linking Adonais (i.e., Keats) with the evening star, Shelley both acknowledged his friend's death and affirmed his belief in the immortality of his soul. Church would have certainly recalled a similar use of evening star imagery in William Cullen Bryant's famous oration at the funeral of Cole, where he compared the loss of the painter to seeing "Hesperus or Jupiter blotted from the sky."[22]

In *The Evening Star* Church expressed both his sorrow over the passing of his friend's child, his namesake, and also his belief in the triumph of Christian afterlife, which was guaranteed to the innocent soul of an infant. Thus, the twilight sky itself may represent both the sorrow and loss of the present and the hope and promise of the future. It marks both a passing away and a new beginning, one of several complex associations a twilight sky could evoke. In *Twilight in the Wilderness* Church expressed a similar mingling of hope and sorrow, optimism and pessimism.

*The Evening Star* is also important in this context because it portrays a pure, untouched wilderness with no sign of man's presence. For the first time in his art Church was stating complete faith in the spiritually regenerative and benevolent influences of pristine nature. This small painting thus represents a crucial step between *Twilight, a Sketch,* with its lingering reference to man (the trapper's hut), and

*Twilight in the Wilderness,* where all such references are completely excluded.

During the spring of 1859, as he was completing *The Heart of the Andes,* Church was already thinking ahead to the choice of subject for his next great work. Although he had initially made plans to go to Europe in the spring and summer of 1859,[23] he abruptly shifted his destination to the far north. According to one report, he was so tired from painting the detailed foliage in *The Heart of the Andes* "as to long for scenes where not a tree or leaf was to be met with, and hence arose the project of pictorially assailing the icebergs."[24] Perhaps this was part of Church's motivation, but general interest in arctic exploration was building in the late 1850s, and his excursion to the far north should be considered part of this trend.[25] Church clearly had in mind a great painting of icebergs, and he chose as his traveling companion for the journey Cole's biographer, Louis Noble, who was to record their experiences in book form.

The details of their two-month expedition "after icebergs" are not important here, but a few general observations will establish the background for the creation of *Twilight in the Wilderness.*[26] The activities of Church and Noble in the north closely paralleled those of the artist and Theodore Winthrop in Maine three summers before. While Church would be busy sketching, Noble, like Winthrop, would record the details of the scene in his notebook, often making enthusiastic references to the associations evoked by the dramatic sights. Noble's observations, as one would expect, are frequently punctuated with religious exclamations, and, at times, he is almost unable to contain himself. Describing a glorious twilight at sea with a freshening breeze filling the sails of their ship, he writes:

> We speed onward. The little ship, like a very falcon, flies down the wind after the game, and promises to reach it by the last of daylight. A long line of gilding tracks the violet sea, and expands in a lake of dazzling brightness under the sun. Beneath all this press of sail,

we ride on fast and steadily, as a car over the prairies. We seem to be all alive. This is fine, inexpressibly fine! This is freedom! I lean forward and look over the bow, and, like a rider in a race, feel a new delight and excitement. Wonderful and beautiful! Like the Arab on his sands, I say, almost involuntarily, God is great![27]

Church and Noble continually turned their eyes toward the sunset sky, captivated by the brilliant displays of color and light. On one memorable evening, they witnessed an overwhelming spectacle:

> All that we anticipated of sunset, or the after sunset, is now present. The ocean with its waves of Tyrian dye laced with silver, the tinted bergs, the dark-blue inland hills and brown headlands underlie a sky of unutterable beauty. The west is all one paradise of colors. Surely nature, if she follows as a mourner on the footsteps of the fall, also returns jubilant and glorious to the scenes of Eden. Here, between the white light of day and the true dark of evening, shade and brightness, like Jacob and the angel, now meet and wrestle for mastery. Close down along the gloomy purple of the rugged earth, beam the brightest lemon hues, soon deepening into the richest orange with scattered tints of new straw, freshly blown lilacs, young peas, pearl and blue intermingled. Above are the royal draperies of the twilight skies. Clouds in silken threads and skeins; broad velvet belts and ample folds black as night, but pierced and steeped and edged with flaming gold, scarlet and crimson as deep as blood; plumes tinged with pink, and tipped with fire, white fire. . . . The painter gazes with speechless, loving wonder, and I whisper to myself: This is the pathway home to an immortality of bliss and beauty.[28]

Although Church had gone north in search of material for a great arctic painting, such stirring sights as this must forcibly have rekindled his long-standing interest in twilight scenes. Indeed, one of the lessons Church learned on this trip was just how essential light and atmosphere, mingling in evanescent, ever-changing forms, were in activating a particular vista. This became quite clear to him as he observed icebergs at sea, which he found to be "purely white, an opaque, dead white,—ghastly and

spiritless in a dull atmosphere; but in bright weather, especially late in the afternoon, kindling with a varied splendor."[29] Thus, during his trip to the far north, Church was constantly sharpening and refining his already keen appreciation for atmospheric effects. Sharing with Noble a constant delight in the twilight panoramas they saw, and listening to the preacher describing them in his richly symbolic language, Church could only have reaffirmed in his own mind just how wonderfully evocative a spectacular sunset could be.

When the painter returned to New York in the fall of 1859, he had with him a plentiful supply of drawings and oil sketches made during his summer voyage. It was naturally assumed that he would immediately begin work on a "Heart of the Icebergs."[30] This, however, was not to be, for other matters required Church's attention over the next ten months. He arranged a second New York showing of *The Heart of the Andes* and a subsequent exhibition of the painting in Boston. He seems to have painted little during the fall, although he did complete a small picture of a volcano in time for the January 1860 artists' exhibition at the Studio Building.[31] Church had also, by early 1860, acquired property near Hudson, New York, directly across the Hudson from Cole's home in Catskill. This property was the future site of Olana, and Church was busy making plans for his new holdings. However, the painter's other major activity, at least after the first of the new year, was the planning and execution of *Twilight in the Wilderness*. He had decided to postpone painting the iceberg picture, and thus the next great work he brought before the public—in a real sense, then, the true sequel to *The Heart of the Andes*—was his summary depiction of the North American landscape. At this point, we must turn to a detailed consideration of the actual process Church followed in creating his masterpiece of 1860.[32]

Church had apparently started the picture by mid-January 1860. On the evening of January 19 an artists' reception was held at the Studio Building.

All of the studios were open to the visitors except that of Church, who had "closed his doors, except to special friends."[33] This was a sure sign that he had something important under way within.[34] Henry Tuckerman has provided a useful description of Church's methods when working on a major picture:

> It is Church's habit to devote the summer to observation and reflection; then he gathers the materials, and thinks over the plan and scope of his pictures, seeking, at the same time, by life in the open air, and wholesome physical exercise and recreation, to invigorate his health, which is not robust, and lay up a stock of strength as well as ideas for work during the winter. That season he passes in the city, resolutely shut up several hours daily in his studio, concentrating his mind upon some long-contemplated task, to which his time and thoughts are given with a rare and exclusive devotion, which, in a few months, makes the sunburnt and active sojourner in the country resemble a pale student, so exhaustive and absorbing are his labors once fairly engaged upon a mature conception. Although rapid in execution, he is slow in working out the artistic problem to be solved in his own mind; he cannot brook interruption for any trivial object, and eschews all dalliance with pastime until his pencil is laid aside for the day.[35]

The execution of *Twilight in the Wilderness* must have followed just such a procedure, with Church studying his numerous oil sketches and drawings of Maine and New England while he contemplated the "artistic problem to be solved." Of course, he already had *Twilight, a Sketch* to serve as the guide for the general character and configurations of the new work, and he must have begun working on the actual canvas itself fairly soon. When beginning a painting, Church liked, in his words, to "chalk down such ideas as may suggest themselves."[36] He no doubt roughed out the scheme of *Twilight, a Sketch* on the larger canvas, but he then proceeded to make additions and adjustments that transformed the tentative promise of the sketch into a fully realized heroic landscape. In doing so, he fol-

71. *Twilight in the Wilderness* (detail of stump).

70. Frederic Edwin Church, *Twilight in the Wilderness,* (detail of trees), 1860, oil on canvas, 40 × 64 in., The Cleveland Museum of Art, Mr. and Mrs. William H. Marlatt Fund (65.233).

lowed a process very similar to the one that intervened between the sketch for *The Heart of the Andes* and the finished work.

The general configurations of the landscape in the sketch—a heavily wooded, mountainous area with an area of water in the middleground—are carried over in the final painting. Church adjusted the contours of the hills and downplayed the pronounced zig-zag of the water as it recedes into space. He also introduced a prominent mountain in the middle distance, with a high left shoulder, abrupt peak, and long trailing ridge to the right.

The principal differences between the sketch and the painting are in the foreground and in the sky. In the lower right foreground the artist eliminated the trapper's hut and waterfall of *Twilight, a Sketch,* replacing them with an outcropping of rock located closer to the picture plane. Nearby, Church introduced a striking group of trees (figure 70), which, although northern in type, are arranged in a manner quite similar to those found in the correspond-

72. *Twilight in the Wilderness* (detail of dead tree).

73. *Twilight in the Wilderness* (detail of sky).

ing area of *The Heart of the Andes*. Moving across the bottom of the canvas, we see that he made the weathered stump (and this is a naturally formed stump, not a sawn one) present in the sketch more prominent and placed a branch of living foliage projecting upward into space (figure 71). At the top of the stump Church carefully delineated several jagged splinters of wood, two of which are arranged to form an unmistakable cross. Farther to the left appears a tree snag (figure 72), at the top of which perches a bird.

In every case, Church's changes and adjustments in the foreground of *Twilight in the Wilderness* have clear prototypes in *The Heart of the Andes*. Indeed, it is essential to remember that while he was actually painting the Andean landscape during the winter of 1858 and spring of 1859, Church had *Twilight, a Sketch* in his studio. He could easily have thought about how that work could be turned into a finished painting as he transformed the preliminary study for the South American painting. Thus, the

creative process involved in *The Heart of the Andes* was also an integral part of the planning of *Twilight in the Wilderness*. As will be discussed, the stylistic and compositional similarities between the paintings are echoed by corresponding thematic parallels.

As mentioned, the other significant differences between the sketch and finished work are in the sky. Here Church transformed the indecisive, somewhat unconvincing clouds of the sketch into a masterful sweep of perfectly rendered altocumulus clouds that recede dramatically into a vortex-like swirl in the far distance (figure 73). Church never surpassed this achievement in any subsequent work. How had he accomplished such an amazing tour-de-force of meteorological drama? The most obvious answer is that his long and patient study of the sky had paid a rich dividend indeed. More specifically, he had finally achieved a synthesis of the vaporous, illusionistic clouds from works such as *Twilight* (figure 57) with the carefully structured, receding formations found in *Sunset* (colorplate 9).

He was now able to portray with supreme conviction the insubstantial, ethereal appearance of light-suffused water vapor, yet also arrange it along a precisely ordered perspective grid.

John Ruskin, who was continually vexed by the fact that clouds refused to stay still and allow thorough study, devoted a lengthy section of the fifth and final volume of *Modern Painters* to "Cloud Beauty." Ruskin attacked this subject with his usual thoroughness and persistence, and included several useful diagrams of cloud perspectives. However, the fifth volume only appeared in June 1860, too late to have been any help to Church. Still, when one studies the great sky in *Twilight in the Wilderness,* it appears certain that it could only have been painted by an artist who had come to understand, through Ruskin, the full measure of J. M. W. Turner's achievement. In volume four of *Modern Painters,* Ruskin discussed "Turnerian Light" and "Turnerian Mystery"; by the latter he meant Turner's mastery of diffuse atmospheric effects.[37] Church, as discussed previously, was exploring the means for depicting vaporous atmosphere as early as 1854, and, by the following year, he had created his first great Turnerian masterpiece, *The Andes of Ecuador* (figure 53). He had avidly studied engravings after Turner's works,[38] and he may also have had access to two outstanding paintings by the English master that were then in New York. These pictures, *Staffa, Fingal's Cave* (1832, Yale Center for British Art, New Haven) and *Fort Vimieux* (1831, private collection), were owned by James Lenox (1800–1880), the wealthy philanthropist, bibliophile, and collector. It was Lenox who would later purchase Church's greatest homage to Turner, *Cotopaxi* (1862, Detroit Institute of Arts).[39] From the two Turner paintings, both of which depict sunsets, Church would have derived invaluable lessons about his remarkable manipulation of paint, his use of color, and his sophisticated glazing techniques. *Staffa* would also have provided a first-hand look at a typical Turner vortex of light and vapor, and the lower left portion of *Twilight in the Wilderness*

strongly suggests that Church did understand this aspect of Turner's work.

Thus, Church's study of Turner was probably of key importance in leading him to his consummate mastery of light and atmosphere in diffused and vaporous states. Yet Turner's work offered another important lesson.[40] Turner often skillfully manipulated his brushstroke so that the movement of the paint itself coincided with the movement and shapes of the forms being depicted, whether water, rocks, or clouds. In *Niagara,* Church's handling of the water, which is rendered with remarkably flowing, yet controlled, strokes, is clear evidence of his familiarity with this aspect of Turner's works. Perhaps even more Turnerian in feeling is the way he used striated areas of pigment in the clouds of *Twilight in the Wilderness* to help give form and directional emphasis to what might otherwise read as amorphous masses of vapor. Church was thus using his brushstroke simultaneously to define form, locate it securely in space, and give it directional force. This was perhaps the most sophisticated handling of paint by any American artist of the era.[41]

By March of 1860 Church had apparently made substantial progress on *Twilight in the Wilderness,* because *The Cosmopolitan Art Journal* for that month noted it was nearing completion.[42] This report may have been a bit premature, for at the end of the month Church once again closed his studio door to visitors during a reception at the Studio Building. According to the *Tribune,* the reason was "a large picture in half finished condition on his easel."[43] Then, in early April, Church allowed the New York correspondent of the *Boston Evening Transcript* an advance look at the new work. The writer immediately provided details to his readers in Boston:

Observers of nature are aware that some phases of the sunset sky, especially in autumn, are peculiar to North America; there is one magnificent spectacle of the kind often seen on approaching our coast at that season; mottled fleecy clouds of crimson and saffron cluster in the west, halfway to the zenith, while along the hori-

zon is a belt of opal, or what Allston calls "apple green"; this splendid combination Church is now transferring to canvas, with his usual skill. It will be a grand and truly American sky-landscape.[44]

This description notes that the season depicted in the painting was autumn, not the early summer of *Twilight, a Sketch*. This writer had access to Church's studio at a time when the painter was actually there working on the picture, and his words doubtless reflect Church's own intentions. The shift is important, for the seasonal change from autumn to winter embodied very different associations than those evoked by the transition from spring to summer. And, as will be seen, the complex meanings of *Twilight in the Wilderness* were better served by the more contemplative tone of autumnal imagery.

By late May, Church was putting the finishing touches on the painting. His work had been briefly interrupted by the necessity of arranging for shipment of *The Heart of the Andes* to England "for the use of the engraver in finishing the work" and by his preparation of "another canvas of the same dimensions" that was awaiting his "magic touch."[45] This second canvas was for *The Icebergs*. Thus, for a few days in May 1860, there was an intriguing physical conjunction of three major works in Church's studio: the famous *Heart of the Andes*, the nearly completed *Twilight in the Wilderness*, and the barely begun *Icebergs*. This fact indicates how closely associated these three works were in Church's creative activities during 1859–60.

*Twilight in the Wilderness* was finally ready for exhibition in early June, but before sending it to Goupil's Gallery, where it would be displayed, Church once again allowed the New York correspondent of the *Boston Evening Transcript* a private viewing.[46] Then, after "a few hundred people" were invited to see the picture on June 6,[47] it went on exhibition the following day. The public and critics could now judge for themselves the work that had occupied Church "for several months past."[48] "This work," wrote the critic for the *Herald*, "will be more highly esteemed than almost any of Mr.

Church's previous efforts," and the reviewer for *The Albion* observed, "It is not one of Mr. Church's largest works, but one of his very best."[49]

Many viewers considered *Twilight in the Wilderness* even finer than *The Heart of the Andes*, to which it was constantly compared.[50] Indeed, in every respect, it was judged by the standards established by the earlier work. Although smaller in size, it was almost as ambitious in intent. Like *The Heart of the Andes*, *Twilight* encourages interpretation from various perspectives, including those of science and religion, and considering the role of nature in the national identity. Although written texts for the painting comparable to the pamphlets connected with Church's earlier work are not extant, ample evidence supports interpreting the painting similarly. The numerous contemporary reviews present direct and specific evidence about the painting, and the writings of Noble and Winthrop (the two *Andes* pamphlets, *Life in the Open Air*, and *After Icebergs with a Painter*) are indispensable aids for interpreting Church's art during the period 1859–61.[51] While considering the meaning of *Twilight in the Wilderness* in detail, it is worth remembering Winthrop's assertion that "a great work of art is both a delight and a lesson" and his admonishment against a superficial viewing of such a work: "It is not enough to look awhile and like a little, and evade discrimination with easy commonplaces."[52] In *The Heart of the Andes* Church had challenged the viewer to join him in seeking the "kernel" at the "core of nature," and in *Twilight in the Wilderness* that invitation was renewed.

Everyone who viewed the painting recognized that it was a composition rather than a depiction of a specific site. As such, *Twilight* was, like *The Heart of the Andes*, an image of a particular zone of the globe. As the *Times* observed: "The picture, to borrow the language of a sister art, may be described as a composition upon a theme drawn from Northern New-England."[53] Many viewers singled out Maine as the most likely inspiration for the painting, but others mentioned the Adirondacks

and the mountains of New Hampshire.[54] In essence, *Twilight in the Wilderness* may be seen as a Humboldtian image of North America, a summary depiction of the New World landscape.[55] With *The Heart of the Andes* representing the tropical zone, *Twilight* the temperate climes of North America, and *Icebergs* of 1861 the wastes of the frozen north, Church created a veritable landscape trilogy that spanned the entire north-south axis of the New World. The artist had earlier paired North and South American scenes as pendants, and, in 1861, many observers noted that *Icebergs* was a pendant to *The Heart of the Andes*. To introduce *Twilight in the Wilderness* into this pair obviously raises problems in terms of scale, for it is much smaller in size. But the point is not that they were, in any literal sense, an actual triptych (as may, in fact, be argued in the case of *Cotopaxi, The Heart of the Andes,* and *Chimborazo*),[56] but that the three were the results of the same creative impulses and were united by the common theme of portraying archetypal portions of the earth. The epic scope of Humboldt's *Cosmos* was thus paralleled by Church's pictorial catalogue of the New World. As W. P. Bayley wrote of *The Heart of the Andes* and *The Icebergs*:

> Mr. Church's object in both these great pictures was, no doubt, to give a comprehensive idea of a specific kind of scenery, to group together as much truth as he could homogeneously, naturally, and to represent as he actually saw it, as much as he could, consistently with higher purposes.[57]

In *The Heart of the Andes* Church employed distinctive mountain forms and plants to convey his message, and in *The Icebergs* he manipulated the three basic elements of the Arctic—"Ice—water—sky," in Tuckerman's words—in order to express the essence of a frozen waste.[58] In *Twilight in the Wilderness,* he relied on atmosphere, topography, and trees to define the elemental character of the North American landscape. The twilight sky itself plays a major role in establishing an unmistakable American identity for the painting. Humboldt, who

drew upon eighteenth-century climate theory when formulating his own ideas, had considered the atmospheric characteristics of a particular region to be an essential part of its identity. North America lay within a different climate zone than those of other regions and thus manifested its own particular atmospheric phenomena. One of the most obvious North American atmospheric traits was the prevalence of especially brilliant sunsets, which Americans often boasted were far superior to any seen in the Old World. As Cole wrote in his "Essay on American Scenery," "the American summer never passes without many sunsets that might vie with the Italian, and many still more gorgeous, that seem peculiar to this clime."[59] The glowing reds, yellows, and oranges in *Twilight* are American by nature and are as much national emblems as are the tropical plants and snow-capped volcanoes of Church's South American landscapes.

Furthermore, the landscape portrayed in the painting is notable for "the peculiar American characteristics it embodies and illustrates."[60] As the title specifies, the setting is wilderness: pure, primeval, and untouched, such as is found only in the New World. Such wilderness, although growing ever scarcer in the Northeast, could still evoke images of a primal planet unsullied by man: "The earth must originally have been covered with forest, like the American continent in the time of Columbus."[61] Interestingly, this was the first time since his *Hooker and Company* of fourteen years earlier that Church had used the word "wilderness" in the title of one of his paintings. In *Hooker* the wilderness was what the travelers passed through, and it carried a strong negative charge of unwholesomeness and darkness. With *Twilight in the Wilderness,* however, Church had come full circle, for it was now the positive virtues of the wilderness that he celebrated. All traces of man and his works have been eliminated, and not even a path disturbs the image of pristine nature. Church had gradually moved toward the depiction of pure wilderness scenes in the late 1850s, but only in *The Evening Star* (figure 69) had he

eliminated all evidence of human presence. In large measure, *Twilight in the Wilderness* represents the vision expressed in *Sunset* (colorplate 9) purged of all vestiges of an anthropocentric outlook. As presented in *Twilight in the Wilderness,* American nature no longer had to be defined in terms of man's interaction with it, and modification of it, but rather on its own terms.

In *Twilight in the Wilderness* Church was thus forcibly stating that the true essence and identity of North America lay in the virgin wilderness itself. It was, to paraphrase the title of the work that immediately preceded *Twilight,* the "heart" of America, the emotional and spiritual center of the living nation. This represents a remarkable reversal from his attitude of just nine years earlier, so confidently expressed in *New England Scenery.* Then he had willed America to be *The Pastoral State* of Cole's dreams, but now his viewpoint was more closely allied to that expressed in *Desolation* (figure 74), where the forces of nature are portrayed as more vital and enduring than man and his works. As one observer noted of *Twilight,* "It is a waste of absolute solitude."[62] In *Desolation* Cole had expressed the ameliorating effects of nature and its regenerative cycles, and in *Twilight in the Wilderness* Church did the same, but with an important difference. This is nature before man has had the opportunity to corrupt and destroy it. The only ruins present are those of nature's making. Thus, the prominent column in Cole's *Desolation* is replaced by a dead tree. As a writer for *The Crayon* observed: "a ruined tree [is] as picturesque as a ruined tower."[63] In both Cole's painting and Church's, a bird perched atop the "ruin" provides affirmation of the persistence of life in the face of death and decay. At the right of *Twilight,* more ruined trees take the place of Cole's scattered architectural fragments, and, just beyond, as in *Desolation,* slender evergreens give additional evidence of nature's enduring permanence.

The trees that dominate the foreground of *Twilight in the Wilderness,* especially those at the

74. Thomas Cole, *Desolation,* from *The Course of Empire,* completed 1836, oil on canvas, 39$^{1}$/$_{2}$ × 61 in.; courtesy New-York Historical Society, New York (1858.5).

right—"a trio of comrades sustaining each other in their vanguard station," to use Winthrop's words describing the similar group in *The Heart of the Andes*—are like actors in a drama of natural history.[64] The foremost one has died and will soon crash to the ground to join the fallen snag below. Its branches trace writhing patterns against the sky, contorted in an arboreal dance of death. Just beyond is a healthy deciduous tree, covered with leaves and in the prime of life. Nevertheless, intimations of mortality are present here as well, for with the coming of winter its leaves will fall, leaving it in a dormant state (neither dead nor alive) waiting for the arrival of spring. The correspondent of the *Boston Transcript* noted that *Twilight* depicted "that season when summer is melting into autumn," so this tree's annual demise is imminent.[65] The tallest of the trees is a hemlock, emblematic of wilderness heights and, like all evergreens, a tree that withstands the seasonal changes. As in Church's earlier *To the Memory of Cole* (figure 19), which also paired deciduous and evergreen trees framing the right side of the composition, a contrast between

life and death is thus evoked. But hints of mortality are also present in the hemlock itself (and, of course, associations of human death through poisoning), because several of its branches are bare. Unlike the luxuriant trees of the tropical lowlands of *The Heart of the Andes,* the trees in *Twilight in the Wilderness* are struggling for survival. As Cole noted, trees, when exposed to "adversity and agitations," must battle for existence: "On the mountain summit, exposed to the blasts, trees grasp the crags with their gnarled roots, and struggle with the elements with wild contortions."[66]

While gazing at these trees, the sensitive viewer would be led to associations of human mortality and struggle. "Trees are like men," wrote Cole, "differing widely in character."[67] Or, as Harland Coultas observed in his *What May be Learned from a Tree* of 1858 (Church owned an 1860 edition): "The biography of a tree, or of a flower, is . . . an illustration of human life."[68] However, the trees in *Twilight in the Wilderness* encourage more than simple associations and individual identifications. Like the foreground spruce in *Sunset* (colorplate 9), they are archetypes for the vast numbers of similar trees that make up the intricate wilderness beyond.[69] Only by providing the viewer with this kind of reference could Church convey the essential nature of an archetypal American primeval forest, which was both a single entity and a congregation of many individual elements. The struggle for survival enacted in the foreground is repeated thousands of times across the miles of forest extending to the horizon. Church presents the American wilderness as a world of natural drama, where vital forces are in a state of balanced tension embracing both life and death. "Change," wrote Coultas, "is the soul of nature."[70] Even the mute rocks of the foreground are witnesses to the external processes of the natural world, for like the rocks in *The Heart of the Andes,* they are "tablets," where we may read "hieroglyphs" of "the myriad traces of Time, the destroyer and renewer."[71]

In *Twilight in the Wilderness,* American nature is presented as a place of vitality, flux, and change, a world with it own immutable laws. Left to its own course, nature was capable of maintaining its countless components in a state of equilibrium, but if man interfered the balance might be irrevocably destroyed. That Church so deliberately and completely purged the landscape of all traces of human presence suggests that his early faith in America's management of its own destiny had now become annealed with doubt. Indeed, unlike such earlier works as *New England Scenery* and *Mount Ktaadn, Twilight in the Wilderness* is manifestly not a purely optimistic vision of the present and future of the nation. Instead, it is a profoundly ambiguous image that mixes hope with pessimism and joy with melancholy.[72] Just as sunset mirrored the troubled mood of Melville's Captain Ahab, so did Church's *Twilight in the Wilderness* reflect the mood of era that saw its creation. And perhaps no other period in the nineteenth century was so indelibly marked by complex national issues, mounting turmoil, and increasing doubt about the destiny of the American nation. The possibility of being damned in the midst of Paradise was, for many, all too real.

*Twilight in the Wilderness* may be seen to address many of the key issues facing the American nation at the close of the 1850s. Most direct is its assertion of the positive values of untouched nature, a plea for preservation of the wilderness. By the mid-1850s, as discussed previously, many Americans were aware of the need of balancing progress and nature. American civilization had, in George P. Marsh's terms, finally reached the "more advanced state of culture [when] conservative influences make themselves felt."[73] In 1858, after some ten years of planning, construction was at last begun on New York's Central Park. Although it was obviously not a wilderness, Central Park was the first important urban preserve in America, and its construction signaled a major direction in public opinion. As the chief engineer of the park wrote:

Public opinion has, within the last few years, been awakening to a sense of the importance of wide open spaces, for air and exercise, as a necessary sanitary provision for the inhabitants of all large towns, and the extension of national enjoyment is now regarded as a great preventative of crime and vice.[74]

Essential to the idea of city parks was the belief that they allowed man access to a state of existence more in harmony with nature. This notion was supported by Humboldt, who quoted the Chinese writer Lieu-tscheu in *Cosmos:*

> What is it we seek in the pleasures of a garden? It has always been agreed that these plantations should make men amends for living at a distance from what would be their more congenial and agreeable dwelling-place, in the midst of nature, free, and unconstrained.[75]

Implicit in the recognition of the positive influences of the manmade garden was a corresponding awareness of the values of untouched nature, which represented the world as God had created it. Thus, the well-educated easterners who saw the value of urban parks also began to call for the preservation of wilderness areas as part of the national domain. Frederick Law Olmsted, the designer of Central Park, was a leader in this crusade, for in his view, the wilderness offered favorable influences on the health and intellect of mankind.[76] Seen against this background, *Twilight in the Wilderness,* in its forthright presentation of primeval nature, is an eloquent pictorial plea for wilderness preservation.

The issues raised by the painting, however, range far beyond wilderness preservation. In emphasizing the values of untouched nature and warning against the wanton destruction of wilderness areas, *Twilight in the Wilderness* reflects a strongly eastern, or, more specifically, northeastern bias. For only in the East was there widespread support of preservationist policies. Olmsted, echoing George P. Marsh's views, realized that "the power of scenery to affect men is, in a large way, proportionate to the degree of their civilization and the degree in which their taste has been cultivated."[77] If one looks at America

of the mid-nineteenth century as a practical illustration of Cole's *The Course of Empire,* the East would represent *Consummation,* but as one moved west, one regressed through *The Pastoral State* to *The Savage State.* Easterners, from the comfortable vantage point afforded by civilization, might well argue in favor of leaving the West in a kind of "savage state" eternally, but the frontier pioneer would have disagreed vehemently.

The issue was, in large measure, how to balance progress with preservation. By the 1850s it had become increasingly obvious that the nation would soon reach the physical terminus of its empire, bringing to an end the comforting belief that expansion could go on indefinitely. Population growth was accelerating at a tremendous rate; in 1776 there were only four million Americans, but by 1860 there were thirty-one million, half of whom lived west of the Appalachian mountain chain. Although Thomas Jefferson had considered the Louisiana Purchase of 1803 as sufficient to provide room for the expansion of a thousand years, it took less than fifty years to push the boundaries of America to their actual geographical limits. Indeed, American expansionism was extraordinarily aggressive during the first half of the century. The Mexican War of 1846-48 can be seen as part of the expansionist venture, as it not only settled the disputed annexation of Texas, but also secured all of California. As the American nation overran the American land, the days of unsettled, unexplored territory quickly became numbered; twilight was descending on the wilderness. The struggle for survival of the foreground trees in Church's painting thus may be seen as enacting the struggle to save some vestige of the primeval, natural American land. It was a struggle that was, as has been seen, very much a topic in Church's day and one that was potentially divisive, because it pitted the eastern intelligentsia against the expansionist settlers of the Midwest and West.

There was, of course, an even more explosive issue facing America during the 1850s that was equally bound up with the questions raised by west-

75. Frederic Edwin Church, *Our Banner in the Sky,* 1861, oil on paper, 7¹/₂ × 11¹/₄ in., New York State, Office of Parks, Recreation and Historic Preservation, Olana State Historic Site (OL.1976.29).

ward expansion: slavery. To the North it was unthinkable that slavery should expand into new territory, but to the South, increasingly aware of its own untenable economic situation, it was absolutely necessary. The West thus became an ideological battleground for the dispute between North and South.

Throughout the decade of the 1850s the conflict flared up in such events as the Kansas-Nebraska Act (1854), the Dred Scott decision (1857), the Lincoln-Douglass debates (1858), and John Brown's raid (1859), all of which captured public attention. Popular literature, most notably Harriet Beecher Stowe's *Uncle Tom's Cabin* (1852) and Hinton Rowan Helper's *The Impending Crisis* (1857), fueled the growing tension. By 1856, George Templeton Strong would

worriedly write in his diary: "This alienation of North and South is an unquestionable fact and a grave one,"[78] and by the time Church was painting *Twilight in the Wilderness* the nation had polarized into two opposing factions with no middle ground left for compromise. "The meteor of the war," as Herman Melville termed the growing tension, was plainly visible to all.[79]

Church's friend Theodore Winthrop saw very clearly the direction in which these events were leading.[80] He "talked of it constantly,—watching the news," and he and Church often discussed the political events of the day.[81] Surely the tension and ambiguity of *Twilight in the Wilderness* reflect Church's awareness of contemporary politics. Indeed, the painting, by the very fact that it is an image of North America (unlike *The Heart of the Andes,* which, although a New World landscape, was not a depiction of the American nation) certainly carries unmistakable nationalistic associations. That it does so is assured by the presence of the eagle—"that truly American bird"[82]—perched on the top of the dead tree. Furthermore, comparing *Twilight in the Wilderness* to Church's *Our Banner in the Sky* of the following year (figure 75), makes clear that the notion of portraying a celestial cloud-flag with a tree flagpole originated with the earlier work.[83] *Twilight in the Wilderness* may thus be seen as representing the nation on the eve of civil war, whereas *Our Banner in the Sky* represents the morning of the war itself. As the viewer stared into the dramatic western sky depicted in *Twilight in the Wilderness,* he beheld the kind of sight that Winthrop described, with obvious military overtones, as "a marshalling of fiery clouds."[84] And, in twilight itself, he saw what Reverend Noble called "that narrow, lonesome, neutral ground, where gloom and splendor interlock and struggle."[85] Indeed, whatever we may make of the painting today, there can be no denying that its most overwhelming effect lies in the tension it creates between the hushed, darkened landscape and the momentarily stilled sweep of blazing clouds. We are at a moment of

transition from light to darkness, seeing the end of one day and recognizing the inevitable coming of the next. Whether one faced the new day with hope or with dread was, for Church, a personal decision; there were no easy answers to the momentous questions faced by the American of 1860.

Church was deeply religious, and *Twilight in the Wilderness* resonates with spiritual significance. The presence of the rustic crucifix supports such a reading. Church frequently included crosses in his landscapes, and he undoubtedly intended for the two pieces atop the blasted stump to form a natural cross in a setting where a manmade cross would have been inappropriate. Although it might be argued that this cross was unintentional, it is located in approximately the same position as the one in *The Heart of the Andes* (about one quarter of the way in from the left side of the painting). As has been noted, Church used the foreground configurations of the great work of 1859 as guidelines when transforming *Twilight, a Sketch* (which has the stump, but not the cross) into the finished work, and he was obviously well aware of each change he made. Church's contemporaries recognized the care and thought he put into his works. As one observed of the painter:

> . . . nothing is accidental; he has meditated his thought, breathed his inspiration, lived in the spirit of his subject, so that every stroke of his pencil is guided by the unerring instinct of a faith in that which he beholds.[86]

If the cross is indeed deliberate, what role does it play in the meaning of the painting? Obviously, it is a reminder of the Christian faith and of Christ's suffering for the redemption of mankind. As a writer in *The Crayon* wrote in 1858, "If a symbol be sufficient to suggest the laws and promises of Christianity, the Cross itself is the best and most perfect . . . 'two sticks nailed crosswise' are enough."[87] More specifically, however, the cross in *Twilight in the Wilderness* serves as a reminder of faith in the depths of the wilderness. It thus may be read as a

"wilderness cross," an image that had strong cur-
rency during the first half of the nineteenth century.
Church certainly knew Cole's radiant *Cross in the
Wilderness* of 1845 (Louvre; see figure 21), which
was based on Felicia Heman's poem of the same
name. Considered by both Tuckerman and Noble to
be one of the finest of Cole's late works, *Cross in
the Wilderness* depicts an Indian chief seated at sun-
set near a cross, which, in Heman's words, "sanc-
tified the gorgeous waste around."[88] The Indian's
encounter of this potent symbol of Christianity was
a catalyst for his conversion.

A similar theme was used by Church's friend
Erastus Dow Palmer in one of his best-known early
works, *Indian Girl (The Dawn of Christianity)* of
1855. The piece is described by Tuckerman:

> An aboriginal maiden is supposed to be wandering in
> the forest in search of stray feathers to decorate her
> person, when she discovers one of the little crosses
> placed here and there in the wilderness, by the early
> missionaries, as symbols of the faith to which they en-
> deavored to convert the savage tribes. As she looks
> upon the hallowed emblem, the divine story of Jesus
> returns to her mind, and awakens emotions of awe and
> tenderness.[89]

Early missionaries had indeed spread crosses
throughout the northeastern wilderness, and not all
of them were small. According to Thoreau, "large
wooden crosses, made of oak, still sound, were
sometimes found standing in this wilderness [of the
Katahdin region] which were set up by the first
Catholic missionaries who came through the Kenne-
bec."[90] Church may well have seen such crosses
during his own travels in the interior of Maine.

Although no contemporary reviewers mentioned
the cross in *Twilight in the Wilderness* specifically,
some did comment on the painting's strongly reli-
gious character. One writer, for example, consid-
ered it an image of "Nature with folded hands,
kneeling at her evening prayer," and another noted
that it portrayed "the holiest hour of the day."[91]
The devout viewer, with hands folded at prayer,

might well be transported in his imagination to the
holiest hour of the day, the moment when heaven
and earth are in their closest communion.[92] Above
him, "in the higher heaven," to use Cole's words,
"are crimson bands interwoven with feathers of
gold, fit to be the wings of angels . . . ."[93] For the
viewer to approach nature with reverence was to be
rewarded with a spiritually purifying experience. As
Cole further observed:

> The delight such a man experiences is not merely sen-
> sual, or selfish, that passes with the occasion leaving no
> trace behind; but in gazing on the pure creations of the
> Almighty, he feels a calm religious tone steal through
> his mind, and when he has turned to mingle with his
> fellow men, the chords which have been struck in that
> sweet communion cease not to vibrate.[94]

*Twilight in the Wilderness* may thus be seen, in
part, as a call for personal devotion and meditation,
as if it were a stained glass window burning with
the intense power of divine light. Indeed, during the
same period Church was painting *Twilight,* he was
also involved with preparing designs for a window
to be erected in memory of Cole in the parish
church at Catskill.[95] That a landscape painting
could function as a devotional object was hardly a
new idea in 1860; Asher Durand's *In the Woods* of
1855 (figure 54), for example, may be seen as an
image of a forest sanctuary that openly invited the
viewer to meditate. Church's work does much the
same; the differences between the paintings are not
so much in terms of intent, but in expression. One
is an image of a small clearing in the forest as a
private devotional chapel; the other is an image of
the American wilderness as a natural cathedral.

The religious content of *Twilight in the Wilder-
ness* however, embraces more than just the benefits
of personal worship and devotion. Its most spiritu-
ally profound message concerns the notion of spiri-
tual testing, as is evident from the implications of
the title itself. Church chose the titles for his major
paintings carefully, and reviewers were highly com-
plimentary of his choice for the painting of 1860. As

the *Tribune* noted, "Mr. Church evinces almost as much invention in bestowing names upon his pictures as he does in painting them."[96] According to the *New York World*, "the very name of Mr. Church's last work is in itself a picture."[97] What was it in the phrase, "twilight in the wilderness," that struck such a responsive chord in so many viewers? Part of the answer lies in the fact that the words "in the wilderness" could evoke specific associations in the mind of any viewer who knew of the Bible's numerous accounts of trial, hardship, temptation, and divine inspiration set in the wilderness.[98]

The biblical stories of Elijah in the wilderness, Hagar and Ishmael in the wilderness, and St. John the Baptist preaching in the wilderness were well known to Americans of Church's day, and, furthermore, were frequently portrayed by American painters. Cole, for example, had painted versions of all of these subjects. But for some observers, *Twilight in the Wilderness* specifically evoked two familiar wilderness epics: the wandering of the Children of Israel in the wilderness and the temptation of Christ.[99] The former story epitomized the Old Testament image of a wilderness as a place where individuals, or entire nations, lost their way in their quest for spiritual salvation. The story of Christ's temptation in the wilderness typifies the New Testament notion of a wilderness where one might face spiritual testing, but where one could also find spiritual refreshment and renewal.

In describing *Twilight in the Wilderness,* a writer for the *Boston Evening Transcript* observed that there were "pillars of fire gleaming below the surface of the water."[100] The phrase, "pillars of fire," evokes the general language of revelation:

> And I saw another mighty angel come down from heaven, clothed with a cloud: and a rainbow was upon his head and his face was as it were the sun, and his feet as pillars of fire. (Revelation 10:1)

More specifically, the phrase brings to mind the story of the wanderings of the Children of Israel

after the Egyptian captivity:

> And the Lord went before them by day in a pillar of cloud, to lead them the way; and by night in a pillar of fire to give the light. (Exodus 13:21)

> Yet thou in thy manifold mercies forsookest them not in the wilderness: the pillar of cloud departed not from them by day, to lead them in the way, neither the pillar of fire by night, to show them the light, and the way wherein they should go. (Nehemiah 9:19)

Although one must stop short of saying that Church explicitly intended to portray the "pillars of fire," it is nevertheless significant that one of his contemporaries would see them in his painting. Church would not have objected to such a reading. He was a devout man and was, of course, quite used to Reverend Noble's constant reading of biblical lessons in the natural world. Moreover, Church himself would seek out some of the areas believed to have been traveled by the Children of Israel while on his way to Petra in 1868.[101]

If *Twilight in the Wilderness* may be seen to evoke the story of the Israelites wandering in the wilderness, might not a parallel be drawn with the American nation of 1860? After all, it was plain to Church, Winthrop, and many others that the country was losing its way and about to enter a period of uncertainty and doubt. If war did come, as Church believed it must, he may have been saying through his painting that the only hope for survival and redemption was through trust in God, who would not forsake the just. America was about to undergo a violent schism and enter a period of wandering in the wilderness of war. In earlier paintings such as *Moses Viewing the Promised Land* (figure 7) and *Hooker and Company* (colorplate 1), Church had expressed an abiding faith in the attainability of the Promised Land, but in *Twilight in the Wilderness* that unquestioning belief in American destiny was no longer evident.

In the trial that faced the nation was a potential test for each citizen. Each American was, even if only for a moment, alone in a wilderness of doubt

and uncertainty. Christ too had faced such a test, and one reviewer of *Twilight in the Wilderness* mentioned that story specifically:

> Solitude reigns over the scene, and as the eye ever turns from the wilderness below to gaze upon the brilliant canopy of the sky, the imagination whispers that he who was once "led up of the spirit into the wilderness to be tempted," must often at the twilight hour have turned his gaze from the gloom and loneliness of the forest to the brightness and beauty of those heavens which to his vision of faith were ever opened, revealing the "Father of Lights."[102]

Once again, *Twilight in the Wilderness* may be seen as a call to belief and trust in God in times of stress. Whether through its presentation of a wilderness cross, its evocation of the wanderings of the Children of Israel and the temptation of Christ, or its "angelic" chorus of clouds, the painting resonates with profound religious sentiment.

That *Twilight in the Wilderness* could be such a complex construction with a variety of meanings embracing science, the national identity, and religious sentiment is fully consonant with Church's intentions as evident in other major works such as *The Heart of the Andes*. As has been shown, the latter encouraged reading on many levels, as did *Icebergs* of 1861. The close association of *Twilight in the Wilderness* with those two great paintings shows that it equally deserves similar interpretation.

Not everyone who saw the painting would have sensed its every meaning, nor would Church have necessarily expected that they would. And, bearing in mind the difference between deliberate meaning and general implication, we cannot be certain that Church himself intended every meaning that the painting seems to offer. But that, of course, is not the point. In creating this powerful image of American nature, Church had addressed his art to the very soul of the national consciousness. He had brought before his public a single, heroic summation of the North American landscape, and had done so at a crucial moment when Americans were, more than ever before, questioning and doubting the very foundations of the country. *Twilight in the Wilderness* brought full expression to Church's vision of the national landscape, but it did so at the last moment that those ideas could be articulated using the artistic vocabulary he had so brilliantly mastered. With the rending of the nation by Civil War came the dissolution of much of what Church's art stood for, and with that dissolution came the end of his use of the American landscape as a valid and vital means for expressing unassailable truths about the nation.

# Chapter 7 · The Waning of the National Landscape

Landscape art disappears year by year from our exhibitions. It was fondly imagined once that we had, or were likely to have, a school of landscape; but, although our best landscape painters scarcely ever exhibit, and although the exhibitions are fast losing all claim to represent the art of the time, still they are to be believed when they indicate a failing interest in landscape subjects among the painters. For the fact is easily ascertainable that the public takes no interest whatever in landscape.
"Fine Arts," *The Nation,* 1869

Gradually, we are becoming aware how imperfect the old representative symbolical Art is,—how insufficiently it exercises the senses.
"Bearings of Modern Science on Art," *Littel's Living Age,* 1871

Following the completion of *Twilight in the Wilderness* Church turned his attention to *The Icebergs,* which went on public view April 24, 1861.[1] His only offering to the National Academy that year was the small *Star in the East* (1860–61, Olana), an evocative work praised "for the brilliancy of the star and the illustration of his singular mastery of light."[2] *The Star in the East* is distilled from the right-hand side of Cole's *The Angel Appearing to the Shepherds* of 1833–34 (Chrysler Museum, Norfolk, Virginia) and indicates Church's continuing fascination with the art of his master.[3] The glowing star in the cool evening sky becomes a radiant cross of light hovering above a landscape of gentle hills dotted with a few palm trees. Although obviously not a representation of North America, or, in fact, derived from any specific place Church had actually visited, *The Star in the East* does reveal the deeply poetic and spiritual associations Church was still capable of expressing through landscape. Following closely the more turbulent and unresolved spiritual drama of *Twilight in the Wilderness,* this small painting may well represent a personal affirmation on Church's part of his own faith and his belief in the possibility for redemption of the American nation.

Church's sentiments during the Civil War were, of course, firmly with the North, and he addressed some of his work to supporting the Union cause. Exhibition fees from the public showings of *The Icebergs*—to which Church had added the subtitle, "The North"—were donated to the Patriotic Fund, a charity that supported the dependents of Union soldiers.[4] *Our Banner in the Sky* (figure 75) was even more obviously related to the war, and some of the proceeds from the sale of a popular chromolithograph after it were also allocated to the war effort.[5] *Our Banner* was considered "a clever and successful piece of symbolical landscape," and the print based on it was one of the most popular of the day.[6] This small, rapidly executed painting, although not one of Church's most compelling visions

76.  Frederic Edwin Church, *Coast Scene, Mount Desert,*
1863, oil on canvas, 36¹/₈ × 48 in., Wadsworth Athe-
neum, Hartford, Connecticut, bequest of Clara Hinton
Gould (1948.178).

of the national landscape, was certainly one of his most sincerely felt, and it expressed its meaning with obvious clarity.

Although Church continued to paint large-scale works during the years of the Civil War, his activities were necessarily diminished. The year 1862 saw the creation and exhibition of two major works, *Cotopaxi* (Detroit Institute of Arts) and *Under Niagara* (unlocated, but known through a contemporary chromolithograph), his second full-scale treatment of the falls. However, it was not until the following year, with the impressive *Coast Scene, Mount Desert* (figure 76), that he once again turned his attention in a major painting to the depiction of North American scenery. Although generally well received by New York critics, the painting was not judged an unqualified success, with some critics complaining about its effects of color. Other observers increasingly found fault with Church's predilection for careful detail, a trait that had, only a few years before, generally been considered a positive part of his art: "Mr. Church has been accused, and not altogether without reason, of crushing himself beneath his subject. He has, that is to say, often sacrificed general effect to a multiplicity and elaboration of detail."[7]

Although critical reprobation concerning his insistent detail had followed Church off and on since the earliest days of his career, it now became increasingly common. Indeed, it became a subject of debate among American connoisseurs as to whether or not precise and realistic detail was even desirable in landscape painting. Although this issue was a topic of discussion in New York art circles, it found perhaps its most interested audience in Boston. Church's *Under Niagara*, while on exhibit in that city in the spring of 1863, inspired an impassioned series of letters to the *Boston Evening Transcript*, letters that questioned the very nature of realism and its role in contemporary art.[8] In the last of these letters, a pseudonymous "Aristotle" closed by "counselling composure of mind, and preparation for the advent of a mystical, antinatural school of art."[9]

Recognizing that while Church's *Under Niagara* was on view in Boston, so also was George Inness's major painting *The Sign of Promise* (destroyed when the artist painted *Peace and Plenty* [figure 77] over it in 1865), "Aristotle's" prediction takes on a ring of truth. Inness, a year older than Church, had been less well known and less successful in New York and elsewhere during the 1850s, the years of Church's greatest fame. Independently pursuing his own artistic program, Inness had continually looked to Europe and European art while Church was making a triumph from the American artistic tradition. Early in Inness's career his art had showed too much reliance on the art of the Old Masters to suit critics under the sway of Ruskinian aesthetics. By the early 1850s, however, he had come under the spell of such contemporary European masters as Théodore Rousseau and was creating powerful works that depended not on precise and detailed

77. George Inness, *Peace and Plenty*, 1865, oil on canvas, 77⅝ × 112⅜ in., Metropolitan Museum of Art, New York, gift of George A. Hearn, 1894 (94.27).

realism, but on a highly expressive manipulation of form and light.

*Peace and Plenty* was an unusually large work for Inness, and its size may well have been inspired by Church's success with grandly scaled paintings. More importantly, like *Twilight in the Wilderness,* it was an overtly and obviously national image, recognized as such by the artist's contemporaries. *Twilight in the Wilderness* and *Peace and Plenty* not only exactly bracketed the years of the Civil War, but also marked the waning of one style of landscape and the rise of another. In celebrating the end of the war, Inness painted a subjective and subtly spiritual view of nature in a style that completely eschewed the kind of detailed realism exemplified by Church's art. Furthermore, Inness not only employed a new aesthetic language that was more cosmopolitan and more internationally up-to-date; he also expressed his meaning through greater recourse to the imagination. He quickly came to seen as a "modern" artist in post-Civil War America, someone to be championed by critics and connoisseurs who had grown disenchanted with the insular, nationalistic character of earlier artists. The old landscape art that had taken for its foundation the ideals and beliefs of the nation in more innocent days no longer had full validity in a land that had violently changed. Something more meditative and more evocative was needed, and Inness was the artist who found it. As James Jackson Jarves, who saw Inness in distinct contrast to Church, wrote in 1864:

> Inness is a representative man of an altogether different aspect. He influences art strongly in its imaginative qualities and feeling; impersonating in his compositions his own mental conditions, at times with a poetical fervor and depth of thought that rises to the height of genius.[10]

Within a very few years Inness was enjoying the kind of critical praise and encouragement that had once been almost exclusively reserved for Church.

This is not to say that Church and his art fell out of favor overnight, but the tide, nevertheless, had turned. We can only guess whether or not Church himself sensed it immediately, but he did increasingly remove himself from the day-to-day activities of the New York art world. He was more and more drawn into the work of preparing his estate at Olana and raising his family (his first child was born in 1862). Financially secure from his artistic successes and his shrewd handling of investments, Church was free to occupy himself as he chose.

Although a detailed consideration of Church's depictions of the North American scene in the later 1860s and the 1870s lies outside the scope of this study, a few observations on this body of work may nonetheless shed light on his earlier achievements. For, whatever one makes of Church's late works in general—and some of them, such as *Morning in the Tropics* (1877, National Gallery of Art), are very great indeed—the inescapable conclusion is that his North American landscapes after 1860 lack the intense conviction and spirit of invention that had earlier characterized his art. A painting such as *Mount Desert Island, Maine* (figure 78), despite certain merits, is ultimately an unconvincing recapitulation of a theme that Church had treated so many times before.[11] The sky is marked by a turgid formlessness, as opposed to the turbulent, but carefully structured sky of *Twilight in the Wilderness.* If this painting was Church's optimistic response to the end of the war,[12] it failed to resonate with the profound implications of his masterpiece of five years earlier, or, for that matter, of Inness's *Peace and Plenty.* Indeed, one detail even borders on the maudlin; at the right-hand side of the painting, a deer ventures forth into the central clearing, a timid creature ready now to reenter a world once again at peace.

Increasingly, Church's interest in the North American landscape became deeply personal. With the acquisition of his spectacular property on the Hudson, and later of a wilderness camp on Lake Millinocket near Mount Katahdin, he came to know the pleasures of possessing his own portion of the New World. As he said to his longtime friend

78. Frederic Edwin Church, *Mount Desert Island,
Maine,* 1865, oil on canvas, 31$^{1}/_{4}$ × 48$^{1}/_{2}$ in., Washington
University Gallery of Art, Saint Louis, gift of Charles
Parsons.

Erastus Dow Palmer: "About an hour this side of Albany is the Center of the World—I own it."[13] His favorite subject now became the view from his own land, and he sketched, on a daily basis and through the seasons, the panoramas of sky and land that lay before him. With the high vantage point of Olana, it was almost as if Church had taken physical possession of the floating viewpoint prevalent in such major works as *The Heart of the Andes* and *Twilight in the Wilderness*. Yet, whereas the pictorial vantage point of those great works provided the spot from which he could unfold, in paint, a composite image of the world, at Olana he saw the same small portion of the world again and again, but each day he saw it revealed anew, in different lights, with different clouds, and in different weather, the same, but not the same. Compiling, over the years, dozens upon dozens of oil sketches from Olana, he documented some thirty years in the history of a place he knew and loved.

Church's late oil sketches are, without question, splendid achievements in every sense, the personal creations of an artist whose vision remained undimmed, even if it had become outmoded, until the end of his life. Still, in retrospect, it is the sequence of North American images—the national landscapes—he painted during the first decade and a half of his career that stand as his most eloquent and powerful statement on his native land. These paintings formed a compelling investigation of key aspects of national identity through the means of landscape.

In *Hooker and Company* Church celebrated American history through portraying one of the past's great events and one that held positive and vital meaning for the present of 1846. With *West Rock* Church was able to fuse the elemental lessons of the historic past with the beauty and potential of the America of his era. Then, in *New England Scenery,* Church achieved what no other American artist before him had been able to do: he made the contemporary realities of American nature and American life into the elements of an exalted history and painted them in a modern American equivalent of a history painting.

Fully confident of the sanctity and promise of American potential, he expanded the vision present in *New England Scenery* to the borders of the frontier in *Home by the Lake* in 1852 and into the promise of the future with his *Mount Ktaadn* of the following year. In these early works Church saw, and interpreted, the North American landscape through the organizing framework of his own conception of the North American nation. In other words, when Church looked at American nature, he saw in it a confirmation of the destiny of the American people. Thus, *New England Scenery* is not an image of the land precisely as God made it, but of what Americans had done with the raw material of God's creation.

Given this early tendency to see nature as the reflection of national identity, Church's shift to portraying the untouched wilderness after the mid-1850s represents a profound change of direction. Indeed, the primeval wilderness, as seen in *Sunset* of 1856, was the polar opposite of the carefully constructed image of nature in *New England Scenery.* Church now looked to American nature itself as the embodiment of the fundamental strength of the American nation. Like others of his generation, he realized that the greatness of America was as much the result of being given the unparalleled opportunity of exploiting the land's natural bounty as it was the result of any inherent virtue on the part of the American people. If Americans were losing touch with nature and were guilty of its wasteful destruction, they were on a perilous course indeed.

In *Twilight in the Wilderness,* Church expressed these concerns, and others of even greater import, with an intensity and heroic force that simply had no equal in the works of his contemporaries. Comparing the painting to that other great *summa* of American nature painted the same year, Jasper Cropsey's *Autumn—on the Hudson River* (figure 79), makes this evident. Cropsey's painting was an unequivocal and optimistic celebration of American

79. Jasper Francis Cropsey, *Autumn—on the Hudson River,* 1860, oil on canvas, 60 × 108 in., National Gallery of Art, Washington D.C., gift of the Avalon Foundation (1963.9.1).

nature and American civilization painted by an artist who was far removed from the reality of the American nation in 1860 (Cropsey was in London at the time, and had been for several years). With its progression from the wild scenery of the foreground, to a pastoral middle zone, complete with resting hunters, a rustic cabin, and grazing animals, to a landscape punctuated with the achievements of civilization, *Autumn—on the Hudson River* reads as an American version of Cole's *The Course of Empire,* but with the last two scenes omitted. Looking at this splendid landscape one would have had no hint of the turmoil and trouble that lay ahead. But Church's work used autumnal imagery to different, more profoundly ambiguous and challenging ends. *Twilight in the Wilderness* equally celebrated the beauty of American nature, but did so to establish a foundation upon which to present some of the most pressing and important issues facing the American nation in 1860.

In the final analysis, *Twilight in the Wilderness* stands as Church's single greatest North American landscape, for in its complex imagery and richness of meaning, it surpasses even the powerful *Niagara* of 1857. It is, then, the true coda to the series of paintings that began with the youthful *Hooker and Company* of 1846. In the brief span of fourteen years, Frederic Church had said, with unrivaled eloquence and power, all he had to say about the national landscape.

# *Appendix* • Twilight in the Wilderness: *Selected Reviews and Notices*

1. Z., "Letter from New York," *Boston Evening Transcript,* 5 June 1860, p. 1.

Church has put the finishing touch to the beautiful and effective landscape we have before mentioned. It will take rank with his best works. It is a happy composition from its simplicity and the peculiar American characteristics it embodies and illustrates. No lover of nature on this continent, no one who has bivouacked in the Adirondacks, explored the hills of New Hampshire or the forests of Maine, will but imagine that he has beheld the very scene. A lake with a range of hills around and a foreground of picturesque cedars, is bathed by the warm reflection of crimson flakes in the sunset-sky; while the horizon is bathed with pale gold verging to opal—a combination of crystaline and glow, of solitude and serenity, of wildness and beauty, such as atmosphere, water, firmament and vegetation only so combine to produce in America, at that season when summer is melting into autumn. As an American sky landscape this 'Twilight in the Wilderness' of Church is as true to nature and as skillfully executed as his 'Heart of the Andes'; less than half the size of that elaborate work, it derives fresh interest from the strong contrast it presents to the tropical beauty of its predecessor. It is hoped that the gentleman for whom it was executed will allow it to be exhibited here and in your city, in order to gratify the lovers of art.[1]

2. "Art Matters; Mr. Church's New Picture, Twilight in the Wilderness," *New York Morning Express,* 7 June 1860, p. 2.

Yesterday a new picture by the artist who has already acquired so enviable a fame as the painter of 'Niagara' and the 'Heart of the Andes,' was exhibited privately to a few hundred people at the Goupil gallery. The painter in this recent work has entered upon a new field; he has not essayed to cope with Nature in her grander aspects, to represent a mighty cataract or a stupendous mountain scene, but is content to portray the peculiarities of 'Twilight in the Wilderness.' His canvas shows a broad calm river almost shut in by sloping hills; tall trees in the foreground stretch out their arms and interlace each other's boughs, and further off the horizon is bounded by purple mountain tops relieved against a sky of yellow; the rich crimson of the higher clouds appears to be rapidly fading into somberer tints, and yet is not so far vanished but that it is reflected in the placid waters, and gleans along the rock and riverside, suffusing all with a peculiar radi-

ance. The view is not at all a remarkable one; the hills are not precipitous, the landscape is not rugged, or extended or uncommonly romantic; the water is not turgid or tumbling; not a house or a human being is visible [—] simply a quiet woodland picture, for which the hills of Maine or any other highland country could furnish many a parallel. This simplicity is so great as almost to induce one to suppose the subject not a composition, but a reminiscence lingering on the artist's fancy of some spot where he has loved to loiter long. The phase under which the landscape is painted is also not uncommon; other painters have painted wildernesses, and painted them at twilight; but the novelty consists in the peculiar color and glow of the crimson clouds. Attentive students of nature have certainly noticed the effect which the artist has chosen, but it is by no means an ordinary one. The twilight sky has so far advanced, that the grey of evening is struggling with the brilliant radiance that yet streams into the upper sky, and it is reflected from that back on glittering rock and shrub and tree.

The composition of the work is admirable; its unity remarkable; not an object is obtruded which can mar the effect or interfere with the perfect harmony of the whole; the elaborate detail of the foreground, the charming middle distance and the exquisite effect of the far off hills and sky, all contribute to this unity, all are in keeping. The detail is remarkable as in all of Church's pictures, and, as usual, is made to add to the general effect, instead of disturbing it, as such elaboration in unskilled hands could not fail; the harmony of color and tone is also wonderful; the light and shade are exquisitely disposed; and, if the perspective is not so wonderful as in some works by this artist, it is because the picture does not call for any display of his powers in this regard. However, these technical merits are not those that challenge the liveliest admiration. What provokes comment most is the charming manner in which Church has contrived to suggest the melancholy, but pleasing influence of a twilight in the wilderness; the sombreness, the quiet, the loneliness, the singular brilliancy of color here and there contrasting with the general and apparently deepening gloom. All these are conveyed with a subtle feeling that is full of power; they are so expressed as only a susceptible nature could have perceived them, and only a great artist could have conveyed them. These constitute the great success of the picture. They are, indeed, only the results of the technical merits. Mr. Church belongs to that class of artists who possess exquisite sentiment and immense ability, but who work consciously; who know what their aim is, and who school their efforts to produce that aim, and who seldom, if ever, fail to produce it. It is singular that Church has so often succeeded, whether attempting to put upon canvas the most magnificent of nature's wonders, or the most splendid of her varied beauties, or to employ simply one exquisite note in the great concert of harmonious thoughts she is ever uttering, this fortunate man seems equally fortunate. To very few is such ability accorded.[2]

3. "Mr. Church's Last Picture," *The New-York Times*, 7 June 1860, p. 4.

Whether the rule holds true in Art, that 'evil communications corrupt good manners,' we shall be able, perhaps, next year to decide, when the few artists, who, having any manner of their own, have exposed that manner to the contagion of this year's Academy exhibition, shall once more come before us with a twelve-month's work. Mr. Church wisely evaded the trial;—how wisely, his latest picture, yesterday privately exhibited to a discerning few at Goupil's rooms in Broadway, may satisfy the observer. This painting is as little like the 'Heart of the Andes,' as twilight is like morning and North like South. Yet, the veriest tyro in connoisseurship could not hesitate a moment as to authorship, were he to stumble on it in the palace of some Hyperborean Prince. This is one of Mr. Church's permanently great qualities,—that his pencil is his own, and speaks his own language in his own way. You can no more mistake Mr. Church's treatment of sunlight, in whatever phase, than Lord Byron's allusions to the sea.

But fine as this quality is, it is only one of the qualities that go to the making up of a painter; and Mr. Church's 'Twilight' bears witness to a much larger circle of gifts.

The picture, to borrow the language of a sister art, may be described as a composition upon a theme drawn from Northern New-England. Those who know the rivers of Maine, know how peculiar their deeply-channeled beauty is—their massive banks, pine-clothed and steep, lending them a special solemnity of character. The Kennebec, for example, through much of its course, is a very river of twilight, hardly less imposing than the Saguenay itself. Mr. Church has given us—or rather he has given Mr. Walters, of Baltimore, who kindly allows us to share for awhile his ownership of this new picture—a most true

and touching version of this Northern river life, flowing silently and grandly on under a gorgeous twilight sky. The same astonishing powers of perspective, which did such wonders in the 'Heart of the Andes,' reappears in the 'Twilight,' lifting the visible heavens high overhead, and leading the eye through miles of luminous atmosphere to a horizon quivering with light, and alive with that 'peculiar tint of yellow-green' whereof Coleridge discourses in such sweetly philosophic fashion.[3] The treatment of the atmosphere in this picture is one of Mr. Church's finest triumphs, and confirms afresh his title to the primacy he has reached in our native art.

4. "Fine Arts," *The New York Herald,* 8 June 1860, p. 10.

The new picture upon which Mr. Church has been engaged for several months past, is at present on exhibition at Goupil's gallery in Broadway. It is entitled 'Twilight in the Wilderness,' and is the property of Mr. Walters, of Baltimore, for whom it was painted. Although a composition, it embodies studies made in the wilds and pine forests of Maine, and gives a perfect idea of the general characteristics of that region. The sun is just setting below the horizon, and the eye is carried in a long stretch of perspective over the waters of a noble stream, whose calm surface reflects the gathering shadows of evening and some of those gorgeous effects of twilight which are only to be seen in a Northern climate, and there but rarely. As a study it is magnificent, and it could only be treated by an artist who, like Mr. Church, has a perfect mastery over light and shade. A weaker pencil would have converted into an exaggeration an effect which, though startling and uncommon, is, nevertheless, as true to nature as any of the atmospheric changes to which we are accustomed. The objects in the foreground are painted with the same minute fidelity to details which distinguish the Heart of the Andes, the character of the flora being distinctly shown, although the tone of the picture is necessarily sombre. Viewing the difficulties of the subject, this work will be more highly esteemed than almost any of Mr. Church's previous efforts. It confirms what we have always maintained, that his creative power is but little, if at all, inferior to his wonderful powers of reproduction and imitation.

5. "Fine Arts," *The Albion,* 9 June 1860, p. 273.

Mr. Church has finished yet another landscape of some importance, which is now exhibiting at Goupil's rooms in Broadway on the corner of Ninth Street. The new picture is very appropriately called *Twilight in the Wilderness.* We look up a valley in a wild and mountainous country, down which flows a broad and placid stream. There are high hills on either side, and the horizon is bounded by a mountain range which runs directly across the course of the little river. The time is about ten minutes after the disappearance of the sun behind the hill-tops. The air is clear and cool; the whole landscape below the horizon lies in transparent shadow; but the heavens are a-blaze. A-blaze, except a luminous belt stretching round the horizon of gradually varying tint, which passes from silvery white to the faintest blue to the tenderest apple-green, and into which the distant mountains thrust their broad, rich purple wedges. From this clear zone of tender light the clouds sweep up in flaming arcs, broadening and breaking toward the zenith, where they fret the deep azure with dark golden glory. The pines here and there show their sharp black points against the sky; the stream gives back a softened, vague reflection of the splendour which glows above it; the stillness of twilight and the solemnity of undisturbed primeval nature brood upon the scene; and that is all the picture. It is not one of Mr. Church's largest works; but one of his very best. As a faithful transcript from Nature in one of her loveliest and richest manifestations, and as an exhibition of mastery over the resources of the palette, we do not know its superior. The unity and simplicity of the effect is very remarkable. We hear that it is the last work of Mr. Church's that the public will have an opportunity of seeing before he completes his great iceberg picture.

6. "Mr. Church's New Painting," *Morning Courier and New-York Enquirer,* 9 June 1860, p. 2.

There is now on exhibition, at the Gallery over Goupils and Co.'s, a new picture by Church. It is entitled 'Twilight in the Wilderness,' and it will be regarded as one of his best efforts. It is admirable in every respect, and the lights and shades surpass those of any painting he has yet exhibited. The peculiar state of the atmosphere surrounding the mountains is such as is often seen, but most difficult to represent on canvas; while the reflection upon the mountain and the lake of the color imparted to the clouds by the setting sun is a triumph of color.[4]

7. "Art Items," *The New-York Tribune,* 9 June 1860, p. 5.

Mr. Church evinces almost as much invention in be-

stowing names upon his pictures as he does in painting them. 'Twilight in the Wilderness,' the title of his new landscape, is almost as good a name as 'The Heart of the Andes;' and there are many who think the new picture is the better of the two. It has, without doubt, more poetical feeling and unity of design, and, in certain parts, has never been excelled by any of his previous performances. Now that he has finished this picture, he will probably go to work upon his studies of Icebergs, which he brought from Newfoundland last year, and give us a composition of Ocean grandeurs worthy of companionship with his Niagara, his Heart of the Andes, and his Twilight in the Wilderness.

8. "Twilight in the Wilderness," *The New-York Tribune,* 13 June 1860, p. 6.

A new picture by Church, called 'Twilight in the Wilderness,' is at Goupil's gallery, and will remain there for a few days on exhibition. It can hardly fail to attract attention for its intrinsic qualities, as well as because it is the work of an artist so well known, and who has so many enthusiastic admirers.

The first feeling excited by looking at this last picture of Mr. Church['s] is wonder, and that, we are inclined to think, is the sensation with which the spectator is always at first filled when standing before any of his works. He is in possession of so subtle a secret of color, holds at his command so wonderful a power of dexterous manipulation, and has so fine a sense of effectiveness of composition, that the senses are taken captive by a combination so marvelous and so overwhelming. As one comes into the presence of this 'Twilight,' he is filled to overflowing with the flood of rich light, intense in purity, in truth, and in tint. The memory of the glories of a radiant sunset, the sight we all look upon so many hundreds of times, and always with renewed delight, flashes out from these clouds torn by the winds, this tender purple haze of the distant mountains, the exquisite azure of the far-off sky, and the splendor of this golden glow, which the departing sun has poured out upon the world where the darkness covers it. It is in this power of observing nature that Mr. Church is unexcelled. It is hardly possible to come before one of his pictures without being dazzled by its brilliancy, even as we are filled with rapture in going from the subdued shadows of our own parlors into the wonders of some gorgeous twilight.

But perhaps it is this very quality in Mr. Church's

works that renders one more critical rather than less so the more they are studied. We do not like to have our judgement taken captive by the senses; and it may be, when we recover full possession of the former, we distrust the first impressions received through the latter more than they deserve. But while guarding ourselves against this natural tendency, our own second, and, it seems to us, sober thought, is that the very brilliancy of Mr. Church's pictures is, in one sense, their fault. He trusts to and is so perfectly sure of the effect which he means to produce, and which comes as the positive result of conscious talent, that there is—perhaps modesty should rather prompt us to say, seems to be—a want of conscience in those details of the work on which he does not rely for effect. And even in those parts on which the effect depends the end is gained by a cunning force of hand and accurate knowledge of means to be used, rather than by that subtle power of genius which, finding inspiration and help not alone in outward things, appeals even with new and irresistible force, not to the eyes merely or chiefly, but through them to an altogether inner sense, and revealing new and different meanings according to the measure of the growth from which it sprang. This appeal we fail to find in Mr. Church's works; and though struck at first by their wonderful power in execution and knowledge, that first impression fades away, and leaves us with a feeling of unsatisfaction at a creation in which we see marvelous power of a human hand, rather than recognize a mysterious work of genius which so long as it exists has new revelations to make for every human beholder. And when tempted, therefore, to analysis, as one always is by anything that partakes in any degree of mechanism, we see, or think we see, faults in execution, which, indeed, are covered up by general effects, but which, nevertheless, when seen, greatly diminish the character of the work as a mere work of art. There are some such faults, we think, even in 'The Twilight.'

9. "Twilight in the Wilderness," *New York World,* 20 June 1860, p. 5.

The very name of Mr. Church's last work is in itself a picture. To the lively imagination it suggests at once a scene of vast and dimly-outlined beauty, but a beauty so vague and evanescent as to make its successful exhibition upon canvas seem quite impossible. But Mr. Church likes to undertake the impossible; and he is quite right, for he so acquits himself as fully to justify his liking.[5]

. . . The new picture is remarkable for its unity of impression, and for its exhibition of a subtle perception and firm grasp of the most delicate and evanescent effects of color, and of light and shadow. The scene is a type of many that may be found in our hill country. High, craggy, hemlock-covered hills are upon each side; a small river flows between them; and along the horizon stretches a mountain range whose distant day-blue is glowing into purple under the light reflected from flurried clouds all glowing in the rays of the unseen sun. Except these clouds and the sky upon whose cool blue they burn, the whole landscape lies in the clear shadow of early twilight. Whoever has often looked upon such scenes, and has been penetrated to his inmost soul with their sweet and solemn beauty, knows just the glory and the tender charm that are united in this picture. As for criticizing its composition or its manipulation, we should just as soon think of parsing 'Hamlet.'

'Twilight in the Wilderness,' by its unity and its embodiment of the subtlest expression of beauty that can come from inanimate nature, as well as by its marvelous, miraculous power and delicacy of color, establishes the supremacy of its painter in his department of the art. He has attained the distinction—the rarest distinction—of being a painter without a manner, almost without a style. His pictures are not tinged with his own personality. He paints, not nature according to Mr. Church, but simply nature. His eye, like every other man's, is a camera with a brain behind it; but his brain gives him the power to transfer to canvas the vanishing forms and tints and shadows thrown upon his eye, unaffected by the medium through which they have passed, except by selection, combination, and unification. It is to this absence of any signs of mood or manner in his works that we attribute the charge of a deficiency of feeling which is sometimes brought against him.[6]

10. W. G. D., "Mr. Church's Picture, 'Twilight in the Wilderness'," *The Evening Post* (New York), 21 June 1860, unpaginated.

Around this soft, though lovely scene,
Twilight breathes thoughtfulness serene.
It is the holiest hour of the day.
Then hearts are touched by every ray
Which welcome dearer, surer wins,
Than joy's high noon of glaring light,
Or flaming morn when youth begins

To gaze with hope's entrancing sight.
The pictures saddens yet inspires
Eve's pensive tears, the glowing fires
Reflected from the hidden sun
Have here comingled victory won,
Which the subdued, calm spirit owns,
While to its ear revealing tones,
Seem all the sky, the river still,
The purple hills, the air to fill;
And Memory, startled in her bower,
Obeys the music of the hour.
Happy the skill which thus can make
Colors, like tones, the heart awake.
Not hues of gold and emerald blended,
Where sky to earth has softly bowed,
With deep, empurpled haze attended,
Not the bright bars of crimson cloud,
That cross the highest sky, and shine
As if with their own light, combine
With wavings hills and leaves that glow
Each like a trembling, glancing star;
And waters that in silence flow,
And gleam through deepening shades afar;
Not all these hues, and light, and shade,
With which the landscape is arrayed,
Combine so deeply to impress
The soul with Nature's loneliness.
And splendor, as they prove the power,
To give to thought her genial dower,
And to sincere emotion sway;
For, this soft close of beauteous day,
Though in the distant wilderness,
Which human footsteps seldom press,
Where there is no sign of human life
Or human care or human strife,
Is full of gentlest sympathy,
And glows with sweet humanity.
It speaks and sings, and breathes of love,
Which earth like heavenly vesture wears,
The priceless gift of skies above;
And every heart that gift which shares,
With nature gleaming in the smiles
Of the sun's radiance, as he springs,
Or reigns at noon-day, or beguiles
With plaintive light his setting brings,
Shall feel the tenderness conveyed
By brightness softening thus to shade,

And shall derive a blessing fair
From every ray that glances there.
Though sadness by the undertone
From this sweet harp of colors thrown,
Yet gladness strikes, in turn, the chords,
And tempered joyfulness affords
The kind transitions, gentle changes
Of feelings sombre, cheerful ranges,
When smiles and tears, in harmony,
Obey alternate melody.
This benison the picture shows,
While parting day in beauty glows,
That memory has a force divine,
To make life's somber scenes to shine
With light whose blended rays shall give
Power in the joyful past to live,
And that hope, also, can bestow
A grace fulfillment cannot know.
So, 'Twilight in the Wilderness'
Shall on the heart the lesson press
Of patience, glorifying sorrow,
And waiting for a blissful morrow.

11. "Art Items," *The Evening Post* (New York), 22 June 1860, unpaginated.

Church's beautiful picture, called 'Twilight in the Wilderness,' is still on exhibition at the rooms over Goupil's store. It represents a glorious sunrise [*sic*] among the hills of New England. The sky and middle distance are painted in the happiest manner of this eminent artist. There is something of stiffness and mechanism, perhaps, in the foreground, but as a whole the work is admirable, and gives more pleasure even than the 'Heart of the Andes.'

12. "Twilight in the Wilderness," *Boston Evening Transcript,* 28 June 1860, p. 2.

From a private letter we clip the following description of Church's new picture:

While in New York I saw Church's new picture 'Twilight in the Wilderness,'—an exquisite creation, so I thought—full of quiet beauty. It does not impress you so vividly as 'The Heart of the Andes,' nor awaken emotions so new and delicious. The latter is the only landscape painting that has ever completely satisfied me,—but, I suppose this was partly owing to the magnificent beauty of the scene, aside from the wonderful execution of the artist. The Heart of the Andes inspires you with great and

noble thoughts; the Twilight in the Wilderness disposes you to dreamy and contemplative ones; it is 'Nature with folded hands, kneeling at her evening prayer.' But I must try to describe to you the picture. The first thing you notice is the soft, floating, red sinus [*sic*] clouds, through which the blue sky seems very far away. A clear band of light stretches across the horizon, and below are [*sic*] a low line of purple hills; at their feet nestles a lake, so very small, that were it not for its rosy reflection you would scarcely perceive it. All this is in the distance. Then you have a larger lake, encircled by hills, upon whose summits every tree stands out in living distinctness. This lake has a soft purple hue, save in spots of rosy light, pillars of fire gleaming below the surface of the water. In the foreground the light strikes over old trees, and fragments of rocks, upon which the moss has just begun to grow; the water, too, has that peculiar green tint, where buds and leaves have tinged it. You know the beauty of his perspective and so can imagine the clear distinctness of every leaf and root. It is perfect repose. The only sign of life is a bird perched on the topmost branch of a tree in the foreground; but he has settled his wings for the night, and one feels there is no rustling of leaf even to disturb the silence.

13. [George William Curtis], "The Lounger; Church's New Picture," *Harper's Weekly,* 14 July 1860, p. 435.

Mr. Church has just completed another picture of about the size of the 'Niagara,' representing 'Twilight in the Wilderness of Maine.' The composition is very simple and impressive. A lake, one of a series, such as are common in Maine, stretches back between wooded hilly shores and the primeval forest—hemlock, oak, and larch—to another lake, beyond which the line of purple mountains closes in, and seems to wall the world. The evening sky—of low-hanging, thick-drifting vapors, ribbed with the gorgeous light from the sun, which has already set upon the water and the shores, leaving a calm brightness along the horizon—is full of solemn splendor. Indeed, the sentiment of the scene is perfect. It is a waste of absolute solitude, with the stern aspect of the northern climate, and with no forms of conscious life but a few birds winging away, dropping hurried homeward notes, if you could hear as well as see; and an eagle poised upon a tree-top at the left. It is a scene unhistoric, with no other interest than that of a wilderness, without human associations of any kind, and without the poetic charm which belongs to the Tropics and the Equator. But the almost

oppressive gloom of gathering evening in such a scene is rendered with profound skill in the picture, while all the details are elaborated with wonderful fidelity.

This latest work of Mr. Church has been exhibited at a room in Goupil's building. Every artist ought to take care that this is done with every important picture he paints. His capital, like an author's, is his reputation; but if the picture passes from his easel to the private gallery or room of the purchaser, nobody but the personal friends of the owner is the wiser. Moreover, works of this character should be shown alone, and not in paralyzing and perplexing contrast with a multitude of others. Some of the artists have undoubtedly felt that any one of their number who exhibited his works separately convicted himself of conceit. But, on the contrary, he merely proves his common-sense. For if the picture be good, the separate exhibition reveals its value most adequately; and if it be bad, the unlucky painter pays the penalty of inviting the public to see what is not worth seeing. He properly takes the risk and the result. And the New York artists, by single direct appeal to attention and criticism of the separate exhibition, have really served the cause dear to them, and helped to place their individual reputations upon an intelligible basis.

14. "Sketchings: Domestic Art Gossip," *The Crayon* 7 (July 1860): 204.

'Twilight in the Wilderness' is the poetical title of Mr. Church's latest work. This picture strikes us as one of his best productions, containing all his excellences and one merit not so prominent in some of his previous works— concentration of interest. It represents one of those phenomenal skies in the portrayal of which the artist may take any liberty with the palette, and apply colors as he pleases without stint. The rest of the composition shows less power, except in manipulation. The poetic aim of this work would have been more impressive to our eye had the foreground been painted in accordance with the natural gloom of twilight, instead of being painted in sunlight: the sun is below the horizon, how could the mass of rocks in the foreground reflect its light[?]

15. H. G. S., "Art Matters in Baltimore," *Boston Evening Transcript,* 4 March 1861, p. 1.
[this article is a description of some of the paintings in the collection of William T. Walters]

The 'Twilight in the Wilderness' is a much larger picture [than Church's *Morning in the Tropics,* also in the

collection], and is a composition of Maine scenery, as 'The Heart of the Andes' is of South American views. The sky is the grand feature of this picture, and all who have witnessed a twilight among the White Mountains, when, as if to rival the splendors of parting day, 'envious night' is ushered in beneath a canopy of more gorgeous hues than day hath ever seen, will bear witness to the truth and beauty with which these glories are here reproduced. Each portion of the landscape is strongly individualized, but all are subordinate to the pompous train of clouds transversing the heavens. The mountains are clothed in richest purple, but the soft color of their evening drapery only serves to heighten the effect of the crimson fringed clouds above them. The river lies in silence under its banks, as if it were but a mirror in which these gaily dressed fairies of the night sky might behold their festal array. The forests, too, have a sombre look, as if they felt that night had robbed them of their beauties and transferred their hues of living green to weave them into the varicolored tapestry of the heavens. Solitude reigns over the scene, and as the eye ever turns away from the wilderness below the gaze upon the brilliant canopy of the sky, the imagination whispers that he who was once 'led up of the spirit into the wilderness to be tempted,' must often have turned his gaze from the gloom and loneliness of the forest to the brightness and beauty of those heavens which to his vision of faith were ever opened, revealing the 'Father of Lights.'

16. "Art Notes," *The Round Table,* 27 January 1866, p. 55.

Church's fine picture of 'Twilight in the Wilderness' is also on exhibition here [i.e., Avery's] and is, for itself alone, worthy of a visit to the gallery. Probably no painter has ever so successfully grappled with the difficulties of an American evening sky as Church has. In this picture the long bar of apple-green, metallic light just above the horizon is noticeable as one of the most peculiar features of a twilight scene among our hills, and one of the most difficult to treat.

17. "Mr. S. P. Avery's Picture Sale," *The New-York Tribune,* 7 March 1866, p. 6.

Among the oil paintings in this collection, we suppose the large picture by Mr. Church will attract a good deal of attention, as anything Mr. Church may paint is pretty sure to do; but this is an effective work and has points that compensate for the manifest faults of the picture.

The trouble with Mr. Church is that his aim is not single. He was born to be—shall we say—a great painter, but he is too eager for applause.

18. "Art Notes," *The Round Table,* 10 March 1866, p. 151.

An English critic has lately been commenting upon the prevalence of 'apple green' in the skies painted by some American artists. In English skies this tint is extremely rare—indeed, we do not remember ever having observed it in them to any noticeable extent. Close observers of nature, however, will frequently see it in our American skies, and generally on the clear space that lies between the bars of clouds over the setting sun and the horizon. It has often been caught by the pencil of Church—very successfully, for instance, in his 'Twilight in the Wilderness.' It is surprising how many people miss what is grandest in the phases of nature, and go on through the world with their eyes fixed upon the dross only.

. . . While we are writing these art notes, the old Düsseldorf gallery is offering a new attraction to the picture fanciers. The collection of pictures—chiefly foreign—some time on exhibition by Mr. S. P. Avery, to whom they have been consigned, are on free exhibition in that gallery, preparatory to their dispersal by the stern decree of the auctioneer. Among the few native pictures in the collection, Church's 'Twilight in the Wilderness' holds a prominent place, and is a center of attention for the visitors. The artist has lately given a few finishing touches to this picture, which add materially to its force.

# Notes

## Notes—Chapter 1.

1. Henry Willard French, *Art and Artists in Connecticut* (Boston: Lee and Shepherd; New York: Charles T. Dillingham, 1879; reprint ed., New York: Kennedy Graphics, 1970), p. 128.

2. Church had studied briefly in Hartford with two local artists, Benjamin H. Coe (1799–after 1883) and Alexander H. Emmons (1816–84). Coe was a drawing teacher of considerable reputation in the 1840s and the author of several popular drawings manuals (e.g., *Easy Lessons in Landscape Drawing, with Sketches of Animals and Rustic Figures, and Directions for Using the Lead Pencil* [New York: Saxton and Miles, 1845]). On the role of such manuals in mid-nineteenth century America, see Peter C. Marzio, *The Art Crusade: An Analysis of American Drawing Manuals, 1820–1860* (Washington: Smithsonian Institution Press, 1976).

3. Letter from Church to Thomas Cole, 20 May 1844, microfilm, Archives of American Art, Smithsonian Institution, Washington, roll ALC2.

4. Ibid.

5. Letter from Church to John D. Champlin, 11 September 1885, microfilm, Archives of American Art, Smithsonian Institution, Washington, roll DDU1.

6. Another pencil portrait of Cole by Church which dates from this same period is owned by the National Portrait Gallery, Smithsonian Institution, Washington.

7. Henry T. Tuckerman, *Book of the Artists; American Artist Life* (New York: G. P. Putnam and Son, 1867), p. 373 (hereafter cited as Tuckerman, *Book of the Artists*).

8. *The Life and Works of Thomas Cole* (1853), ed. Elliot S. Vessel (Cambridge, Mass.: The Belknap Press of Harvard University Press, 1964), p. 272 (hereafter cited as Noble, *Cole*).

9. Ibid., p. 272. Cole was so confident of Church's ability that he asked him to give drawing lessons to his young son, Theodore Cole.

10. Tuckerman, *Book of the Artists*, p. 373.

11. Letter from Cole to G. W. Greene, undated (probably August 1842), quoted in Noble, *Cole*, p. 249.

12. Letter from Cole to Robert Gilmor, 21 May 1828, quoted in "Correspondence between Thomas Cole

and Robert Gilmor, Jr.," in *Studies on Thomas Cole, an American Romanticist* (Baltimore: Baltimore Museum of Art, 1967), p. 58. The distinction was one that Cole's contemporaries recognized; see, e.g., the biography of Cole in "The Artists of America," *The Crayon* 7 (February 1860):45–46, which refers to such paintings as in a "higher sphere of imaginative composition."

13. Unfortunately, we may only judge the series today from the surviving sketches for it. Recently discovered photographs showing some of the finished paintings suggest that they were more detailed and precise than the sketches (as one would expect), but that the landscapes were nevertheless highly fantastical and imaginary.

14. Barbara Novak, *American Painting of the Nineteenth Century* (New York: Praeger Publishers, 1969), p. 79.

15. E.g., *The Meeting of the Waters*, ca. 1847, in the Preston Morton Collection, Santa Barbara Museum of Art. Cole also envisioned a number of serial paintings late in his career, including four to be known as "Sowing and Reaping," and three to be called "Death and Immortality"; see letter to Daniel Wadsworth, undated (1844), cited in Noble, *Cole*, p. 267.

16. Letter to John M. Falconer, 1 February 1848, quoted in Noble, *Cole*, p. 284. Cole was stating some of the thoughts he would have expressed in a planned letter to his fellow artists in New York.

17. Mary Bartlett Cowdrey, *National Academy of Design Exhibition Record, 1826–1860*, vol. 1, *New-York Historical Society Collections,* no. 74 (New York: New-York Historical Society, 1943), p. 80 (hereafter cited as Cowdrey, *NAD*).

18. *The American Monthly Magazine,* n.s. 1 (January 1836); quoted in John W. McCoubrey, *American Art, 1700–1960: Sources and Documents* (Englewood Cliffs, N.J.: Prentice Hall, 1965), p. 100.

19. Nicolai Cikovsky, Jr., " 'The Ravages of the Axe': The Meaning of the Tree Stump in Nineteenth-Century American Art," *The Art Bulletin* 61 (December 1979): 611–26.

20. In a letter to Cole of 17 October 1846 Church wrote: "Some of the gentlemen connected with the Wadsworth Gallery are trying to purchase my Hooker picture. This I have improved by glazing, etc." Quoted in *Frederic Edwin Church* [exh. cat.] (Washington: National Collection of Fine Arts, 1966), p. 82. The

sale was made, and Church received $130 for the picture. The new work that Church mentions having done may explain the presence of an "8" (i.e., August) that appears with the date 1846.

21. David C. Huntington, *The Landscapes of Frederic Edwin Church* (New York: George Braziller, 1966), p. 28 (hereafter cited as Huntington, *Landscapes*).

22. See Perry Miller, *Errand into the Wilderness* (Cambridge, Mass.: The Belknap Press of Harvard University Press, 1956), pp. 23–24.

23. John Winthrop, *Journal,* I, p. 128; quoted in Miller, *Errand,* p. 23.

24. "Thomas Cole's List 'Subjects for Pictures'," in *Studies on Thomas Cole,* p. 90.

25. *A Complete History of Connecticut, Civil and Ecclesiastical from the Emigration of its First Planters from England, in the Year 1630, to the Year 1764 and to the Close of the Indian Wars* (1818; New London: H. D. Utley, 1898), p. 43.

26. There were, in fact, well-established Indian paths along the route the Hooker company followed. See William DeLoss Love, *The Colonial History of Hartford* (Hartford: By the Author, 1914), pp. 40–43.

27. Matthew Baigell has briefly discussed the ways in which Americans of the 1840s might have perceived the story of Hooker and his followers. He suggests that Church's painting was one of several "nationalistic images of the 1840s" that might have been created in response to then current doubts about the fortunes of the nation. See his "Frederic Church's 'Hooker and Company': Some Historic Considerations," *Arts Magazine* 56 (January 1982): 124–25.

28. Scaeva [I. W. Stuart], *Hartford in Olden times* (1853), p. 9; quoted in Huntington, *Landscapes,* p. 28. This account was illustrated with an engraving based on Church's painting. The same engraving appears in Love, *Colonial History of Hartford,* p. 33.

29. Church's relationship to the mid-century landscape style now known as "Luminism" has been discussed by Huntington in "Church and Luminism: Light for America's Elect," in John Wilmerding, et al., *American Light: The Luminist Movement, 1850–1875* [exh. cat.] (Washington: National Gallery of Art, 1980), pp. 155–90.

30. On one of Church's earliest sketches he wrote, "the most beautiful sunset that was ever seen." Similar inscriptions appear on sketches from through his career

and his letters often include detailed descriptions of the light and atmosphere in places he visited.

31. Church would eventually abandon the use of such stylized "rays of light," because his careful study of atmospheric effects would teach him that they cannot appear in a cloudless sky. What we perceive as rays of light are actually caused by areas of shadow formed by clouds blocking out portions of sunlight.

32. Love, *Colonial History of Hartford,* p. 43. Church considered Hartford Edenic, and referred to it as "Eden's centre" in a letter of 1848; see Christopher Kent Wilson, "The Landscape of Democracy: Frederic Church's *West Rock, New Haven,*" *American Art Journal* 18 (1986): 27. Church continued to refer to parts of the New World as Eden, as in his letter of 28 April 1871 to Erastus Dow Palmer: ". . . you and Mrs. Palmer should take the farm south of mine—It could be made an Eden in three years"; quoted in David Huntington, *Frederic Edwin Church, 1826–1900, Painter of the New World Adamic Myth,* (unpublished Ph.D. dissertation, Yale University, 1960; Ann Arbor and London: University Microfilms, 1969) p. 194 (hereafter referred to as Huntington, *Church*).

33. *Transactions of the American Art-Union* (1844), pp. 7, 15; quoted in Baigell, "Church's Hooker and Company," p. 125.

34. Esther Seaver, *Thomas Cole, One Hundred Years Later* [exh. cat.] (Hartford: Wadsworth Atheneum, 1948), p. 39; Alfred Frankenstein, *William Sidney Mount* (New York: Harry N. Abrams, Inc., 1975), pp. 29–30. George Francis (1790–1873) painted a small oil of the tree for Daniel Wadsworth in 1818 (Connecticut Historical Society); see Richard Saunders, *Daniel Wadsworth, Patron of the Arts* (Hartford: Wadsworth Atheneum, 1981), p. 62.

35. See *Arcadian Vales: Views of the Connecticut River Valley* [exh. cat.] (Springfield, Mass.: George Walter Vincent Smith Art Museum, 1981), p. 65 and Elaine Evans Dee, *To Embrace the Universe: The Drawings of Frederic Edwin Church* [exh. cat.] (Yonkers: The Hudson River Museum, 1984), p. 20.

36. "The Charter Oak," *The National Magazine* 3 (December 1853): 539. The tree was nearly destroyed by fire in 1849 and finally killed in a storm on August 21, 1856. By 1860 Church was in possession of an armchair made from its "roots and boughs"; see Z,

"Correspondence of the Transcript, *Boston Evening Transcript,* 7 April 1860, p. 6. A large log from the Charter Oak is still stored at the Wadsworth Atheneum, and a painting of the tree by Charles De Wolf Brownell of 1857 at the Atheneum is surrounded by a frame made from its wood; see Theodore E. Stebbins, Jr., *The Hudson River School: 19th Century American Landscapes in the Wadsworth Atheneum* (Hartford: Wadsworth Atheneum, 1976), p. 64.

37. "The Charter Oak," p. 539. A similar set of associations was embodied in the so-called Genesee Oaks of western New York, which had been preserved since the eighteenth century as part of the area's original forest. A painting of them by Asher Durand from 1860 is owned by the Memorial Art Gallery of the University of Rochester; see *The Course of Empire: The Erie Canal and the New York Landscape* [exh. cat.] (Rochester: Memorial Art Gallery, 1984), pp. 20, 53. Yet another famous oak, "The Apostle's Oak," was painted by George Harvey in 1844 (New-York Historical Society), This tree was reputed to have been for many years the site of religious meetings.

38. Church's address was listed as Hartford in the catalogue of the spring exhibition of the National Academy of Design (see Cowdrey, *NAD,* p. 80). By the time of the fall exhibition at the American Art-Union, his address was given as New York (Mary Bartlett Cowdrey, *American Academy of Fine Arts and American Art-Union Exhibition Record, 1816–1852, New-York Historical Society Collections,* vol. 77 [New York: New-York Historical Society, 1953], p. 70; hereafter cited as Cowdrey, *AA-U*).

39. *July Sunset* has in the past been considered a view of Berkshire County, Massachusetts, and I discussed it as such in my dissertation (pp. 35–36). However, Gerald Carr has recently argued that it depicts Catskill Creek scenery; see Franklin Kelly and Gerald Carr, *The Early Landscapes of Frederic Edwin Church, 1845–1854* (Fort Worth: Amon Carter Museum, 1987), pp. 84–85.

40. "American and European Scenery Compared," in *The Home Book of the Picturesque* (New York: G. P. Putnam, 1852; reprint ed., Gainesville, Florida: Scholar's Facsimiles and Reprints, 1967), p. 58.

41. "Essay on American Scenery," in McCoubrey, *American Art,* p. 109.

42. "The Fine Arts; Exhibition at the National Academy," *The Literary World*, 15 May 1847, p. 348.

43. *The Harbinger* 1 (October 1845): 267; quoted in Bernard Rosenthal, *City of Nature: Journeys to Nature in the Age of American Romanticism* (Newark, Del.: University of Delaware Press, 1980), p. 30.

44. James Thomas Flexner, *That Wilder Image* (Boston: Little, Brown, and Company, 1962), p. 107. See also James T. Callow, *Kindred Spirits: Knickerbocker Writers and American Artists, 1807–1855* (Chapel Hill, N.C.: The University of North Carolina Press, 1967), pp. 12–29.

45. "Subjects for Artists," *Boston Evening Transcript*, 21 December 1847, p. 2. I am grateful to Colonel Merl M. Moore for providing me with a copy of this reference.

46. The painting was sold by Barridoff Galleries, Portland, Maine, on 10 November 1979 under the title "Main Street."

47. Edward P. Hamilton, *The Village Mill in Early New England* (Sturbridge, Mass.: Old Sturbridge Village, 1964), p. 15. See also John R. Stilgoe, *Common Landscape of America, 1580 to 1845* (New Haven and London: Yale University Press, 1982), pp. 309–24.

48. James Brooks, "Our Own Country," *The Knickerbocker* 5 (January 1835): 48–51; quoted in Kenneth W. Maddox, *In Search of the Picturesque: Nineteenth Century Images of Industry Along the Hudson River Valley* (Bard College, New York: Milton and Sally Avery Center for the Arts, 1983), p. 23.

49. Maddox, *In Search*, p. 52. One of these sawmills was depicted by Cole in his 1841 painting *Mill Dam on the Catskill Creek* (Henry Melville Fuller Collection). Although the mill in Cole's painting looks decrepit, there are sawn tree stumps in the foreground of the landscape that are graphically suggestive of its effect on nature.

50. "Ktaadn and the Maine Woods," *The Union Magazine* (1848); reprinted in *The Maine Woods* (New York: Thomas Y. Crowell, 1961), p. 6. These mills, according to Thoreau, sawed two hundred million feet of boards annually. Thoreau's figures agree with those given in John S. Springer, *Forest Life and Forest Trees* (New York: Harper and Brothers, 1851), p. 222.

51. See, e.g., "Mill near Hartford," in Coe, *Easy Lessons*.

52. For a more dramatic image, see the engraving of a sawmill in Fort Anne, New York in Hamilton, *The Village Mill*, p. 5, where the open end of the mill has disgorged a veritable avalanche of sawn lumber.

53. See the list in Maddox, *In Search*, p. 29, note 9.

54. William S. Talbot, *Jasper F. Cropsey, 1823–1900* (New York: Garland Publishing, Inc., 1977), pp. 210–211.

55. Stilgoe, *Common Landscape*, p. 317.

56. Gary Kulik, "Dams, Fish, and Farmers: Defense of Public Rights in Eighteenth-Century Rhode Island," in Steven Hahn and Jonathon Prude, *The Countryside in the Age of Capitalist Transformation* (Chapel Hill, N.C. and London: University of North Carolina Press, 1985), pp. 25–50.

57. See Barbara Novak, "The Double-Edged Axe," *Art in America* 64 (January-February 1976): 44–50, for a discussion of the axe as symbol of both progress and destruction.

58. Huntington, *Church*, pp. 13–14.

59. Samuel Carter III, *Cyrus Field: Man of Two Worlds* (New York: G. P. Putnam's Sons, 1968), p. 50.

60. I am grateful to Elizabeth G. Holahan, president of the Rochester Historical Society, for her help in identifying the building depicted in Church's painting.

61. Kelly and Carr, *Early Landscapes*, pp. 86–87, 96–97.

62. Cowdrey, *NAD*, p. 80.

63. For a review of *Christian*, see "The Fine Arts: Exhibition at the National Academy," *The Literary World*, 22 May 1847, p. 371.

64. *The Literary World*, 22 May 1847, p. 371.

65. "Fine Arts," *The Literary World*, 16 November 1850, p. 392.

66. "The American Art-Union," *The Knickerbocker* 32 (November 1848): 444. Despite the fact that the scene depicted was an imaginary one, the critic praised "the truth with which a partial rippling of the stream is represented, and the great accuracy of touch in the foliage." The critic for *The Literary World* also praised the picture, noting "the sky and water are well done and there is good handling throughout the picture," but he found *View Near Stockbridge* "a much better and more pleasing picture" ("The Fine Arts: National Academy Exhibition," *The Literary World*, 13 May 1848, p. 288). Precisely the same point was made by the reviewer for the *New York Evening Post*, who praised the truth of the sky in

*Stockbridge* especially ("National Academy of Design," *New York Evening Post,* 30 May 1848, p. 2). Even at this early date, Church was being encouraged to paint realistic works instead of imaginary ones.

67. "The National Academy of Design," *Bulletin of the American Art-Union* 2 (May 1849): 14. The subject of the painting was derived from Exodus 10: 21–22, and the verses were quoted in the catalogue of the National Academy exhibition; see *Catalogue of the 24th Annual Exhibition of the National Academy of Design* (New York: National Academy of Design, 1849), p. 15.

68. See, e.g., Samuel Isham, *The History of American Painting* (1905); rev. ed. with additional chapters by Royal Cortissoz (New York: The Macmillan Company, 1927), p. 248: "and of Cole's story-telling, moral, allegorical subjects, he made no use." To be sure, recent scholarship has been more aware of Church's debt to Cole, but the notion that he somehow rejected much of what the older man believed has persisted.

69. I am grateful to J. Gray Sweeney for sharing information about this painting with me. Jasper Cropsey, who was also deeply influenced by Cole, considered painting a memorial after hearing of the artist's death. He envisioned a properly Colean suite depicting "the art pilgrim, or the pathway to genius—to the memory of *Cole,* to be four pictures." See Kenneth W. Maddox's entry for Cropsey's so-called *Ideal Landscape: Homage to Thomas Cole* in Barbara Novak, ed., *The Thyssen-Bornemisza Collection: Nineteenth-Century American Painting* (New York: The Vendome Press, 1986), pp. 74–75. Cropsey's small landscape was, as Maddox notes, more probably related to the panorama of *Pilgrim's Progress* on which he, like Church, worked in 1850 (see chapter 2).

70. Durand did paint a few imaginary works, but these remained very much a limited side of his art; see Wayne Craven, "Asher B. Durand's Imaginary Landscapes," *Antiques* 116 (November 1979): 1120–27.

71. S. G. W. Benjamin, *Art in America: A Critical and Historical Sketch* (New York: Harper and Brothers, 1880), p. 81.

## Notes—Chapter 2.

1. *A Mountain Tempest* is unlocated; for a brief review, see "National Academy of Design," *The Knickerbocker* 33 (May 1849): 469–70. Judging from the description, the painting was similar to *Above the Clouds at Sunrise* (Warner Collection, Gulf States Paper Corporation), also of 1849. *A Mountain Tempest* was accompanied by lines from Byron's *Childe Harold* quoted in the Academy catalogue; see *Catalogue of the 24th Annual Exhibition* (New York: National Academy of Design, 1849), p. 13.

2. "National Academy," *Knickerbocker;* and "Fine-Art Gossip," *Bulletin of the American Art-Union* 2 (April 1849): 20.

3. "Fine-Art Gossip," p. 20.

4. Olana 1980.1399. The drawing notes "white flowers and weeds in the area that appears as the hayfield in the painting; at the top of the sheet Church included a thumbnail sketch of a steeple. Vignettes of men with hay carts are found in other drawings at Olana.

5. *The American Monthly Magazine,* n.s. 1 (January 1836); quoted in John W. McCoubrey, *American Art, 1700–1960: Sources and Documents* (Englewood Cliffs, N.J.: Prentice Hall, 1965), p. 108.

6. (New York: G. P. Putnam, 1852; reprint ed., Gainesville: Fla.: Scholar's Facsimiles and Reprints, 1967).

7. At the time of its exhibition at the National Academy, *West Rock* had been purchased by Cyrus Field. See Christopher Kent Wilson, "The Landscape of Democracy: Frederic Church's *West Rock, New Haven,*" *American Art Journal* 18 (1986): 37. Wilson provides an excellent discussion of *West Rock,* with particular emphasis on its connection with Field.

8. *The Home Book of the Picturesque,* pp. 137–38.

9. Ibid., p. 138.

10. Ibid., p. 141. See also "The Connecticut Shore of the Sound," in William Cullen Bryant, ed., *Picturesque America* (New York: D. Appleton and Co., 1876), p. 444.

11. *Home Book,* p. 141.

12. W., "Country Correspondence," *The Crayon* 6 (December 1859): 382. This letter recounts an artist's visit to the "Judges' or Regicides' Cave upon the West Mountain."

13. "Thomas Cole's List, 'Subjects for Pictures'," in *Studies on Thomas Cole, an American Romanticist* (Balti-

more: Baltimore Museum of Art, 1967), p. 87. John Dixwell (c. 1607–1688/9), like Whalley and Goffe, fled to America after opposing the King. Although he was acquainted with the other men, he was not hidden in the cave with them.

14. Before leaving *West Rock,* we should also note that a singular geological monument as a subject here makes its first appearance in Church's art. West Rock was famed not only for its historical associations, but also as a geological wonder: a "bold, red rock, a columned wall,—seamed and scarred, and piled up half its height with fragments of stone" (*The Home Book of the Picturesque,* p. 138). It was well known to such prominent scientists as Benjamin Silliman; in Samuel Morse's portrait of Silliman (1825, Yale University Art Gallery, New Haven) a profile view of West Rock is included in the background. See Gary A. Reynolds and Paul J. Staiti, *Samuel F. B. Morse* [exh. cat.] (New York: Gray Art Gallery and Study Center, 1982), p. 50.

15. The painting is owned by the University of Virginia Art Museum in Charlottesville, and was exhibited at the Royal Academy in London in 1852; see Algernon Graves, *The Royal Academy of Arts: A Complete Dictionary of Contributors and their work from its foundation in 1769 to 1904* (London: Henry Graves and Co. and George Bell and Sons, 1905), p. 62. The most famous site Church would ultimately depict was, of course, Niagara Falls.

16. "Fine-Art Gossip," *Bulletin of the American Art-Union* 2 (August 1849): 28.

17. The painting is not dated, but was probably begun in the fall of 1849.

18. "The Fine Arts: The National Academy: A First View: Durand and the Landscapes," *The Literary World,* 27 April 1850, p. 424.

19. "National Academy of Design: XXVth Annual Exhibition (Second Article)," *New-York Daily Tribune,* 15 May 1850, p. 1.

20. *The Literary World,* 27 April 1850, p. 424.

21. There were a total of five paintings exhibited by Church at the National Academy and eight at the Art-Union.

22. *The Literary World,* 27 April 1850, p. 424.

23. "Fine Arts: National Academy of Design," *The Albion,* 27 April 1850, p. 202. "The Exhibition of the National Academy," *Bulletin of the American Art-Union* (May 1850): 21.

24. *Bulletin of the American Art-Union,* p. 21.

25. X, "Country Correspondence; At a Farm-house Window," *The Crayon* 3 (September 1856): 281.

26. *The Norton Anthology of Poetry* (New York: W. W. Norton, 1970), p. 316. William H. Gerdts was the first to cite the source; see "Early American Paintings from the Newark Museum," in *Aspects of a Collection—18th and 19th Century American Painting from the Newark Museum* [exh. cat.] (New York: M. Knoedler and Co., 1977), p. 9.

27. *Letters from a Landscape Painter* (Boston: James Munroe and Co., 1845), pp. 9–10.

28. Tuckerman, *Book of the Artists,* p. 227. According to Tuckerman, Cole's other favorite poets were Dante and Wordsworth.

29. "Essay on American Scenery," in McCoubrey, *American Art,* p. 108.

30. Noble, *Cole,* p. 304.

31. At just what stage in the creation of the painting Church chose the title is unclear, and it is impossible to say with certainty that he had it in mind from the beginning. The earliest reference to the painting refers to it as *Sunset Among the Hills* ("Movements of Artists," *Bulletin of the American Art-Union,* series for 1850 [1 April 1850]: 15). However, the picture was exhibited with the full title at both the Academy and the Art-Union.

32. See Jack Lindsay, *The Sunset Ship: The Poems of J. M. W. Turner* (Lowestoft: Scorpion Press, 1966).

33. This important aspect of American landscape painting has, however, received little attention. For a brief overview, see the author's "La poétique du paysage dans la peinture Américaine au xix° siècle." in *Dictionaire des Poétiques* (Paris: Flammarion, forthcoming).

34. On Cole's poetry, see Marshall Tymn, *Thomas Cole's Poetry* (York, Pa.: Liberty Cap Books, 1972).

35. The painting is now in the Cummer Gallery of Art, Jacksonville, Florida; for a reproduction and brief discussion, see William S. Talbot, *Jasper F. Cropsey* [exh. cat.] (Washington: National Collection of Fine Arts, 1970), pp. 17–18.

36. David B. Lawall, *Asher B. Durand; A Documentary Catalogue of the Narrative and Landscape Paintings* (New York and London: Garland Publishing, 1978), pp. 79–82.

37. Ibid., p. 80.

38. *The Literary World,* 27 April 1850, p. 424. This is the same review that discusses Church's works.

39. *The Albion,* 27 April 1850, p. 201. Again, this is a review in which Church's works are also discussed.

40. See "Panorama of Pilgrim's Progress," *Bulletin of the American Art-Union,* series for 1850 (August 1850): 82; and "Panorama of Pilgrim's Progress: A More Particular Notice," *The Literary World,* 7 December 1850, p. 460.

41. Wolfe worked on this panorama with William L. Sonntag, and it was ready for exhibition by the spring of 1851. On Sonntag's connection with the project, see Nancy Dustin Wall Moure, *William Louis Sonntag: Artist of the Ideal, 1822–1900* (Los Angeles: Goldfield Galleries, 1980), pp. 18–19. An announcement for the panorama, which went on display at Barnum's American Museum, is found in the *New-York Daily Tribune,* 5 May 1851, p. 8. Henry Cheever Pratt, an artist much influenced by Cole, exhibited a successful panorama of "The Garden of Eden," inspired by *Paradise Lost* in Boston in 1849 and 1850; see Alice Doan Hodgson, "Henry Cheever Pratt (1803–1880), *Antiques* 102 (November 1972): 843–46.

42. Samuel Carter III, *Cyrus Field: Man of Two Worlds* (New York: G. P. Putnam's Sons, 1968), p. 30.

43. *Milton's Paradise Lost* (New York: The Cassell Publishing Co., n.d.), pp. 87–90. Church owned volume II of *Milton's Poems,* edited by James Montgomery, which is still in the library at Olana today.

44. See Cowdrey, *AA-U,* p. 71. This work has long been called "The Harp of the Winds," but it agrees with the description of *A Passing Storm* given in the Art-Union catalogue. There is no record of Church ever having painted a work called "The Harp of the Winds."

45. R. W. B. Lewis, *The American Adam* (Chicago: University of Chicago Press, 1955). For a discussion of the Miltonic overtones of the American Adamic myth, see Bryan Jay Wolf, *Romantic Revision: Culture and Consciousness in Nineteenth-Century American Painting and Literature* (Chicago: University of Chicago Press, 1982), pp. 81–101.

46. Lewis, *American Adam,* p. 1. On the idea of Americans as post-Fall, second Adams, see also Frederic I. Carpenter, " 'The American Myth': Paradise (to be) Regained," *Publications of the Modern Language Association of America* 74 (December 1959): 599–606; and Bernard Rosenthal, *City of Nature: Journeys to Nature in the Age of American Romanticism* (Newark, Del.: University of Delaware Press, 1980), pp. 112–37. A central theme in Emerson's "Nature" is that "A man is a god in ruins;" see William H. Gilman, ed., *Selected Writings of Ralph Waldo Emerson* (New York: New American Library, 1965), p. 220.

47. "Essay on American Scenery," in McCoubrey, *American Art,* p.109. For examples of Church's use of Edenic language, see chapter 1, note 32.

48. There was, as well, at this moment some specter of competition from other artists (such as Cropsey) who were drawing inspiration from Cole's dramatic works. As Charles Lanman observed: "the servile imitators of Cole may now be numbered in the dozens" (*Our Landscape Painters," Southern Literary Messenger* 16 [May 1850]: 279). Church was not one to leave such competition, no matter how weak, unanswered.

49. The painting eventually lost its full title, which was admittedly rather cumbersome, and came to be known simply as *Twilight.* See *The Washington Exhibition in Aid of the New-York Gallery of Fine Arts at the American Art-Union* (New York: John F. Trow, 1853), p. 8; see also "The Fine Arts: The Washington Exhibition: Second Article," *The Albion,* 19 March 1853, p. 141. The painting, then owned by Robert Dillon, was considered by *The Albion*'s critic to be "one of the most original American landscapes we have ever seen."

50. These elements appear in several earlier pictures, but *Twilight, "Short Arbiter"* established the basic format. For a discussion of the symbolic role of the reflecting windows which Church frequently used in his early paintings, see the author's "Frederic Church and the North American Landscape," pp. 96–104.

51. Frank H. Goodyear, *Thomas Doughty, 1793–1856: An American Pioneer in Landscape Painting* [exh. cat.] (Philadelphia: Pennsylvania Academy of the Fine Arts, 1973), pp. 17, 30. The well-known *Desert Rock Lighthouse, Maine* of 1847 (Newark Museum) is a replica of the original of 1836, which is now in a private collection in Massachusetts.

52. Noble, *Cole,* p. 270.

53. "Ktaadn and the Maine Woods," *The Union Magazine* (1848); reprinted in *The Maine Woods* (New

York: Thomas Y. Crowell Co., 1961; Apollo ed., 1966); see also Roderick Nash, *Wilderness and the American Mind,* rev. ed. (New Haven and London: Yale University Press, 1973), pp. 90–92.

54. It has also been suggested that the paintings of Maine subjects that Fitz Hugh Lane exhibited at the Art-Union in 1849 may have influenced Church. See John Wilmerding, *Fitz Hugh Lane* (New York: Praeger Publishers, 1971), pp. 48–50.

55. "Chronicle of Facts and Opinions: American Art and Artists: Movements of Artists," 89 *Bulletin of the American Art-Union,* series for 1850 (August 1850): 81.

56. E.g., "Gallery of Düsseldorf Artists," *Bulletin of the American Art-Union* 2 (June 1849): 12. See also Alfred Frankenstein, *William Sidney Mount* (New York: Harry N. Abrams, 1975), p. 187, for Mount's impression of the picture.

57. "The School of Art at Düsseldorf," *Bulletin of the American Art-Union,* series for 1850 (1 April 1850): 6. See also the article "Gallery of the Düsseldorf Artists," in the *Bulletin* 2 (June 1849): 8–17, for an extended commentary on how American artists could profit by studying the German works.

58. Huntington, in *Landscapes,* p. 35, suggests that Düsseldorf landscapes would have encouraged Church's instinctive tendencies and notes that he successfully avoided the affectations of the school. Other artists were not so fortunate; Jasper Cropsey, for example, was criticized for taking the Düsseldorf manner to an extreme by putting too much emphasis on detail at the expense of overall impression; see [George William Curtis], "The Fine Arts: The Exhibition of the National Academy, II," *New-York Daily Tribune,* 24 April 1852, p. 5.

59. *Bulletin of the American Art-Union* (August 1850): 81.

60. The reference to Church's "new field" is found in "Art and Artists," *The Home Journal,* 15 February 1851, third page. It was George William Curtis, in "The Fine Arts: Exhibition of the National Academy, IV," *New-York Daily Tribune,* 8 May 1852, p. 5, who placed Church at the head of American marine painters.

61. Lane's visit probably coincided with that of Church, and they may even have crossed paths on the island (Wilmerding, *Lane,* pp. 52–54; see also Frederic Alan Sharf, "Fitz Hugh Lane: Visits to the Maine Coast, 1848–1855," *Historical Collections* [Essex Institute], vol. 98 [April 1962]: 111–20).

62. Series for 1850 (November 1850): 129–31. Although the letters are unsigned, Huntington (*Church,* p. 24) has convincingly attributed them to Church.

63. *Bulletin,* p. 130.

64. *The Home Journal,* 15 February 1851, third page.

65. See George Levitine, "*Vernet Tied to a Mast in a Storm: The Evolution of Art Historical Romantic Folklore,*" *Art Bulletin* 49 (June 1967): 92–100, for a discussion of how the myth of Vernet's storm experiences evolved during the nineteenth century. Turner, in defending the truth of his *Snow Storm* of 1842 (Tate Gallery), claimed to have been aboard the steamer depicted in the painting and to have been lashed to the mast for four hours while observing the elements; see Martin Butlin and Evelyn Joll, *The Paintings of J. M. W. Turner* (New Haven and London: Yale University Press, 1977), p. 224.

66. *Bulletin of the American Art-Union* (November 1850): 130.

67. Ibid.

68. Ibid., p. 131.

69. Ibid.

70. Ibid.

71. [George William Curtis], "The Fine Arts: The National Academy of Design, III," *New-York Daily Tribune,* 10 May 1851, p. 5.

72. "National Academy of Design: By an Artist," *The Home Journal,* 10 May 1851, third page.

73. 11¹/₂ x 15³/₈ inches, AA-U 1852 no. 119; in recent years this painting has been called simply "Mt. Desert, Maine." However, it agrees in all respects with the Art-Union picture, as it is described in the catalogue; see Cowdrey, *AA-U,* p. 72.

74. Ibid. The following lines from Genesis 6:17 were quoted in the Academy catalogue: "And, behold I, even I, do bring a flood of waters upon the earth, to destroy all flesh, wherein is the breath of life, from under Heaven; and every thing that is in the earth shall die"; see *Catalogue of the Twenty-Sixth Annual Exhibition of the National Academy of Design* (New York: National Academy of Design, 1851), p. 1. The concept of portraying a family group clinging tenuously to a rock—often with a wild animal nearby—

was common in British paintings of the Deluge. For a discussion of this tradition, see Morton D. Paley, *The Apocalyptic Sublime* (New Haven and London: Yale University Press, 1986), pp. 7–16.

75. "The Fine Arts: The National Academy," *The Literary World,* 19 April 1851, p. 320. Further criticism of the painting's lack of truth to nature is found in *The Home Journal,* 26 April 1851, third page, and a specific critique of Church's depiction of lightning is in Ibid., 12 July 1851, second page.

76. *The Literary World,* 19 April 1851, p. 320.

77. I am grateful to John Wilmerding for his help in identifying the location depicted in the painting. The day marker was erected by the government in 1839–40 on East Bunker's Ledge and was one of the first aids to coastal navigation established in the Mount Desert vicinity; see Samuel Eliot Morison, *The Story of Mount Desert Island, Maine* (Boston: Little, Brown and Company, 1960), p. 38.

78. [Curtis], "National Academy of Design, III," p. 5.

79. "Affairs of the Association," *Bulletin of the American Art-Union,* series for 1851 (1 December 1851): 153. Cowdrey, *AA-U,* p. 298, gives the prices: *The Deluge,* which the Art-Union had purchased for $450, was sold for $300; *Beacon,* for which they had paid $300, was sold for $380.

80. "Twenty-Sixth Exhibition of the National Academy of Design," *Bulletin of the American Art-Union,* series for 1851 (1 May 1851): 23.

81. "The National Academy of Design, III," p. 5.

82. *Westward Empire, or the Great Drama of Human Progress* (New York: Harper and Brothers, 1856), p. xv; quoted in Ella Foshay and Sally Mills, *All Seasons and Every Light: Nineteenth Century American Landscapes from the Collection of Elias Lyman Magoon* [exh. cat.] (Poughkeepsie, N. Y.: Vassar College Art Gallery, 1983), p. 71.

83. The National Academy catalogues of the Annual Exhibitions are arranged by gallery, allowing one to form some idea of how the exhibition was actually installed.

## Notes—Chapter 3.

1. "The Fine Arts," *The International Magazine* 3 (June 1851): 327.

2. The painting was finished too late to be assigned a catalogue number for the exhibition.

3. Cowdrey, *AA-U,* p. 73.

4. Ibid.

5. Ibid. See also "Fine Arts," *The Home Journal,* 5 February 1853, p. 3 and "Fine Arts: The American Art-Union," *The Literary World,* 27 September 1851, p. 252.

6. See Huntington's discussion in *Landscapes,* pp. 34–37.

7. "Humboldt," *New York Times,* 5 May 1853, p. 2. On Humboldt and his influence on Church, see Huntington, *Landscapes,* pp. 17, 20, 41–42; Albert Ten Eyck Gardner, "Scientific Sources of the Full-Length Landscape: 1850," *Metropolitan Museum of Art Bulletin* 4 (October 1945): 59–65; Edmunds Bunkse, "Humboldt and an Aesthetic Tradition in Geography," *The Geographical Review* 71 (April 1981): 127–46; and Barbara Novak, *Nature and Culture* (New York: Oxford University Press, 1980), pp. 66–75.

8. *Cosmos: Sketch of a Physical Description of the Universe,* Edward Sabine, trans. (London: Longman, Brown, Green, and Longmans, and John Murray, 1848).

9. See, e.g., "The Fine Arts: Professor Sattler's Cosmorama," *The Literary World,* 11 January 1851, p. 31, where it is noted the images "would not discredit, as illustrations, the magnificent 'Cosmos' of Humboldt himself." Hubert Sattler (1817–1904) created this popular panorama from "magnified oil paintings, by himself, from original drawings on the spot—Egypt, Nubia, Arabia, and the other lesser wonders of the West."

10. Humboldt, *Cosmos,* vol. 2, p. 74.

11. Ibid., p. 86.

12. "Nationality in Literature," in *Literary Criticism of James Russell Lowell,* ed. Herbert F. Smith (Lincoln, Nebraska: University of Nebraska Press, 1969); quoted in Cecilia Tichi, *New World, New Earth: Environmental Reform in American Literature from the Puritans through Whitman* (New Haven and London: Yale University Press, 1979), p. 151.

13. Tichi, *New World,* p. 153.

14. Huntington, *Landscapes,* pp. 35–36.

15. Ibid.

16. Ibid.

17. Humboldt, *Cosmos,* vol. 2, p. 80.

18. Ibid., p. 86.

19. Letter of 25 December 1825, quoted in Noble, *Cole,* p. 63.

20. Certain aspects of Church's composition also echo Cole's *L'Allegro* of 1846 (figure 43). These include the sandy spit of land projecting into the water, the motif of the light-filled arch at the right (transformed in Church's painting into a natural arch made of trees), and the form of the background mountain. Church also drew inspiration from *L'Allegro* in 1852 when he painted *Home by the Lake.* David Huntington has pointed out to me that the tempo of *New England Scenery,* with its mood of industriousness, is more in keeping with that of *L'Allegro* than *The Pastoral State,* which is more relaxed in feeling. Cole's *Landscape (Mountain Scenery)* of 1839 (Art Institute of Chicago) also has some similarities to Church's *New England Scenery,* especially in the presence of a foreground bridge and a white-steepled church. For a reproduction of Cole's painting, see David A. Hanks, "American Paintings at the Art Institute of Chicago; Part II: The Nineteenth Century," *Antiques* 104 (November 1973): 899.

21. *Exhibition of Paintings of the Late Thomas Cole at the Gallery of the American Art-Union* (New York: Snowden and Prall, 1848), pt. 2, no. 7.

22. Letter to S. R. Lambdin, 26 April 1852, microfilm, Archives of American Art, Smithsonian Institution, roll P22.

23. Anna Wells Rutledge, *Cumulative Record of Exhibition Catalogues; The Pennsylvania Academy of the Fine Arts, 1807–1870* (Philadelphia: The American Philosophical Society, 1955), p. 48. This painting has been confused with the version of 1851; however, when shown in Philadelphia, it was listed as "for sale." The more famous *New England Scenery* had by then been sold to the Art-Union, so it was clearly not the one exhibited at the Pennsylvania Academy.

24. Gerald Carr, "New Information on Church's Paintings at Olana," *The Crayon* [Olana] (Spring 1983): 10, 12.

25. The painting is frequently called *Scene in the Catskills,* despite the fact that there is very little about the topography it depicts to suggest that area. The title used here is the one Church gave it, and the one under which it was exhibited at the National Academy in 1852. In 1860 Church traded the painting, which he had reacquired at some point, to his friend Erastus Dow Palmer for a sculpture. At that time Church titled the work *Home of the Pioneer,* and it was exhibited under that name several times during the nineteenth century; see, e.g., *Catalogue of the Third Annual Exhibition at the Rooms of the Young Men's Association in the Atheneum, Troy* (Troy, New York: D.H. Jones, 1860), no. 54; and *Catalogue of Painting and Sculpture Exhibited at Palmer's Studio in Aid of the United States Sanitary Commission* (Albany: Van Benthuysen's Steam Printing House, 1864), no. 50.

26. "Exhibition of the National Academy of Design," *The Knickerbocker* 39 (June 1852): 567. [George William Curtis], "The Fine Arts; Exhibition of the National Academy," *New-York Daily Tribune,* 8 May 1852, p. 5. See also the favorable criticism in "Fine Arts," *The Home Journal,* 15 May 1852, p. 2.

27. See "The Fine Arts; Exhibition at the National Academy of Design—No. III," *The Literary World,* 8 May 1852, p. 332, where it is noted: "his pictures are full of the qualities of nature; but as wholes they lack breadth and system, not giving them a single and unified impression."

28. N. N., "The Exhibition of the National Academy," *Bulletin of the American Art-Union,* series for 1850 (May 1850): 20. This is the same review that discusses Church's *Twilight, Short Arbiter.* These ideas, of course, were hardly new ones in 1850; see, e.g., Daniel Webster's similar words from 1821: "Two thousand miles westward from the rock where their fathers landed, may now be found the sons of the Pilgrims, cultivating smiling fields, rearing towns and villages, and cherishing, we trust, the patrimonial blessings of wise institutions, of liberty, and religion;" (*A Discourse, Delivered at Plymouth . . . in Commemoration of the First Settlement of New-England* [Boston: Wells and Lilly, 1821] pp. 60–61; quoted in Tichi, *New World,* p. 156.

29. *Star Papers; or, Experiences of Art and Nature* (New York: J. C. Derby, 1855), p. 281.

30. Stumps appear in both Cole's *The Hunter's Return* and *Home by the Lake.* For an excellent discussion of the role of the tree stump in images of log cabins, see Nicolai Cikovsky, Jr., " 'The Ravages of the Axe': The Meaning of the Tree Stump in Nineteenth-Century American Art," *Art Bulletin* 61 (December 1979): 622–23. For a general treatment of the tree

stump in nineteenth-century American landscape painting, see Barbara Novak, "The Double-Edged Axe," *Art in America* 64 (January-February 1976): 44–50, and idem, *Nature and Culture* (New York: Oxford University Press, 1980), pp. 157–65.

31. Comparison of *Home by the Lake* with *L'Allegro* provides an instructive example of how Church was able to transform the compositional methods of his teacher, which always remained rather self-conscious and deliberately Old-Masterish. *Home by the Lake* is both more cohesive and coherent than *L'Allegro* and more sweeping in its evocation of vast space.

32. There was no regular exhibition of the Art-Union in 1852, only the December sale. The organization was declared unconstitutional and disbanded in 1853; Church thus not only lost one of the most important places in which he had exhibited since the early years of his career, but also a major source of income, because the Union had regularly purchased his paintings. However, by 1852, he seems to have been receiving numerous commissions, since there are several small works from that year that were not publicly exhibited and probably went directly from Church's studio to their owners. Both of the paintings exhibited at the National Academy in 1852 were sold; *The Wreck* went to J. F. Stone and *Home by the Lake* to Henry Dwight, Jr.; see Cowdrey, *NAD*, p. 80.

33. "The Fine Arts; Exhibition of the National Academy," p. 5.

34. Ibid.

35. "Fine Arts; The National Academy of Design—No. III," *The Albion*, 8 May 1852, p. 225.

36. "Exhibition of the National Academy," p. 567.

37. "The Fine Arts; Exhibition at the National Academy of Design—No. III," p. 332.

38. For an interesting discussion of the scenery on the island, see Edward Abbott, "Grand Manan and 'Quoddy Bay," *Harper's New Monthly Magazine* 56 (March 1878): 541–56.

39. On the general theme of shipwrecks and storm-tossed boats, see T. S. R. Boase, "Shipwrecks in English Romantic Painting," *Journal of the Warburg and Courtauld Institutes* 22 (July-December 1959): 332–46; Lorenz Eitner, "The Open Window and the Storm-Tossed Boat: An Essay in the Iconography of Romanticism," *Art Bulletin* 37 (December 1955): 281–90; and

Adele M. Holcomb, "John Sell Cotman's *Dismasted Brig* and the Motif of the Drifting Boat," *Studies in Romanticism* 14 (Winter 1975): 29–40. For a specifically American context, see Gerald Eager, "The Iconography of the Boat in 19th-Century American Painting," *The Art Journal* 35 (Spring 1976): 224–30; Roger Stein, *Seascape and the American Imagination* [exh. cat.] (New York: Whitney Museum of American Art, 1975), pp. 35–43; and John Wilmerding, *A History of American Marine Painting* (Boston and Toronto: Little, Brown, and Co., 1968), passim.

40. Kenneth W. Maddox, *An Unprejudiced Eye: The Drawings of Jasper F. Cropsey* [exh. cat.] (Yonkers: The Hudson River Museum, 1980), p. 14–15.

41. John Wilmerding, *Fitz Hugh Lane*, (New York: Praeger Publishers, 1971), fig. 79.

42. Henry Wadsworth Longfellow; quoted in "Letter from a Light-House; By a Landscape Painter," *The Crayon* 1 (17 January 1855): 35.

43. "On Boats," *The Crayon* 3 (November 1856): 335. The article is a discussion of several passages from Ruskin's introduction to Turner's *The Harbors of England*.

44. Cole had recognized the evocative potential of wrecks, although he saw them functioning on a more individual level than architectural ruins. In his list of subjects he described a scene with the funeral rites of "Pompey on the Egyptian shore—after or just at sunset—the wreck of the fishing boat and the fire raised on some masses of rock, with the two human figures standing close by in the foreground." See "Thomas Cole's List 'Subjects for Pictures'," in *Studies on Thomas Cole, an American Romanticist* (Baltimore: Baltimore Museum of Art, 1967), p. 85.

45. John R. Stilgoe, "A New England Coastal Wilderness," *The Geographical Review* 71 (January 1981): 33–50.

46. Ibid., p. 33.

47. Henry David Thoreau, *Cape Cod*, (New York: Thomas Crowell, 1966; first published 1865), p. 81; quoted in Stilgoe, p. 50.

48. The prominent mother and child in Church's *Deluge* of 1851 (see figure 34) raises the possibility that it may have been inspired, at least in part, by the wreck that killed Fuller and her daughter.

49. Lawall, *Durand*, p. 44.

50. Ibid.

51. Ibid., p. 83.

52. "The Fine Arts; The National Academy of Design," *The Albion,* 27 April 1850, p. 201.

53. Church expressed his admiration for Cole's *Desolation* in a letter to John D. Champlin, 11 September 1885, microfilm, Archives of American Art, Smithsonian Institution, Washington, roll DDU1.

54. *The Wreck* (no. 145) and *Home by the Lake* (no. 456) did not hang together in the National Academy, and, as noted above, they were sold to different buyers. But this does not preclude their having been conceived as pendants, for such works were often assigned different catalogue numbers and sold separately. See, e.g., John William Casilear's *Landscape Composition: Morning* (no. 127, owned by J. R. Burton) and *Landscape Composition: Sunset* (no. 134, owned by A. B. Durand), which were exhibited at the Academy in 1836 (Cowdrey, *NAD,* p. 71). Henry Adams has recently argued convincingly that George Caleb Bingham's well-known paintings *Fur Traders Descending the Missouri* and *The Concealed Enemy* were conceived as pendants (see "A New Interpretation of Bingham's *Fur Traders Descending the Missouri,*" *Art Bulletin* 65 [December 1983]: 675–80]). He also suggests that their thematic message concerned the opposition of the civilized and the savage, and they thus may be read as emblematic of American civilization. That two paintings so famous in the history of American art could, until now, have been seen as unrelated, suggests that there may well be many other examples of pendants among the works of mid-century artists. Furthermore, Adams notes that Bingham frequently thought of the thematic relationships between paintings executed several years apart and which often differed in size and general composition. Clearly, American artists—whether following the example of Cole, or not—were well aware of the potential of paired paintings.

## *Notes—Chapter 4.*

1. The spelling used here—"Ktaadn," instead of the modern "Katahdin"—agrees with that used when the picture was exhibited in 1853. Ktaadn is an Indian word meaning "highest land." The mountain is located in the northern part of the state and rises to an elevation of 5,268 feet, the highest point in Maine.

2. The others were *Natural Bridge* (1852, University of Virginia Art Museum), *Grand Manan, Bay of Fundy* (1852, Wadsworth Atheneum, Hartford), and *Valley of the Madawasca* (1853; probably the painting formerly in the collection of the University of Virginia Art Museum and now in the Blount Collection, Montgomery Museum of Fine Arts, Alabama). The first two works show Church's interest in spectacular geological formations. The latter, a relatively minor effort, was considered "a companion to the Ktadn [*sic*]" (see "The Fine Arts; Exhibition of the Academy," *The Literary World,* 30 April 1853, p. 358). For additional reviews, see "Fine Arts," *Putnam's Monthly* 1 (June 1853): 701–3; "Editor's Table; Exhibition of the National Academy of Design," *The Knickerbocker* 42 (July 1853): 93–94; and "Exhibition of the National Academy," *New-York Daily Tribune,* 2 July 1853, p. 6. There were very few reviews of any substance for the Academy exhibition of 1853, since most journals and newspapers devoted the space normally allotted to art matters to extensive coverage of the Art-Union trial.

3. Theodore E. Stebbins, Jr., in *Close Observation; Selected Oils Sketches by Frederic E. Church* [exh. cat.] (Washington: Smithsonian Institution Press, 1978), p. 18, wrote that "there seem to be no preliminary drawings and possibly one oil sketch . . . which is undetailed and atmospheric. . . ." The oil sketch Stebbins refers to was probably the product of Church's 1856 visit to the mountain.

4. *Life in the Open Air and Other Papers* (Boston: Ticknor and Fields, 1863), pp. 50, 55. For a useful, although not entirely reliable, overview of Church's visits to Mount Katahdin, see Myron H. Avery, "The Artists of Katahdin; American Mountain Painters III; Frederic Edwin Church," *Appalachia* 10 (December 1944): 147–54.

5. Winthrop, *Life in the Open Air,* pp. 96–97. Church and Winthrop stayed with the same Mr. Hunt when they visited the mountain in 1856; see "Going to Mount Katahdin," *Putnam's Monthly* 8 (September 1856): 247. See also "Arbor Ilex" [A. L. Holley], "Camps and Tramps about Ktaadn," *Scribner's Monthly* 16 (May 1878): 37, which refers to " 'the farm,' or 'Hunt's,' where hay and vegetables were raised in the early lumbering days."

6. Winthrop, *Life in the Open Air,* p. 97. Such rainy

weather was common in the vicinity of the mountain. For an interesting and informative account of an earlier ascent, see J. W. Bailey, "Account of an Excursion to Mount Katahdin, in Maine," *The American Journal of Science and Arts* 32 (July 1837): 20–34; a shorter version of this article appeared in *Maine Monthly Magazine* 1 (June 1837): 544–47.

7. "Ktaadn and the Maine Woods," *The Union Magazine* (1848); reprinted in *The Maine Woods* (New York: Thomas Y. Crowell, 1961; Apollo ed., 1966).

8. Bailey, "Account of an Excursion to Mount Katahdin," p. 20; "Ktaadn and the Maine Woods," p. 4.

9. "Ktaadn and the Maine Woods," p. 14. Bailey recounts similar difficulties in making the journey; see pp. 28, 31–32.

10. "Ktaadn and the Maine Woods," p. 18.

11. Ibid., p. 86. Other accounts (e.g., Bailey, pp. 22 and 24) stressed that a visit to Mount Katahdin meant leaving civilization behind.

12. Ibid., pp. 91–92. Bailey (p. 33) noted the almost complete absence of sound in the region: "A solemn stillness reigned upon these lakes, broken only by the sound of our paddles, the wild laugh of a loon, or cry of a white eagle."

13. "Ktaadn and the Maine Woods," p. 106. For a good discussion of Thoreau's experiences on Katahdin see Roderick Nash in *Wilderness and the American Mind,* rev. ed. (New Haven: Yale University Press, 1973), pp. 90–95. See also, Cecilia Tichi, *New World, New Earth: Environmental Reform in American Literature from the Puritans through Whitman,* (New Haven and London: Yale University Press, 1979), pp. 159–167.

14. See the author's "Myth, Allegory, and Science: Thomas Cole's Paintings of Mount Etna," *Arts in Virginia* 23 (1983): 15.

15. Bailey, "Account of an Excursion to Mount Katahdin," pp. 26, 30; "Going to Mount Katahdin," p. 250.

16. "The Fine Arts. The Exhibition of the National Academy," *The Literary World* 12 (April 1853): 358. For similar cupola-topped textile mills (e.g., Slater's Mill, Pawtucket, Rhode Island, Crown Mill, North Uxbridge, Massachussetts, Cheshire Mill, Harrisville, New Hampshire), see William H. Pierson, Jr., "The New Industrial Order: The Factory and the Factory Town," in *American Buildings and their Architects: Technology and the Picturesque* (Garden City, New York: Doubleday and Co., 1978), pp. 28–90. One aspect of American civilization that Church, unlike some of his contemporaries, never portrayed in his paintings was the railroad. Perhaps it, like the sawn tree stump, was potentially too troublesome in its implications to find an easy place in his pastoral landscapes.

17. "Fine Art," *Putnam's Monthly* 1 (June 1853): 701.

18. Thoreau, "Ktaadn and the Maine Woods," p. 104.

19. Theodore E. Stebbins, Jr. ("American Landscape: Some New Acquisitions at Yale," *Yale University Art Gallery Bulletin* 33 [Autumn 1971]: 16) has noted this transformation of the wilderness and considers *Mount Ktaadn* to be Church's last great pastoral painting. More recently, David Huntington ("Church and Luminism," in Wilmerding, et al., *American Light,* p. 160) has observed: "The youth at the foot of the tree in Mt. Ktaadn . . . envisages Maine's interior as it will be in his manhood, a 'middle ground' (to quote Leo Marx) between the city and wilderness." My discussion of the painting is, in large measure, an expansion of Stebbins' and Huntington's observations.

20. Leo Marx, *The Machine in the Garden; Technology and the Pastoral Ideal in America* (New York: Oxford University Press, 1964; reprint ed., 1977), especially pp. 105–16.

21. Ibid., pp. 106–7. My synopsis is based on that of Marx.

22. Quoted in Earl A. Powell III, "Thomas Cole and the American Landscape Tradition: The Naturalist Controversy," *Arts Magazine* 52 (February 1978): 114. Dwight, who was president of Yale College, was describing his impressions of the Connecticut River Valley in 1803.

23. See Roger Stein, *Susquehana: Images of the Settled Landscape* [exh. cat.] (Binghamton: Roberson Center for the Arts and Sciences, 1981), especially pp. 11–15, for an excellent discussion of the "settled landscape" tradition that coexisted with the more familiar wilderness aesthetic. The complexity of American attitudes toward nature in this period has been examined by Bernard Rosenthal in *City of Nature; Journeys to Nature in the Age of American Romanticism* (Newark, Del.: University of Delaware Press, 1980). Rosenthal's study provides an important alternative interpretation to that found in the now classic studies

of wilderness and American thought by Perry Miller and Henry Nash Smith. Indeed, Rosenthal has gone so far as to suggest that perhaps the "most pervasive" vision of American nature in this period "recounted the transformation of nature into its purest form, civilization" (pp. 17–18).

24. "Essay on American Scenery," *The American Monthly Magazine* 1 (January 1836); reprinted in John McCoubrey, *Sources and Documents in American Art, 1700–1960* (Englewood Cliffs: Prentice-Hall, Inc., 1965), pp. 108–9.

25. *American Landscape* (New York: Elam and Bliss, 1830), p. 16; quoted in James C. Moore, "The Storm and the Harvest: The Image of Nature in Mid-Nineteenth Century American Painting," (Ph.D. dissertation, Indiana University, 1974), p. 29.

26. The appeal that the middle landscape held for Americans was not limited to descriptions in literature and depictions in paintings. Consider, for example, A. J. Davis's Llewellyn Park, in Orange, New Jersey (built in the 1850s) as described by Pierson (*American Buildings and their Architects*, p. 430): "a suburban community intended, as advertised in its day, to provide 'country houses for city people.' Within one hour of New York City by railroad and ferry, it offered the harried businessman an escape from the tensions and pressures of the city in the tranquility of a forest retreat."

27. "Editor's Table; Exhibition of the National Academy of Design," *The Knickerbocker* 42 (July 1853): 94.

28. Letter II, *The Crayon* 1 (17 January 1855): 34.

29. I am indebted to Moore's stimulating "The Storm and the Harvest" (see note 25) for information about the associations evoked by the various types of trees (pp. 112–25).

30. Cole, "Essay on American Scenery," p. 107.

31. *Star Papers: or, Experiences of Art and Nature* (New York: J. C. Derby, 1855), p. 135.

32. Ibid., p. 273.

33. Bailey, "Account of an Excursion to Mount Katahdin," p. 22, lists the trees that grew in the area.

34. Henry T. Tuckerman, "To an Elm," in Rufus Griswold, ed., *Readings in American Poetry* (New York: John C. Riker, 1843), pp. 260–61.

35. Holley, "Camps and Tramps about Ktaadn," p. 33.

36. Moore, "The Storm and the Harvest," pp. 114–15.

37. See Wayne Craven, "Asher B. Durand's Imaginary Landscapes," *Antiques* 116 (November 1979): 1121–22, and Lawall, *Durand*, pp. 47–50.

38. "Editor's Table," p. 95. See Craven, "Durand's Imaginary Landscapes," pp. 1125–26, for an analysis of *Progress*. The expansive vigor and heroic intent of *Progress* are atypical of Durand and suggest the influence of Church's *New England Scenery* of 1851.

39. "Letter IV," *The Crayon* 1 (1855): 98.

40. The events of their journey are thoroughly recorded in Huntington, *Church*, pp. 39–49, and Idem, "Landscape and Diaries: The South American Trips of F. E. Church," *The Brooklyn Museum Annual* 5 (1963–64): 83–86. For a somewhat different perspective on Church's first South American trip, see Virginia Lee Wagner, "The South American Landscapes of Frederic Edwin Church," (M.A. thesis, University of Delaware, 1981).

41. Wagner, "South American Landscapes," pp. 1–2.

42. *Cosmos: Sketch of a Physical Description of the Universe*, vol. II, Edward Sabine, trans. (London: Longman, Brown, Green, and Longmans, and John Murray, 1848), p. 89.

43. Ibid., p. 86.

44. Ibid., p. 84.

45. Ibid., pp. 89–90.

46. Ibid., p. 85.

47. Letter from Church to his sister Elizabeth, 23 July 1853, Joseph Downes Manuscript and Microfilm Collection, Henry Francis DuPont Winterthur Museum, Delaware.

48. See Huntington, *Landscapes*, fig. 26. The sketchbook is owned by the Cooper-Hewitt Museum.

49. Humboldt, *Cosmos*, p. 84; "Influence of Climates," *The Home Journal*, 23 June 1849, second page. The article in *The Home Journal* is a series of quotations from "Guyot's Lectures on Comparative Physical Geography as translated by Professor Felton." It reads like a gloss on Humboldt, but he, of course, had not invented the notion of climate zones and their influence. For a discussion of the development of climate theory in the eighteenth century, see Clarence J. Glackens, *Traces on the Rhodian Shore* (Los Angeles: University of California Press, 1967), pp. 551–622. For a brief discussion of Arnold Guyot and his influential book, *The Earth and Man* (1849), see Tichi, *New World, New Earth*, pp. 221–23.

50. *The Diary of George Templeton Strong*, Allan Nevins

and Milton Halsey Thomas, eds., vol. 2 (New York: The Macmillan Co., 1952), pp. 215–16.

51. *Book of the Artists,* p. 371.

52. Cowdrey, *NAD,* p. 81.

53. "Academy of Design (Seventh Article)," *New York Evening Mirror,* 18 April 1854, p. 2. I am very grateful to Gerald Carr for providing me with a copy of this important review, which he was the first to locate.

54. Usually called simply *Sunset Landscape* today, it is possible to establish the painting's correct title from the description provided by the review cited above.

55. "Fine Arts; National Academy of Design (Second Article)," *The Albion,* 15 April 1854, p. 177; "Editorial Notes—Fine Arts," *Putnam's Monthly* 2 (May 1854): 567.

56. "Editor's Easy Chair," *Harper's New Monthly Magazine* 8 (May 1854): 846.

57. "The Fine Arts; Exhibition of the National Academy (Second Article)," *New-York Daily Tribune,* 22 April 1854, p. 6.

58. Ibid.

59. "Editorial Notes—Fine Arts," *Putnam's,* p. 567; "Fine Arts," *The Albion,* p. 177.

60. For a reproduction and discussion of *Scene in Vermont,* see Franklin Kelly and Gerald L. Carr, *The Early Landscapes of Frederic Edwin Church, 1845–1854* (Fort Worth, Texas: Amon Carter Museum, 1987), pp. 123–24.

61. "Fine Arts. National Academy of Design (Second Notice)," *The Albion,* 15 April 1854, p. 177.

62. Another of the South American pictures Church exhibited at the Academy in 1855, *Tequendama Falls* (Cincinnati Art Museum), would also seem to borrow its general composition from a northern work. In this case, the great, looming walls of carefully detailed rock and the low vantage point have their precedent in the *Natural Bridge* Church painted for Cyrus Field in 1852 (University of Virginia Art Museum).

63. Adam Badeau, *The Vagabond* (New York: Rudd and Carleton, 1859), pp. 154–55.

64. *Cosmos,* 2: p. 91.

65. "Letters on Landscape Painting, No. V," *The Crayon* 1 (7 March 1855): 146.

## Notes—Chapter 5.

1. "Sketchings; The National Academy of Design," *The Crayon* 4 (July 1857): 222. This reviewer found the picture "striking and bewildering" in its fusion of intricate detail with vast space. *The Andes of Ecuador* was first exhibited at the Boston Atheneum in 1855; it was not publicly shown in New York until it appeared in the National Academy exhibition of 1857.

2. Roderick Nash, *Wilderness and the American Mind,* rev. ed. (New Haven and London: Yale University Press, 1973), p. 96.

3. "Chesuncook," in *The Maine Woods* (New York: Thomas Y. Crowell Co., 1961; Apollo ed., 1966), p. 157. This essay originally appeared in *The Atlantic Monthly* in 1858.

4. Ibid., p. 201.

5. Ibid., p. 205; see also Nash, *Wilderness,* pp. 102–3.

6. Nash, *Wilderness,* pp. 31, 104–5.

7. *Man and Nature; or, Physical Geography as Modified by Human Action* (New York: Charles Scribner, 1864), p. 35. Church owned a copy of this book, and it is still in the library at Olana today. Marsh had earlier expressed many of these same ideas in public lectures.

8. See especially his chapter 3, "The Woods," pp. 128–329.

9. Marsh, *Man and Nature,* p. 5.

10. Ibid., p. 49.

11. "The Fine Arts; The National Academy; A First View; Durand and the Landscapes," *The Literary World,* 27 April 1850, p. 424.

12. Noble, *Cole,* pp. 44–45.

13. Ibid., p. 219.

14. Nash, *Wilderness,* p. 96.

15. "Sketchings; Exhibition of the National Academy of Design, No. III," *The Crayon* 1 (11 April 1855): 234.

16. The fourteen "chapters" are "The Threshold," (14 March 1855): 163–65; "A Forest Episode," (21 March): 180–81; "The Camp," (28 March): 194–95; "Smooth Water Fishing," (11 April): 227–28; "The River," (18 April): 242–43; "A Heavy Draught," (25 April): 258–59; "The Rapids," (2 May): 275–76; "Up Stream," (9 May): 291–92; "The Hunter's Home," (16 May): 307–8; "A Hunt," (23 May): 324–25; "Clear River Falls," (30 May): 338–39; "A Home in the Woods," (6

June): 355–56; "Dolce Far Niente," (21 June): 387–88; and "Erratics," 2 (4 July): 5–6.

17. "Letter II," *The Crayon* 1 (17 January 1855): 34–35.

18. "Sketchings; Exhibition of the National Academy of Design; No. III," p. 234.

19. Few details are known concerning Church's trip of 1854. According to a letter to Mrs. Thomas Cole from Church's sister Elizabeth of 22 August 1854 (Albany Institute of History and Art), the artist was planning to visit the Bay of Fundy: "a very few days more with us [i.e., Church's family in Hartford] and then commenced his journey to the Bay of Fundy." Elizabeth wrote that Church had been gone about a week and that she expected a letter soon. There was rumored to have been an outbreak of cholera in the region of St. John's, New Brunswick, where Church was planning to catch a boat for the trip "to the extreme end of the Bay." It is possible that Church elected to avoid the risk and did not, in fact, make the trip to the Bay. For a brief account of Church's 1855 visit to Mount Desert, see Huntington, *Church,* pp. 50–54.

20. "Sketchings," *The Crayon* 1 (3 January 1855): 12. Church was attempting to sell this painting for Mrs. Cole. There are presently two major works by Cole at Olana, *Solitary Lake in New Hampshire* (1831; painted over *Hagar in the Wilderness* of 1829) and *View of the Protestant Burying Ground, Rome* (1834), either of which might conceivably be the work referred to in 1855, although the two works cited in the following reference are more likely candidates.

21. "Sketchings," *The Crayon* 3 (January 1856): 30.

22. In all recent publications the painting has been referred to as *Sunset,* and it was exhibited under that title in the 1966 Church exhibition (*Frederic Edwin Church* [Washington: National Collection of Fine Arts, 1966], p. 48). However, it is listed in Erastus Palmer's account book as *Twilight* (I am grateful to Professor J. Carson Webster for providing me with information concerning Palmer's ownership of the painting), and it was exhibited under that name in 1859; see *Second Annual Exhibition at the Rooms of the Young Men's Association in the Atheneum, Troy* (Troy: George Abbot's Steam Press, 1859), no. 8. However the issue becomes confused by 1864, when

the picture was exhibited as *Sunset;* see *Catalogue of Painting and Sculpture Exhibited at Palmer's Studio in Aid of the United States Sanitary Commission* (Albany: Van Benthuysen's Steam Printing House, 1864), no. 5. In 1865, it was once again exhibited as *Twilight* (*Catalogue of Paintings, Statuary, Etc. in the Art Department of the Great North-Western Fair* [Chicago: n. p., 1865], no. 53, p. 4). From the foregoing evidence, it seems most likely that the painting's proper title is *Twilight.* "Domestic Art Gossip," *The Crayon* 2 (21 November 1855): 330, notes that Palmer "has in Mr. Church's studio a fine medallion head, which although a portrait, is sufficiently ideal in its treatment to be called an ideal subject." An entry for 7 November 1855 in Palmer's account book noted that Church owed two hundred dollars for this relief; the account was marked "paid" in February 1856 by *Twilight.*

23. *Frederic Edwin Church,* (1966), p. 48.

24. *Second Annual Exhibition, Troy,* no. 8.

25. Gwendolyn Owens has recently analyzed the composition of *Twilight* as "a use of space [that] contradicts the norm of the period in which the spatial relationships are generally carefully and unambiguously laid out." See *Golden Day Silver Night: Perceptions of Nature in American Art, 1850-1910* [exh. cat.] (Ithaca: Herbert F. Johnson Museum of Art, 1982), p. 35.

26. See, e.g., *South American Landscape,* in *Lines of Different Character: American Art from 1727 to 1947* [exh. cat.] (New York: Hirschl and Adler Galleries, 1982), p. 32. Like *Twilight,* this painting has a body of water in the foreground, a small waterfall, and a steeply elevated middleground running parallel to the picture plane. In the distance, the smoking cone of a volcano (probably Cotopaxi) takes the place of the cottage chimney.

27. This may be the painting entitled *Twilight on Lake George* Church exhibited in Washington, D. C., in late 1857 and early 1858; see *Catalogue of the Second Annual Exhibition of the Washington Art Association* (Washington: Henry Polkihorn, 1857), no. 25, and "Opening of the Art Exhibition," *Daily National Intelligencer,* 16 December 1857, p. 3. However, I have not found a description that would verify this assumption. The other major Washington paper, *The Evening Star,* mentions the exhibition, but apparently

did not review it; other brief notices are found in: "Sketchings; Exhibitions," *The Crayon* 5 (April 1858): 115, and "Washington Art Association Exhibition," *The Cosmopolitan Art Journal* 2 (March-June 1858): 140–41, which includes a quotation from the article in the *Daily National Intelligencer* cited above. At the time of the Washington exhibition, *Twilight on Lake George* was owned by "A. K. Smith."

28. *The Works of John Ruskin,* eds. E. T. Cook and Alexander Wedderburn, vol. 36: *Letters I, 1827–1869* (London: George Allen, 1909), p. 495. Ruskin was writing to Charles Eliot Norton (15 August 1865) and describing Church's *Cotopaxi.* Despite his words of praise, Ruskin concluded that Church did "not know yet what painting means, and I suppose he never will, but he has a great gift of his own."

29. *Sunset* seems not to have been exhibited during the 1850s or 1860s and was probably retained by Church rather than sold. The first exhibition of which I am aware in which it appears was held in Utica, New York in 1879; see *Catalogue of the Seventh Exhibition of Paintings Now Open at the Utica Art Association* (Utica: Ellis Roberts and Co., 1879), no. 82. The painting is listed as being owned by Church, but for sale at two thousand dollars. It was purchased by Mrs. James Watson Williams of Utica, who gave it to her son-in-law, Frederick T. Proctor, who gave it the Munson-Williams-Proctor Institute. Church may have retained the painting from the time it was painted until it was sold in 1879.

30. See, e.g., his long description of the sunset of 23 July 1852, which is both accurate in its details and poetic in its vivid language, in *The Writings of Henry David Thoreau,* eds. Bradford Torrey and Franklin Benjamin Sanborn, vol. 10: *Journal 4* (Boston and New York: Houghton, Mifflin and Co., 1906), pp. 248–49.

31. The trip is recounted in Winthrop's book *Life in the Open Air* (in *Life in the Open Air and Other Papers* [Boston: Ticknor and Fields, 1863]). Winthrop refers to Church as "Iglesias" (from the Spanish "iglesia," meaning church) throughout the book. On Winthrop see Elbridge Colby, *Theodore Winthrop* (New York: Twayne Publishers, 1965); George William Curtis, "Theodore Winthrop," *The Atlantic Monthly* 8 (August 1861): 242–51 (reprinted as the preface to Winthrop's novel *Cecil Dreeme* [Boston: Ticknor and

Fields, 1861]); and Eugene T. Woolf, *Theodore Winthrop: Portrait of an American Author* (Washington: University Press of America, 1981).

Huntington, *Church,* provides an excellent discussion of Church and Winthrop's trip, using numerous quotations from *Life in the Open Air.* In his subsequent *Landscapes,* Huntington discusses *Sunset* in relation to the trip, making many insightful observations (pp. 73–78). My own discussion is strongly indebted to Huntington's work, and some duplication is inevitable. In relating various passages from *Life in the Open Air* to the picture, I have endeavored to expand on Huntington's discussion.

32. Curtis deserves further study, because he was perhaps the most intelligent art critic in America before James Jackson Jarves. For a brief discussion of his importance, see John Simoni, "Art Critics and Criticism in Nineteenth Century America," (Ph.D. dissertation, Ohio State University, 1952), p. 1821. See also Edward Cary, *George William Curtis* (Boston and New York: Houghton, Mifflin, and Co., 1894), and Gordon Milne, *George William Curtis and the Genteel Tradition* (Bloomington: Indiana University Press, 1956).

33. *Life in the Open Air,* p. 50.

34. Ibid.

35. Ibid., p. 4.

36. Ibid., p. 6. One wonders if Winthrop's sarcastic dismissal of the Adirondack region as the province of "tyros" might not have been aimed at "The Wilderness and its Waters," which had been published in *The Crayon* the year before his trip with Church and which described experiences in the Adirondacks.

37. *Life in the Open Air,* p. 6.

38. Ibid., p. 7

39. Ibid., pp. 7–8.

40. Ibid., p. 18.

41. Ibid., p. 9.

42. Ibid., p. 30.

43. Ibid., p. 50.

44. Ibid., p. 57.

45. Ibid., p. 59.

46. Ibid., p. 67.

47. Ibid., p. 71.

48. Ibid., p. 108.

49. Ibid., p. 119.

50. Ibid., p. 103.

51. There are, in fact, no oil sketches that can be securely dated to the 1856 trip, although numerous small drawings on light green paper now at the Cooper-Hewitt Museum may well have formed a sketchbook that Church had with him on the trip. These sketches are primarily of sunsets, trees, and various details of scenery. They are quite summary and lack the detailed precision of most of his pencil drawings.

52. Huntington, *Landscapes,* p. 77 and fig. 59, relates a pencil drawing, now at Olana, inscribed "Spruce, Aug. 1851," to the tree in *Sunset.*

53. Ibid., p. 77.

54. "Trees in Assemblages," *The Atlantic Monthly* 8 (August 1861): 129.

55. Winthrop, *Life in the Open Air,* p. 42.

56. Ibid., p. 102.

57. Ibid., p. 58.

58. Ibid., pp. 75–76.

59. "The National Academy of Design," *Putnam's Monthly* 5 (May 1855): 506.

60. *The Crayon* 1 (14 February 1855): 98.

61. For a discussion of this painting, which may be the one entitled *A Tropical Morning* that Church exhibited at the National Academy in 1856, see the author's "Frederic Church in the Tropics," *Arts in Virginia* (1987): 16–33.

62. E.g., *South American Landscape* (1856, Currier Gallery of Art) and its companion, *North America* (location unknown), which were painted for John Earl Williams. See *19th Century American Painting from the Collection of Henry Melville Fuller* [exh. cat.] (Manchester, N. H.: The Currier Gallery of Art, 1971), p. 30. Church's friend Louis Remy Mignot also painted such pairs; see "Sketchings. Domestic Art Gossip," *The Crayon* 7 (March 1860): 83.

63. See Huntington, *Church,* pp. 85–96, and *Landscapes,* pp. 1–4, 64–71. More recently, Jeremy Elwell Adamson, in his "Frederic Church's 'Niagara': The Sublime as Transcendence," (Ph.D. dissertation, University of Michigan, 1981), has provided a thorough and thoughtful analysis of *Niagara.*

64. See Elizabeth McKinsey, *Niagara Falls: Icon of the American Sublime* (Cambridge: Cambridge University Press, 1985) and Jeremy Elwell Adamson, et al., *Niagara: Two Centuries of Changing Attitudes, 1697–1901* [exh. cat.] (Washington: Corcoran Gallery of Art, 1985).

65. On this trip, see Huntington, *Church,* pp. 97–105; *Landscapes,* pp. 44–48; and Idem, "Landscape and Diaries: The South American Trips of F. E. Church," *The Brooklyn Museum Annual* 5 (1963–1964): 86–93.

66. "Landscape and Diaries," p. 86.

67. Ibid., pp. 86–87.

68. "Sketchings," *The Crayon* 5 (January 1858): 24.

69. On the Tenth Street Studio, see T. B. Aldrich, "Among the Studios, No. 1," *Our Young Folks* 1 (September 1865): 594–98; Mary Sayre Haverstock, "The Tenth Street Studio," *Art in America* 54 (September-October 1966): 48–57; and Garnett Mc Coy, "Visits, Parties, and Cats in the Hall: The Tenth Street Studio Building and its Inmates in the Nineteenth Century," *Journal of the Archives of American Art* 6 (January 1966): 1–8.

70. Annette Blaugrund, "The Tenth Street Studio Building: A Roster, 1857–1895," *The American Art Journal* 14 (Spring 1982): 67–71. Blaugrund is completing a dissertation for Columbia University on the Studio Building.

71. Aldrich, "Among the Studios," p. 596.

72. An Old Contributor [Henry T. Tuckerman], "New-York Artists," *The Knickerbocker* 48 (July 1856): 33.

73. Huntington, *Landscapes,* p. 50.

74. "Mr. Church's New Picture," *The New York Times,* 28 April 1859, p. 4.

75. Huntington, *Church,* pp. 1–13; *Landscapes,* pp. 5–9, 50–53.

76. See Gerald L. Carr, *Frederic Edwin Church: The Icebergs* [exh. cat.] (Dallas: Dallas Museum of Fine Arts, 1980), pp. 23–30, for an excellent discussion of this type of exhibition in the context of the European "Great Picture" tradition. See also Kevin J. Avery, "Frederic Church's *The Heart of the Andes* Exhibited," *American Art Journal* 18 (1986): 52–72.

77. Noble, *Church's Painting, The Heart of the Andes* (New York: D. Appleton and Co., 1859); Theodore Winthrop, *A Companion to the Heart of the Andes* (New York: D. Appleton and Co., 1859); reprinted in *Life in the Open Air and Other Papers,* pp. 329–74; citations given here are from a facsimile reprint of Winthrop's original pamphlet (New York: Olana Gallery, 1977).

78. "A Visit to the 'Heart of the Andes'," *Spirit of the Times,* 26 November 1859, p. 500. This account dates

from the painting's second New York exhibition. A
very complimentary review from the first showing is
found in ibid., 14 May 1859, p. 157.

79. Huntington, *Church,* p. 10.

80. Ibid., p. 5.

81. T[heodore] L[edyard] C[uyler], "Church's 'Heart of
the Andes'," *Littel's Living Age* 62 (2 July 1859): 64;
reprinted from the *Christian Intelligencer.* Cuyler was
a well-known Presbyterian minister in New York and,
later, in Brooklyn, who wrote numerous articles and
reviews for the religious press.

82. *Companion,* p. 4.

83. Elizabeth Stevens, review of Huntington, *Landscapes,*
in *Arts Magazine* 40 (April 1966): 72.

84. *Companion,* p. 6.

85. Ibid., p. 4.

86. Cuyler, "Church's 'Heart of the Andes'," p. 64.

87. *Companion,* p. 12.

88. Ibid., pp. 13–42; this analysis made up most of the
*Companion.*

89. Ibid., p. 43.

90. Ibid., p. 1.

91. Curtis, "Theodore Winthrop," p. 244. According to
George Templeton Strong (entry for 5 May 1859 in
*The Diary of George Templeton Strong,* eds. Allan
Nevins and Milton Halsey Thomas, vol. 2 [New
York: The Macmillan Co., 1952], p. 450.), Winthrop
was in these days "letting off gas about atheism . . .
and giving judgement on heaven and earth and all
things visible and invisible, and generally puts their
alleged creator out of court in a summary way." If
Winthrop did tend toward atheism, Church certainly
did not, for he was a regular church-goer during his
years in New York.

92. Cuyler, "Church's 'Heart of the Andes'," p. 64.

93. "The Heart of the Andes," *The Christian Examiner*
68 (March 1860): 279, 298. Although ostensibly a re-
view of the pamphlets of Noble and Winthrop, this
article is, in fact, a thirty-two page discourse on the
painting itself.

94. "Church's Heart of the Andes," *Russell's Magazine* 5
(August 1859): 427.

95. "Blanche d'Artois," "World of Art; 'The Heart of the
Andes'," *Leader* (New York), 28 May 1859; quoted in
Carr, *Icebergs,* p. 61.

96. Barbara Novak, ed., *The Thyssen-Bornemisza Col-*

*lection: Nineteenth-century American Painting* (New
York: The Vendome Press, 1986), pp. 94–95.

97. Noble, *Church's Painting,* p. 4.

98. Ibid., p. 21.

## Notes–Chapter 6.

In the following notes initial citations for reviews of
*Twilight in the Wilderness* are given in full, fol-
lowed by the number in the Appendix for a com-
plete transcript of the same review. Subsequent
references appear as follows: name and date of the
newspaper or periodical (e.g., *Times,* 7 June 1860),
followed by the number for the transcript in the
Appendix.

1. "Mr. Church's Last Picture," *New-York Times,* 7
June 1860, p. 4 (Appendix, no. 3).

2. "Art Gossip," *The Cosmopolitan Art Journal* 4 (Sep-
tember 1860): 126.

3. Advertisements for the picture appeared frequently in
New York newspapers and journals; see, e.g., *The
Albion,* 9 June 1860, p. 270. The wording of these
notices offered an opportunity for satire that was not
overlooked by *Vanity Fair:* "An advertisement reads,
On View for a Short Time/Twilight in the Wilder-
ness. The first part of the sentence is quite superflu-
ous we think—twilight being generally on view for a
few minutes only at any time" ("Over Particular,"
*Vanity Fair,* 7 July 1860, p. 24).

4. At Olana there is a letter of that date postmarked 32
Beekman Street.

5. These drawings are now in the Cooper-Hewitt
Museum.

6. See Theodore E. Stebbins, Jr., *American Master
Drawings and Watercolors* (New York: Harper and
Row, 1976), p. 129.

7. "National Academy of Design; No. 3," *Spirit of the
Times,* 14 May 1859, p. 157. Although primarily a
journal of the "turf" (i.e., horse racing), *Spirit of the
Times* does include art reviews, many of which are
very useful and informative.

8. Huntington, *Church,* p. 137. See, e.g., fig. 97, p.
102, in Stebbins, *Close Observation;* this sketch is
identified as depicting Hudson, New York (the clos-

est town to Olana), but I know of no evidence to support this assumption. It is difficult to see the buildings in these sketches, but they appear to be part of a substantial urban area, which could easily be New York. Annette Blaugrund, who is preparing a dissertation on the Tenth Street Studio Building, has informed me that she cannot positively identify the buildings, but it is possible they may have been in the vicinity of the Tenth Street Studio.

9. Other New York artists may have sketched this same sunset; see "Art Items," *New-York Tribune,* 16 December 1865, p. 4. I am grateful to Gerald Carr for providing me with a photocopy of this reference.

10. The storm was reported in detail in the papers for Tuesday, June 22. See, e.g., "A Great Storm in New-York," *New-York Daily Tribune,* 22 June 1858, p. 5.

11. *New-York Times,* 22 June 1858, p. 1.

12. See, e.g., "Exhibition of the National Academy of Design; Second Article," *New-York Daily Tribune,* 13 May 1859, p. 7. Brief complimentary notices, in addition to that in the *Spirit of the Times,* are found in: "Fine Arts; National Academy of Design; Second Notice," *The Albion,* 14 May 1859, p. 237; and "National Academy of Design," *The Crayon* 6 (May 1859): 153; see also "National Academy of Design; Second Notice," *The Crayon* 6 (June 1859): 191.

13. "National Academy of Design," *Supplement to the New-York Times,* 20 April 1859, p. 2.

14. Church and other New York artists had an opportunity to study a group of Turner's drawings in 1858; see "The British Gallery in New York," *The Atlantic Monthly* 1 (February 1858): 501–7.

15. "National Academy of Design," p. 2.

16. The painting was sold as *Sunset* at Sotheby Parke Bernet, Los Angeles, in 1978 (sale 229, 5–8 June, lot no. 541). It is signed and dated 1858 and inscribed on the reverse: "F. E. Church to E. D. Palmer/ Jan. 1 1859." Gerald Carr was the first to identify it correctly as *The Evening Star*; see "Beyond the Tip: Some Addenda to Frederic Church's 'The Icebergs'," *Arts Magazine* 56 (November 1981): 108.

17. "Domestic Art Gossip," *The Cosmopolitan Art Journal* 3 (March 1859): 87. The painting was exhibited under the title *The Evening Star* in 1864; see *Catalogue of Painting and Sculpture Exhibited at Palmer's Studio in Aid of the United States Sanitary Commis-*

*sion* (Albany: Van Benthuysen's Steam Printing House, 1864), no. 103. It has recently been suggested by Katherine Manthorne that Church's *Cross in the Wilderness* (figure 66) was also a memorial commissioned by a family that had recently lost an infant daughter; see her entry on the painting in Barbara Novak, ed., *The Thyssen-Bornemisza Collection: Nineteenth century American paintings* (New York: The Vendome Press, 1986), p. 94.

18. For Blake's poem, see *The Norton Anthology of Poetry* (New York: W. W. Norton, 1970), p. 525. Emerson's reference to the evening star is found in his "Goodbye, Proud World," in Rufus Griswold, ed. *Readings in American Poetry* (New York: John C. Riker, 1843), p. 210.

19. *Norton Anthology,* p. 662. Church owned numerous volumes of poetry, but whether or not he was familiar with Shelley's "Adonais" is unknown to me.

20. Ibid.

21. Ibid., p. 672.

22. *A Funeral Oration Occasioned by the Death of Thomas Cole Delivered Before the National Academy of Design* (New York: D. Appleton, 1848), p. 4. Church particularly admired the sky in Cole's late painting of *Prometheus Bound* (1846–47, private collection), and the serene and luminous atmosphere in his own painting strongly resembles that in his master's work. We should further note that in painting *The Evening Star* for Palmer, Church may have also drawn inspiration from the sculptor's exactly contemporary reliefs depicting the morning and evening stars; on these works see William H. Gerdts, *American Neo-Classic Sculpture: The Marble Resurrection* (New York: Viking Press, 1973), pp. 45, 86–87, and *Carved and Modeled: American Sculpture, 1810–1940* [exh. cat.] (New York: Hirschl and Adler Galleries, 1982), p. 28. Another of Church's longtime friends, the sculptor Edward S. Bartholomew, also executed an *Evening Star*; see "Edward S. Bartholomew," *The Cosmopolitan Art Journal* 2 (September 1858): 185, and Tuckerman, *Book of the Arts,* p. 611. Church and Bartholomew had known each other since boyhood; according to Tuckerman (p. 609), "They discussed art with each enthusiasm, read, studied, and dreamed of its divine possibilities, and mutually encouraged each other in self-dedication to its pursuit."

23. "Domestic Art Gossip," *The Cosmopolitan Art Journal* 3 (March 1859): 87, notes that Church and Palmer were planning to go to Europe for "study and recreation." Gerald Carr (*Frederic Edwin Church: The Icebergs*, [Dallas: Dallas Museum of Fine Arts, 1980], p. 36) has noted that Church may have planned to make this trip during the time that *The Heart of the Andes* was to be shown in London and Berlin. The artist hoped to meet with von Humboldt in Germany, but the scientist died on May 6, 1859, and his death may have been one factor in causing Church to cancel his trip.

24. W. P. B[ayley], "Mr. Church's Picture of 'The Icebergs'," *The Art-Journal* n. s. 2 (1 September 1863): 187.

25. Carr, *Icebergs,* pp. 34–42.

26. The best source of information on the trip remains Noble's *After Icebergs with A Painter: A Summer Voyage to Labrador and Around Newfoundland* (New York: D. Appleton and Co., 1861). See also Carr, *Icebergs,* pp. 43–54; Huntington, *Church,* pp. 116–28; and Idem, *Landscapes,* pp. 83–85.

27. Noble, *After Icebergs,* pp. 98–99.

28. Ibid., pp. 139–40.

29. "The North, Painted by F. E. Church, from Studies of Icebergs made in the Northern Seas, in the Summer of 1859" (broadside accompanying the painting when it was shown in New York and Boston); quoted in Huntington, *Landscapes,* pp. 86–87.

30. *Evening Post* (New York), 5 August 1859; quoted in Carr, *Icebergs,* p. 59.

31. "Sketchings; Domestic Art Gossip," *The Crayon* 7 (February 1860): 56–57. At this time, Church also was represented by three paintings in an exhibition in Troy, New York (*Twilight Scene, Cotopaxi,* and *Home of the Pioneer* [i.e., *Home by the Lake* of 1852]); see *Catalogue of the Third Annual Exhibition at the Rooms of the Young Men's Association in the Atheneum, Troy* (Troy: D. H. Jones, 1860), nos. 21, 32, 54.

32. Unlike the major works that immediately preceded and followed it (i.e., *Niagara, The Heart of the Andes,* and *The Icebergs*), *Twilight in the Wilderness* was a commissioned work. The patron was William Thompson Walters (1820–94), the wealthy Baltimorean who was actively collecting American art in the late 1850s. By 1858 he was commissioning works directly from artists such as Durand and Kensett. Walters generally left the subject of commissioned works up to the artist, and this was probably the case with *Twilight in the Wilderness.* Unfortunately, Walters' papers were destroyed in the great Baltimore fire of 1904. For a discussion of Walters and *Twilight in the Wilderness,* see the author's dissertation, pp. 293–97 and appendix A.

33. "The Artists' Reception in the 'Studio'," *New-York Daily Tribune,* 20 January 1860, p. 5. Church was, however, represented in the exhibition by a small painting of a volcano (see above, note 31) and one of the Castle of Chillon, which Cole had begun and he had finished. The latter work, according to the *Tribune,* "naturally excited great interest."

34. Church was well known for guarding his privacy and bolting his door while he was working on his important paintings; see Mary Sayre Haverstock, "The Tenth Street Studio," *Art in America* 54 (September-October 1966): 51.

35. *Book of the Artists,* pp. 385–86.

36. Letter to E. P. Mitchell, 14 December 1854, Gratz Collection, Historical Society of Pennsylvania, microfilm, Archives of American Art, Smithsonian Institution, roll P22. Another reference to Church "chalking" on a canvas (in this case, *The Icebergs*) is found in the *New York Times* for 22 December 1860; see Carr, *Icebergs,* p. 73. According to William Sidney Mount, Church, when beginning to paint a sky, did "the distant objects first" and "mixed up a set of sky tints of different gradations to facilitate his work" (diary entry, 1858; quoted in Alfred Frankenstein, *William Sidney Mount,* [New York: Harry N. Abrams, 1975], p. 316.).

37. *The Works of John Ruskin,* eds. E. T. Cook and Alexander Wedderburn, vol. 6, *Modern Painters, Volume Five* (London: George Allen, 1909), pp. 49–105.

38. "Frederic E. Church Dead; Famous Landscape Painter Passes Away in this City—His Career," *The New York Times,* 8 April 1900, p. 16.

39. *Staffa* was purchased by Lenox in 1845 and was the first oil by Turner in America. *Fort Vimieux* was purchased five years later; see Martin Butlin and Evelyn Joll, *The Paintings of J. M. W. Turner* (New Haven and London: Yale University Press, 1977), pp. 175, 180–81.

40. John Wilmerding, *A History of American Marine Painting* (Boston and Toronto: Little, Brown, and Co., 1968), p. 80.

41. Two additional sources of influence—meteorology and photography—may have played a role in the creation of *Twilight in the Wilderness*. Church was certainly aware of the new science of meteorology; as Tuckerman noted, throughout his life he was "attracted to the electrical laws of the atmosphere" (*Book of the Artists*, p. 371). There are numerous books on various meteorological subjects in the library at Olana. The carefully observed and meticulously conceived cloud formation in *Twilight in the Wilderness* may well indicate that Church, like John Constable, knew and understood the scientifically defined characteristics of different types of clouds. On Constable's awareness of cloud classification, see Kurt Badt, *John Constable's Clouds* (London: Rutledge and Kegan Paul, 1950), and Louis Hawes, "Constable's Sky Sketches," *Journal of the Warburg and Courtauld Institutes* 32 (1969): 344–65. Church may well have been aware of Constable's cloud studies, because Cole, after all, had visited the English painter's studio during his first trip to Europe.

    The role of photography in Church's art is considerably more problematic. It has often been stated that he used photographs of twilight skies as aids in composing *Twilight in the Wilderness;* Huntington (*Landscapes*, p. 79) was the first to make this suggestion. In Elizabeth Lindquist-Cock's dissertation of 1967, *The Influence of Photography on American Landscape Painting* (New York and London: Garland Publishing Co., 1977), an entire chapter is devoted to Church. She states (p. 120): "Church later used such photographic studies [of clouds] to furnish correct details in paintings like *Twilight in the Wilderness*." More recently, David Huntington has repeated his belief that Church used photographs when painting *Twilight* ("Church and Luminism," in Wilmerding, et al., *American Light*, p. 170). However, the twilight photographs he supposedly used (Olana collection) most likely postdate *Twilight in the Wilderness*. For a discussion of these photographs and the photographer, M. M. Griswold, see the author's dissertation, pp. 305–7.

    Another matter that has often been discussed in connection with *Twilight in the Wilderness* is the role played by chemical pigments, which supposedly made brighter colors available to artists around 1860. This, however, has been much overemphasized. Recent technical studies have shown that *Twilight in the Wilderness* was painted primarily with colors that had long been available (e.g., vermillion). For a discussion of this issue and a summary of technical information available on *Twilight,* see the author's dissertation, appendix C.

42. "Art Gossip," *The Cosmopolitan Art Journal* 4 (March 1860): 35.

43. "The Last Artists' Reception for the Season," *New-York Daily Tribune,* 27 March 1860, p. 8. Church also contributed nothing to the exhibition held in conjunction with the reception, but there is evidence that he was not devoting all of his time to *Twilight*. In a letter of 16 March 1860 to Theodore Winthrop (New York Public Library; quoted in Huntington, *Church,* pp. 128–29), he noted that he had been summoned for jury duty. Church worried that this would disrupt his work schedule: "If I am interrupted now— I should very probably be obliged to give up attempting the Icebergs until next winter which will be serious damage because I wished to commence it this season and after getting it fairly started lay it by for the summer months in order that I might see it with refreshed eyes next season."

44. Z., "Correspondence of the Transcript, New York, April 2, 1860," *Boston Evening Transcript,* 7 April 1860, p. 6. Allston's use of the term "apple green" occurs in *Monaldi: A Tale* (Boston: Charles C. Little and James Brown, 1841; reprinted in Nathalia Wright, ed., *Lectures on Art and Poems and Monaldi* [Gainesville, Fla.: Scholar's Reprints and Facsimiles, 1967], p. 7): "the bright orange of the horizon, fading into a low yellow, and here and there broken by a slender bar of molten gold, with the broad masses of pale apple-green blending above, and the sheet of deep azure over these, gradually darkening to the zenith. . . ." I am grateful to Elizabeth Garrity Ellis for her help in identifying the source for the Allston quote.

    On 26 April 1860, Church's agent, John McClure, wrote to him about *Twilight in the Wilderness* from Baltimore, where he was overseeing the exhibition of

*The Heart of the Andes* (letter at Olana). McClure wrote that he hoped the painting would live up to Church's expectations and asked when it would be finished. McClure also advised against exhibiting the painting in Baltimore, because the receipts from the showing of *The Heart of the Andes* had fallen short of his expectations and the press had been somewhat unsympathetic. He suggested that it be shown in New York instead and perhaps in London. It may well have been McClure who made arrangements with Walters to allow *Twilight* to be exhibited in New York before he took possession of it.

45. "Art Items," *Boston Evening Transcript,* 31 May 1860, p. 2. Much of Church's time was also occupied by preparations for his marriage to Isabel Carnes and their move to Hudson.

46. Z., "Letter from New York," *Boston Evening Transcript,* 5 June 1860, p. 1 (appendix no. 1).

47. "Art Matters; Mr. Church's New Picture, Twilight in the Wilderness," *New York Morning Express,* 7 June 1860, second page (appendix no. 2).

48. "Fine Arts," *The New York Herald,* 8 June 1860, p. 10 (appendix no. 4).

49. Ibid., and "Fine Arts," *The Albion,* 9 June 1860, p. 273 (appendix no. 5).

50. See, e.g., "Art Items," *The Evening Post* (New York), 22 June 1860, second page (appendix no. 11). There were, however, scattered negative reviews of *Twilight. The Cosmopolitan Art Journal* considered it "unworthy of the artist, being a mere piece of scene painting, which it was vanity to exhibit" ("Art Gossip," 4 [September 1860]: 126).

51. Noble was busy writing *After Icebergs* in the same period Church was painting *Twilight.* Winthrop's first draft of *Life in the Open Air* dates from the fall of 1856 (contemporary with Church's *Sunset*), but during 1859–61 he made extensive revisions while in his quarters in the Studio Building.

52. *A Companion to the Heart of the Andes,* pp. 4, 6.

53. *The New York Times,* 7 June 1860 (appendix no. 3).

54. See, e.g., *Boston Evening Transcript,* 5 June 1860 (appendix no. 1).

55. It is, in other words, a "typical" landscape as defined by Bernard Smith in *European Vision and the South Pacific, 1768–1850* (Oxford: Clarendon Press, 1960), pp. 4–5.

56. See W. P. Bayley, "Mr. Church's Pictures: Cotopaxi, Chimborazo, and The Aurora Borealis," *The Art-Journal* 4 (1 September 1865): 265–67. According to both Bayley and G. W. Curtis ("The Lounger; Cotopaxi," *Harper's Weekly,* 4 April 1863, p. 210), *Cotopaxi* and *Chimborazo* were painted as pendants to *The Heart of the Andes* (Bayley calls them a "triptic" [*sic*] and Curtis refers to them as "a series . . . which is nothing less than an epic of the tropics in color"). However, the great work of 1859 was unavailable for the London showing of 1865, and thus the *Aurora* was substituted.

57. "Mr. Church's Picture of 'The Icebergs'," *The Art-Journal* 2 (1 September 1863): 188.

58. *Book of the Artists,* p. 381.

59. "Essay on American Scenery," *The American Monthly Magazine* n.s. 1 (January 1836); quoted in John W. McCoubrey, ed., *American Art 1700–1960: Sources and Documents* (Englewood Cliffs, N. J.: Prentice Hall, 1965), p. 108.

60. *Boston Evening Transcript,* 5 June 1860 (appendix B, no. 1).

61. "Trees in Assemblages," *The Atlantic Monthly* 8 (August 1861): 130.

62. [George William Curtis], "The Lounger: Church's New Picture," *Harper's Weekly,* 14 July 1860, p. 435 (appendix B, no. 13). Curtis founded "The Lounger" column in *Harper's* in 1857 and continued it until December 1863. He touched on a variety of subjects, ranging from art to literature to music to theater. His art criticism of this period, although often informative, is far less incisive than that he wrote during his tenure at the *Tribune* in 1851–52. After all, he was no longer a professional critic, but rather a commentator on various aspects of the New York scene.

63. "Sketchings; Exhibition of the Academy of Design; No. II," *The Crayon* 1 (4 April 1855): 218. The association between columns and trees was , of course, a long-standing one in European architectural theory.

64. *A Companion to the Heart of the Andes,* p. 35; Huntington, *Landscapes,* p. 81.

65. *Boston Evening Transcript,* 5 June 1860 (appendix no. 1). This writer also mentioned autumn in his earlier notice on the picture (7 April 1860).

66. Quoted in Noble, *Cole,* pp. 41–42.

67. "Essay on American Scenery," in McCoubrey, *American Art,* p. 107.

68. (Philadelphia: C. Sherman and Sons, 1860 ed.) p. v.

69. "Fissures or cavities sometimes occur in a large rock, allowing a solitary tree that has become rooted there to attain its full proportions. It is in such places, and on sudden eminences that rise above the forest-level, on a precipice, for example, that overlooks the surrounding wood, that the forest shows individual trees possessing the character of standards. . . ." ("Trees in Assemblages," *The Atlantic Monthly,* p. 133).

70. *What May be Learned from a Tree,* p. 9.

71. Winthrop, *A Companion to the Heart of the Andes,* p. 34.

72. This ambiguous quality of the picture was noted by several reviewers; see, e.g., *Morning Express,* 7 June 1860 (appendix no. 2), which mentions "the melancholy, but pleasing influence" and the "loneliness" of the work. A long poem by a W. G. D.," ("Church's Picture, 'Twilight in the Wilderness'," *The Evening Post,* 21 June 1860 [appendix no. 10]) takes for its theme the mixing of hope and sorrow in the painting.

73. *Man and Nature; or, Physical Geography as Modified by Human Action* (New York: Charles Scribner, 1864), p. 49.

74. Quoted in Paul Shepard, *Man in Landscape: An Historic View of the Esthetics of Nature* (New York: Alfred Knopf, 1967), p. 93.

75. Vol. 2, p. 97.

76. Roderick Nash, *Wilderness and the American Mind,* rev. ed. (New Haven and London: Yale University Press, 1973), p. 106. It was early in 1860 that Church began acquiring the land near Hudson, New York that would become Olana, his own personal wilderness preserve. The artist would later champion the idea of a "grand international park" to be designed by Olmstead, although nothing ultimately came of the venture; see "Personal," *Daily Evening Transcript* (Boston), 6 March 1880, pp. 7–8.

77. Quoted in Nash, *Wilderness,* p. 106.

78. Entry for 8 July 1856, *The Diary of George Templeton Strong,* Allan Nevins and Milton Halsey, eds., vol. 2 (New York: The Macmillan Co., 1952), p. 284.

79. "The Portent," *Norton Anthology of Poetry,* p. 795.

80. [George William Curtis], "Theodore Winthrop," *The Atlantic Monthly* 46 (August 1861): 244.

81. Ibid. See also Huntington, "Church and Luminism," in Wilmerding, et al., *American Light,* p. 160.

82. "The American White Head or Bald Eagle," *The Crayon* 2 (July 1855): 25. Although it has frequently been stated that this is the only living creature in the scene, there is a line of birds flying above the water at the lower center of the composition.

83. Doreen Bolger Burke, "Frederic Edwin Church and 'The Banner of Dawn'," *The American Art Journal* 14 (Spring 1982): 46.

84. *A Companion to the Heart of the Andes,* p. 14.

85. Noble, *After Icebergs,* p. 25.

86. "Church's Heart of the Andes," *Russell's Magazine* 5 (August 1859): 426–27. This is the same review that calls *The Heart of the Andes* a "truly religious work of art."

87. F.G.S., "The Idea of a Picture," *The Crayon* 5 (February 1858): 65.

88. Quoted in Tuckerman, *Book of the Artists,* p. 232.

89. Ibid., p. 358.

90. "Ktaadn and the Maine Woods," *The Union Magazine* (1848); reprinted in *The Maine Woods* (New York: Thomas Y. Crowell, 1961; Apollo ed., 1966), p. 59.

91. "Twilight in the Wilderness," *Boston Evening Transcript,* 28 June 1860, p. 2 (appendix no. 12); *The Evening Post,* 21 June 1860 (appendix no. 10).

92. "Twilight in the Wilderness," *New York World,* 20 June 1860, p. 5 (appendix no. 9).

93. "Essay on American Scenery," in McCoubrey, *American Art,* p. 108.

94. Ibid., p. 100.

95. Carr, *Icebergs,* p. 63.

96. "Art Items," *New-York Daily Tribune,* 9 June 1860, p. 5 (appendix no. 7).

97. *New York World,* 20 June 1860 (appendix no. 9). *The Crayon* considered the title to be "poetical" ("Domestic Art Gossip," 7 [July 1860]: 204; appendix no. 14).

98. The term "wilderness," as used in the Bible, generally refers to any uncultivated, wild region. For a discussion of the term's usage, see *A Dictionary of the Bible,* vol. 4 (New York: Charles's Scribner's Sons, 1902), pp. 917–18.

99. Again, these were subjects of direct interest to Cole. He actually painted a large picture of *Christ After the*

*Temptation* (see William H. Gerdts, "Cole's Painting 'After the Temptation'," in *Studies on Thomas Cole*, pp. 102–11) and had considered painting a picture of the "Children of Israel in the Wilderness" ("Cole's List," in Ibid., p. 84).

100. *Boston Evening Transcript,* 28 June 1860 (appendix no. 12).

101. See Huntington, *Church,* 1960, pp. 165–66. Church also painted a small landscape depicting one of the areas associated with the wandering of the Children of Israel, *The Mountains of Edom* (private collection), upon his return to New York. In 1863 a writer in the *New-York Tribune* specifically mentioned the story of the Children of Israel when discussing *Cotopaxi.* He noted that volcanoes are "crested with the pillar of cloud by day and the pillar of fire by night, . . . pillars of warning rather than of guidance, like those which led the Israelites out of the land of bondage;" quoted in Huntington, "Church and Luminism," p. 180.

102. H. G. S., "Art Matters in Baltimore," *Boston Evening Transcript,* 4 March 1861, p. 1 (appendix no. 15). The story of Christ's temptation in the wilderness is recounted in Matthew 4: 1–12.

## Notes–Chapter 7.

1. See Gerald Carr, *Frederic Edwin Church: The Icebergs,* (Dallas: Dallas Museum of Fine Arts, 1980), pp. 80–96, for an excellent discussion of the initial showing of the painting and its subsequent exhibition in England. Church also painted in the fall of 1860 a small twilight picture for use as an illustration in a volume of poetry edited by John Williamson Palmer (*Folk Songs* [New York: Charles Scribner and Company, 1867]). Church's illustration accompanied Alfred, Lord Tennyson's "Evening." See *New-York Tribune,* 8 September 1860, p. 4 and "Personal," *The Home Journal,* 29 September 1860, p. 2.

2. [George William Curtis], "The Lounger; The Academy Again," *Harper's Weekly,* 13 April 1861, p. 226. See also "Art Gossip: National Academy of Design," *New York Times,* 22 March 1861, p. 2. For a reproduction of *The Star in the East,* see Carr, *The Icebergs,* p. 62.

3. "Beyond the Tip: Some Addenda to Frederic Church's 'The Icebergs'," *Arts Magazine* 56 (November 1981): 108.

4. Carr, *The Icebergs,* p. 80.

5. For contemporary references to *Our Banner,* see "Letter from New York," *Boston Evening Transcript,* 25 May 1861, p. 1; "Patriotic Art," *Boston Evening Transcript,* 5 June 1861, p. 2; and "Art Items," *New York Times,* 30 June 1861, p. 2. A pamphlet published with the chromolithograph included quotations from several well-known poems about the flag and from Francis Scott Key's "Star Spangled Banner" (copy in clipping file, New York Public Library).

6. *Boston Evening Transcript,* 5 June 1861, p. 1.

7. "Fine Arts; National Academy of Design; Second Notice," *The Albion,* 2 May 1863, p. 213.

8. See H., "Under Niagara," 19 February 1863, p. 2; "Under Niagara," 5 March 1863, p. 2; "Diogenes," "Church's Realism," 10 March 1863, p. 1; and "Aristotle," "Church's Realism," 16 March 1863, p. 1.

9. "Church's Realism," 16 March 1863, p. 1.

10. *The Art Idea,* ed. Benjamin Rowland, Jr., (Cambridge, Mass.: The Belknap Press of Harvard University Press, 1960; first published 1864), p. 195.

11. This is probably the painting exhibited at the National Academy in 1865 under the title *Twilight* and described (as "A New England Twilight") in H. B. H., "A Visit to the Studios of Some American Painters," *The Art-Journal* 48 (December 1865): 362–63. See also William M. Bryant, *Philosophy of Landscape Painting* (St. Louis: The St. Louis News Co., 1882), pp. 267–71, for a discussion of this painting when it was in the Charles Parsons collection in St. Louis.

12. Huntington, *Landscapes,* p. 62.

13. Quoted in Huntington, *Landscapes,* p. 114.

## Notes—Appendix.

1. This review was reprinted in the *Morning Courier and New-York Enquirer,* 9 June 1860, p. 2.

2. This same review also appeared in the *New York Evening Express* of the same date.

3. The quotation is from Coleridge's "Dejection: An Ode" (1802, 1817), second stanza:

A grief without pang, void, dark and drear,
  A stifled, drowsy, unimpassioned grief,

Which finds no outlet, not relief,
  In word, or sigh, or tear—
O Lady! in this wan and heartless mood,
To other thoughts by yonder throstle wooed,
  All this long eve, so balmy and serene,
Have I been gazing on the western sky,
  And its peculiar tint of yellow green:
And still I gaze—and with how blank an eye!
And those thin clouds above, in flakes and bars,
That give away their motion to the stars;
Those stars, that glide behind them or between,
Now sparkling, now bedimmed, but always seen:
Yon crescent Moon, as fixed as if it grew
In its own cloudless, starless lake of blue;
I see them all so excellently fair,
I see, not feel, how beautiful they are!
See *The Norton Anthology of Poetry,* p. 611. Church
owned a seven-volume edition of Coleridge's works (Pro-
fessor Shedd, ed., [New York: Harper and Brothers,
1854], which is still in the library at Olana.

4. The remainder of this notice is a quotation of the re-
view in the *Boston Evening Transcript* of 5 June 1860.

5. There follows at this point a brief discussion of
Church's *Niagara.*

6. This review, without the section on *Niagara,* was re-
printed in the *Boston Evening Transcript,* 22 June 1860.

# Select Bibliography

Additional sources appear in the Notes.

I. Manuscript collections and special resources

Archives of American Art, National Museum of American Art, Smithsonian Institution, Washington, D.C.

Inventory of American Paintings Executed Before 1914, National Museum of American Art, Smithsonian Institution, Washington, D.C.

Joseph R. Downes Manuscript Collection, H. F. DuPont Winterthur Museum, Winterthur, Delaware

Rare Book Room and Manuscript Collection, Library of Congress, Washington, D.C.

McKinney Library, Albany Institute of History and Art, Albany, New York

National Museum of American Art Pre-1877 Art Exhibition Catalogue Index, Smithsonian Institution, Washington, D.C.

Rare Book Room and Manuscript Collection, New York Public Library, New York

Olana State Historic Site Archives, Hudson, New York

II. Nineteenth-century newspapers, magazines, and journals consulted for exhibition reviews and miscellaneous notices about art and artists (see Notes for references to specific exhibitions and individual works)

*The Albion*
*The Art-Journal*
*The Atlantic Monthly*
*The Boston Evening Transcript*
*Bulletin of the American Art-Union*
*The Christian Examiner*
*The Cosmopolitan Art Journal*
*The Crayon*
*The Evening Post*
*Harper's New Monthly Magazine*
*Harper's Weekly*
*The Home Journal*
*The International Magazine*
*The Knickerbocker*
*The Literary World*
*Littel's Living Age*
*Morning Courier and New York Enquirer*
*The Nation*
*The New-York Daily Tribune*
*The New York Evening Mirror*
*The New York Morning Express*

*The New York Herald*
*The New York Times*
*The New York World*
*Putnam's Monthly Magazine*
*The Round Table*
*Russell's Magazine*
*The Southern Literary Messenger*
*Spirit of the Times*

III. Books and articles

Abbott, Edward. "Grand Manan and 'Quoddy Bay." *Harper's New Monthly Magazine* 56 (March 1878): 541–556.

Abrams, M. H. *The Mirror and the Lamp: Romantic Theory and the Critical Tradition.* Oxford: Oxford University Press, 1958.

Adamson, Jeremy Elwell. "Frederic Church's 'Niagara': The Sublime as Transcendence." Ph.D. dissertation, University of Michigan, 1981.

Aldrich, T. B. "Among the Studios, No. 1." *Our Young Folks* 1 (September 1865): 594–98.

"American Art." *New York Quarterly* 1 (June 1852): 229–51.

"American Studio Talk." *International Studio Supplement* 2 (1900): xiii–xvi.

"Aristotle." "Church's Realism." *Boston Evening Transcript,* 16 March 1863, p. 1.

Avery, Myron H. "The Artists of Katahdin; American Mountain Painters, III; Frederic Edwin Church." *Appalachia* 10 (December 1944): 147–54.

Avery, Samuel P. *The Diaries, 1871–1882 of Samuel P. Avery, Art Dealer.* Edited by Madeline Fidell Beaufort, Herbert L. Kleinfield, and Jeanne K. Welcher. New York: Arno Press, 1979.

Badeau, Adam. *The Vagabond.* New York: Rudd and Carleton, 1859.

Badt, Kurt. *John Constable's Clouds.* London: Rutledge and Kegan Paul, Ltd., 1950.

Baigell, Matthew. "Frederic Church's 'Hooker and Company': Some Historic Considerations." *Arts Magazine* 56 (January 1982): 124–25.

Bailey, J. W. "Account of an Excursion to Mount Katahdin, In Maine." *The American Journal of Science and Art* 32 (July 1837): 20–34.

Barker, Alan. *The Civil War in America.* Garden City: Anchor Books, 1961.

Bayley, W. P. [W. P. B.]. "Mr. Church's Picture of 'The Icebergs'." *The Art-Journal* 2 (September 1863): 187–88.
———. "Mr. Church's Pictures. Cotopaxi, Chimborazo, and The Aurora Borealis. Considered Also with Reference to English Art." *The Art-Journal* 4 (September 1865): 265–67.

Beecher, Henry Ward. *Star Papers: or, Experiences of Art and Nature.* New York: J. C. Derby, 1855.

Benjamin, S. G. W. *Art in America.* New York: Harper and Brothers, 1880.
———. "Fifty Years of American Art, 1828–1878; II." *Harper's New Monthly Magazine* 59 (September 1879): 487–92.

Benson, Eugene. "Pictures in the Private Galleries of New York; II; Gallery of John Taylor Johnson." *Putnam's Magazine* 6 (July 1870): 81–87.

Bercovitch, Sacvan. *The Puritan Origins of the American Self.* New Haven and London: Yale University Press, 1975.

Blaugrund, Annette. "The Tenth Street Studio Building: A Roster, 1857–1895." *The American Art Journal* 14 (Spring 1982): 67–71.

Boase, T. S. R. "Shipwrecks in English Romantic Painting." *Journal of the Warburg and Courtauld Institutes* 22 (July–December 1959): 332–46.

Born, Wolfgang. *American Landscape Painting.* New Haven: Yale University Press, 1948.

Brooks, Van Wyck. *The Flowering of New England: Emerson, Thoreau, Hawthorne and the Beginnings of American Literature.* New York: E. P. Dutton, 1936.

Bryant, William Cullen, ed. *Picturesque America.* New York: D. Appleton and Co., 1876.
———. *Poems by William Cullen Bryant.* New York: D. Appleton and Co., 1854.

Bryant, William M. *Philosophy of Landscape Painting.* St. Louis: St. Louis News Co., 1882.

Bunksé, Edmunds. "Humboldt and an Aesthetic Tradition in Geography." *The Geographical Review* 71 (April 1981): 127–46.

Burke, Doreen Bolger. "Frederic Church and 'The Banner of Dawn'." *The American Art Journal* 14 (Spring 1982): 39–46.

Butlin, Martin and Joll, Evelyn. *The Paintings of J. M. W. Turner.* New Haven and London: Yale University Press, 1977.

Caffin, Charles H. *The Story of American Painting*. New York: Frederick A. Stokes Co., 1907.

Callow, James T. *Kindred Spirits: Knickerbocker Writers and American Artists, 1807–1855*. Chapel Hill: University of North Carolina Press, 1967.

Cantor, Jay E. *The Landscape of Change; Views of Rural New England, 1790–1865*. Sturbridge, Mass.: Old Sturbridge Village, 1976.

———. "The New England Landscape of Change." *Art in America* 64 (January–February 1976): 51–54.

Carpenter, Frederic I. "The American Myth: Paradise (to be) Regained." *Publications of the Modern Language Association of America* 74 (December 1959): 599–606.

Carr, Gerald L. *Albert Bierstadt*. New York: Alexander Galleries, 1983.

———. "American Art in Great Britain: The National Gallery Watercolor of *The Heart of the Andes*." *Studies in the History of Art* 10 (1982): 81–100.

———. "Beyond the Tip: Some Addenda to Frederic Church's 'The Icebergs'." *Arts Magazine* 56 (November 1981): 107–111.

———. *Frederic Edwin Church: The Icebergs*. Dallas: Dallas Museum of Fine Arts, 1980.

———. "New Information on Church's Paintings at Olana." *The Crayon* [Olana] (Spring 1983): 10–12.

Carroll, Peter N. *Puritanism and the Wilderness: The Intellectual Significance of the New England Frontier, 1629–1675*. New York and London: Columbia University Press, 1969.

Carter, Samuel III. *Cyrus Field: Man of Two Worlds*. New York: G. P. Putnam's Sons, 1968.

Cary, Edward. *George William Curtis*. Boston and New York: Houghton, Mifflin and Co., 1894.

[Church, Frederic Edwin]. "Mountain Views and Coast Scenery, By a Landscape Painter." *Bulletin of the American Art Union* series for 1850 (November 1850): 129–31.

Cikovsky, Nicolai Jr. *George Inness*. New York: Praeger Publishers, 1971.

———. *The Life and Works of George Inness*. New York and London: Garland Publishing, Inc. 1977.

———. " 'The Ravages of the Axe': The Meaning of the Tree Stump in Nineteenth-Century American Art." *The Art Bulletin* 61 (December 1979): 611–26.

———. *Sanford Robinson Gifford*. Austin: University of Texas Art Museum, 1970.

Clark, Eliot. *History of the National Academy of Design, 1825–1953*. New York: Columbia University Press, 1954.

Coe, Benjamin H. *Easy Lessons in Landscape Drawing, with Sketches of Animals and Rustic Figures, and Directions for Using the Lead Pencil*. New York: Saxton and Miles, 1845.

———. *A New Drawing Book of American Scenery, Containing Thirty Four Views From Nature, with Instructions for Beginners in Landscape*. New York: Saxton and Miles, 1845.

Coke, Van Deren. *The Painter and the Photograph*. Albuquerque: University of New Mexico Press, 1972.

Colby, Elbridge. *Theodore Winthrop*. New York: Twayne Publishers, 1965.

Conron, John. *The American Landscape: A Critical Anthology of Prose and Poetry*. New York: Oxford University Press, 1974.

Coultas, Harland. *What May Be Learned From a Tree*. Philadelphia: C. Sherman and Sons, 1860.

Cowdrey, Mary Bartlett. *American Academy of Fine Arts and American Art Union Exhibition Record, 1816–1852*. Vol. 77: *Collections of the New-York Historical Society*. New York: New-York Historical Society, 1953.

———. *National Academy of Design Exhibition Record, 1826–1860*. Vol. 74: *Collections of the New-York Historical Society*. New York: New-York Historical Society, 1943.

Craven, Wayne. "Asher B. Durand's Imaginary Landscapes." *Antiques* 116 (November 1979): 1120–27.

Crospey, Jasper F. "Up Among the Clouds." *The Crayon* 2 (August 1855): 79–80.

[Curtis, George William]. "Theodore Winthrop." *The Atlantic Monthly* 8 (August 1861): 242–51.

Davenport, Guy, ed. *The Intelligence of Louis Agassiz: A Specimen Book of Scientific Writings*. Boston: Beacon Press, 1963.

Dee, Elaine Evans. *To Embrace the Universe: The Drawings of Frederic Edwin Church*. Yonkers: The Hudson River Museum, 1984.

Downes, William Howe and Robinson, Frank Torrey. "Our American Old Masters." *New England Magazine* 13 (November 1895): 289–307.

Durand, John. *The Life and Times of A. B. Durand*. New York: Charles Scribner's Sons, 1894.

Eager, Gerald. "The Iconography of the Boat in 19th-Century American Painting." *The Art Journal* 35 (Spring 1976): 224–30.

Eisenwerth, J. A. Schmoll gen. "Fensterbilder: Motivketten in der europäischer Malerei." *Beiträge zur Motivkunde des 19. jahrhunderts.* Vol. 6 in: *Studien zur Kunst des neunzehnten Jahrhunderts* (Munich: Prestel-Verlag, 1970).

Eitner, Lorenz. "The Open Window and the Storm-Tossed Boat." *The Art Bulletin* 37 (December 1955): 281–90.

Eliot, Ellsworth Jr. *Theodore Winthrop.* New Haven: Yale University Library, 1938.

*An Exhibition of Paintings by Thomas Cole. N. A., from the Artist's Studio, Catskill, New York.* New York: Kennedy Galleries, 1964.

"A Few Thoughts on Clouds." *The Knickerbocker* 35 (February 1850): 125–28.

"The Fine Arts: The Cole Exhibition." *The Literary World* 3 (April 1848): 186–87.

Flexner, James Thomas. *Nineteenth Century American Painting.* New York: G. P. Putnam's Sons, 1970.

———. *That Wilder Image.* Boston: Little, Brown, and Co., 1962.

Forster, Thomas. *Researches about Atmospheric Phenomena.* London: Harding, Mavor, 1823.

Foshay, Ella and Mills, Sally. *All Seasons and Every Light: Nineteenth-Century American Landscapes from the Collection of Elias Lyman Magoon.* Poughkeepsie: Vassar College Art Gallery, 1983.

Frankenstein, Alfred. *William Sidney Mount.* New York: Harry N. Abrams, Inc., 1975.

Frankenstein, John. *American Art: Its Awful Altitude: A Satire.* Cincinnati: By the Author, 1864.

"Frederic E. Church Dead; Famous Landscape Painter Passes Away in this City—His Career." *The New York Times,* 8 April 1900, p. 16.

French, Henry Willard. *Art and Artists in Connecticut.* Boston: Lee and Shepard; New York: Charles T. Dillingham, 1879; reprint ed., New York: Kennedy Graphics, 1970.

Frisinger, Howard H. *The History of Meteorology to 1800.* New York: Science History Publications, 1977.

Frye, Roland Mushat. *Milton and the Visual Arts: Iconographic Tradition in the Epic Poems.* Princeton: Princeton University Press, 1978.

Gage, John. *Colour in Turner: Poetry and Truth.* London: Studio Vista, 1969.

Gardner, Albert Ten Eyck. "Scientific Sources of the Full-Length Landscape: 1850." *The Metropolitan Museum of Art Bulletin* 4 (October 1945): 59–65.

Gavin, William J., III and Perkins, Robert F. *The Boston Atheneum Art Exhibition Index, 1827–1874.* Boston: The Library of the Boston Atheneum, 1980.

Gaylord Willis. "Influence of the Great Lakes on Our Autumnal Sunsets." *The American Journal of Science and Arts* 33 (January 1838): 335–41.

*Gems of Poetry, from Forty-Eight American Poets Embracing the Most Popular Authors.* Hartford: S. Andrus and Sons, 1852.

Gerdts, William H. *American Luminism.* New York: Coe Kerr Gallery, 1978.

Gilpin, William. *Mission of the North American People, Geographical, Social and Political.* Philadelphia: J. B. Lippincott and Co., 1873.

Glackens, Clarence J. *Traces on the Rhodian Shore.* Los Angeles: University of California Press, 1967.

"Going to Mount Katahdin." *Putnam's Monthly* 8 (September 1856): 242–56.

Gottlieb, Carla. *The Window in Art.* New York: Abaris Books, 1981.

Griffith, George Bancroft, ed. *The Poets of Maine.* Portland: Elwell, Pickard, and Co., 1888.

Griswold, Rufus W., ed. *Readings in American Poetry.* New York: John C. Riker, 1843.

H., H. B. "A Visit to the Studios of Some American Painters." *The Art-Journal* 48 (December 1865): 362–63.

Hahn, Steven and Prude, Jonathon. *The Countryside in the Age of Capitalist Transformation.* Chapel Hill and London: University of North Carolina Press, 1985.

Hanson, Bernard. *Frederic Edwin Church: The Artist at Work.* Hartford: University of Hartford, Joseloff Gallery, 1974.

Harding, Walter, and Francine Amy Koslow. *Henry David Thoreau as a Source of Artistic Inspiration.* Lincoln, Mass.: DeCordova and Dana Museum and Park, 1984.

Harris, Neil. *The Artist in American Society: The Formative Years, 1790–1860.* New York: George Braziller, Inc., 1966.

Hartmann, Sadakichi. *A History of American Art.* Boston: L. C. Page, 1902.

Haverstock, Mary Sayre. "The Tenth Street Studio." *Art in America* 54 (September–October 1966): 48–57.

Hawes, Louis. *The American Scene.* Bloomington: Indiana University Art Museum, 1970.

———. "John Constable's Sky Sketches." *Journal of the Warburg and Courtauld Institutes* 32 (1969): 344–65.

Hendricks, Gordon. *Albert Bierstadt.* Fort Worth: Amon Carter Museum, 1972.

———. *Albert Bierstadt, Painter of the American West.* New York: Harry N. Abrams, 1973.

Holcomb, Adele M. "John Sell Cotman's *Dismasted Brig* and the Motif of the Drifting Boat." *Studios in Romanticism* 14 (Winter 1975): 29–40.

Holley, A. L. ["Arbor Ilex"]. "Camps and Tramps About Ktaadn." *Scribner's Monthly* 16 (May 1878): 33–47.

*The Home Book of the Picturesque: Or, American Scenery, Art and Literature.* New York: G. P. Putnam, 1852; facsimile edition, Gainesville, Fla.: Scholar's Facsimiles and Reprints, 1967.

Howat, John K. *The Hudson River and Its Painters.* New York: Viking Press, 1972.

Huddleston, Eugene L. and Douglas A. Noverr. *The Relationship of Painting and Literature: A Guide to Information Sources.* American Studies Information Guide Series. Detroit: Gale Research Co., 1978.

Humboldt, Alexander von. *Cosmos: Sketch of a Physical Description of the Universe.* Trans. Edward Sabine. London: Longman, Brown, Green, and Longmans, and John Murray, 1848.

"Humboldt." *New-York Daily Times,* 5 May 1853, p. 2.

Huntington, David C. *Art and the Excited Spirit: America in the Romantic Period.* Ann Arbor: University of Michigan Museum of Art, 1972.

———. "Frederic Church's *Niagara:* Nature and the Nation's Type." *Texas Studies in Literature and Language* 25 (Spring 1983): 100–138.

———. *Frederic Edwin Church.* Washington: National Collection of Fine Arts, 1966.

———. "Frederic Edwin Church, 1826–1900: Painter of the Adamic New World Myth." Ph.D. dissertation, Yale University, 1960.

———. "Landscape and Diaries: The South American Trips of F. E. Church." *The Brooklyn Museum Annual* 5 (1963–64): 65–98.

———. *The Landscapes of Frederic Edwin Church: Vision of an American Era.* New York: George Braziller, 1966.

Hussey, Christopher. *The Picturesque: Studies in a Point of View.* London: Frank Cass and Co., 1967.

Jarves, James Jackson. *The Art-Idea.* Edited by Benjamin Rowland, Jr. Cambridge, Mass.: The Belknap Press of Harvard University Press, 1960.

Johnson, William R. "American Paintings in the Walters Art Gallery." *Antiques* 106 (November 1974): 853–61.

———. *The Nineteenth Century Paintings in the Walters Art Gallery.* Baltimore: The Walters Art Gallery, 1982.

Kelly, Franklin. "Church: Panoramas du Nouveau Monde." *Beaux-Arts* 12 (April 1984): 32–41.

———. "Frederic Church in the Tropics." *Arts in Virginia* 27 (1987): 16–33.

———. "Lane and Church in Maine," in John Wilmerding, ed., *Paintings by Fitz Hugh Lane.* Washington: National Gallery of Art, 1988.

———. "Myth, Allegory, and Science: Thomas Cole's Paintings of Mount Etna." *Arts in Virginia* 23 (1983): 2–15.

———, and Gerald L. Carr. *The Early Landscapes of Frederic Edwin Church, 1845–1854.* Fort Worth: Amon Carter Museum, 1987.

Ketner, Joseph D., II, and Michael Kammenga. *The Beautiful, The Sublime, and The Picturesque: British Influences on American Landscape Painting.* St. Louis: Washington University Gallery of Art, 1984.

Keyes, Donald D. *The White Mountains: Place and Perceptions.* Durham, N. H.: University Art Galleries, University of New Hampshire, 1980.

Kimball, Herbert. "The Duration and Intensity of Twilight." *Monthly Weather Review* 44 (November 1916): 614–20.

Kramer, Hilton. "The Visionary Landscapes of Frederic Church." *The New York Times,* 6 March 1966, p. 17.

Lanman, Charles. "The Epic Paintings of Thomas Cole." *Southern Literary Messenger* 15 (June 1849): 351–56.

———. *Letters From a Landscape Painter.* Boston: James Monroe and Co., 1845.

———. "Our Landscape Painters." *Southern Literary Messenger* 16 (May 1850): 272–80.

Lawall, David B. *A. B. Durand, 1796–1886.* Montclair, N. J.: Montclair Art Museum, 1971.

———. *Asher B. Durand: A Documentary Catalogue of the Narrative and Landscape Paintings.* New York and London: Garland Publishing Inc., 1978.

Lewis, R. W. B. *The American Adam.* Chicago: University of Chicago Press, 1955.

Lindquist-Cock, Elizabeth. "Frederic Church's Stereographic Vision." *Art in America* 61 (September–October 1973): 70–75.

———. *The Influence of Photography on American Landscape Painting, 1839–1880.* New York and London: Garland Publishing, Inc., 1977.

Lord, David N. *An Exposition of the Apocalypse.* New York: Harper and Brothers, 1847.

Love, William DeLoss. *The Colonial History of Hartford.* Hartford: By the Author, 1914.

Lurie, Edward. *Louis Agassiz: A Life in Science.* Chicago: The University of Chicago Press, 1960.

———. *Nature and the American Mind: Louis Agassiz and the Culture of Science.* New York: Science History Publications, 1974.

McClinton, Katherine Morrison. "Letters of American Artists to Samuel P. Avery." *Apollo* 120 (September 1984): 182–87.

McCoubrey, John W. *American Art, 1700–1960: Sources and Documents.* Englewood Cliffs, N. J.: Prentice-Hall, Inc., 1965.

McCoy, Garnett. "Visits, Parties, and Cats in the Hall: The Tenth Street Studio Building and its Inmates in the Nineteenth Century." *Journal of the Archives of American Art* 6 (January 1966): 1–8.

McNulty, J. Bard, ed. *The Correspondence of Thomas Cole and Daniel Wadsworth.* Hartford: The Connecticut Historical Society, 1983.

Maddox, Kenneth W. *An Unpredjudiced Eye: The Drawings of Jasper F. Cropsey.* Yonkers: The Hudson River Museum, 1980.

"Mairan's Description of Anti-Twilight." *Monthly Weather Review* 44 (November 1916): 623–44.

Mann, Maybelle. *The American Art-Union.* Washington: Collage Inc., 1977.

Marlor, Clark S. *A History of the Brooklyn Art Association, with an Index of Exhibitions.* New York: James F. Carr, 1970.

Marsh, George P. *Man and Nature: or, Physical Geography as Modified by Human Action.* New York: Charles Scribner, 1864.

Marx, Leo. *The Machine in the Garden.* London, Oxford, and New York: Oxford University Press, 1964.

Marzio, Peter C. *The Art Crusade: An Analysis of American Drawing Manuals, 1820–1860.* Washington: Smithsonian Institution Press, 1976.

Matthiessen, F. O. *American Renaissance: Art and Expression in the Age of Emerson and Whitman.* New York, London, and Oxford: Oxford University Press, 1941.

Mellon, Gertrude A., and Elizabeth F. Wilder, eds. *Maine and its Role in American Art.* New York: Viking Press, 1963.

Merk, Frederick. *Manifest Destiny and Mission in American History: A Reinterpretation.* New York: Alfred A. Knopf, 1963.

Merritt, Howard S. *Thomas Cole.* Rochester: Memorial Art Gallery of the University of Rochester, 1969.

———. *To Walk With Nature: The Drawings of Thomas Cole.* Yonkers: The Hudson River Museum, 1981.

"Meteorology: A Glance at the Science." *The Atlantic Monthly* 6 (July 1860): 1–15.

Miller, Perry, ed. *The American Transcendentalists: Their Prose and Poetry.* Garden City, N. Y.: Doubleday and Co., 1957.

———. *Errand into the Wilderness.* Cambridge, Mass.: The Belknap Press of Harvard University Press, 1956.

———. *Nature's Nation* Cambridge, Mass.: The Belknap Press of Harvard University Press, 1967.

Milne, Gordon. *George William Curtis and the Genteel Tradition.* Bloomington: Indiana University Press, 1956.

Montgomery, Walter, ed. *American Art and American Art Collections.* Boston: E. W. Walker and Co., 1889.

Moore, James Collins. "The Storm and the Harvest: The Image of Nature in Mid-Nineteenth Century American Landscape Painting." Ph.D. dissertation, Indiana University, 1974.

———. "Thomas Cole's *The Cross and the World:* Recent Findings." *The American Art Journal* 5 (November 1973): 50–60.

Morison, Samuel Eliot. *The Story of Mount Desert Island, Maine.* Boston: Little, Brown, and Co., 1960.

Moure, Nancy Dustin Wall. *William Louis Sonntag, Artist of the Ideal, 1822–1900.* Los Angeles: Goldfield Galleries, 1980.

Naef, Weston J. and Wood, James N. *Era of Exploration: The Rise of Landscape Photography in the American West, 1860–1885.* New York and Buffalo: Metropolitan Museum of Art and Albright-Knox Art Gallery, 1975.

Nash, Roderick. *Wilderness and the American Mind.* Rev. ed. New Haven and London: Yale University Press, 1973.

Naylor, Maria. *The National Academy of Design Exhibition Record, 1861–1900*. New York: Kennedy Galleries, Inc., 1973.

Nicholson, Marjorie Hope. *Mountain Gloom and Mountain Glory: The Development of the Aesthetics of the Infinite*. Ithaca: Cornell University Press, 1959.

———. *Newton Demands the Muse*. Princeton: Princeton University Press, 1946.

*Nineteenth-Century American Landscape Drawings in the Collection of the Cooper-Hewitt Museum*. New York: Cooper-Hewitt Museum, 1982.

Noble, Louis L. *After Icebergs With a Painter: Summer Voyage to Labrador and Around Newfoundland*. 2d ed. New York: D. Appleton and Co., 1862.

———. *Church's Painting, The Heart of the Andes*. New York: D. Appleton and Co., 1859.

———. *The Life and Works of Thomas Cole*. Ed. Elliot S. Vessel. Cambridge, Mass.: Harvard University Press, 1964.

*The Norton Anthology of Poetry*. New York: W. W. Norton, 1970.

Novak, Barbara. "American Landscape: Changing Concepts of the Sublime." *The American Art Journal* 4 (Spring 1972): 36–42.

———. "American Landscape: The Nationalist Garden and the Holy Book." *Art in America* 60 (January–February 1972): 46–58.

———. *American Painting of the Nineteenth Century*. New York: Praeger Publishers, 1969.

———. "The Double-Edged Axe." *Art in America* 64 (January–February 1976): 45–50.

———. "Grand Opera and the Still Small Voice." *Art in America* 59 (March–April 1971): 64–73.

———. *Nature and Culture: American Landscape Painting, 1825–1875*. New York: Oxford University Press, 1980.

———. *Next to Nature: American Landscape Paintings from the National Academy of Design*. New York: National Academy of Design, 1980.

Olcott, William Tyler. *Sun Lore of All Ages*. New York: G. P. Putnam's Sons, 1914.

Oram, William. *Precepts and Observations on the Art of Colouring in Landscape Painting*. London: White and Cochrane, 1810.

"Our Artists; I: F. E. Church." *New York Commercial Advertiser*, 19 March 1861, p. 1.

P., G. W. "Some Remarks on Landscape Art. No. II." *Bulletin of the American Art-Union* 2 (December 1849): 15–19.

Paley, Morton D. *The Apocalyptic Sublime*. New Haven and London: Yale University Press, 1986.

Parish, Peter J. *The American Civil War*. New York: Holmes and Meier, Inc., 1975.

Parry, Lee. "Landscape and Theater in America." *Art in America* 59 (November–December 1971): 52–61.

Peterson, R. E., ed. *Peterson's Familiar Science: or, the Scientific Explanation of Common Things*. Philadelphia: Sower, Barnes, and Potts, 1863.

Pinto, Holly Joan. *William Cullen Bryant and the Hudson River School of Painting*. Roslyn, N. Y.: Nassau County Museum of Fine Art, 1981.

Pointon, Marcia. *Milton and English Art*. Manchester: Manchester University Press, 1970.

Polehampton, Edward. *The Gallery of Nature and Art: or, a Tour Through Creation and Science*. London: Walker and Co., 1821.

Richardson, Edgar P. "Allston and the Development of Romantic Color." *The Art Quarterly* 7 (Winter 1944): 33–57.

———. *Painting in America*. New York: Crowell, 1956.

Ridner, John P. *The Artist's Chromatic Handbook*. New York: George P. Putnam, 1850.

Ringe, Donald A. "Painting as Poem in the Hudson River Aesthetic." *American Quarterly* 12 (Spring 1960): 71–83.

———. *The Pictorial Mode: Space and Time in the Art of Bryant, Irving and Cooper*. Lexington: The University Press of Kentucky, 1971.

Rockwell, Charles, ed. *The Catskill Mountains and the Region Around*. New York: Taintor Brothers and Co., 1867.

Ronchi, Vasco. *The Nature of Light*. Cambridge, Mass.: Harvard University Press, 1970.

Rosenblum, Robert. *Modern Painting and the Northern Romantic Tradition: Friedrich to Rothko*. New York: Harper and Row, 1975.

Rozenberg, Georgii Vladimirovich. *Twilight: A Study in Atmospheric Optics*. New York: Plenum Press, 1966.

Ruskin, John. *The Works of John Ruskin*. Edited by E. T. Cook and Alexander Wedderburn. London: George Allen, 1903.

Rutledge, Anna Wells. *Cumulative Record of Exhibition*

*Catalogues: The Pennsylvania Academy of Fine Arts.* Philadelphia: The American Philosophical Society, 1955.

St. Armand, Barton Levi. "Luminism in the Work of Henry David Thoreau: The Dark and the Light." *The Canadian Review of American Studies* 2 (Spring 1980): 13–30.

Saunders, Richard. *Daniel Wadsworth, Patron of the Arts.* Hartford: Wadsworth Atheneum, 1981.

Seaver, Esther Isabel. *Thomas Cole, 1801–1848, One Hundred Years Later.* Hartford and New York: Wadsworth Atheneum and Whitney Museum of American Art, 1948.

Sharf, Frederic Alan. "Fitz Hugh Lane: Visits to the Maine Coast, 1848–1855." *Essex Institute Historical Collections* 98 (April 1962): 111–20.

Shepard, Lewis A. *American Painters of the Arctic.* Amherst and New York: Mead Art Gallery, Amherst College and Coe Kerr Gallery, 1975.

Shepard, Paul. *Man in Landscape: An Historic View of the Esthetics of Nature.* New York: Alfred A. Knopf, 1967.

———. "Paintings of the New England Landscape: A Scientist Looks at their Geomorphology." *College Art Journal* 17 (Fall 1957): 30–42.

———. "Place in American Culture." *The North American Review* 262 (Fall 1977): 22–32.

Simoni, John. "Art Critics and Criticism in Nineteenth Century America." Ph.D. dissertation, Ohio State University, 1952.

Smith, Henry Nash. *Virgin Land.* Cambridge, Mass.: Harvard University Press, 1950.

Spencer, Harold, ed. *American Art: Readings from the Colonial Era to the Present.* New York: Charles Scribner's Sons, 1980.

Springer, John S. *Forest Life and Forest Trees.* New York: Harper and Brothers, 1851.

Stebbins, Theodore E., Jr. "American Landscape: Some New Acquisitions at Yale." *Yale University Art Gallery Bulletin* 33 (Autumn 1971): 10–16.

———. *American Master Drawings and Watercolors.* New York: Harper and Row, 1976.

———. *Close Observation: Selected Oil Sketches by Frederic E. Church.* Washington: Smithsonian Institution Press, 1978.

———. *The Hudson River School: 19th Century American Landscape Paintings in the Wadsworth Atheneum.* Hartford: Wadsworth Atheneum, 1976.

———. *The Life and Works of Martin Johnson Heade.* New Haven and London: Yale University Press, 1975.

———. *Luminous Landscape: The American Study of Light, 1860–1875.* Cambridge, Mass.: Fogg Art Museum, Harvard University, 1966.

———. *Martin Johnson Heade.* College Park, Md.: Art Department, University of Maryland, 1969.

———. *A New World: Masterpieces of American Painting, 1760–1910.* Boston: Museum of Fine Arts, 1983.

Stehle, R. H. "The Düsseldorf Gallery of New York." *The New-York Historical Society Quarterly* 58 (October 1974): 305–14.

Stein, Roger B. *John Ruskin and Aesthetic Thought in America, 1840–1900.* Cambridge, Mass.: Harvard University Press, 1967.

———. *Seascape and the American Imagination.* New York: Whitney Museum of American Art, 1975.

———. *Susquehana: Images of the Settled Landscape.* Binghampton, NY: Roberson Center for the Arts and Sciences, 1981.

Stevens, Elisabeth. "An Observant Melodramatist." *Arts Magazine* 40 (April 1966): 44–47.

Stilgoe, John R. *Common Landscape of America.* New Haven and London: Yale University Press, 1982.

———. "A New England Coastal Wilderness." *The Geographical Review* 71 (January 1981): 33–50.

Stillman, William James. *Autobiography of a Journalist.* Boston and New York: Houghton, Mifflin, and Co., 1901.

Strong, George Templeton. *The Diary of George Templeton Strong.* Edited by Allan Nevins and Milton Halsey Thomas. New York: Macmillan Co., 1952.

*Studies on Thomas Cole, An American Romanticist.* Baltimore: Baltimore Museum of Art, 1967.

Sweeney, J. Gray. "The Artist-Explorers of the American West, 1860–1880." Ph.D. dissertation, University of Michigan, 1975.

———. *Themes in American Painting.* Grand Rapids: The Grand Rapids Art Museum, 1977.

Sweet, Frederick A. *The Hudson River School and the Early American Landscape Tradition.* New York and Chicago: Art Institute of Chicago and Whitney Museum of American Art, 1945.

Sylvester, W. "Sunsets." *The Crayon* 2 (September 1855): 191–92.

Talbot, William S. "American Visions of Wilderness."

*Bulletin of the Cleveland Museum of Art* 61 (April 1969): 151–65.

———. *Jasper F. Cropsey.* Washington: National Collection of Fine Arts, 1970.

———. *Jasper F. Cropsey, 1823–1900.* New York and London: Garland Publishing, Inc., 1977.

Thoreau, Henry David. *The Maine Woods.* New York: Thomas Y. Crowell, 1961.

———. *Walden.* New York: New American Library, 1960.

———. *The Writings of Henry David Thoreau.* Ed. Franklin Benjamin Sanborn and Bradford Torrey. Boston and New York: Houghton, Mifflin, and Co., 1906.

Tichi, Cecilia. *New World, New Earth: Environmental Reform in American Literature from the Puritans through Whitman.* New Haven and London: Yale University Press, 1979.

"Trees in Assemblages." *The Atlantic Monthly* 8 (August 1861): 129–41.

Truettner, William. "The Genesis of Frederic Edwin Church's *Aurora Borealis.*" *The Art Quarterly* 31 (Autumn 1968): 267–83.

Trumbull, Benjamin. *A Complete History of Connecticut, Civil and Ecclesiastical, from the Emigration of its First Planters from England, in the Year 1630, to the Year 1764 and to the Close of the Indian Wars.* New London: H. D. Utley, 1898.

Tuckerman, Henry T. *The Book of the Artists.* New York: G. P. Putnam and Son, 1867.

———.["An Old Contributor"]. "New-York Artists." *The Knickerbocker* 48 (July 1856): 26–42.

"Von Bezold's Description of Twilight." *Monthly Weather Review* 44 (November 1916): 620–23.

Warner, Charles Dudley. *Paintings by Frederic Edwin Church, N. A.* New York: Metropolitan Museum of Art, 1900.

Weinberg, Albert K. *Manifest Destiny: A Study of Nationalist Expansion in American History.* Baltimore: Johns Hopkins Press, 1935.

Weiss, Ila. *Sanford Robinson Gifford (1823–1880).* New York and London: Garland Publishing, Inc., 1977.

Whittier, John Greenleaf. "The River Path." *Boston Evening Transcript.* 21 July 1860, p. 1.

Wilmerding, John. *American Art.* New York: Penguin Publishers, 1976.

———. *An American Perspective: Nineteenth-Century Art from the Collection of Jo Ann and Julian Ganz, Jr.* Washington: National Gallery of Art, 1981.

———. *Fitz Hugh Lane.* New York: Praeger Publishers, 1971.

———, ed. *The Genius of American Painting.* New York: William Morrow and Co., 1973.

———. *A History of American Marine Painting.* Boston and Toronto: Little, Brown, and Co., 1968.

———. Review of *The Landscapes of Frederic Edwin Church,* by David Huntington. *The Massachusetts Review* 8 (Winter 1967): 208–212.

Wilson, Christopher Kent. "The Landscape of Democracy: Frederic Church's *West Rock, New Haven.*" *American Art Journal* 18 (1986): 20–39.

Wilton, Andrew. *J. M. W. Turner: His Art and Life.* New York: Rizzoli, 1979.

———. *Turner and the Sublime.* Ontario and New Haven: Art Gallery of Ontario and Yale Center for British Art, 1980.

Winthrop, Theodore. *Cecil Dreeme.* Boston: Ticknor and Fields, 1861.

———. *A Companion to the Heart of the Andes.* New York: D. Appleton and Co., 1859.

———. *Life in the Open Air.* Boston: Ticknor and Fields, 1863.

Wolf, Bryan Jay. *Romantic Revision: Culture and Consciousness in Nineteenth-Century American Painting and Literature.* Chicago and London: University of Chicago Press, 1982.

Woolf, Eugene T. *Theodore Winthrop: Portrait of an American Author.* Washington: University Press of America, 1981.

# List of Illustrations

## Colorplates

# Index

176